THE ART OF ROME
c. 753 B.C. – A.D. 337

Sources and Documents

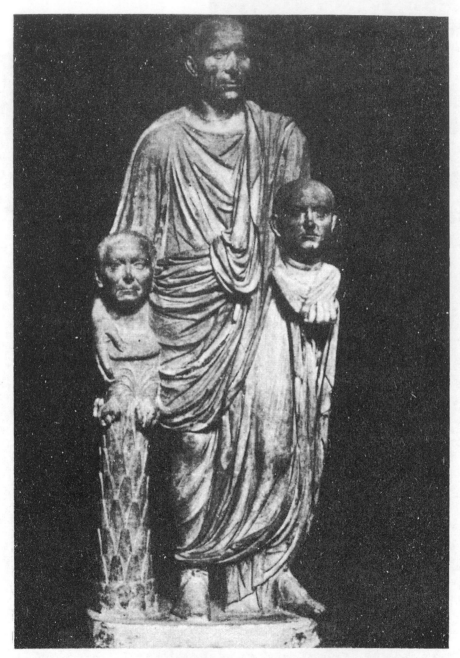

Portrait of a Roman patrician holding portrait busts of his ancestors. Late first century B.C. Height 1.65 m. Marble. The statue was formerly in the Palazzo Barberini in Rome and is hence sometimes referred to as the 'Barberini Togatus'. Now in the Museo Nuovo Capitolino, braccio nuovo. Photo Alinari 28576.

The Art of Rome

c. 753 B.C. – A.D. 337

Sources and Documents

by

J. J. POLLITT

*John M. Schiff Professor of Classical Archaeology
and History of Art, Yale University*

CAMBRIDGE
UNIVERSITY PRESS

Published by the Press Syndicate of the University of Cambridge
The Pitt Building, Trumpington Street, Cambridge CB2 1RP
40 West 20th Street, New York, NY 10011-4211 USA
10 Stamford Road, Oakleigh, Melbourne 3166, Australia

First published by Prentice-Hall, Inc. 1966
Reissued by Cambridge University Press 1983
Reprinted 1986, 1988, 1989, 1992, 1995, 1998

Printed in the United Kingdom at the University Press, Cambridge

Library of Congress catalogue card number: 82–23439

British Library Cataloguing in Publication Data
Pollitt, J. J.
The art of Rome c. 753 B.C. – 337.
1. Art, Roman
I. Title
709'.37 N5760

ISBN 0 521 25367 5 hard covers
ISBN 0 521 27365 X paperback

NWP

Contents

Appendix *231*

Index *237*

Preface

The purpose of this book is to make the most important ancient literary testimonia relating to Roman art accessible to students who are not specialists in the Classical languages or Classical archaeology. At the same time it is hoped that the convenience of the collection will make it of use to specialists.

The original texts for many of the passages dealing with the sculpture and painting of the Republic may be found in O. Vessberg's extremely useful *Studien zur Kunstgeschichte der Römischen Republik* (Lund/Leipzig, 1941). No equivalent collection exists for the sculpture and painting of the Empire, nor is there any collection dealing with Roman architecture. Consequently, with the exception of a few texts which are given in the final section ("Nachblüthe der Kunst") of Overbeck's *Schriftquellen*, the passages on Imperial art in the present volume cannot be correlated with any anthological collection. Texts, some of which are of art historical interest, relating to the topography and monuments of ancient Rome, are collected in G. Lugli, *Fontes ad Topographiam Veteris Urbis Romae* (Rome, 1952-1965). A collection of texts illustrating Roman artistic taste may be found in G. Becatti, *Arte e Gusto negli Scrittori Latini* (Florence, 1951).

In view of the close relationship between Roman art and Roman history (see the Introduction which follows), I have included fairly extensive historical sketches of the periods covered by each major section of this book. These, once again, are intended to provide background for the non-specialist, and I take it for granted that specialists will view them in that light.

The bibliographical references in the footnotes, as with the companion volume on Greek art, attempt mainly to correlate the literary evidence with extant monuments and to point out difficulties in the text. They are intended to be helpful rather than exhaustive.

It should be noted that when the word "Forum" is capitalized and not accompanied by any qualifying phrase (e.g., "Forum of Trajan"), it refers to the *Forum Romanum*.

All the translations employed in this volume are my own.

The drawings and diagrams illustrating Vitruvius' descriptions of the Tuscan temple and the basilica at Fanum are by H. L. Warren and were originally published in M. H. Morgan's *Vitruvius, The Ten Books on Architecture* (Cambridge, Mass., 1914).

I am indebted to my wife for invaluable help in preparing the manuscript and map, to H. W. Janson for unfailingly good advice, and to James M. Guiher and William R. Grose of Prentice-Hall for their patience and perseverance.

J. J. POLLITT

Preface to the reissue of 1983

The purpose of this book remains the same as that expressed in its original preface, i.e. to make the most important ancient literary testimonia relating to Roman art accessible to readers who are not necessarily specialists in the Classical languages or Classical archaeology.

It may be useful to take note of a few works that have appeared since the original version of this book was published in 1966 and that can be used either to supplement the sources collected here or to supplement my footnotes with additional illustrations and commentary. D. R. Dudley's *Urbs Roma* (Aberdeen, 1967), a collection of translations along with some Latin texts of sources dealing with the city of Rome, is particularly useful for its citations of inscriptions. K. Chisholm and J. Ferguson, *Rome, the Augustan Age* (Oxford, 1981) assembles translations of sources dealing with the art and also the politics, social history, and religion of the Augustan period.

In correlating the many texts that describe the topography of ancient Rome with surviving monuments, the references given in the notes to Platner–Ashby, *A Topographical Dictionary of Ancient Rome* and Nash, *Pictorial Dictionary of Ancient Rome* can now be supplemented by two recent and very useful works of F. Coarelli: *Guida archeologica di Roma* (Verona, 1974) and *Roma* (*Guide archeologiche Laterza*, Bari, 1981). In connection with the archaeological evidence for the earliest periods of Rome's history, it should be noted that Gjerstad's *Early Rome* (cited on p. 5, note 2) is now complete in six volumes (as of 1973) and that the final volume provides a useful summary of the detailed information contained in the earlier ones.

Of the many general works that have appeared on Roman art in the last fifteen years, four deserve special citation not only for their interesting texts but also for their extensive illustrations: B. Andreae, *The Art of Rome* (English translation, London, 1978); R. Bianchi-Bandinelli, *Rome: the Center of Power* (English translation, New York, 1970) and *Rome: the Late Empire* (English translation, New York, 1971); and A. Boethius and J. B. Ward-Perkins, *Etruscan and Roman Architecture* (Harmondsworth, 1970).

All of the books cited above contain useful bibliographies of more specialized articles and monographs.

I now hope that readers will ignore my ill-advised attempts in several footnotes to translate the value of Roman sesterces into U.S. dollars as of 1966 (pp. 76, 79, 85, and 88). The dollar, of course, is not what it was, and, in any case, it is extremely difficult to equate the purchasing power of currency in a modern industrialized society with that of an ancient currency. Suffice it to say that, whatever the sum was which Lucullus paid to the sculptor Arkesilaos (p. 85), it was a lot of money.

I am grateful to Susan Matheson and Diana Kleiner for advice and assistance in preparing this reprint and also to Pauline Hire and the Syndics of Cambridge University Press for giving the book a new lease on life.

New Haven, 1982 J. J. POLLITT

NOTE TO THE 1995 IMPRESSION

I have taken the opportunity of altering the cross-references to my *The Art of Greece: 1400-31 B.C.* (Englewood Cliffs, NJ 1965) to accord with the pages of the second edition (*The Art of Ancient Greece: Sources and Documents*, Cambridge 1990).

Introduction

THE HISTORICAL CONSCIOUSNESS
OF ROMAN ART

When the Greeks sought for beginnings and for an order in the cosmos they turned to a divine mythology like that contained in the *Theogony* of Hesiod, in which primeval forces—chaos, earth, heaven, and night—shaped a universe which was ever after dominated by divine personalities. The Roman pantheon, by contrast, had almost no mythology behind it. The deities of the early Romans were forces rather than personalities, and almost all the mythological deeds and characteristic personalities which eventually came to be ascribed to them were borrowed from the Greeks. When the Romans sought for beginnings and for an order in the cosmos they turned not to the gods, but to mortal men—Aeneas and Latinus, founders of the race; Romulus, founder of the city; Numa the giver of laws, and so on. Of these it could be alleged both that they were born and that they died at a specific time and in a specific place. Objects associated with these founders, such as the Palladium brought by Aeneas from Troy or the hut in which Romulus had lived, could be seen and respected by their descendants. By at least as early as the 1st century B.C. the Romans' natural inclination to dwell on human history and their own place in it had blossomed into a firm conviction that the city had a divinely appointed historical destiny. The relentless process by which a small agrarian village had become master first of Italy and then of most of the civilized world suggested that there was something inevitable and irresistible guiding it. This spirit pervades Vergil's *Aeneid*, in which, as the reader follows the struggles of Aeneas and is given a description of the primitive site of Rome, he is compelled to think of all the struggles which were to follow and of the grandeur of the city under Augustus. At many points in the narrative, but especially in the supernatural realm of the Underworld, where time is telescoped and the workings of destiny become clear, Aeneas confronts through prophecy, symbol or vision almost all the great heroes of later Roman history. It is during the vision of Rome's future in the Underworld that Aeneas' father Anchises utters the familiar lines which not only capture the Roman sense of historical destiny but put the arts in their proper perspective:

Others with greater subtlety will hammer out breathing images from bronze
(this, at least, I believe), and will, from marble, draw forth the faces of
living men. They will plead cases better, describe with a staff the course
of the heavens, and predict the rising of the stars; You, O Roman, must
remember to rule with might over nations. Let these be your arts, to crown
tradition with peace, to spare the conquered, and to humble the proud
(*Aeneid*, VI, 847-853).

Rome's native art was government. The skill of others, most obviously
the Greeks, in the visual arts might surpass that of the Romans, but this
shortcoming seems not to have been regarded as serious. The art of ruling
brought with it the advantages of all the other arts. By conquering and
controlling Greece and Asia the city became filled with the finest works
of art which the Hellenistic world could offer. Statues and paintings, in
any case, were luxuries, not essentials, of life. Some conservative Romans,
in fact, felt that they were better off without them (see pp. 32-34). Even
Cicero, a devotee and collector of Greek art, felt compelled to explain
to the Senate that the devotion which the Sicilian Greeks felt for the
works of art plundered by Verres would undoubtedly seem incredible
and inexplicable to a Roman (see p. 74).

In view of these conditions it is not surprising that Roman art was
to a great extent the servant of Roman history and that its function
was above all commemorative. Virtually every major work of Roman
art—from huge buildings to small engraved gems—commemorated spe-
cific historical events and personalities. Great buildings celebrated mili-
tary victories or political programs and bore the names of their builders.
Paintings and statues came as booty from great military victories or at
least celebrated great political and military achievements. Portraits pre-
served a detailed likeness of an individual, primarily for his descendants,
but in the case of a famous man, for all his countrymen. It is true, of
course, that other artistic traditions have produced commemorative art.
The Greeks, for example, had votive portraits of athletes, statesmen,
orators and other prominent citizens, and some of their buildings—the
Periclean monuments on the Acropolis are a good example—commemo-
rated military and political achievements. But a contrast of these Greek
creations with their Roman counterparts is illuminating. The Classical
Greeks always sought for the general, universal, and archetypal element
underlying any specific form or event. In the architectural sculpture of
the Parthenon the great Greek victory over the Persians was referred to
obliquely by the use of more generalized mythological symbols—the
battle of the Gods and Giants, the Greeks and the Amazons, and so on.
Moreover, no Greek temples and, prior to the Hellenistic period, few
other public monuments, were identified by the names of their builders.
In Greek portraits the general category to which the person represented
belonged was always of more importance than the details of his phys-
iognomy. It may be that Myron's *Diskobolos* was a votive portrait of a

particular athlete, but even in Antiquity it soon come to be viewed as a "type." The Charioteer of Delphi may well be a portrait of a specific person, but one seldom thinks of it as such. Even in the case of a relatively late portrait of a known person, like the Agias attributed to Lysippos, one is more conscious of the genre than the individual. Looking at a characteristic Roman portrait, even if it is anonymous, one is conscious of looking at a specific mortal man with all his idiosyncrasies and limitations. Even when his status is indicated by dress or gesture, one thinks first of the man, and then of the category.

The present volume will, it is hoped, help to illuminate this historical consciousness of Roman art by documenting many examples of that art's commemorative function. It may be that the Romans valued art most for its ability to keep the specific events and personalities of history alive. "For is there anyone," asks Polybios, after describing the Roman custom of making funeral portraits, "who would not be edified by seeing these portraits of men who were renowned for their excellence and by having them all present as if they were living and breathing?" (see p. 53). And in the same spirit, Pliny praises Varro for having invented a method of adding portraits to his [Varro's] works, "thereby not allowing human appearances to be forgotten nor the dust of ages to prevail against men" (see p. 91).

ASPECTS OF ROMAN ART CRITICISM

In a general way this intense consciousness of history may be said to form the most consistent element in Roman art criticism, since it was the quality which the Romans most often looked for and appreciated in art.

Another less comprehensive but frequently recurring attitude toward the visual arts might be called the *lament over decadence*. Beginning at least as early as the Elder Cato (243-149 B.C.) it became a fashion among Roman orators and writers to decry the demoralizing effect of the arts upon the natural austerity of the Roman character. The lamenter's own time is usually compared unfavorably to some epoch in the past when a "no nonsense" simplicity dominated Roman life and thought. Such nostalgic puritanism seems to have been especially common in eras of accentuated social and political change. When the Romans' political intervention in South Italy, Greece, and the East gave them their first prolonged exposure to the seductions of Hellenistic art, we find Cato ridiculing those who cared more about sculpture and painting than about goodness of character (see p. 55), and inveighing against those who marvelled at Corinthian or Athenian temple ornaments but laughed at the simple terracotta antefixes of Roman temples (p. 33). When Marcellus, after the sack of Syracuse in 211 B.C., adorned Rome

with a spectacular display of Greek art, he seems to have found himself compared unfavorably by the older Romans with Fabius Maximus, the general who had been so admirably contemptuous of the artistic glories of Tarentum (pp. 32, 42). Later, when the Roman government came increasingly under the sway of powerful, potentially autocratic military leaders such as Pompey and Caesar, and the provinces were being pillaged by unscrupulous profiteers like Verres, we find Cicero striking the lamenter's pose and proclaiming how the great military leaders of old had lived in simple homes adorned only by "virtue and honor" (p. 48). The most persistent of the lamenters, however, is the Elder Pliny, who bemoans the decadence which came to Rome from Asia (p. 33), complains that competence in bronze-casting had completely died out in his own time (p. 145), rejects the wall-painting and portrait painting of his time as degenerate (p. 156), and describes how "vice" slowly manifested itself in Roman architecture (pp. 81-82). The recurrence of this theme in the *Natural History* is probably to be explained by the fact that Pliny wrote it during the reign of Vespasian, when there was a deliberate attempt, fostered by the emperor, to expunge the physical and moral vestiges of the reign of Nero and re-establish respect for old Roman virtues.

Beyond the general attitudes toward art thus far described, one may isolate a few specific theories of art criticism, which, while not necessarily Roman in origin, are propounded by Roman writers. Of these theories the one which seems to have stirred up the most controversy was that which Vitruvius called the *ratio decoris* (VII, 5, 4), perhaps best translated as the "rational theory of appropriateness." *Decor*, "appropriateness," is recognized by Vitruvius as one of the basic considerations in the aesthetics of architecture (I, 2, 5). It is the principle whereby one judges whether the form of a building is appropriate to its site and function and whether the details of a building are appropriate to its total form. For example, not only should the order chosen for a temple be appropriate to the deity to whom the temple was dedicated (Doric temples to warlike deities like Mars; Corinthian temples to flowery deities like Venus and Flora, etc.), but the details of one order cannot be applied to another without "offending." Each architectural detail is "appropriate" only to its own order. A corollary of the *decor* theory is that things should "make sense" in terms of our experience of the natural world. Things which have prototypes in nature should not be employed in art in a way which is inappropriate to nature. A simple example of this concept applied to architecture is Vitruvius' contention that in a set of superimposed columns, the columns in the upper row should be smaller than those in the lower row because tree trunks, the natural prototype of columns, diminish as they grow higher (see p. 124). But the most famous use of this aspect of the *decor* theory is Vi-

truvius' denunciation of the imaginative and fantastic wall-painting of his day because it depicted things which did not and could not exist in nature (see pp. 127-129).

Another tenet of the *decor* theory was apparently that the scale of a cult image should be appropriate to the temple in which it was placed. Strabo, for example, who was a contemporary of Augustus, criticizes the otherwise universally praised Zeus of Pheidias at Olympia, because, had it been able to stand up, it would have gone right through the roof of the temple.[1] The same criticism was applied by the architect Apollodoros of Damascus to the Emperor Hadrian's plan for the temple of Venus and Rome (see p. 176). Hadrian, apparently unimpressed by the *decor* theory, is said to have had the architect put to death a short time afterward.

The origin of the *decor* theory is probably to be sought in the literary and rhetorical criticism of the peripatetic school of Greek philosophy. *Decor,* according to Cicero (*Orator,* 70) was the Latin translation of the Greek *to prepon* ("propriety" or "appropriateness"), which Aristotle emphasized as a basic element in a good rhetorical style and which Aristotle's pupil Theophrastos seems to have classified as one of the four basic constituents of rhetoric.[2] It has been suggested that it was the Hellenistic Greek poet and critic Neoptolemos of Parion (3rd century B.C.) who first formulated the *prepon-decor* concept in such a way that it appealed to Roman writers such as Cicero (*De Oratore*), Horace (*Ars Poetica*), and Vitruvius.[3]

Although the Romans derived most of their factual and theoretical knowledge of art history from Greek sources,[4] there is a trace of at least one systematic theory of the development of sculpture which may be of Roman origin and which is perhaps best called the *museographic theory.* In book XXXIV, sections 6-17, of the *Natural History,* Pliny sketches what seems to be a history of bronze-working from relatively humble beginnings when it was used for making vessels, furniture, etc., to gradually more exalted stages in which it was used for making portraits of men and eventually images of the gods. Different places first specialized in the use of bronze for their own characteristic minor art—Corinth in vessels (XXXIV, 6), Delos in furniture (XXXIV, 9), and Aegina in candelabra (XXXIV, 10-11)—but eventually the art came to be applied everywhere to making figures of animals, portraits of men, and images of

[1] Cf. Strabo, VIII, 353-354. The passage is given in the present writer's companion volume on Greek art, *The Art of Ancient Greece: Sources and Documents* (Cambridge, 1990), pp. 61-62.

[2] Aristotle, *Rhetoric,* III, vii, 1 ff; on Theophrastos' view cf. Cicero, *Orator,* 75-79.

[3] Cf. Pietro Tomei, "Appunti sull'Estetica di Vitruvio," *Bollettino del Reale Istituto di Archeologia e Storia dell'Arte,* X, 1943, pp. 57-73.

[4] Cf. *The Art of Ancient Greece,* pp. 2-9.

gods.[5] These representational statues were then apparently classified according to the degree of realism (*successus*) and technical daring (*audacia*) which they exhibited (*N.H.* XXXIV, 38). This "museographic theory" may have been designed to provide a system of classification for the vast number of statues, vessels, furniture, etc., which came to Rome as the spoils of war during the late 3rd, 2nd, and 1st centuries B.C. (see pp. 33-48 and 63-74). The inventor of the theory is not known, although Varro, whose writings on art were used extensively by Pliny, is a likely candidate.

Art criticism in Late Antiquity is marked by a reaction to Classical rationalism, as embodied, for example, in the *decor* theory, in favor of a more intuitional apreciation of art. The details of this change, which is characteristic of Classical civilization in general, are examined on pp. 189 and 215-219 of this volume and need not be repeated here.

SOURCES

The literary sources for the history of Roman art resemble the sources on Greek art in that, with a few exceptions, the authors in question do not deal directly and exclusively with art. In most cases an artist or a monument is mentioned only in passing by an author who is pursuing a more general subject such as the history of a certain period or the biography of an individual. The exception to this rule is, above all, Vitruvius' book on architecture, the only extant technical treatise dealing with one of the visual arts of Antiquity. Specialized descriptive poems (Statius' description of the equestrian statue of Domitian), letters (the Younger Pliny's descriptions of his villas), and rhetorical display pieces (the descriptions of paintings and statues by the Philostrati and Kallistratos) might also be considered exceptions. The Elder Pliny's *Natural History*, in which the chapters on art are really digressions but digressions of such great length that they almost seem to be works in themselves, is unique.

Our sources on Roman art differ from those on Greek art, however, in that there are more authors who provide us with information based on first-hand observation of contemporary artistic developments. Since

 [5] Cf. *N.H.* XXXIV, 9: *pervenit deinde et ad deum simulacra effigiemque hominum et aliorum animalium;* also XXXIV, 15: *transiit deinde ars vulgo ubique ad effigies deorum.* The components of this theory were first identified by F. Münzer, "Zur Kunstgeschichte des Plinius," *Hermes,* XXX, 1895, pp. 499 ff. It is analyzed and ascribed to a Roman source by B. Schweitzer, "Xenokrates von Athen," *Schriften der Königsberger Gelehrten Gesellschaft (Geisteswissenschaftliche Klasse),* 1932, pp. 41-46. Schweitzer notes that the theory seems to be modelled on the scheme for the histories of sculpture preserved by Quintilian and Cicero. These histories, in turn, are to be associated with the late Hellenistic *phantasia* theory of the development of Greek sculpture, in which perfection in making images of men (by Polykleitos) and perfection in making images of gods (by Pheidias) were regarded as the culminating points of the development. On these conceptions see *The Art of Ancient Greece,* pp. 5-6; 221-3.

all but a few of the authors who fall into this category date from the time of the Empire or later, most of the material based on first-hand observation is limited to this period. Plautus' picture of the Roman Forum c. 200 B.C., Polybios' observations on Roman portraiture in the mid 2nd century B.C., and Cicero's picture of the artistic life of the 1st century B.C. in his letters and speeches stand out among the rare contemporary references to the art of the Republic. The type of information which is derived from those passages which can be said to be contemporary references to art varies from author to author. Sometimes, as with Cicero's letters or the discussions of contemporary painting by Vitruvius and Pliny, they shed light both on the taste of the author and the taste of the time. Occasionally they give us rare intimate glimpses of famous personalities and their interest in art, as when Suetonius recounts that he gave a small bronze portrait of the young Augustus to the Emperor Hadrian and notes that Hadrian worshiped it among the Lares in his bedroom (p. 180). More often than not, however, these contemporary records are simply narrative descriptions of unusual vividness, as, for example, Dio Cassius' description of the funeral of Pertinax (pp. 192-193).

The writers who deal with the artistic personalities, events, and monuments of earlier epochs are usually historians or antiquarian encyclopaedists (e.g., Dionysios of Halikarnassos, the Elder Pliny, Athenaeus, Aulus Gellius). Most of the information which these authors preserve about the early and middle Republic seems ultimately to go back to the *annales*, year by year accounts of important civic, military, and religious events based on records which were originally kept by the Roman priests and were later expanded by the earliest Roman historians (see p. 3). The elaborate descriptions of the details of early triumphal processions preserved by Livy, Plutarch, and others must ultimately, although not necessarily directly, go back to the annals. Our sources undoubtedly also derived a certain amount of information from the inscriptions on earlier statues and buildings. For the historical events of the late Republic and the Empire it was possible to draw not only upon the evidence of earlier writers and extant epigraphical evidence but also upon the *acta Senatus,* the official records of the proceedings of the Senate, and the *acta diurna,* an official daily register inaugurated by Julius Caesar which preserved news about the activities of government and society. Tacitus and Suetonius drew extensively on these and also upon personal memoirs, biographies, and, at times, pure gossip.

Books XXXIII-XXXVI of the Elder Pliny's *Natural History* occupy a special place in any study of how information on art was transmitted from one generation to another because Pliny provides a bibliographical index for each book.[6] The Roman authors whom he cites offer consid-

[6] The far-reaching influence of his Greek sources has been discussed in the Introduction to *The Art of Ancient Greece.*

erable variety and may serve as a general illustration of the types of sources from which an encyclopaedist or historian of the Imperial period could draw. The following is a minimal list of the Roman writers mentioned in the indices who may be said to have supplied Pliny with some sort of information about art: Lucius Piso, Valerius Antias, Fenestella, Pomponius Atticus, Cornelius Nepos, Licinius Mucianus, Vitruvius, Fabius Vestalis, Deculo, and Marcus Varro.

At least four of the writers in this group are known to have been annalists, and it may be assumed that they provided Pliny with a chronological framework and also with records of when certain statues were set up, when certain painters flourished, when certain temples were dedicated, etc. Lucius Piso (L. Calpurnius Piso Frugi, consul in 133 B.C. and censor in 120 B.C.), who is cited in every index except that of book XXXV, seems to have been of particular importance. He was probably the source for Pliny's information about early portrait statues (see p. 55). Valerius Antias, active around the time of Sulla (c. 80 B.C.), seems to have kept records of the disposal or confiscation of property belonging to prominent Romans and therefore provided information about the minor arts.[7] Fenestella (c. 52 B.C.-c. A.D. 19), was an antiquarian scholar with wide-ranging interests. Pliny cites him directly as a source for information about developments in the history of furniture (see p. 133). Pomponius Atticus (109-32 B.C.), the friend and correspondent of Cicero, provided Pliny with useful information about the history of portraiture (see p. 91).

Cornelius Nepos (c. 99-24 B.C.), a friend of both Cicero and Atticus, was a biographer, poet, and historian. Pliny cites him as the source for his remarks about the house of Mamurra on the Caelian (see p. 82). Nepos has sometimes been recognized as the source for much of Pliny's biographical information about artists.[8]

Mucianus (Gaius Licinius Mucianus, fl. c. A.D. 70), the politician and general who played a key role in winning the principate for Vespasian (see p. 151), was the author of a geographical work describing artistic marvels in the Aegean and eastern Mediterranean. Little, if any, of Mucianus' work appears to have dealt with Roman art. Pliny seems to have looked to him mostly for information about architecture and sculpture in Ionia and the Cyclades.[9]

7 Cf. Pliny, *N.H.*, XXXIV, 14, where he is cited along with L. Piso. Antias was also used by Livy (see p. 42).

8 Cf. H. Brunn, "Cornelius Nepos und die Kunsturteile bei Plinius," *Sitzungsberichte der Bayrischen Akademie der Wissenschaften, Phil.-Hist. Klasse*, 1875, pp. 311 ff. The idea is disputed by Münzer, *Hermes*, XXX, 1895, p. 543, who holds that Pliny probably used the *Chronica* of Nepos, a universal history, for information about the gradual influence of Greek art on Rome.

9 Cf., for example, *N.H.*, XXXIV, 36, where he is cited as a source for the number of statues on Rhodes. The evidence for Mucianus' influence on Pliny is carefully summarized in A. Kalkmann, *Die Quellen der Kunstgeschichte des Plinius* (Berlin, 1898), pp. 131-143.

Vitruvius probably served as one of Pliny's sources for information on the Mausoleum at Halikarnassos.[10] Otherwise there is little indication that he was used as a direct source.

Of Fabius Vestalis almost nothing is known except that he wrote a book on painting (index, *N.H.* XXXV) and that he contradicted Varro on the question of when the first sun-dial was set up in Rome (*N.H.,* VII, 213).

Deculo is cited as the source for the story that the Emperor Tiberius became so attached to a painting by Parrhasios that he kept it shut up in his bedroom (*N.H.* XXXV, 70). He was perhaps the author of some kind of gossipy memoirs about the Julio-Claudian emperors.[11]

Outweighing in importance all the sources thus far mentioned, however, was the great scholar and antiquarian Marcus Terentius Varro (116-27 B.C.), who was the author of over fifty-five works treating virtually every area of knowledge in the ancient world. Pliny cites Varro more often than any other writer [12] for information on the arts. Modern scholars have been puzzled by the fact that among the many preserved titles of Varro's works there is no record of a treatise which dealt with sculpture or painting. His large work entitled *Antiquitatum rerum humanarum et divinarum* seems to be ruled out as a source for this material by the fact that it dealt primarily with the antiquities of Rome, while Varro's study of sculpture and painting apparently treated Greek art at length. The same may be said of his history *de vita populi Romani.* Kalkmann argued persuasively, if not altogether conclusively, that Varro must have included sketches of the development of sculpture and painting in a work known as the *disciplinarum libri novem,* an examination of nine "liberal arts." [13] The last of the liberal arts examined in this treatise was architecture, and it may be that histories of sculpture and painting were appended to the chapter on architecture.[14] Vitruvius, who was acquainted with Varro's work on architecture (VII, praef. 14) and who also emphasized architecture's importance as a liberal art, insisted that a good architect should have at least theoretical knowledge of all

10 As suggested by Kalkmann, *op. cit.,* pp. 31-32. On the passages in question see *The Art of Ancient Greece,* pp. 196-8.

11 Kalkmann, *op. cit.,* pp. 205-206, suggests that anecdotes about Tiberius' affection for the *Apoxyomenos* of Lysippos (*N.H.* XXXIV, 62) and about the statue of an Amazon which Nero ordered to be carried around in his retinue (*N.H.* XXXIV, 48 and 82) might be ascribed to the same author.

12 Cf., for example, *N.H.* XXXIII, 155 (on Mentor); XXXIV, 56 (on Polykleitos); XXXV, 154 (on the temple of Ceres in Rome); XXXV, 155 (on Possis and Arkesilaos); XXXV, 156-157 (on Pasitcles), XXXVI, 17 (on the Nemesis of Agorakritos); XXXVI, 41 (on statues in Rome); XXXVII, 11 (on gems). Varro's name also appears in each of the indices for books 33-36.

13 Cf. Kalkmann, *op. cit.,* pp. 86 ff. The liberal arts examined were apparently grammar, dialectic, rhetoric, geometry, arithmetic, astronomy, music, medicine, and architecture.

14 Kalkmann, *op. cit.,* p. 95, points out that other disciplines, such as optics and metrics, seem to have been appended to the nine primary disciplines.

the allied arts, especially the decorative arts which served architecture
(I, 1, 12-15).

In discussing architecture, painting, and sculpture in the context
of the liberal arts, Varro probably emphasized their theoretical and
intellectual aspects, since these were what an educated man might be
expected to have knowledge of.[15] In tracing the development of artistic
theory in the Classical world he must first have paraphrased information
found in Greek treatises such as those of Xenokrates and Antigonos,[16]
to which he himself then added material on Roman art. It was probably
through the mediation of Varro that Pliny preserved as much as he did
of Greek art criticism, and it was probably also from Varro that Pliny
learned how to write about art in other than an anecdotal manner. If
there is any validity in the view that Varro both preserved the Hellenistic
art histories and served as an exemplar to the Romans of how to write
about architecture, sculpture, and painting in a serious and systematic
manner, he must be recognized as the most important Roman writer on
art.

[15] Again compare Vitruvius, I, 1, 15, where the distinction between the theory
(*ratiocinatio*) and practice (*opus*) of individual arts is emphasized. An educated man
was expected to be familiar with the *ratiocinatio* of a given art; the *opus* was of im-
portance only to specialists.
[16] Cf. *The Art of Ancient Greece*, pp. 3-4.

I

The
Roman Republic

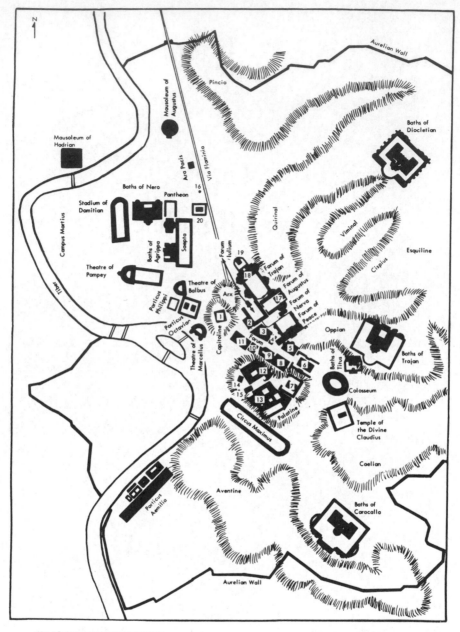

KEY TO THE NUMBERED BUILDINGS:

1. Temple of Jupiter Optimus Maximus
2. Curia
3. Basilica Aemilia
4. Temple of Antoninus and Faustina
5. Basilica of Constantine
6. Temple of Venus and Rome
7. Aedes Divorum
8. Vestibule of the Domus Aurea
9. Atrium of Vesta
10. Temple of Castor
11. Basilica Iulia
12. Domus Tiberiana
13. Domus Augustana
14. Temple of the Magna Mater
15. Temple of Apollo
16. Column of Marcus Aurelius
17. Temple of Mars Ultor
18. Basilica Ulpia
19. Temple of the Divine Trajan
20. Temple of the Divine Hadrian

Sketch map of Rome showing the sites of important structures mentioned in the text. (Based on Lugli, Gismondi, Forma Urbis Romae, *1949, with minor modifications based on more recent discoveries.)*

THE PERIOD OF KINGS: c. 753-510 B.C.

In the 3rd century B.C., when the Romans began to write about their own history, the circumstances surrounding the origin of Rome were already obscured by time and shrouded in myths and legends. The only documents available to supplement the legends which had been transmitted orally from generation to generation were the ancient *Fasti*, ritual calendars which were repeatedly drawn up and revised by the high priest (*Pontifex Maximus*) of Rome. These calendars originally listed days on which religious festivals and rites were to be observed. The practice eventually arose of recording on the calendars unusual or propitious events which occurred in the course of the year —eclipses and important military victories, for example. Since no formal dating system existed, the individual years were identified by noting names of the magistrates who held office during that year. The events and names so recorded were written on white boards and posted in or near the *Regia* (originally the king's house; later the office of the high priests) in the Forum. These *Tabulae Pontificum* or Priests' Tablets were collected and published in 130 B.C. by the *Pontifex Maximus* Mucius Scaevola under the title of the *Annales Maximi*. It was on the basis of information found in this collection (and in others like it which circulated in the late 2nd century B.C. and throughout the 1st) that the Roman annalists, whose work culminates in Livy's history *Ab Urbe Condita*, were able to construct a chronology for the early history of their city.[1] Since the lists of magistrates found in the various collections of *Fasti* were not always consistent, the chronologies used by different writers varied somewhat. Estimates of the date of the founding of Rome, for example, varied from 754 to 728 B.C. Most modern writers follow, as we shall in this volume, the system of dating which was worked out by the scholarly antiquarian Marcus Varro (116-27 B.C.) and by Atticus (109-32 B.C.), the friend of Cicero.

According to the traditional history which resulted from the fusion of orally transmitted legends with the chronology of the annalists, Rome was founded by Romulus, her first king, on April 21, 753 B.C., and continued to be ruled by kings until 509 B.C. Romulus was held to have been a distant descendant of the Trojan hero Aeneas, who had settled in Latium after the fall of Troy. Aeneas' son Ascanius had founded the Latin town of Alba Longa after his father's death, and Alba was ruled for about four hundred years by the descendants of Ascanius. Numitor, the last of these kings, was deposed by his brother Amulius, and lest Numitor have descendants who might avenge him, his daughter Rhea Silvia was forced to become a Vestal Virgin. But in spite of this precaution, Rhea eventually bore twin sons, Romulus and Remus, whose father was the god Mars. Amulius attempted to drown the twins by throwing them into the Tiber, but the river carried them safely to a spot near the Palatine hill, where they were deposited on shore beneath a fig tree and suckled by a wolf. Later the children were adopted by a local shepherd and his wife and when they reached manhood, they returned to Alba, killed Amulius, and reestablished their grandfather on his throne. The twins then set out to build a new city on the site where they had been saved. During a dispute which arose

[1] Some modern scholars doubt that there were any reliable *Fasti* or consular lists for the period prior to the Gallic invasion of 390 B.C. There is some evidence that remarkable events—eclipses, etc.—were not recorded by the priests until shortly after 300 B.C. For a general review of the sources for early Roman history and their reliability, cf. H. H. Scullard, *A History of the Roman World from 753 to 146 B.C.* (3rd ed. London and New York 1961), pp. 405-16.

over certain details involved in the founding of the city, Romulus slew Remus and proceeded alone to lay out his new city on the Palatine. Romulus ruled from 753 to 717 B.C. One of the problems which the new city faced was a shortage of women. To alleviate this situation Romulus devised a festival of games and invited some of the neighboring people, but most particularly the Sabines, to attend them. At a prearranged time in the course of the games, the Romans abducted the Sabine maidens; this extreme action naturally led to a war, which was only brought to an end by the mediation of the Sabine women themselves. As a result of the peace treaty which followed, the Romans and the Sabines agreed to live together in Rome, and Romulus for a time shared his throne with the Sabine king Titus Tatius.

Romulus' earthly career ended when, during a violent storm in the Campus Martius, he was carried up to heaven in a cloud and became a god. He was succeeded by a Sabine, Numa Pompilius (715-672 B.C.), who was traditionally credited with founding most of Rome's religious institutions, including a reformed calendar of religious festivals and a new college of priests. The following king, Tullus Hostilius (672-640 B.C.), was more aggressive than religious. During his reign Rome fought with, conquered, and completely destroyed its mother city Alba Longa. The first Senate House in the Forum, the *Curia Hostilia,* was also ascribed to this period. Ancus Marcius (640-616 B.C.), the next king, was a grandson of Numa Pompilius and applied to war the same lawgiving instinct which his grandfather had applied to peace. It was he who instituted the formulae whereby Rome declared war, arranged truces, and drew up peace treaties. Tradition also held that he founded the Roman port of Ostia and built the first bridge across the Tiber.

Upon the death of Ancus Marcius an Etruscan dynasty established itself in Rome, and throughout the 6th century B.C. cultural influences emanating from Etruria exerted a formative influence on Roman politics, religion, and art. The first Etruscan king, Tarquinius Priscus (616-578 B.C.), was the son of a Greek exile, Demaratus of Corinth (see pp. 6-7), and an Etruscan lady. He was born in Tarquinii but settled in Rome and received the kingship by election. Tarquinius Priscus instituted constitutional changes by enlarging the senate and expanding the lists of enfranchised citizens; he also sought to expand the city physically by creating new building projects. It seems to have been during his reign that the Etruscan preoccupation with omens and divination became extremely important to the Romans.

The Elder Tarquin, as Tarquinius Priscus is sometimes called, was assassinated by the sons of Ancus Marcius, who wanted to restore their family to the throne. But Servius Tullius (578-534 B.C.), the son-in-law (according to some versions of the story) of Tarquin and a Latin by birth, was installed on the throne, through the influence of Tarquin's wife. It was Servius who instituted the *Comitia Centuriata,* the popular assembly of Rome, which lasted at least until the time of Augustus. The citizens of Rome were divided into five classes which were in turn subdivided in rolls of muster called *centuriae.* The assembly voted by *centuriae,* and since the two upper classes, the wealthy classes, were assigned a majority of the *centuriae,* control of the assembly by the aristocracy was assured. Servius also expanded the boundaries of Rome and surrounded them with a strong defensive wall.

Like Tarquin before him, Servius was assassinated by the sons of his predecessor, and the eldest of these, Lucius Tarquinius (534-510 B.C.), called Tarquinius *Superbus* ("the arrogant"), became the next and last king of Rome. The Younger Tarquin's reign had its military successes and also saw the glorification of Rome through an ambitious building program which carried forward, in part, the designs of the Elder Tarquin. But the arrogant behavior of the

king—he is depicted as a heartless megalomaniac—and of his relatives proved to be his undoing. In 510 B.C. they were driven from Rome and the Republic was established.

This traditional picture of Rome in the period of kings is undoubtedly obfuscated by fancies and anachronisms, but it probably has some factual basis. The evidence of modern archaeology indicates that Rome was probably founded somewhere around the beginning of the 8th century B.C. and that its first settlement was a small village of shepherds' huts on the Palatine. During this early period the swampy lowlands which later became the Roman Forum were used as a cemetery. Excavations in this early burial ground, the *sepulcretum* of the Forum, have shown that the earliest graves are cremation burials, but after a short time inhumation also appears. The advent of inhumation burials, the custom which was characteristic of Latium and the south, has been thought to be an indication of the incorporation of Sabines and other Latins into the Roman polity.[2] The rise of Etruscan influence at Rome in the early 6th century B.C. and its increase throughout the century also has archaeological as well as literary support.[3]

The Earliest Phase

Traditional Roman chronology, as already noted, held that Romulus had founded the city of Rome in the 8th century B.C. The Romans of the 1st century B.C. and later apparently believed that the earliest city had contained no sculptured or painted representations of the gods.[4]

St. Augustine, *de Civitate Dei* IV, 31: For [Varro] says that the ancient Romans worshipped the gods for more than 170 years without images.

Varro is probably also the source for Plutarch's ascription of a ban on images to Numa Pompilius, the second king of Rome.

Plutarch, *Life of Numa* 8: His [Numa's] ordinances about the setting up of images are in many ways in accord with the beliefs of Pythagoras, for Pythagoras proposed that the first principle was beyond the senses

2 The most thoroughgoing examination of the archaeological evidence for early Rome is E. Gjerstad's *Early Rome*, Vols. I-III (Lund 1953-1960). For a general review of the evidence in a more popular form cf. also R. Bloch, *The Origins of Rome* (New York 1960), chap. IV. Many modern archaeologists have accepted the eighth century B.C. as a reasonable date for the early Iron Age huts on the Palatine and for the earliest burials in the Forum. An earlier date (tenth century B.C.) has been suggested by H. Müller-Karpe, "Vom Anfang Roms," *Röm. Mitt., Ergänzungsheft* 5, 1959. Gjerstad has also found evidence for the habitation of Rome during the Bronze Age (second millennium B.C.), but this does not necessarily mean that the historical city of Rome had been founded at that time. Cf. "Chalcolithic and Bronze Age Finds in Rome," *Acta Archaeologica*, XXXII (1961), 1 ff. The general reader may profit by reading the short review of Roman prehistory given by Scullard, *op. cit.*, pp. 417-22.

3 Cf. Bloch, *op. cit.*, chap. V, pp. 85-110 and bibliography, pp. 154-59.

4 Although small terracotta statuettes, some perhaps with a religious significance, have been found in early Iron Age graves in Latium, the spirit of simplicity which our literary testimonia convey about the primeval city is amply supported by the archaeological evidence.

and feelings, invisible and undefiled, perceptible only by the intellect, and consequently Numa prohibited the Romans from making use of any kind of image of the divine, either anthropomorphic or zoomorphic. Thus there was neither a painted nor a sculptured image among them at this early stage; but during the first 170 years of their history, though they built temples and established holy shrines, they did not undertake to make an image, since it was not holy to liken exalted things to baser things nor to come in contact with the divine by any other means than the intellect.

Tertullian, *Apologeticum* XXV, 12-13: [In spite of Tertullian's objection to Numa's superstitions he admits] worship of the divine among the Romans did not involve either images or temples. It was a simple religion with humble rites, involving not a Capitolium contending with the sky, but rather temporary altars of sod and, at this early time, Samian ritual vessels with a thin vapor coming from them and the god himself nowhere. For at that time the genius of the Greeks and the Etruscans had not yet inundated the city by modeling images.

The Beginnings of Sculpture

As the preceding passage indicates, and as the archaeological record demonstrates, the earliest strong artistic influences on Rome came from Etruria and Greece.

Pliny, *N.H.* XXXV, 152: There are those who hold that the art of modeling was first invented at Samos by Theodoros and Rhoikos well before the Bacchiadai were expelled from Corinth [c. 657 B.C.], but in fact, when Demaratus (who in Etruria begot Tarquinius the king of the Roman people) was exiled from the same city, he took with him Eucheir, Diopos, and Eugrammos, who were modelers in clay; from these men the art of modeling was imported into Italy.[5]

Although Pliny apparently accepts the tradition that Demaratus' artists introduced modeling into Italy, he suggests in the following passage that other kinds of statuary, including bronze images, existed in Rome prior to that time.

Pliny, *N.H.* XXXIV, 33: That the art of statuary in bronze was familiar to Italy and, in fact, venerable is indicated by the statue of Hercules, dedicated, as they say, by Evander,[6] in the *Forum Boarium*, an image

[5] On the presence of Corinthian pottery and terracotta ornaments in early Etruria cf. E. H. Richardson, *The Etruscans, Their Art and Their Civilization* (Chicago 1964), chap. V.

[6] Evander was a mythological king of a settlement of Arcadian Greeks on the Palatine hill (described in Vergil's *Aeneid,* Book VIII).

which is called "the Triumphant" and which is dressed in triumphal costume during triumphal processions; and also by the double Janus [7] dedicated by King Numa which is worshiped as a sign of peace and war and which has its fingers so arranged that they make marks signifying the 365 days of the year (meaning, in other words, a year of time) [8] and indicate also that Janus is the god of unending time.

Since the sanctuaries of Hercules in the Forum Boarium *and of Janus in the Forum were among the oldest in Rome, Pliny probably assumed that the bronze statues in them were much older than they actually were. If these images did, in fact, go back to the period of kings, they would refute Pliny's own contention that the first bronze image of a god was that of Ceres done in 485 B.C. (see p. 19). Vessberg is probably correct in explaining the passage as a private attempt on the part of Pliny to harmonize literary and artistic evidence.* [9]

The Beginnings of Painting

Pliny also knew of a tradition that painting had first been introduced into Italy from Corinth by the artists in Demaratus' retinue, but here again he hesitates to accept the tradition completely.

Pliny, *N.H.* XXXV, 16-18: The inventor of filling in these lines [10] with the color of ground clay was, they maintain, Ekphantos of Corinth. We will make clear subsequently that this was a different man (with the same name) and not the one mentioned by Cornelius Nepos as having followed Demaratus, the father of the Roman king Tarquinius Priscus, who fled from Corinth to escape vengeful reprisals at the hands of the tyrant Kypselos.

For painting was already highly developed by that time, even in Italy. There exist, to be sure, even today, paintings in the sacred structures at Ardea which are older than the city [of Rome] and at which I marvel as at no others, in that they have remained for so long a time without the protection of a roof and yet are like new. The same is true of Lanuvium, where there are paintings of Atalanta and Helen facing one another—nude figures done by the same artist—each of the most exquisite beauty (the former is represented as a maiden); these remained

[7] Janus, the god of gateways, was represented as having two faces.

[8] The phrase in parentheses is obscure in the Latin and is dropped by some editors.

[9] O. Vessberg, *Studien zur Kunstgeschichte der Römischen Republik* (Lund 1941), pp. 8-9; hereafter cited as Vessberg, *Studien*.

[10] That is, the lines of colorless drawings. For the material which preceded this passage see the present writer's *The Art of Ancient Greece: Sources and Documents* (Cambridge, 1990), p. 124. This volume will hereafter be cited simply as *The Art of Ancient Greece*.

intact even during the collapse of the temple. The Emperor Gaius [Caligula], inflamed with lust, attempted to remove them [and would have done so] if the nature of the plaster had permitted it. At Caere pictures have survived which are even older, and whoever shall assess these carefully will admit that none of the arts was perfected more rapidly [than painting], since at the time of the Trojan War it seems not to have existed.

The paintings at Caere mentioned by Pliny were perhaps early Etruscan tomb paintings. That the paintings at Ardea and Lanuvium were as old as Pliny implies seems unlikely.

Etruscan Influence at Rome: Tarquinius and Vulca

The one artist whose name pierces through the general veil of anonymity which shrouds the art of the period of kings is an Etruscan sculptor named Vulca, a native of Veii, the southernmost of the Etruscan cities, about nine miles north of Rome. Vulca was commissioned to make the terracotta sculptural ornament and also one of the cult images for the temple of the Capitoline triad (Jupiter, Juno, and Minerva), which was the greatest architectural monument of early Rome.

Although Pliny assigns Vulca's work to the time of Tarquinius Priscus, other writers, as well as the archaeological evidence,[11] make it reasonably certain that the work actually took place during the reign of Priscus' grandson, Tarquinius Superbus, the last Roman king, whose building program gave a definitive shape to early Rome.

Pliny, N.H. XXXV, 157: [Varro records] further that this art [modeling in clay] was well developed in Italy and especially in Etruria; that Vulca, the artist to whom Tarquinius Priscus awarded the contract to make the image of Jupiter which was to be dedicated on the Capitoline, was summoned from Veii; that this image was of terracotta, for which reason, as is usual, it was colored red; that there were terracotta quadrigas, of which we have spoken often, on the peak [12] of the temple; and that the Hercules, which even today in the city retains the name of

[11] The foundations and some terracotta ornaments of the original temple of the Capitoline triad for which Vulca's image must have been made date from the late 6th century B.C. Cf. Gjerstad, *Early Rome*, III, 168-90. The excellent terracotta sculptures, including the famous "Apollo of Veii" which adorned the roof of the "Portonaccio temple" (apparently a temple of Minerva) at Veii, probably date from the first decades of the 5th century B.C. and are in all likelihood products of the workshop of Vulca; cf. Giglioli, *L'Arte Etrusca* (Milan 1935), plates CLXXXIX-CXCVI; M. Pallottino, *La Scuola di Vulca* (Rome 1945).

[12] On the peak = *in fastigio*. This phrase could refer to the pediment of the temple, but since early Italic temples rarely had pedimental figures, it more probably refers to the end of the ridge pole of the roof.

the material [from which it was made],[13] was also done by this artist. For these were the most praiseworthy images of deities of that era; nor do we feel dissatisfied with those [earlier] men who worshiped such images; for it was not their habit to make gold and silver images, not even for gods. Images of this sort have survived in many places today; they survive, in fact, even on a great many rooves of temples in Rome and in the municipal towns—images which are to be marveled at for their surface detail and artistry and for their stolidity, more revered than gold, and certainly more innocent.

Plutarch, *Life of Poplicola, 14:* Tarquin the son of Demaratus, when at war with the Sabines, vowed that he would build the temple of Jupiter *Capitolinus;* Tarquinius *Superbus,* the son or grandson of the one who vowed the temple, actually built it. Tarquin did not succeed in dedicating it however, for, when it was only a little short of complete, he fell from power.

Livy I, 55, 1-I, 56, 1: Thereupon he [Tarquinius *Superbus*] turned his attention to projects within the city; of these his foremost concern was that he leave behind the temple of Jupiter on the Tarpeian Mount as a monument to his reign and name, [commemorating the fact that] there were two Tarquin kings—the father who vowed the temple and the [grand]son who actually built it. And in order that the area in which the construction was going on should be free from other religious uses and totally devoted to Jupiter and his temple, he decided to deconsecrate the sanctuaries and chapels (there were several in that place) which had first been vowed by King Tatius at the crisis of his battle against Romulus, and later consecrated and inaugurated. . . . In his intensity to bring the temple to completion, workmen were summoned from every part of Etruria, and he made use, toward the desired end, not only of public money but also of workers drawn from the plebian class [see p. 14]. The task was not at all light and, in addition to that, it was added to their military obligations. The plebs found the work much less galling however, when they were building the temples of the gods with their own hands than they found it later when they were transferred to other projects which, besides being less impressive in appearance, were also considerably more laborious—namely the construction of rows of seats in the Circus and excavation beneath ground level of the *Cloaca Maxima,* the Great Sewer, which was a receptable for all the waste of the city; even the new magnificence [of today] has hardly been able to produce anything equal to these works.

Pliny, N.H. XXXVI, 106-108, relates that the work on the Cloaca Maxima *was so arduous that some of those who were forced to work on*

[13] The statue was the Hercules *Fictilis,* the "Clay Hercules."

it committed suicide. To discourage this the king, Tarquinius Priscus, according to Pliny, crucified their dead bodies and left them for the birds of prey. He also tells us that some of the tunnels of the Cloaca were wide enough for a wagon loaded with hay to pass through and that they were so well built that not even earthquakes or the collapse of buildings upon them caused any damage.

A little more information about the image of Jupiter and the quadriga which Vulca made for the Capitoline temple can be gleaned from several other sources. The image of Jupiter had a special connection with Roman military victories. It was an ancient custom in Rome that victorious military commanders might be officially awarded a "triumph," the essence of which was a religious procession from the gates of the city to the Capitoline, where a sacrifice was offered to Jupiter. During this procession the victorious commander, dressed in the garb and attributes of Jupiter himself, was conveyed in a quadriga to the temple of Jupiter, accompanied by his army, his captives, and the spoils of his victory. In describing the similarity between the triumphator and Jupiter, which even involved the custom (mentioned by Pliny) of painting the commander's face red,[14] Livy and Servius preserve some hints of what the attributes of Vulca's image of Jupiter were.

Servius, Commentary on Vergil, Eclogue X, 27: [In the course of commenting on the word minium, "vermilion, red," Servius says that the color red is associated with Jupiter], whence even those who celebrate triumphs, who have all the insignias of Jupiter—the scepter, palm-branch tunic [15] (whence Juvenal says "in the tunic of Jupiter")—even color the face with red. . . .

Livy X, 7, 9 [Part of a speech delivered c. 300 B.C. by the consul Publius Decius Mus in support of admitting the plebs into the traditionally patrician priesthood]: . . . To whom of the gods or of men is it possible to ascribe indignation if those men whom you have honored with the curule chair, the toga praetexta,[16] the palm-branch toga and the painted

14 The origin of the custom is obscure. In most ancient sculpture the flesh parts of a male figure were normally painted reddish-brown (while the flesh of women was painted white), and the redness of the image of Jupiter may simply be a reflection of this custom. Pliny, however, states that the face of the image was continually repainted in red on holidays (N.H. XXXIII, 111), which suggests that the red color had some religious significance.

15 The tunica palmata, a tunic apparently embroidered with a palm branch decoration, and the toga picta, a purple toga embroidered with designs in gold, were perhaps originally ceremonial garments worn by the early kings; they were preserved on the image of Jupiter and became part of the garb of the triumphator.

16 The curule chair (sella curulis) was an ivory folding chair which may have been the seat in which the early kings sat while giving judgment. It became another of the symbols of the Republican magistrates who had imperium (see p. 14). The toga praetexta, the "bordered" or "fringed" toga, was worn by the "curule magistrates" as an emblem of office.

toga, and the triumphal crown and laurel . . . should add to these the insignias of the *pontifex* and augur?

Plutarch preserves a curious story about the quadriga of the Capitolium which may contain a distant memory of the chariot's colossal size.

Plutarch, *Life of Poplicola* 13: When Tarquinius was still king of Rome and had brought the building of the temple of Jupiter *Capitolinus* to the stage where there was not much left to be done, acting either on the basis of some oracle or on his own judgment, he commissioned some Etruscan artisans from Veii to set up a terracotta chariot on the peak of the temple, and then, only a little later, he fell from power. The Etruscans, after modeling the work, put it in the furnace, but the clay, when in the fire, did not undergo those changes which it usually does —that is, to condense and contract as the moisture evaporates—but rather, it stood out and swelled to such a size that, when it was firm and hard, it was only with considerable difficulty that it could be withdrawn after the roof of the furnace had been removed and its walls taken away.

It would seem that almost all traces of Vulca's work on the Capitoline had disappeared by the time of Pliny and Livy. The terracotta quadriga was replaced by a bronze version in 296 B.C. (Livy X, 23, 12), and the Jupiter was lost in a fire which destroyed the temple in 83 B.C. (Cicero, in Catilinam III, 9).

Although most of the great buildings of early Rome may be attributable to Tarquinius Superbus, his predecessor Servius Tullius was responsible for at least one famous early temple in Rome—that of Diana on the Aventine. Diana was one of the chief deities of Rome's Latin neighbors, and the temple was apparently built to harmonize native Roman and Latin elements in the population of the early city.

Dionysios of Halikarnassos, *Ant. Rom.* IV, 26, 3-5: [Servius Tullius] advised them [the Romans and the Latins] to build a mutually inviolate temple in Rome with the expense being borne by both sides, a temple in which the cities, coming together each year, should perform both individual and joint sacrifices and should celebrate festivals at such times as they should agree upon. . . . And afterward, with funds contributed by all the cities, he built the temple of Diana—the one on the Aventine, the largest of the hills of Rome. He also had laws drawn up for the cities prescribing their behavior toward one another and arranged the other details concerning the holiday and the festival and the manner in which these were to be celebrated. Moreover, in order that time should not obscure these institutions, he had a bronze stele made on which were inscribed both the decrees of the representatives

and the names of the cities which had taken part in the council. This very stele remained in place in the temple of Diana down to my own time; the inscription on it is written in the characters which Greece made use of long ago.

Portrait Statues

Commemorative portrait statues were one of the most common forms of sculpture to be found in ancient Rome. The interest in portraiture among the Romans had, to some extent, a religious and social basis (see pp. 53-54), and the Romans began to set up commemorative portraits in public places from a very early date. Pliny himself saw some ancient portrait statues in Rome, presumably made of bronze, which he assigned to the period of kings.

It has been suggested that the portrait types which are described in the following passages (as well as the statues of deities described earlier) are Etruscan in origin. Most of the types in question can be paralleled by Etruscan bronzes of the late 6th and early 5th centuries B.C.[17] The adornment of Rome with portrait statues at this time was probably part of a plan to glorify the city, initiated by Tarquinius Superbus and carried on under the early Republic.

Pliny, *N.H.* XXXIV, 22-23: Indeed, I do not marvel at the fact that there are statues of the Sibyl near the *Rostra* [in the Forum], not even though there happen to be three of them: one which was restored by Sextus Pacuvius Taurus,[18] aedile of the plebs, and two which were restored by M. Messalla.[19] I would have thought that these and the statue of Attus Navius,[20] all set up in the time of Tarquinius Priscus, were the first such statues, were it not that there are statues on the Capitoline of earlier kings, among which are figures of Romulus and Tatius without a tunic, like that of Camillus on the *Rostra.*"

As the following passage indicates, the statues of the kings apparently numbered seven in all, including Titus Tatius. Which king was missing is not known.

Dio Cassius XLIII, 45, 3 [Discussing the honors paid to Julius Caesar shortly before his death]: . . . and they set up another statue on the

17 Cf. E. H. Richardson, "The Etruscan Origins of Early Roman Sculpture," *Memoirs of the American Academy at Rome*, XXI (1953), 77-124.

18 Possibly the contemporary of Augustus who was Tribune of the plebs in 27 B.C.; or perhaps an earlier member of the same family.

19 Probably M. Valerius Messalla Corvinus, a contemporary and friend of Augustus.

20 A famous augur in the time of Tarquinius Priscus whose divine powers were demonstrated when he cut a whetstone in half with a razor; cf. Livy I, 36, 3-6.

Capitoline next to [the image of] those who had been kings of Rome in former times. And I am compelled to marvel at the coincidence. For, there being eight statues there altogether—seven representing kings and the eighth representing that Brutus who overthrew the Tarquins— they set up the statue of Caesar at this time next to the latter.

We are also told by Pliny that two of these statues of kings, those of Numa and Servius Tullius, wore rings on their fingers but that the others did not (N.H. XXXIII, 9 and 24).

The statue of Attus Navius, mentioned by Pliny, is also referred to by Livy.

Livy I, 36, 5: There was a statue of Attus, with his head covered, exactly on the spot where the act was accomplished [that is, the cutting of a whetstone with a razor] in the *Comitium* on the very steps of the *Curia*, off to the left.

This statue of Attus, destroyed by fire in 52 B.C. (Pliny, N.H. XXXIV, 21), is similarly described by Dionysios of Halikarnassos, Ant. Rom. III, 71, 5. Dionysios of Halikarnassos also mentions portraits of Romulus and Servius Tullius which were said to have been set up by these kings themselves.

Dionysios of Halikarnassos, *Ant. Rom.* II, 54, 2: As a result of this campaign [against the Camerini] Romulus celebrated a second triumph, and from the spoils of victory he offered a four-horse chariot in bronze to Hephaistos [Vulcan] and also set up a statue of himself with an inscription in Greek letters recording his own deeds.

Dionysios of Halikarnassos, *Ant. Rom.* IV, 40, 7: For in the temple of Tyche [Fortuna], which he himself [Servius Tullius] had built, there was a wooden statue, covered with gold leaf, of [the king] himself, and when a conflagration broke out [21] and everything else was consumed by it, this statue alone remained and was not harmed by the fire. And even today the temple and all the things in it, which were restored after the fire according to the original design, are clearly products of modern workmanship, while the statue, remaining just as it was, has that old-fashioned look.[22]

A statue of Tanaquil, the wife of Tarquinius, in the temple of the

[21] Apparently in 213 B.C. This temple was one of two temples of Fortuna built by Servius in the Forum Boarium; cf. Dionysios of Halikarnassos, *Ant. Rom.* IV, 27, 7.

[22] The same story is told by Valerius Maximus I, 8, 11. Apparently the statue was swathed in a toga or similar garment, and its features were not clear. Pliny, *N.H.* VIII, 194 and 197 (and perhaps also Dio Cassius LVIII, 7, 2) identifies it as a statue of Fortune. Ovid, *Fasti* VI, 569-572, also identifies it as Servius.

ancient Roman deity Semo Sancus, may also have been an early portrait dating back to the period of kings.[23]

THE EARLY REPUBLIC: 509-390 B.C.

According to the traditional history of early Rome it was the arrogant behavior of Tarquinius *Superbus* and his sons, culminating in the infamous rape of Lucretia, which led to the overthrow of the kings and the establishment of constitutional government at Rome in 510/509 B.C. The Tarquins fled to Caere and made two attempts to win back the city, once by themselves and once with the aid of the Etruscan king Lars Porsenna of Clusium. In both cases, according to the patriotic tradition preserved by Livy, the invaders were repelled with the help of conspicuous heroism on the part of such legendary figures as Horatius Cocles and Mucius Scaevola.[24]

At the beginning of the Republic two distinct social strata characterized Roman society—the patricians (*patricii*), a group of aristocratic families who owned most of the land and hence controlled most of the wealth, and the plebians (*plebs*), the poor classes comprising small farmers, tradesmen, and servants.

The new republican government at Rome consisted of three basic elements—the popular assemblies, the Senate, and the magistrates. Of the three popular assemblies—the tribal assembly, the *Comitia Curiata,* and the *Comitia Centuriata*—the last, which has already been mentioned, was by far the most influential.[25]

Among the magistrates who took over the powers of the king the most prestigious were the two consuls, who were elected annually by the *Comitia Centuriata*. The consuls were invested with *imperium,* perhaps best translated as "executive power," by virtue of which they had the power of life and death over the soldiers whom they commanded in the field and the judicial authority (subject to appeal) to coerce citizens within the city. The *quaestores* were originally two judicial and military assistants appointed by the consuls. This office

23 A few other statues of women who lived during the time of the kings are mentioned in the sources, but the statues themselves were probably later in date; on all of these portraits cf. Vessberg, *Studien,* p. 14.

24 Cf. Livy II, 9, 1 ff. According to Tacitus, *Histories* III, 72, Porsenna actually took Rome, but his victory did not result in the restoration of the Tarquins. Porsenna's real mission may have been to suppress the cities of Latium which had been incited to revolt from Etruscan domination by the south Italian Greeks led by Aristodemos of Cumae. Aristodemos defeated Porsenna at Aricia in 506 B.C.

25 The *Comitia Curiata* was the oldest of the assemblies, having originally been founded, according to tradition, by Romulus. It was based on *curiae,* groups of families which were subdivisions of the original Romulean tribes. Most of the functions of this assembly were usurped by the *Comitia Centuriata,* but it did retain in historical times the function of confirming the election of magistrates. The actual election of magistrates, the enacting of laws, and the power to declare war were left to the *Comitia Centuriata*. There were actually two tribal assemblies, the *Concilium Plebis,* an extra-constitutional assembly formed in the 5th century B.C. through which the plebs struggled for greater representation, and the *Comitia Populi Tributa,* a tribal assembly of all the citizens, which was founded in imitation of the *Concilium Plebis* after the value of the latter had been recognized.

was made elective (by the *Comitia Populi Tributa*) in 447 B.C., and when the plebs were admitted to the office in 421 B.C. the number of quaestors was raised to four. In the later Republic the quaestors became primarily financial officers, and their number was again increased. The two *censores*, elected every four years (later five) beginning in 443 B.C., were charged with keeping the rolls of citizens up to date and of assessing the economic status, and hence military obligations and privileges, of each citizen. The censor in time came to be the overseer of public morals and even had the power to unseat senators. Although the censorship lacked *imperium*, it was one of the most revered magistracies and was usually held by a man who had had a long and distinguished career in public service.

The *tribuni*, of whom there were ten by 449 B.C., were originally extraconstitutional officers elected by the *Concilium Plebis*, which swore to protect them. The tribunes were the voice of the plebs during the struggle of the orders, and by virtue of their *de facto* power were gradually incorporated into the constitutional framework by the patricians. Although the power of the tribuneship continued to grow throughout the Republic, its principal weapon was always its power to veto acts of the magistrates, laws passed by the assembly, and decrees of the Senate. The *aediles* were originally two plebian officers who assisted the tribunes and looked after the archives of the plebs in the temple of Ceres on the Aventine (hence probably the name *aedile*, from *aedes*, "temple"). In 367 B.C. two new aediles, called the "curule aediles" were elected by the *Comitia Populi Tributa*, and thereafter the four aediles (two "plebian" and two "curule") were considered magistrates of the whole populace. They became in time something like ministers of public welfare and were given charge of public buildings, the food and water supplies, market regulations, and certain public festivals.

Another important magistracy, which was not created until 366 B.C. but which it will be convenient to mention here, was that of the *praetor*, who had *imperium* in both military and judicial affairs but was considered subordinate to the consul. A second praetor was created c. 242 B.C., and a theoretical distinction was drawn between the older praetor, called the *praetor urbanus*, whose judicial function was primarily concerned with Roman citizens, and the new *praetor peregrinus*, who heard cases in which foreigners were involved.

In addition to these regular magistrates there were a number of extraordinary magistrates who were appointed during times of crisis. Foremost among these was the *dictator*, who was appointed by the consuls, usually for a period of six months, and given absolute if temporary power to deal with external military threats and also with violent civil disturbances. The dictator usually appointed an assistant called the *magister equitum*, "master of horses." Another temporary magistrate was the *interrex*. The early kingship had theoretically been an elective office, and the *interrex* was the official who administered affairs during the time between the death of one king and the election of another. Under the Republic an *interrex* was appointed by the Senate when both consuls died simultaneously, and he held office until new elections were held.

Finally there was the Senate, which was originally a council of elders appointed by the king to advise him on state affairs. The Senate became the most enduring and influential body in Roman politics and always remained aristocratic in nature. Under the Republic senators were originally appointed by the consuls, whom they served as advisors. In the late 4th century B.C. appointment of senators became the province of the censors. The number of members was not constant and seems to have fluctuated from 300 to 900 during the Republic. Since most important magistrates entered the Senate after their term of office, the magistrates were usually sympathetic to the Senate and re-

ferred to it for advice on all important political questions. Legally the Senate's main function was to advise the magistrates and ratify the laws passed by the assembly, but in practice its resolutions, *senatus consulta,* were treated as laws, since they were issued by the most experienced, powerful, and wealthy men in Rome.

The change in government at Rome in the late 6th century B.C. does not seem to have caused any immediate drastic cultural and artistic changes. The archaeological evidence suggests that Etruscan influence remained strong at Rome during the first quarter of the 5th century B.C.; it would even appear that the building program of Tarquinius *Superbus* was pushed forward vigorously. At least four major temples were erected during this period—those of Saturn in the Forum in 496 B.C. (Livy II, 21, 2), of Mercury near the *Porta Capena* in 495 B.C. (Livy II, 21, 7; II, 27, 5), of Ceres, Liber, and Libera on the Aventine in 493 B.C. (*vide infra*), and of the Dioscuri in the Forum in 484 B.C. (Livy II, 20, 12; II, 42, 5). It has been suggested [26] that extensive Etruscan influence lasted at Rome until 474 B.C., when the political decline of Etruscan civilization as a whole set in after the Etruscans suffered a disastrous naval defeat off Cumae at the hands of the south Italian Greeks.

The two themes which run through what little is known of Rome's history in the 5th century B.C. are internal dissension between the patricians and plebs (the "conflict of the orders") and the gradual domination of Latium and the surrounding area by the Romans. One cause of the conflict of the orders was the fact that the plebs were excluded from the major magistracies. Another was the laws on debt which made it possible for a plebian debtor to be reduced to slavery. Since the basis of the Roman economy was agrarian and since most land was held by the patricians, plebian citizens were often obliged to go deeply into debt to support themselves. In their struggle to gain representation and to be free of financial oppression the plebs organized themselves, through the *Concilium Plebis,* into a state within a state. The strongest weapon wielded by the plebs was the threat of secession *en masse* from the Roman state. Tradition held that such a secession did occur in 494 B.C. and that the plebs were persuaded to return only by the promise that the authority of the tribunes and the *Concilium Plebis* would be recognized. The next plebian aim, after gaining recognition for their magistrates, was to obtain a written code of laws. Agitation toward this end resulted in the formation of two commissions of ten men, *decemviri*—the first in 451 B.C. and the second in 450 B.C.—which drew up Rome's first written law code, the Twelve Tables. Either because some of the laws passed by the second commission were oppressive, or because of the tyrannical acts of some of its members, or because the patricians hesitated to return to the normal form of government which the *decemviri* had temporarily replaced, the plebs seceded again in 449 B.C. but were persuaded to return by the Valerio-Horatian laws, the details of which are uncertain, but which seem to have guaranteed legal recognition of the rights of the tribunes and the plebian assembly. In 445 B.C. a law proposed by the tribune Canuleius made it possible for plebians and patricians to intermarry. This law undoubtedly contributed substantially to breaking down the hard and fast distinction between the two classes. When in 421 B.C. the plebs were made eligible for the quaestorship, a process of enfranchisement was initiated which eventually led to political equality between the two orders.

While the conflict of the orders went on, Roman military power, if we may believe the traditional history, grew inexorably. The Republic was unable to

[26] Cf. R. Bloch, "Rome de 509 à 475 environ avant J.C.," *Revue des études latines,* XXXVII (1959), 118-131.

reassert the hegemony over the neighboring cities of Latium which had been exercised by the kings; instead, in 493 B.C. they entered into a defensive alliance on an equal footing with the Latins. Also in this alliance were the Hernici, a people of uncertain ethnic background who lived in the Trerus valley east of Rome. Part of the reason for this alliance was that the parties involved were surrounded by hostile people on all sides. To the north were the Etruscans, and to the east and south were the Sabines, Aequi, and Volsci, Italic mountain peoples who were pressing toward the more fertile plains near the Tyrrhenian coast. The Romans apparently soon came to terms with the Sabines, but wars with the Aequi and Volsci were waged intermittently throughout the 5th century B.C. Many of the details of these wars are hazy, and they are best remembered for the colorful personalities—such as Coriolanus, who defected to the Volsci, or Cincinnatus, the farmer-dictator who defeated the Aequi—by means of which Livy sought to bring them to life. Control of trade along the Tiber seems to have been the principal point of contention between the Romans and the Etruscans. The sack of Fidenae in 425 B.C. and the famous defeat of Veii (see pp. 18-19) in 396 B.C. guaranteed that the Tiber would be Rome's river.

These victories of the city over her neighbors were of considerable importance in Rome's artistic history, since they often meant that works of art were brought to Rome as plunder. The acquisition of works of art as military plunder, in fact, was to become a venerable Roman institution and is perhaps the single most important source of artistic influence on the sculpture and painting of the Republic.

This early phase of Rome's artistic history may be said to come to an end in 390 B.C. when the city was sacked and largely destroyed by marauding Gallic tribes. In weathering this colossal disaster the Romans seem to have developed a new unity of purpose which helped them conquer Italy and much of the Mediterranean world in the next three centuries.

The Temple of Ceres on the Aventine

Pliny, *N.H.* XXXV, 154: Very highly praised as modelers and also as painters, were Damophilos and Gorgasos, who did the decorative refinements, employing their skill in both arts, on the temple of Ceres facing the *Circus Maximus* in Rome; they added inscribed verses in Greek, by which they indicated that Damophilos did the work on the right side and Gorgasos that on the left. It is the view of Varro that prior to the building of this temple everything in the temples was done in the Tuscanic [Etrusco-Roman] style and that from this particular temple, when it was in the process of restoration, the embossed work on the walls was cut out and enclosed in framed panels, and that the statues from the roof were likewise dispersed.

Damophilos and Gorgasos were Greeks, probably from south Italy. Although the advent of two important Greek sculptors in Rome is an important landmark in this city's artistic history and certainly points to an intensification of cultural connections with south Italy, it does not necessarily contradict what was said previously about the continuation of Etruscan influence in the early Republic, since itinerant Greek artists

must have worked from time to time not only in Rome but in Etruria as well.

The Tomb of Lars Porsenna

Pliny preserves a description given by Varro, who in turn seems to have derived it from Etruscan sources, of the tomb of Lars Porsenna at Clusium. While the description obviously has elements of fantastic exaggeration, it perhaps also has a kernel of fact and may have had some influence on later architectural developments in Rome.[27]

Pliny, *N.H.* XXXVI, 91-93: For it is proper to use the term "Italian" for that [labyrinth] which Porsenna, the king of Etruria, built for himself as a sepulcher, in order to show at the same time how even the vanity of foreign kings is exceeded by those of Italy. But since the fabulous nature of the description exceeds all bounds, I shall make use of the words of Varro himself in presenting it: "He is entombed just outside Clusium in a place where he has left a square monument built of squared stones; each side is three hundred feet long, and the height is fifty feet. Within the square base there is an extremely complex labyrinth, from which if a person were to enter it without a ball of thread, he would not be able to find the exit again. On this base there stand five pyramids, four at the corners and one in the middle, which measure seventy-five feet along the base and 150 feet in height. They slope in such a way that a single bronze disc and a hat-shaped cupola are placed on top of all of them, from which hang bells connected by chains. . . . Above this disc are four more pyramids, each of which rises to a height of one hundred feet, and above these, on a single disc, are five more pyramids." As to the height of these last, Varro was too embarrassed to give it. But the Etruscan fables hold that it was equal to the total height of the work up to the level of these five pyramids—insane madness. . . .

The Sack of Veii

The growing cultural independence of Rome from Etruria became evident about a century later, however (c. 396 B.C.), when the Romans, led by the dictator Camillus, captured and plundered Veii after a protracted struggle.

Livy V, 22, 3-8: When the human wealth had been taken out of Veii, they began to remove the treasures of the gods and, in fact, the gods

27 E. H. Richardson, *The Etruscans,* p. 70, cites the "tomb of the Horatii" on the Appian Way and the tumulus of Cucumella at Vulci as monuments which have a combination of pyramidal and conical elements remotely similar to the description of the tomb of Porsenna.

themselves, but they did this more in the manner of worshipers than of plunderers. Certain young men, chosen out of the whole army, to whom the task of transporting [the statue of] Queen Juno to Rome had been assigned, entered her temple in a spirit of reverence, with their bodies purified and dressed in white vestment. They handled the statue at first with religious awe because, according to Etruscan custom, no one was normally allowed to touch it except a priest from a certain family. Eventually, when one of the young men, either prompted by divine inspiration or by a youthful sense of humor, said, "Do you want to go to Rome, Juno?," the others cried out that the goddess had consented. A detail which has been added to this fable ever since is that her voice was even heard saying that she consented. We know for certain, in any case, that she was raised from her seat with little effort through the use of props, and that, as if she were following willingly, she was light and easy to transport and was conveyed intact to the Aventine, her eternal seat to which the vows of the Roman dictator had called her, where afterward the same Camillus dedicated the temple which he had promised to her. Thus fell Veii, the richest and most powerful city of the Etruscan nation. . . .

The aftermath of the capture of Veii was marked by series of squabbles in which Camillus was accused by the plebians of having improperly expropriated some of the spoils. Among these was a set of Etruscan bronze doors which Camillus installed on his own house (cf. Plutarch, Life of Camillus *12; Pliny, N.H. XXXIV, 13). Camillus on his part had vowed that a tenth of the booty was to be offered to Apollo, but once the spoils had been divided up, he had considerable difficulty in collecting the tithe. Eventually, however, the money was raised and a golden bowl was sent to Delphi (Livy V, 25, 10).*

The Beginning of Sculpture in Bronze

Pliny, *N.H.* XXXIV, 15-16: Eventually this art [bronze-working] came commonly and everywhere to be used for images of gods. The first such image made of bronze at Rome, I find, was that dedicated to Ceres from the property of Spurius Cassius, who was put to death by his own father for aspiring to become king [485 B.C.]. The art of bronze-working then passed over from [images of] the gods to many varieties of statues and portraits of men. The ancient artists used to tinge their statues with bitumen, which makes it more of a marvel that they [now] delight in covering them with gold. I do not know whether this was a Roman invention or not; it certainly does not have a name of long standing.[28]

[28] The text of the best manuscript reads *certe etiam nomen non habet vetustum;* others read *Romae non* for *nomen non.* Some editors would read *Romae nomen,* which completely reverses the meaning—i.e., "For certainly it has a name of long-standing at Rome."

Livy II, 41, 10: There are some who make his [Spurius Cassius'] father responsible for his punishment; and say that, after hearing the case in his own house, the father flogged his son, put him to death, and consecrated the son's property to Ceres; from this a statue was made with the inscription: "given by the Cassian family."

Portrait Statues

The custom of honoring important citizens with commemorative statues set up in public places dated back, as we have seen, to the late stage of the period of kings. An early statue of Junius Brutus, the instigator of the overthrow of the kings, has already been noted (p. 13). The same statue is also referred to by Plutarch.

Plutarch, *Life of M. Brutus* 1: An ancestor of Marcus Brutus was Junius Brutus, of whom the Romans of old set up a bronze statue standing amidst the kings with his sword drawn, as an indication of the great resolution he showed in overthrowing the Tarquins.

Another great hero of the early Republic was Horatius Cocles, whose famous stand on a bridge across the Tiber had prevented Porsenna and the Etruscans from taking Rome.

Dionysios of Halikarnassos, *Ant. Rom.* V, 25, 2: And when he [Horatius] escaped death the populace set up a bronze statue of him in full armor in the most prominent part of the Forum,[29] and they gave him from the public domain as much land as he could plough in a day with a single team of oxen.

Aulus Gellius IV, 5: A statue set up in the *Comitium* in Rome of Horatius Cocles, a very brave man, was struck by lightning. On account of this lightning bolt soothsayers were summoned from Etruria to arrange expiatory rites, and being inimical—in fact hostile—in spirit to the Roman people, they undertook to perform the rite contrary to the proper religious procedure, and thus offered deceptive advice to the effect that the statue should be transferred to a lower position, which the sun never illuminated owing to the interposition of tall buildings all around it. Just when they had persuaded the Romans to do this, they were betrayed and brought to trial before the people, and when they confessed their perfidy, they were killed, and it became obvious that the statue, in exact accordance with what later turned out to be the true

29 According to Livy II, 10, 12, the statue stood in the *Comitium* (the meeting place of the *Comitia* in the Forum). According to Plutarch (*Life of Poplicola* 16, 9) and the treatise entitled *de Viris Illustribus Urbis Romae* 11, the statute stood in a sanctuary of Vulcan, presumably the altar of Vulcan behind the *Rostra* in the Forum.

and valid injunctions, should be taken to a higher place and should be set up in a more dominant spot in the area of Vulcan.

After Porsenna's first attack on Rome, the Romans, led by Poplicola, made a peace treaty with him and gave as security ten sons and ten daughters from prominent patrician families. The daughters, led by an independent-minded girl named Cloelia, escaped en masse from the Etruscans by swimming the Tiber. In some versions of the story Cloelia managed to find a horse which carried her across the Tiber. In order to keep the treaty intact the Romans were forced to send the girls back, and upon their return, the chivalrous Porsenna, impressed by Cloelia's spirit, made her a present of one of his own horses. Both Cloelia and Porsenna were later honored with statues.

Plutarch, *Life of Poplicola* 19: There is a statue of a woman on horseback situated on the *Via Sacra* as you proceed toward the Palatine, which some say is Cloelia but others call Valeria [the daughter of Poplicola]. . . . A bronze statue of him [Porsenna] also stood by the *Curia* [Senate House], a statue which was simple and old-fashioned in its workmanship.

Pliny, *N.H.* XXXIV, 28: Statues of people on foot were without doubt held in great esteem at Rome for a long time; the origin of equestrian statues, however, also occurred very early, since, with the equestrian statue of Cloelia, the honor was even extended to women (as if it were too little just to clothe her in a toga), while to Lucretia and Brutus, who expelled those kings on account of whom Cloelia happened to be among the hostages, no statues were decreed.

The statue in question is also identified as Cloelia by Livy (II, 13, 11), Dionysios (Ant. Rom. V, 35, 2) and Seneca (ad Marciam de consolatione, 16, 2).

Aside from brief mention of a statue of Mucius Scaevola (de Vir. Illust. 12), the soldier who thrust his hand into a fire in order to demonstrate his fearlessness to Porsenna, the other figures who were said to have been honored with statues during the 5th century B.C. *are less well known.*

Pliny, *N.H.* XVIII, 15: L. Minucius Augurinus, who convicted Spurius Maelius, reduced the price of spelt for three market days to one *as* when he was the eleventh tribune for the plebs, for which reason a statue of him, the cost of which was defrayed by a donation from the populace, was set up outside the *Porta Trigemina* [439 B.C.].

Pliny, *N.H.* XXXIV, 21-23: [There still stands in the Forum a statue of] L. Minucius, the prefect of the grain supply, outside the *Porta Trigemina*, a work paid for through a donation of one twelfth of an *as*.

As far as I know this was the first time such an honor was awarded by the populace, for previously it had been given by the Senate; this would be an illustrious honor if it had not originated from such trivial occasions. . . . [Another such statue] was that of Hermodoros of Ephesos, the interpreter of the laws which the *decemviri* drew up [451-450 B.C.], dedicated in the *Comitium* at public expense. . . . Also among the very oldest statues are those of Tullus Cloelius, L. Roscius, and Spurius Nautius, who were killed by the people of Fidenae [30] while on an embassy [438 B.C.]; the Republic customarily awarded this tribute to those who were killed unjustly.

Another type of portrait which was common throughout most of Rome's artistic history was the clipeus (or clupeus), *the portrait-shield. According to Pliny, this type of portrait originated very early in the Republic.*

Pliny, *N.H.* XXXV, 12: But the person who first instituted the practice of privately dedicating portrait-shields in shrines or in public places, I find, was Appius Claudius who was consul with P. Servilius in the 259th year of the city [495 B.C.]. For he set up [portrait-shields representing] his ancestors in the temple of Bellona. It was his will that they be viewed in an elevated position and that inscriptions stating their honors be read; shields of this sort are very proper, especially if there is a crowd of children represented on them by little images arranged in a sort of nest like small birds, for there is no one who does not look on such scenes with joy and favor.

On the subsequent development of shield-portraits see pp. 56, 95, and 156.

ROMAN EXPANSION IN ITALY: c. 390-264 B.C.

Rome did not take long to recover from the shock of the Gallic invasion. In the thirty years immediately following 390 B.C. the Romans set out to reassert their influence over the neighboring Latin cities and to meet the threats to their power posed by the Etruscans to the north and by the Italic hill peoples—the Volsci, Aequi, and the now hostile Hernici—to the west and south. At some point during this period the city was surrounded with a massive stone wall of which impressive traces still remain.[31] In 358 B.C. Rome had renewed its

30 An Etruscan city allied with Veii which the Romans fought with and eventually conquered c. 435-425 B.C. On the embassy commemorated by these statues, cf. Livy IV, 17.

31 Sometimes called the "Servian" wall because of a mistaken association with the wall built by Servius Tullius (see p. 4). The exact date of this wall was established with certainty by G. Säflund, *Le mura di Roma repubblicana* (Lund 1932).

alliance (originally drawn up in 493 B.C.) with the restive neighboring Latin cities, but the terms of the new treaty put the Latins in a more dependent position, and in 340 B.C. the Latin cities rebelled. When Rome subdued the revolt in 338 B.C., the alliance was dissolved and all of Latium now became dependent on Rome. At about the same time the Romans heeded a call from the Italic peoples in the civilized coastal cities of Campania for protection against the incursions of the Samnites, a somewhat backward but very vigorous mountain people who had wrested Campania away from the Etruscans in the 5th century B.C. (The Samnites were in fact cousins of the Italic peoples whom they were now attacking.) This call gave Rome a toehold in southern Italy but also embroiled it in a protracted series of wars against the Samnites (343-341, 326-304, 298-290 B.C.). Although the Romans suffered a number of disastrous defeats, their dogged tenacity in the end wore down the Samnites, and by 290 B.C. Rome had control, by conquest or diplomatic alliance, of all of southern Italy excepting some of the important Greek cities on the coast.

During the final Samnite War the Samnites sought to envelop Rome by forming alliances with the Etruscan cities and Gallic tribes of the north. In the previous century the Romans had had intermittent minor struggles with individual Etruscan cities. It was now decided to settle relations with these northern neighbors on a more permanent basis. By 280 B.C. the Gauls were driven back to the Po valley while the Etruscans were subdued and admitted into an alliance on easy terms.

Roman control of the entire Italian peninsula south of the Po was now thwarted only by the Greek cities of southern Italy, of which the most prosperous at the time was Tarentum. In 282 B.C. the Romans antagonized the Tarentines by sending ships into the Gulf of Taranto in order to aid the Greek city of Thurii against an attack by the neighboring Italic Lucanians. The Tarentines sank some Roman ships and later refused a Roman request for compensation. When Rome sent an army to attack Tarentum, the Tarentines appealed for help to the Hellenistic king and adventurer, Pyrrhus of Epirus. In 280 B.C. Pyrrhus landed in Italy with a professional army of some 25,000 men equipped with all the devices of Hellenistic Greek warfare, including a contingent of elephants. At Heraclea in 280 B.C. and Asculum in 279 Pyrrhus defeated the Roman consular armies, but his own losses were almost as heavy as those of the Romans (whence the term "Pyrrhic victory"). Realizing that the long-range value of such victories was slight, he then sought to break up Rome's Italic confederacy by diplomacy and coercion and, when this failed, he offered to negotiate a peace treaty. But the Romans, influenced partly by the die-hard, patriotic stand of the aged censor Appius Claudius and partly by pressure from the Carthaginians, who feared that Pyrrhus was planning to interfere with their holdings in Sicily, refused to make peace. In 278 B.C. Pyrrhus left Italy for Sicily, where, in league with the Sicilian Greeks, he waged an indecisive campaign against the Carthaginians. Rome in the meantime set about to punish the Samnites and other Italians who had joined forces with Pyrrhus. In 276 B.C. Pyrrhus returned to Italy to help these former allies but was repulsed (if not defeated) by the Romans in a battle at Beneventum in 275 B.C. Discouraged and weakened, he returned to Greece. Rome, as so often in her history, had lost most of the battles but won the war. By 270 B.C. the Greek cities of south Italy, including Tarentum, were under Roman control.

During the century in which Rome gained control of Italy, the internal "conflict of the orders" had slowly been resolved. The plebs had slowly won recognition for their representatives, the tribunes, and for the decrees of their assembly, the *Concilium Plebis*. In 367 B.C. the Licinian laws, proposed by the tribunes, took steps to reform the oppressive regulations about land ownership

and debt which had often driven plebian citizens into slavery; the *lex Poetelia* of 326 (or 313) B.C. made imprisonment for debt illegal. The Licinian laws also made the plebs eligible for the consulship; in time they became eligible for all the major patrician magistracies.

By the middle of the 3rd century B.C. Rome had thus become internally stable and externally strong. Within the city a delicate and complex balance of power existed between the popular assemblies, the magistrates, and the Senate (the power of which was growing steadily). Of the conquered and allied towns throughout the rest of Italy, a few received full Roman citizenship, some citizenship without the right to vote, while others remained independent allies bound by treaty *(Socii)*. To stabilize this arrangement colonies of Roman citizens were founded throughout Italy.

These Roman institutions were not, like the constitutions of many Greek cities, the products of conscious planning, but were rather accumulations of tradition adapted to changing situations. Their great virtue was that, in spite of their complexity, they worked.

Rome had now become one of the great powers of the Mediterranean world, and its entrance onto the stage of international politics was only a matter of time.

Triumphs and Plunder

The events of the history just narrated had the effect of continually widening Rome's artistic horizons, a process begun soon after the Gallic invasion. In 381/380 B.C. the Romans subdued and plundered the Latin city of Praeneste, which was and long remained an important artistic center.

Livy VI, 29, 8-9: [The Roman general] Titus Quinctius, who became the victor in a single pitched battle, after capturing two of the enemy's camps and nine towns and having accepted the surrender of Praeneste, returned to Rome. As part of his triumph he carried off the statue of Jupiter *Imperator* from Praeneste and brought it to the Capitolium.[32] It was set up between the cellas of Jupiter and Minerva with a dedicatory tablet fixed in place beneath it as a memorial of his great deeds; the inscription incised upon it ran something like this: "Jupiter and all the gods granted that Titus Quinctius, the dictator, should capture nine towns."

Other images of deities also appeared on the Capitol as a result of Roman military victories.

Livy IX, 44, 16 [On the culmination of a series of Roman military victories over the Samnites in 305 B.C.]: In the same year Sora, Arpinum,

[32] The temple of the Capitoline triad—Jupiter, Juno, and Minerva—which has already been discussed.

and Cesennia were recovered from the Samnites. The great image of Hercules was set up and dedicated on the Capitoline.

Pliny, *N.H.* XXXIV, 43: Italy also frequently used to make colossal statues. For indeed we see a Tuscanic [33] statue of Apollo in the library of the temple of Augustus which is fifty feet high, measuring from the big toe; and it is difficult to say whether it is more remarkable for [the quality of] its bronze or for its beauty. [In 293 B.C. the consul] Spurius Carvilius, after the Samnites were conquered by the Romans, who fought in accordance with a very sacred vow, had the statue of Jupiter which is now on the Capitoline made from the breastplates, greaves, and helmets [of the enemy]. Its size was so great that it was visible from the sanctuary of Jupiter *Latiaris*.[34] With the metal left over from the filings, Carvilius had a statue of himself made, which stood before the feet of his image [of Jupiter].

Florus, *Epitomae* I, 13, 26-27: Nor scarcely ever did a triumphal procession enter the city which was more beautiful and splendid [than the triumph following the victory over Pyrrhus in 275 B.C.]. For prior to this you would have seen nothing but the cattle of the Volsci, the flocks of the Sabines, the wagons of the Gauls, and the shattered armor of the Sabines; but on this day if you looked at captives you would have seen Molossian, Thessalian, and Macedonian as well as Bruttian, Apulian, and Lucanian; and if you looked at the procession you would have seen richly adorned statues of gold and charming Tarentine painted panels.

One of the last acts in Rome's settlement of Etruria after the Samnite Wars was her conquest of the venerable Etruscan city of Volsinii in 264 B.C.

Pliny, *N.H.* XXXIV, 34: Moreover, that the Tuscanic statues which are disposed around the world were made in Etruria, there can be no doubt. I would have thought that they were all statues of deities had not Metrodoros of Skepsis, whose cognomen was given to him from his hatred of the name of Rome,[35] made the reproach that the people of Volsinii were conquered [by the Romans] for the sake of two thousand statues.

[33] By "Tuscanic" Pliny means either "Etruscan" or "in the Etruscan style." The exact date of this Apollo is not known. Tiberius perhaps had it transported from one of the Etruscan cities to the library in the precinct of the temple of the Divine Augustus on the Palatine.

[34] A religious center of the Latins, on the Alban mount about ten miles southeast of Rome.

[35] Metrodoros of Skepsis in Mysia (northwest Asia Minor) was a Greek politician and writer active in the late 2nd and early 1st centuries B.C. He was an intimate of King Mithridates VI *Eupatōr* of Pontus, Rome's strongest enemy in the east, and was perhaps for that reason called *Misoromaeus*, "the Roman-hater."

Painting

Throughout the Republic and the early Empire a number of Roman nobles won distinction as painters.[36] *The first and perhaps most famous of these was Fabius Pictor.*

Pliny, N.H. XXXV, 19: Among the Romans also honor came to be attached to this art [painting] at an early time, since a very renowned family, the Fabii, derived its cognomen *Pictor* from it; the first member to have this name painted the temple of Salus [Health] in the year 450 from the foundation of the city [304 B.C.]. This painting survived into our own time when the temple was destroyed by fire during the principate of Claudius [A.D. 41-54].

Valerius Maximus 8, 14, 6: For what did C. Fabius want for himself, that most distinguished citizen, who painted the walls in the temple of Salus (which was dedicated by C. Iunius Bubulcus) and inscribed his name on them? For this fell short of the pride of his family, which had been dignified with consulships and priesthoods and triumphal celebrations. But, for all that, after having exercised his talent on this rather lowly undertaking he did not want his labor, no matter what kind it was, to be obliterated by anonymity, obviously following in this regard the example of Pheidias, who included his own image on the shield of Athena [Parthenos],[37] by wrenching which all the interconnections of the work came undone.

The following statement from a fragmentary section of Dionysios' Roman Antiquities is probably part of a description of Fabius Pictor's paintings.

Dionysios of Halikarnassos, Ant. Rom. XVI, 3, 6: The paintings on the walls were both very precise in their lines and also pleasing in their mixture [of colors], which had a brightness[38] completely free of gaudiness.

As we have already seen, sculpture and painting were often used to adorn the triumphal processions which followed military victories. The

[36] It is interesting to note that the Romans, like the Greeks, considered painting a learned art and therefore not beneath the dignity of a man of high social standing. Sculpture, on the other hand, required much more intense physical labor and was looked down upon by the Romans and even by the later Greeks. For passages relating to the Greek and Roman views on the importance of these professions see *The Art of Ancient Greece*, pp. 157-8 and 227-8.

[37] On this image, see *ibid.*, pp. 66-67.

[38] "Brightness" translates the Greek *to anthēron*, which may have been a technical term for certain types of colors; cf. *ibid.*, p. 228.

*statuary carried in such processions was usually booty; the paintings, on
the other hand, were often new, since the* triumphator *would commission
local artists to depict his heroic exploits. An early example of such paint-
ings is mentioned by Festus.*

Festus, *De Verb. Sig., Epit.* **228** (ed. Lindsay): The toga which is now
called "the painted" was previously called "the purple" and was at that
time without painting. A representation of this object . . . is depicted
in the temples of Vertumnus and Consus; [39] M. Fulvius Flaccus in the
former and T. Papirius Cursor in the latter are depicted celebrating their
triumphs.

Portrait Statues

*The importance of military triumphs in Rome's artistic history is
also noticeable in the portrait statuary of the 4th and 3rd centuries* B.C.
*It seems to have been around this time that the custom of representing
the* triumphator *on horseback or in a chariot became common. Pliny
gives a sketch of the history of such figures.*

Pliny, *N.H.* **XXXIV, 19-20:** Equestrian statues in particular have con-
siderable popularity at Rome, the prototype for them, without a doubt,
having originated among the Greeks. They [the Greeks], however, used
to honor only those who were victors on horseback in the sacred games,
although later they also honored those who were victorious in two-horse
and four-horse chariots. And it is from this source that our chariot groups
commemorating those who have celebrated a triumph originated. This
type, however, appeared late, and it was not until the time of the Divine
Augustus that chariots with six horses, and also with elephants, occurred.

Nor is it a very old custom to honor with two-horse chariot groups
those who have served as praetor and who have ridden around the
Circus [40] in a chariot. The custom of erecting statues on columns is older;
an example is that of C. Maenius, who subjugated the ancient Latins
[338 B.C.], to whom the Roman people used to guarantee by treaty a third
of the booty; it was in the same consulship, in the 416th year from the
foundation of the city, that the Roman people installed upon the speaker's
platform the ships' prows taken after the defeat of Antium.[41]

[39] Consus was an ancient Roman deity, perhaps a harvest god; the temple of
Consus dedicated by Papirius was on the Aventine. Vertumnus was apparently an
Etruscan deity of fertility, and his temple seems also to have been on the Aventine.

[40] Pliny is presumably referring to a triumphal procession accorded to a praetor
after a successful foreign campaign. The *Circus Maximus*, the great racecourse set in
the valley between the Palatine and Aventine, was on the triumphal route.

[41] Antium (modern Anzio) sided with the Latins during their revolt and was
defeated by Rome in a naval battle in 338 B.C. The Romans set up some of the prows
(*rostra*) of the captured ships on the speaker's platform in the Forum, and the platform
was thereafter conventionally known as the *Rostra* (whence the modern term *rostrum*).

Livy VIII, 13, 9: In addition to the honor of a triumph it was decreed that equestrian statues—a rare thing at that time—be set up to them [C. Maenius and L. Furius Camillus,[42] the consuls who defeated the Latins in 338 B.C.] in the Forum.

The statues of C. Maenius—the one mentioned by Pliny which stood on a column and the equestrian statue mentioned by Livy—were perhaps one and the same.

Another early equestrian statue was that of Q. Marcius Tremulus, the consul who defeated the Hernici in 306 B.C.

Pliny, N.H. XXXIV, 23: And in front of the temple of Castor [in the Forum] there was an equestrian statue of Q. Marcius Tremulus clad in a toga. He had twice defeated the Samnites and, with the capture of Anagnia, had freed the people from the necessity of paying the war tax.[43]

The growing influence of Greek culture on Rome, which resulted from the Roman advance into south Italy and which has already been noticeable in connection with triumphs and equestrian statues, affected free-standing votive statues as well.

Pliny, N.H. XXXIV, 26: I also find that there were statues of Pythagoras and Alcibiades set up in the corners of the *Comitium,* since, in the course of the war with the Samnites, Pythian Apollo had commanded that images be set up in a prominent place in honor of the bravest man among the Greeks and also of the wisest. These statues survived up until the time when the dictator Sulla [re]built the Senate House there. It is remarkable, moreover, that our ancestors preferred Pythagoras to Socrates, who was considered superior in wisdom to all others by that very god [Apollo], or that they considered Alcibiades so superior to others in manliness, or, for that matter, that they considered anyone superior to Themistocles in both these qualities.[44]

South Italian Greeks were also the first foreigners to set up commemorative statues in Rome.

Pliny, N.H. XXXIV, 32: The first statue set up in public at Rome by foreigners was that of C. Aelius, the tribune of the plebs, who had a

42 The grandson of the conqueror of Veii.

43 The statue is also mentioned by Livy IX, 43, 22, and Cicero, *Philippics* VI, 13.

44 The statues are also referred to by Plutarch, *Life of Numa* 8. The choice of Pythagoras and Alcibiades which so mystifies Pliny probably reflects the influence of the south Italian Greeks on Roman thinking. Pythagoras lived, taught, and died in south Italy. Alcibiades, prior to his fall from power in Athens in 415 B.C., had traveled up and down Magna Graecia in an effort to find allies for the Sicilian expedition, and was perhaps remembered with fondness.

law passed against Sthennius Stallius the Lucanian, who had twice attacked the people of Thurii [289 and 285 B.C.]. On account of this the people of Thurii gave Aelius a statue and a gold crown. The same people later presented a statue of Fabricius [45] after he had liberated them from a siege.

The Dedications of the Ogulnii

Although most of the stimuli which produced public artistic projects in Rome came from foreign affairs, the following passage indicates that there were exceptions.

Livy X, 23, 11-12: In the same year [296 B.C.] the Ogulnii, Gnaeus and Quintus, who were curule aediles, undertook the prosecution of some moneylenders; these were compelled to pay fines and with the resulting money, which went into the public treasury, the Ogulnii had bronze door frames [46] installed in the Capitolium and also had silver vessels (sufficient for three tables) made, which were put in the cella of Jupiter, and placed a statue of Jupiter in a quadriga on the roof. They also set up near the Ruminal fig tree images of the founders of the city as infants being suckled by the wolf,[47] and they also paved the path from the *Porta Capena* to the temple of Mars [48] with squared blocks. Likewise games were put on, and golden offering bowls were placed in the temple of Ceres by the plebian aediles, L. Aelius Paetus and C. Fulvius Corvus, with the money from fines which they had collected from convicted *pecuarii.*[49]

EXPANSION IN THE MEDITERRANEAN: c. 264-133 B.C.

The attempt by Carthage to influence Rome's policy during the Pyrrhic Wars had been a harbinger of things to come. In 264 B.C. a group of Italian mercenaries called the Mamertines who had served the Syracusan king Agathokles (304-289 B.C.) seized the Sicilian city of Messana (modern Messina). The Mamertines were besieged in turn by Hieron of Syracuse and appealed for aid to both Rome and Carthage. The latter sent help immediately and garri-

45 C. Fabricius Luscinus, consul in 282 B.C., drove off the Lucanians from Thurii.
46 Door frames = *limina*, which includes threshold, jambs, and lintel.
47 Whether this quadriga replaced the one made by Vulca or stood with it is not known. The famous bronze "Capitoline Wolf," now in the Conservatori Museum, dates from the early 5th century B.C. and is unconnected with the group set up by the Ogulnii.
48 This temple stood on the Appian Way outside the *Porta Capena*.
49 *Pecuarii* were farmers and shepherds who used the public land to pasture their flocks and paid a fee for such use. If they failed to pay the fee they were fined.

soned the city. The Romans were at first reluctant but, sensing a potential threat in a Carthaginian stronghold so near their south Italian possessions, they eventually sent a force which expelled the Carthaginians from Messana; thus began the First Punic [50] War (264-241 B.C.). The necessities of this war compelled the Romans, who had very little naval experience, to build their first large fleet. While the Roman land army, allied with Hieron, was driving the Carthaginians out of central and southern Sicily, the new fleet won two decisive victories at Mylae on the northern Sicilian coast (260 B.C.) and at Ecnomus off the southern coast (256 B.C.). These successes emboldened the Romans to invade Africa and strike at Carthage itself, but the Roman army, led by the consul Atilius Regulus, was badly defeated and withdrew. During the next five years, while the Roman land army tried in vain to take the Carthaginian stronghold in western Sicily, the fleet was destroyed several times by severe storms, and the tide of the war seemed to be turning in Carthage's favor. The Roman fleet under Claudius Pulcher was defeated in 249 and in 247 B.C., and the Carthaginian general Hamilcar Barca began to wage effective guerilla warfare against the Romans in western Sicily. The war, however, had become a burden to both sides, and when, in 241 B.C., a new Roman fleet surprised and defeated a poorly prepared Carthaginian fleet off Drepana in western Sicily, the Carthaginians agreed to surrender their holdings in Sicily and pay an indemnity. Rome had once again outlasted its opponent.

When the Carthaginian mercenary soldiers stationed on Corsica and Sardinia revolted in 238 B.C., the Romans intervened on these islands and subdued them. In 227 B.C. Sardinia-Corsica and Sicily were organized as the first two Roman "provinces"—that is, conquered areas which were governed by a Roman magistrate and which paid taxes to the Roman treasury.

The Roman urge to expand now broke out in all directions. In 232 B.C. the tribune C. Flaminius passed a law authorizing Roman farmers to settle in the Po valley. When the Gauls resisted, the Romans defeated them in a series of battles, and by 220 B.C. Cisalpine Gaul (and hence all of Italy south of the Alps) belonged to Rome. During the same period the Romans resolved to eradicate a group of petty piratical states on the coast of Illyria (Yugoslavia and Albania) which had been interfering with Italian shipping. In 229-228 B.C. and again in 219 B.C. the Romans defeated the pirates and established protectorates on the Illyrian coast, opening the door to eventual Roman involvement in Greece.

In the west, meanwhile, the Carthaginians, deprived of their holdings in Sicily, had begun to expand in Spain. This alarmed the prosperous Greek trading city of Massilia (Marseilles), which called upon Rome to intervene. The Romans tried to impose territorial limits upon the Carthaginian expansion and at the same time made an alliance with Saguntum, an Iberian city within the Carthaginian sphere of influence. The Carthaginians lost patience and, under the leadership of a brilliant young general named Hannibal, laid siege to Saguntum and took it in 219 B.C. Rome declared war.

The Second Punic War (218-201 B.C.) came near to being Rome's ultimate disaster. While Roman consular armies slowly set out for Spain and Africa, Hannibal astounded the world by crossing the Alps and invading Italy. In 217 B.C. at Lake Trasimene and in 216 B.C. at Cannae he annihilated Roman consular armies; the Romans did not dare to meet him in open battle thereafter, although he remained in Italy until 203 B.C. But Hannibal's long range plan, which was to break up the Roman federation by inciting the allies to revolt,

[50] From the Latin *Poeni,* literally "Phoenicians," the Roman term for the Carthaginians. Carthage was founded by Phoenician traders in the 8th century B.C.

was never wholly successful. Rome's policy of partial and gradual enfranchise-
ment of her allies had proved durable. Those major cities which did revolt,
principally Syracuse and Capua, were besieged and brought into line in 211
B.C. In the meantime the Roman army in Spain proceeded to campaign against
the Carthaginians, and in 209 B.C., finding a gifted young general of its own in
Publius Scipio (later called "Africanus"), it took the city of Carthago Nova.
This proved to be the beginning of the end of Carthaginian power in Spain;
by 206 B.C. Spain was under Roman control, Scipio was preparing to carry the
war into Africa, and Hannibal was running out of supplies. In 207 B.C. Has-
drubal, Hannibal's brother, crossed the Pyrenees from Spain with a Carthaginian
army of reinforcements but was defeated and killed at the river Metaurus
near Fanum. Hannibal, with the tide turning against him, retired to Bruttium.
In 204 B.C. Scipio invaded Africa, and the Carthaginians were forced to recall
Hannibal. After a brief truce, the final great battle of the war was fought at
Zama in 202 B.C. Rome won, using tactics it had learned from Hannibal, and
Carthage surrendered.[51]

While Rome had been embroiled with Hannibal in Italy, King Philip V
of Macedonia had joined in alliance with Hannibal and attacked the Roman
protectorates in Illyria. This interference led to the three "Macedonian Wars"
(214-205, 200-196, 172-167 B.C.) which paved the way for Roman control of
Greece. Initially the Romans were hailed by the Greeks as champions of liberty
because the philhellene consul Flamininus, after having defeated the Mace-
donians at Cynoscephalae in 197 B.C., had guaranteed the freedom of all Greek
cities. The defeat of Macedonia, however, tempted the Syrian king Antiochos III
to encroach upon Macedonian holdings in Asia Minor and even in Greece;
this resulted in an appeal for help from Pergamon, which had allied itself with
Rome during the Macedonian Wars, and the Romans were soon back in Greece.
An army led by Lucius Scipio and advised by his brother Africanus drove
Antiochos out of Greece and soundly defeated him at the battle of Magnesia
in Asia Minor (189 B.C.). This defeat of one of the great Hellenistic monarchs
served to establish Rome as the greatest power in the Mediterranean and ini-
tiated the process which led to the Roman conquest of Asia. In 168 B.C., when
Antiochos IV seemed to be about to attack Egypt, Rome was able to halt him
simply by the power of a threat.

The final step leading to Roman control of Greece came when Rome's
suspicion about the motives of the new Macedonian king, Perseus, became so
intense that war was declared against him (171 B.C.). After the consul L. Aemilius
Paullus finally defeated the Macedonians at Pydna in 168 B.C., Macedonia was
divided up into four republics. When these were stirred to revolt by a pre-
tender in 150 B.C., the Romans quelled Macedonia once and for all, making it
a province in 147 B.C. The older cities of southern Greece had sided with Rome
against Macedonia during the first half of the 2nd century B.C., but by 146 B.C.,
after a series of Roman atrocities combined with inept interference in the in-
ternal affairs of the cities, the goodwill created by Flamininus was exhausted,
and the Achaean League in desperation went to war with Rome. It was easily
defeated, and, as part of its punishment, the consul L. Mummius sacked and
completely destroyed Corinth. The works of art which were carried off as
plunder from Corinth flooded Rome and had a profound effect on the artistic
taste of the age.

The policy of suspicion and violence which characterized Rome's treat-

[51] Hannibal fled to the east where he was relentlessly pursued by Roman agents
until 183 B.C.; when he was about to be betrayed by his host, King Prousias of Bithynia,
he committed suicide.

ment of Greece in the mid 2nd century B.C. was also applied to Carthage. Although Carthage had undergone an economic revival, it was no match for the Romans when they, spurred on by the somewhat fanatical urgings of M. Cato ("the Censor"), embarked upon the Third Punic War in 150 B.C. In 146 B.C. Scipio Aemilianus, the adoptive grandson of Africanus, took Carthage and completely destroyed it. The territory of Carthage was thereafter organized into the province of Africa.

By 133 B.C. Sicily, Corsica-Sardinia, Spain, Macedonia, and northern Africa were organized as Roman provinces; southern Greece was administered by the governor of Macedonia; the kingdom of Pergamon in Asia Minor was willed to Rome by its last king; and Rome's influence upon the rulers of Syria and Egypt, while not yet absolute, was strong. The Romans with some justice began to regard the Mediterranean as "our sea."

Plunder from Syracuse: 211 B.C.

Plutarch, *Life of Marcellus* **21:** When the Romans recalled Marcellus to the war with which they were faced at home, he returned bringing with him many of the most beautiful public monuments in Syracuse, realizing that they would both make a visual impression of his triumph and also be an ornament for the city. Prior to this Rome neither had nor even knew of these exquisite and refined things, nor was there in the city any love of what was charming and elegant; rather it was full of barbaric weapons and bloody spoils; and though it was garlanded with memorials and trophies of triumphs, there was no sight which was either joyful or even unfearful to gentle and refined spectators. But just as Epaminondas called the Boeotian plain the "dancing floor of Ares" and Xenophon called Ephesos "the workshop of war," so too, in my opinion, one might apply Pindar's phrase "the war-deep precinct of Ares" to the Rome of that day. For this reason Marcellus was even more respected by the populace —he had decorated the city with sights which both provided pleasure and possessed Hellenic charm and persuasiveness—while Fabius Maximus was more respected by the older Romans. For Fabius neither disturbed nor carried any such things from Tarentum when he took it, but rather, although he carried off the money and other valuables of the city, he allowed the statues to remain, adding this widely remembered remark: "Let us leave," he said, "these aggravated gods to the Tarentines." The elders blamed Marcellus first of all because he made the city an object of envy, not only by men but also by the gods whom he had led into the city like slaves in his triumphal procession, and second because he filled the Roman people (who had hitherto been accustomed to fighting or farming and had no experience with a life of softness and ease, but were rather, as Euripides says of Herakles, "vulgar, uncultured but good in things which are important") with a taste for leisure and idle talk, affecting urbane opinions about the arts and about artists, even to the point of wasting the better part of a day on such things. But Marcellus, far from feeling this way, proclaimed proudly even before

the Greeks that he had taught the Romans, who had previously under-
stood nothing, to respect and marvel at the beautiful and wondrous
works of Greece.

Livy XXV, 40, 1-3: . . . Marcellus, after taking Syracuse and after ar-
ranging the other affairs in Sicily with such good faith and integrity that
he increased not only his own glory but also the majesty of the Roman
people, carried off the decorations of the city—the statues and paintings,
of which Syracuse had a great abundance. These were no doubt the spoils
of the enemy and were property taken by the right of war; all the same
it was from these that one can trace the beginning of the craze for works
of Greek art and, arising from that, the licentiousness with which all
places everywhere, be they sacred or profane, were despoiled; this li-
centiousness turned finally even against the Roman gods, the first such
instance being the very temple which was ornamented with such dis-
tinction by Marcellus. For the temples dedicated by M. Marcellus at the
Porta Capena used to be visited by foreigners because they had excellent
ornaments of this sort, of which, however, only a small part is now in
existence.

*Both of the foregoing passages convey some sense of the conserva-
tive Roman's reaction to the potentially degenerative effect of Greek art
and oriental luxury in Rome. This feeling is most clearly conveyed in the
following excerpt from a speech which Livy ascribes to Cato.*

Livy XXXIV, 4, 1-4: You have often heard me complaining about the
extravagances of women and often about those of men—not only of pri-
vate citizens but even of magistrates—and how the state suffers from two
diverse vices, avarice and luxury, those pests which have overturned all
great empires. I come to fear these even more as the fortune of the Re-
public becomes greater and more pleasant every day and the empire
grows—now we have even moved over into Greece and Asia, places which
are full of every sort of libidinous temptation, and we are even putting
our hands on royal treasuries—for I fear that these things will make
prisoners of us rather than we of them. They are dangers, believe me,
those statues which have been brought into the city from Syracuse. For
now I hear far too many people praising and marveling at the ornaments
of Corinth and Athens and laughing at our terracotta antefixes of the
Roman gods. I prefer these gods, who are propitious and will remain
so, I hope, if we permit them to remain in their proper places.

The Luxury of Asia

Pliny, N.H. XXXIV, 34: And to me it seems remarkable that, even
though the origin of bronze statuary is so old, the images of the gods

which were dedicated in sanctuaries were more often of wood or terra-cotta right down to the time of the conquest of Asia, whence came luxury.

With the last phrase of this passage—unde luxuria—*Pliny, like Cato in the previous passage, expresses what to many Romans was the foremost effect of Rome's conquest of the Mediterranean. The legacy of centuries of relative cultural isolation in which the old Romans, thanks to their simple, stolid, country-farmer virtues, had survived perpetual adversity and molded a great state, was confronted with and partially succumbed to the* luxuria Asiae. *It was above all the Hellenistic king-doms of the East—Ptolemaic Egypt and Seleukid Asia—with their com-bination of Greek artistry and intellectualism with Oriental pomp and grandeur, which made the Romans conscious of their own poverty.*

The ancient author who most vividly conveys the nature of this luxuria Asiae *is Athenaeus. In the* Deipnosophistae *196A-209E, he quotes a series of lengthy and elaborate descriptions of (1) a festival pavilion built by Ptolemy II Philadelphos, probably in 276* B.C.; *(2) a procession which was part of the same festival; (3) a river boat built by Ptolemy IV, Philopatōr (ruled 221-205* B.C.); *and (4) another pleasure ship built by the tyrant Hieron II of Syracuse (ruled c. 265-215* B.C.) *which was later given to one of the Ptolemies. Athenaeus took the first three descriptions from the Hellenistic writer Kallixeinos of Rhodes (mid 2nd century* B.C.) *who wrote a volume about the city of Alexandria. The last is taken from a writer named Moschion, of whom nothing else is known.*

Architecture, sculpture, painting, and the minor arts are all in-extricably intermingled in these descriptions, as the excerpts which follow will indicate. They are important for the study of Roman art not only because they preserve a picture of the type of pomp and splendor which so impressed the Romans but also because they indicate the source from which many characteristic features of Roman imperial art were derived. One might note in particular the use of portraiture for propa-ganda, the use of theatrical settings to display works of art, the interest in architectural fantasy, the illustration of great works of literature through a series of mosaics, and, above all, the use of symbolism and allegory, especially political allegory, in sculpture.

The Festival Pavilion of Ptolemy II [52]

Athenaeus 196A: Before I begin [to describe the procession] I will de-scribe the pavilion which was built within the circuit wall on the citadel away from the area which was set aside for the reception of soldiers,

[52] For a thorough study of the text of this passage and for a reconstruction of the building cf. F. Studniczka, "Das Symposion Ptolemaios II," *Abh. Sächs. Akad. Wissen-schaften zu Leipzig* XXX (1914), 51-188.

artisans, and travelers; for it was extremely beautiful and well worth hearing about. Its size was such that it could hold 130 couches arranged in a circle, and its construction was of the following sort.[53] Wooden columns were set up at regular intervals, five along the length of each long side fifty feet in height; but there was one less column [i.e., four on each side] along its width. Fitted on top of these was a square epistyle, supporting the whole roof of the *symposion* [banquet room]. The middle of the roof was draped with a red canopy bordered with white, while on either side there were crossbeams weighted down with tapestries which were half white and had a tower pattern border; between these beams painted compartments were arranged. Of the columns the four corner ones resembled palm trees while those in the middle had the appearance of *thyrsoi*.[54] On the outside of these coluumns a peristyle gallery with a vaulted roof was constructed around three sides [of the main part of the pavilion], in which it was possible for the attendants of those who were reclining [i.e., the guests in the *symposion*] to stand by. The inside of the pavilion was hung all around with purple screens, while in the spaces between hides of animals, wondrous in their variety and size, were suspended. The surrounding part which faced the open air [55] was thickly shaded with myrtle and laurel and other suitable branches, while the floor was strewn with all sorts of flowers. [A section praising the flowers of Egypt follows.] . . . Placed by the supporting piers of the pavilion were one hundred marble statues by artists of the first rank. In the spaces between these were panels by painters of the Sikyonian school, alternating with selected portraits, gold embroidered tunics, and extremely beautiful soldiers cloaks, some with portraits of kings woven into them, others with mythological scenes. Above these there were oblong shields, alternately of silver and gold, hung all around. In the spaces above these, measuring eight cubits, recesses were built, six along the short sides. In these recesses there were figures arranged to face one another as if in drinking parties; the draped garments on them were real. They represented characters from tragic, comic, and satyric drama; beside them there were also gold drinking cups. Between the recesses were left niches, in which golden Delphic tripods with bases were set up. On the highest part of the ceiling there were gold eagles facing one another, their size being fifteen cubits. On the two sides of the pavilion were one hundred golden, sphinx-footed couches. [Kallixeinos then enumerates the rugs, tables, goblets, etc., which were placed around the *symposion*.] . . . It appeared to me that it would take a long time to indicate in detail the different varieties of equipment which were on

53 The building was a *symposion* ("banquet hall"), probably reserved for the king and his special guests.

54 *Thyrsos* = a Dionysiac wand, usually surmounted by a pinecone.

55 What this refers to is not clear. Perhaps it was the space between the upper canopy and its supporting beams.

hand. But the weight of all the utensils taken together was about ten thousand talents.

The Festival Procession

This procession combined elements of an Egyptian harvest festival, a Greek theatrical festival, and a political parade. It is chiefly interesting as a source for the type of theme and symbolism which Hellenistic art passed on to Roman art. Only the highpoints of this lengthy description are given here.

Athenaeus 197C: Since we have gone over the details of the pavilion, we shall proceed to a description of the procession. It was held in the stadium of the city. First came the division [within the procession] of the "Morning Star." For the procession had its beginning at the time when that star appeared. Next came the division which was named after the parents of the king and queen. Then came the division of all the gods, having the attributes which were appropriate to the stories about each of them. At the end marched the "Evening Star," the season bringing it around to that moment.[56] If anyone wants to know about each detail, let him look at the *graphoi* [57] of the penteteric games. First in the Dionysos procession came Sileni [58] who held back the crowd; some were dressed in dark red cloaks, others in purple. Following after them came Satyrs, twenty in each part of the stadium, carrying gilded ivy torches. Following them came Victories with gold wings. These carried incense burners six cubits high and decorated with gilt ivy sprigs . . . Amidst these walked a man over four cubits tall dressed in tragic costume and mask and bearing a golden horn of Amaltheia. He was called "the Year." Following after him came a very beautiful woman, equal to him in size, adorned with much gold and with a conspicuous tunic and holding in one hand an Egyptian wreath and in the other a palm staff. She was called *Penteteris.*[59] The Four Seasons followed her, elaborately decked out and each carrying the fruits appropriate to her. [Satyrs, athletes, and actors followed.] . . . After these came a four-wheeled float, fourteen cubits long and eight cubits wide, which was drawn by 180 men; on it was a statue of Dionysos ten cubits tall pouring a libation from a gold goblet and wearing a dark red chiton which reached to his feet; over this there was a diaphanous saffron-colored robe. Over his shoulder there was thrown a dark red cloak studded with gold. Set out in front of him was a gold Lakonian krater holding fifteen measures [150 gallons] and a gold tripod, on which there

[56] The meaning of the last phrase is uncertain.

[57] *Graphoi* = either "paintings" or "written records."

[58] Here and in many other cases the description refers to men in Dionysiac costumes.

[59] The festival was penteteric; that is, it was held every fifth year, counting both the years of its occurrence and recurrence (or, as we would say, a four-year interval).

was a gold incense burner and two gold offering bowls, filled with cassia
and saffron. Over him there was a canopy decorated with ivy, grape vines,
and other fruits, and attached to it were wreaths, ribbons, *thyrsoi*, tam-
bourines, fillets, and also satyric, comic, and tragic masks. [Priests and
female devotees of Dionysos followed.] . . . After these came a four-
wheeled float eight cubits wide and drawn by sixty men, on which there
was a seated statue of Nysa [the nurse of Dionysos] eight cubits high and
dressed in a yellow tunic studded with gold; a Lakonian cloak was thrown
over her shoulders. This image stood up by mechanical means, without
anyone putting his hands on it, and after pouring out milk from a golden
offering bowl, it would sit down again. In its left hand it held a *thyrsos*
wound around with fillets. She also wore a crown with gold ivy leaves
richly studded with grape clusters of jewels. . . . [Nysa was followed by
more Satyrs and Sileni and a vast array of giant wine vessels, tripods, etc.].

(Sec. 200B) After these he [Kallixeinos] catalogues some four-cubit
tables on which many richly wrought scenes, well worth seeing, were put
on display. Among these was the bridal chamber of Semele, in which
some figures wear gold-embroidered tunics studded with the costliest of
gems. Nor would it be right to overlook the four-wheeled float which
followed; it had a length of twenty-two cubits, and a width of fourteen
cubits, drawn by five hundred men. On it there was a deep cave covered
over with ivy and yew. From this pigeons, doves, and turtledoves flew
out over the whole course of the parade with ribbons bound to their
feet so that they would be easily caught by the spectators. There also
gushed forth from it two springs, one of milk, one of wine. And all
around him [presumably the infant Dionysos] stood Nymphs with gold
crowns. Hermes held a gold staff and wore costly robes. On another
four-wheeled cart, which carried a representation of the return of
Dionysos from India, there was a figure of Dionysos twelve cubits high
seated on an elephant, with a purple cloak on his shoulders and wearing
a crown of golden ivy and grape leaves. In his hands he held a gold
thyrsos-spear, and his shoes were bound on his feet with gold laces.
Seated in front of him on the elephant's neck is a Satyr five cubits high,
crowned with a gold pine wreath; with his right hand he is making a sign
with a gold goat horn. The elephant had gold trappings and around his
neck was a gold garland of ivy. . . . [After this float came Satyrs, Sileni,
hunters, and some African and Indian animals.]

(Sec. 201C) . . . Next on a four-wheeled cart was Dionysos after having
fled to the altar of Rhea when he was being pursued by Hera; he wears
a gold crown, and next to him stands Priapos with a gold ivy crown.
The image of Hera also has a gold crown. Then came images of Alex-
ander and Ptolemy [60] crowned with ivy wreaths of gold. The image of

60 Alexander and Ptolemy I preceded Ptolemy *Philadelphos* as rulers of Egypt.
The legitimacy of his reign was derived from his connection with them.

Virtue [Aretē] which stood beside Ptolemy had a gold olive crown. Priapos also appeared with them, wearing a gold ivy wreath. The City of Corinth stood by Ptolemy and was crowning him with a gold diadem.[61] . . . [Next came more vessels and Dionysiac symbols, followed by women from cities of Asia Minor which Alexander had liberated from the Persians. After these there were other images of kings and gods, musicians and various animals.]

(Sec. 202B) . . . After these came the division of the procession in honor of Zeus, and others in honor of all the other gods, and after all these that of Alexander, whose gold statue was placed on a chariot drawn by real elephants, with Victory and Athena occupying the space on each side of him. [Crowns, altars, tripods, etc., followed.] . . . There also passed by seven gilded palm trees eight cubits high, a gilded herald's staff forty-five cubits long, a gilded thunderbolt forty cubits long, and a gilded temple, of which the perimeter was forty cubits. In addition to these there was a double horn eight cubits long. There was also a large number of gilded figures in the procession, many of which were twelve cubits high, and there were wild beasts, extraordinary in their size, and eagles twenty cubits high. . . .

A River Boat of Ptolemy IV, Philopatōr

Athenaeus V, 204E: *Philopatōr* also had a river boat called the "state barge," which was half a stade long [c. three hundred feet] and thirty cubits in width at the widest point. The height, including that of the canopy, was almost forty cubits. Its design was neither like long war boats nor like the round-hulled merchant ships, but rather its water displacement had been altered somewhat for use on the river. For at the bottom it was flat and broad, but in its massiveness it rose high in the air. And parts of the upper edges of its hull, especially around its prow, extended quite far outward, with a reverse curve which displayed an excellent profile. It had a double prow and a double stern which projected quite far into the air, since the waves in the river often rise to a great height. In the hold at the middle of the ship there were *symposia* and bedrooms and the other necessities for pleasant living. Around the ship on three sides were double promenades. The perimeter of one of these was not less than five *plethra* [c. 505 feet]. The design of the promenade on the lower deck was like a peristyle; that of the one on the upper deck was like a hidden portico with partitions and doors all around. As you first entered by the stern the arrangement you met was a vestibule open at the end but flanked by colonnades; in it, in the part leading toward the

[61] The League of Corinth had first declared the deification of Alexander, a gesture which carried political weight in Egypt where the divinity of kings was an ancient institution. The figure of Corinth crowning Ptolemy thus further emphasized the legitimacy of Ptolemy's rule.

prow, a propylon [gateway] was constructed from ivory and extremely expensive wood. Going through this you came to a sort of *proskenion* [stage front] which was designed with a roof over it. Repeating this earlier arrangement there was behind this another vestibule along the middle of the side, and there was a gate with four doors leading into it. On both the left and the right side there were portholes which furnished a breeze. The largest cabin was connected with these. It had a peripteral colonnade and could hold twenty couches. Most of it was made of split cedar and Milesian cypress wood. The twenty doors which ran all around it were composed of panels of fragrant African wood, fastened together, and equipped with decorations in ivory. Both the nail heads on the surface of it and also the door knockers were of red bronze and had received gilding from the fire. The shafts of the columns were of cypress wood, while the capitals were in the Corinthian order and were decorated all around with ivory and gold. The epistyle was completely of gold. On its frieze remarkable figures of ivory were attached, over a cubit in height, and while they were of only middling artistic merit, they were remarkable for their lavishness. There was a beautiful roof over the *symposion,* with a squared design, made of cypress wood. On it were sculptured ornaments with a gold surface. [Other rooms—dining rooms and bedrooms—are mentioned briefly, and Kallixeinos then turns to a description of the upper deck.]

. . . There was a *tholos*-shaped sanctuary of Aphrodite, in which there was a marble image of the goddess. Opposite this there was another lavish *symposion* with a peripteral colonnade. The columns were made of stone from India. Beside this *symposion* there were bedrooms which followed the arrangement of those already described. Going forward toward the prow there was a Bacchic chamber with thirteen couches and a peripteral colonnade which had a gilded cornice running along the entablature. The [decoration of the] roof was appropriate to the characteristics of the god. In this chamber on the right-hand side a recess was constructed, which had a surface like a rock cave wrought from real stones and gold. Set up in it were portrait statues of the royal family made from Parian marble. Also quite delightful was another *symposion* set on the roof of the largest chamber and arranged like a pavilion. There was no roof over it, but bow-shaped curtain rods were arranged along a certain part of its extension; on these purple curtains were spread out when the ship was under way. After this there was an open space which occupied the spot right above the underlying vestibule. A circular stairway was placed there leading to the hidden portico and to a *symposion* with nine couches, of which the construction was in the Egyptian style. For the columns which were placed here rose with rounded profiles,[62] and the drums of the columns were differ-

62 "With rounded profiles" = Greek *strongyloi,* perhaps suggesting that either the individual drums bulged out like beads or that the column as a whole had an ellipsoidal profile.

entiated with a black drum followed by a white drum set in an alternating pattern. The capitals of some of them are circular, and the complete design of them is like rosebuds which have opened a little. But around the part called the *kalathos* ["basket"] there are no volutes as on the Greek columns, nor are there rough leaves, but rather there are the calyxes of river lotuses and the fruit of palms [dates] which have recently bloomed. In some cases there are several other varieties of flowers sculptured on them. The part below the root, which rests upon the drum connected to the capital, has a design which is like the interwoven flowers and leaves of the Egyptian bean-plant. In this manner then the Egyptians make their columns. They also vary their walls with white and black bricks, and sometimes they make them from the stone called alabaster. There were many other such rooms within the hollow of the ship's hold and in every part of it. Its mast was seventy cubits high, and it had a sail of fine linen ornamented with a purple topsail.

The Ship of Hieron II

Since Athenaeus' description deals mainly with details about the ship's capacities and its technical equipment, only a few excerpts are given here.

Athenaeus V, 207C ff.: . . . Along the middle passageway, along the walls on each side, were living quarters for the men, thirty in all, large enough to hold four couches. The officers' quarters had room for fifteen couches, and also had three chambers large enough for three couches; toward the stern there was a galley. All of these had a mosaic floor composed of many sorts of stones, in which the whole story of the *Iliad* was represented in a marvelous fashion. Likewise on the furniture, the ceilings, and the doors all these things were also represented. . . . A shrine of Aphrodite was built, large enough for three couches, with a floor made of agate and as many other pleasing stones as are found on the islands. It had walls and a ceiling of cypress wood, with doors of ivory and fragrant African wood. And it was lavishly equipped with paintings and statues as well as vessels for drinking. . . . Around the outside of the ship ran a row of Atlases six cubits high which held up the bulk, including the triglyph frieze, which was above, and they were all placed in position according to a symmetrical pattern. . . . The name of the ship was *Syracusia*; but when Hieron sent it on its way, the name was changed to *Alexandris*.

The effects of Asian wealth and Asian "attitudes" on Rome are elaborated upon by Pliny and Livy in the following passages.

Pliny, *N.H.* XXXIII, 148-50: It was conquered Asia which first sent luxury to Italy, since L. Scipio brought over 1,400 pounds of engraved

silverware and gold vases weighing 1,500 pounds for his triumphal procession in the 565th year from the foundation of Rome [189 B.C.]. But it was the receipt of this very same Asia as a gift which afflicted our morals much more gravely; our inheriting it from King Attalos upon his death was more harmful than that victory [of Scipio]. For when it came to buying the possessions of the king which were being auctioned off at Rome, all restraint was abandoned (that is, in the 622nd year of the city [132 B.C.]), and in the fifty-seven year interval, the city learned not just to admire foreign opulence but actually to love it. The victory over Achaia also gave immense impetus to the overthrow of our morals, for this victory, occurring during the interval in question—that is to say, in the 608th [63] year of the city—introduced captured statues and paintings into Rome. And lest anything be lacking, luxury was also born at the same time through the fall of Carthage,[64] with the effect that, as if by the connivance of the fates, there was freedom to enjoy vices and the enjoyment of them became permissible.

As Pliny indicates, the triumphs which followed the defeat of Antiochos (i.e., those of L. Scipio and Manlius Vulso, the consul who succeeded Scipio) were particularly important in bringing a taste for the luxury of Asia to Rome.

Livy XXXVII, 59, 3-5: [L. Scipio] carried in his triumphal procession 224 military standards; 134 images [65] of towns; 1,231 ivory tusks; 234 gold crowns; 137,420 pounds of silver; 224,000 Attic tetradrachms; 321,070 *cistophori;* 140 gold *Philippeioi;* [66] 1,423 pounds of silver vases—all with engraved surfaces—and 1,023 pounds of gold.

Livy XXXIX, 6, 7: The origin of foreign luxury in the city can be traced to the return of the Asiatic army [of Manlius Vulso in 186 B.C.]. It was these soldiers who first brought to Rome bronze couches, precious coverings, curtains, and other textiles, and also what they used to consider magnificent furniture in those days—one legged tables and buffet tables.[67]

63 146 B.C. Pliny refers here to the Achaean campaign which culminated in the sack of Corinth by Mummius.

64 That is, in 146 B.C., at the end of the Third Punic War. Pliny's idea seems to be that luxury itself began to invade Rome after the defeat of Antiochos, that the taste for luxury matured with the fall of Corinth and Carthage, and that the opportunity for it appeared with the bequest of Attalos III.

65 Images = *simulacra.* These may have been models of conquered towns or perhaps statues which personified the towns.

66 The Attic tetradrachm was an Athenian silver coin weighing four drachmas (one drachma = 4.31 grams). The *cistophorus* was an Asiatic coin roughly equal in value to the tetradrachm. *Philippeioi* were gold coins first issued by Philip II of Macedon.

67 Pliny, *N.H.* XXXIV, 14, gives the same information and cites Lucius Piso (on whom see p. xviii) as his source.

The triumph over Antiochos seems to have brought not only Asiatic art but also Asiatic artists to Rome.

Livy XXXIX, 22, 9-10: About this time L. Scipio held games, which he said he had vowed during the war with Antiochos, lasting for ten days and paid for with money from the [Asian] kings and cities. Valerius Antias is the source for the story that after his condemnation and the sale of his possessions [68] he was sent to Asia as a special ambassador to settle a dispute between Kings Antiochos and Eumenes; it was at that time that he collected this money and assembled artists from throughout Asia. . . .

Further Triumphs and Their Fruits

FROM THE SIEGE OF CAPUA (211 B.C.)

Livy XXVI, 34, 12: The images and bronze statues which were said to have been captured from the enemy they turned over to the college of priests to determine which of them were sacred and which profane.

FROM THE SIEGE OF TARENTUM (209 B.C.)

Tarentum had gone over to Hannibal during the Second Punic War. It was retaken by Fabius Maximus.

Livy XXVII, 16, 7 ff.: Thirty thousand people are said to have been taken as slaves, as well as a huge amount of silver, both wrought and coined, 83,000 pounds of gold, and statues and paintings which will almost have equaled the decorations taken from Syracuse. But Fabius, being a man of greater spirit than Marcellus, abstained from taking these as booty; when asked by a scribe what he wished to be done with these statues which were of such great size—they were gods, and were represented as dressed in the habit which is characteristic of warriors—he ordered that they should "leave those angry gods to the Tarentines."

In spite of the reported reluctance of Fabius to remove the images of the gods from Tarentum, we are told by several authors that he carried off a colossal image of Herakles by the famous Greek sculptor Lysippos and dedicated it on the Capitoline.[69]

[68] As part of a senatorial reaction to the dominance of Scipio's family, L. Scipio was tried in 187 B.C. on the charge of having embezzled some of the money which came from the settlement of the war with Antiochos. Valerius Antias was an annalist active during the time of Sulla (c. 80 B.C.).

[69] On this statue see *The Art of Ancient Greece*, p. 101.

THE TRIUMPH OF SCIPIO AFRICANUS IN 201 B.C. FOLLOWING THE BATTLE OF ZAMA

Appian, *Punic Wars* **66:** Everyone wore a crown, and trumpeters and wagons filled with spoils led the way; towers were carried along as representations of cities which had been taken and also paintings illustrating all the events which had occurred. . . .

THE RETURN OF L. STERTINIUS FROM SPAIN (196 B.C.)

Livy XXXIII, 27, 3-4: L. Stertinius, [the proconsul, upon returning] from Further Spain, without even being tempted by the hope of a triumph, brought into the treasury fifty thousand pounds of silver; from this money, which came as booty, he built two arches [70] in the *Forum Boarium* in front of the temples of Fortune and of the Mater Matuta,[71] and one in the *Circus Maximus,* and on these arches he set up golden statues.

THE PLUNDER AND TRIUMPH OF FLAMININUS

Livy XXXII, 16, 17 [Following the capture of Eretria, a Greek city on the island of Euboea, in 198 B.C.]: The money seized, both gold and silver, hardly amounted to very much; but statues and paintings of ancient workmanship and other ornaments of that sort were found in far greater quantity than the size of the city and its wealth in other respects would have led one to believe.

Livy XXXIV, 52, 4-5 [Flamininus' triumph in Rome in 194 B.C. celebrating the defeat of Philip]: The triumph lasted for three days. On the first day armor and weapons were exhibited, and also statues in bronze and marble, more of which were expropriated from Philip than were captured from cities of Greece. On the second day gold and silver, worked, unworked, and coined, were paraded. Of unwrought silver there were 43,270 [72] pounds; of wrought silver there were many vases made of bronze and, in addition to all this, ten shields of silver. . . .

THE TRIUMPH IN 187 B.C. OF M. FULVIUS NOBILIOR FOLLOWING HIS DEFEAT OF THE
AETOLIANS AND THE CAPTURE OF AMBRACIA IN 189 B.C.

Polybios XXI, 30, 9: Marcus [Fulvius Nobilior], having taken Ambracia, released the Aetolians under a truce and carried off the cult

70 "Arch" here translates *fornix,* which implies a relatively small and simple arch, usually part of a gateway. The term *arcus* was used for the more ambitious and monumental triumphal arches of the Imperial period. Another such *fornix* was set up by Scipio Africanus prior to his departure for Asia and the war against Antiochos; cf. Livy XXXVII, 3, 7. This arch was more in the nature of a propitiatory offering than a symbol of triumph.

71 The Mater Matuta, "the Mother of Ripening" (or, according to some, the "Dawn Mother") was a Roman goddess of growth.

72 Restored by analogy with Plutarch, *Titus Flamininus* 14. The mss. read 18,270.

images,[73] statues, and paintings from the city; there was a great number of these owing to Ambracia's having been the royal city of Pyrrhus.

Livy XXXIX, 5, 13-16: He celebrated his triumph over the Aetolians and Cephallenia on the tenth day before the kalends of January. Golden crowns weighing 112 pounds were carried before his chariot and also . . . [A catalogue of the amount of unworked and coined gold and silver carried in the procession follows; compare the similar catalogue connected with the procession of Lucius Scipio, p. 41] . . . 285 bronze statues, 230 marble statues, arms, weapons, and the other spoils of war in great number. . . .

Livy XXXIX, 22, 1-2: Thereafter M. Fulvius put on for ten days with great pomp the games which he had vowed during the Aetolian War. Out of respect for him, many artists came from Greece. . . .

One of the works brought to Rome from Ambracia by Fulvius Nobilior is identified by Pliny as a sculptural group representing the Muses.[74]

THE TRIUMPH OF AEMILIUS PAULLUS AFTER PYDNA (168 B.C.)

This is the most vivid of all the triumphal descriptions and captures better than any other the pomp and cruelty of the custom. Only the portions which deal with the arts are given here.

Plutarch, *Life of Aemilius Paullus* 32-33: The triumph was spread out over three days. The first day was just barely sufficient for seeing the statues which had been seized, and the paintings and the colossal images, all carried along on 250 wagons drawn by teams. On the next day the most beautiful and most expensive of the Macedonian arms were sent along, the newly polished bronze and iron glittering as they went, in 250 carriages. . . . Others carried silver mixing bowls, horn-shaped goblets, offering bowls, and drinking cups; each group was carefully laid out so as to look its best and each specimen was outstanding in size and the density of its engraving. . . . [On the third day came] those who carried the sacred offering bowl which Aemilius had had made from ten talents of gold and which was set with stones. Then the Antigonid, Seleukid, and Theriklean [75] cups and all the gold utensils used at the table of Perseus were exhibited.

Among the statues brought to Rome by Aemilius Paullus was an Athena by Pheidias, which was eventually dedicated in the temple of

[73] Cult images = *agalmata;* it could also simply mean "votive offerings."
[74] Cf. *The Art of Ancient Greece*, p. 150. (Pliny, *N.H.* XXXV, 66).
[75] Theriklean cups were named after a Corinthian potter who invented the type; cf. *The Art of Ancient Greece*, p. 217.

Today's Fortune. It is also known that Paullus retained the Athenian painter Metrodoros to do some of the paintings for his triumphal procession.[76]

In the same war Gnaeus Octavius, the praetor, defeated the navy of Perseus and celebrated a triumph.

Pliny, *N.H.* XXXIV, 13: The early Romans used to make the door frames and folding doors of their temples from bronze. I find also that Gnaeus Octavius, who received a triumph after his naval victory over Perseus [168 B.C.] made the double portico in the Flaminian Circus which was called the "Corinthian Portico" after the bronze capitals of its columns, and that it was resolved that even the temple of Vesta should have its roof covered with a surface of Syracusan metal.[77]

THE FINAL CONQUEST OF MACEDONIA (148 B.C.)

Velleius Paterculus I, 11, 2-5: Quintus Metellus, the praetor, who as a result of his bravery was given the title *Macedonicus,* conquered the same people [the Macedonians] with a distinguished victory. . . . This is the same Metellus who made the portico which surrounded the two temples set up without inscriptions (the same temples which are now surrounded by the *Porticus Octaviae*) and who brought from Macedonia a squadron of equestrian statues which stand facing the temples and are, even today, the outstanding ornament of the place. As to the origin of this squadron, they tell the following story: Alexander the Great prevailed upon Lysippos, an artist of unique skill in making works of this sort, to model portraits and make statues of those of the cavalrymen in his own squadron who had fallen at the river Granikos and to place a statue of himself among them.[78]

This same Metellus was the first man to build a temple of marble in Rome (the temple, that is, which stood among the monuments under discussion) and was consequently the originator of this type of magnificence or, one might say, of this type of luxury.

The Porticus Octaviae *mentioned in this passage (which is to be distinguished from the* Porticus Octavia *mentioned previously) was built by the Emperor Augustus in the name of his sister Octavia (see pp. 105, 109). It replaced the* Porticus Metelli *built by Metellus on the same site, and it surrounded the temples of Jupiter Stator and Juno Regina, which had also been built by Metellus. It is one of these temples which Velleius Paterculus mentions above as the first marble temple in Rome. They are also mentioned by Pliny.*

76 For these passages cf. *ibid.,* pp. 68 and 210.
77 This building, called the *Porticus Octavia,* was later restored by Augustus; see p. 119.
78 On this monument cf. *The Art of Ancient Greece,* pp. 98, 100.

Pliny, *N.H.* XXXVI, 42-43: Nor is it proper that Sauras and Batrachos, who made the temples within the *Porticus Octaviae* and who were Spartans by nationality, should be forgotten. Certain people think that these men were extremely wealthy and that they constructed it with hope of [being honored by] an inscription; when this honor was refused them, however, they claimed the work as their own by another means. There are even now, at any rate, figures of a lizard and a frog, in conformity with their names, carved on the bases of the columns.⁷⁹ In the temple which is dedicated to Jupiter, the painting and the rest of the adornments are completely concerned with feminine subjects; for it was made as a temple of Juno, but tradition holds that when the cult statues were being brought in, the porters mixed them up, and that this arrangement was preserved for religious reasons, the feeling being that the final positions were chosen in that way by the gods themselves. Therefore the decoration is now in the temple of Juno which ought to have been in the temple of Jupiter.

Triumph over Carthage (146 b.c.)

Appian, *Punic Wars* 135: When everything had been arranged by him [P. Scipio Africanus the Younger] and he had sailed home, he celebrated the most glorious of all triumphs, rich in gold and ornamented by as many images and offerings as the Carthaginians had been able to collect over many years from the whole of Libya through a continuous series of victories.

Cicero, *Verr.* II, II, 3: . . . P. Africanus, after the destruction of Carthage, adorned the cities of Sicily with some extremely beautiful statues and monuments, since he decided that most of the monuments of victory should be placed among those people who most greatly rejoiced at the victory of the Roman people.

The sack of Corinth (146 b.c.) ⁸⁰

Pausanias VII, xvi, 7-8: On the third day after the battle he [Mummius] took Corinth by force and burned it. Of those men who were left in the city the Romans slew the greater part; the women and children Mummius sold into slavery. He also sold the slaves—that is, as many as did not perish as victims of the war at its outset—after they received their freedom and fought along with the Achaians. Those of the public votive offerings and other decorations which were held in the greatest admira-

⁷⁹ *Saura* means "lizard" and *batrachos* means "frog" in Greek. The names seem at first sight to be fictional creations, invented after the time of Metellus to account for the fact that the temples had no dedicatory inscriptions. The identification of Sauras and Batrachos as Spartans, however, is an odd bit of historical realism. It is just possible that these are the names of Greek architects employed by Metellus.

⁸⁰ For other references see pp. 41 and 79-80.

tion he carried off; while those among them which were not quite of the same quality Mummius gave to Philopoimen, the general sent by Attalos. And even in my time there were spoils from Corinth at Pergamon.

De Vir. Illust. 60: Mummius despoiled Corinth of its statues and paintings, filled the whole of Italy with them, and kept none for his own home.

The preceding passage helps to explain the following remark:

Pliny, N.H. XXXIV, 36: Mummius, having conquered Achaia, filled the whole city [with statuary, which meant in the long run that] he would not leave a dowry for his daughter. Why not mention this along with the excuse for it?

Strabo VI, 381: . . . The greatest number and the best of the public monuments of Rome come from it [the plunder carried off by Mummius], and the cities which surround Rome also have a part of it.

Livy, topic from a summary of book LII [which has not survived]: L. Mummius celebrated a triumph over the Achaians. Bronze and marble statues and also painted panels were carried in the procession.

To the more sophisticated Romans of the early Empire the barbaric and boorish aspect of Mummius' sack of Corinth was more apparent than at the time when it occurred. Mummius himself came to be caricatured as a Philistine, and some amusing anecdotes are told about his lack of expertise in artistic matters.

Pliny, N.H. XXXV, 24: L. Mummius, whose victory won him the cognomen *Achaicus,* was the first to enhance the esteem which is publicly accorded to foreign paintings at Rome. For when, during the sale of the booty [from Corinth] King Attalos [II of Pergamon] bought a painting by Aristeides, *The Father Liber,* for six hundred thousand [81] denarii, Mummius, amazed at the price and having begun to suspect that there might be something good in the painting which he himself did not comprehend, demanded that it be brought back, and, over the prolonged protests of Attalos, placed it in the sanctuary of Ceres; this, I believe, was the first foreign picture to become public property in Rome.[82]

Velleius Paterculus I, 13, 4: Mummius, however, was so lacking in culture that, when he had captured Corinth and was arranging for the transportation to Italy of paintings and statues, which were masterpieces

[81] The reading of the number is uncertain in the manuscripts, and the figure given here is an emendation proposed by Detlefsen. On the painter Aristeides see *The Art of Ancient Greece*, pp. 168-9.

[82] The story of the division of the spoils and the role of Attalos which is told by Pausanias in the first passage above is probably more trustworthy.

by the hands of the greatest artists, he warned those in charge of the transportation that if they destroyed any of the statues and paintings, they would have to replace them with new ones.

One of the most popular products to come out of the spoils of Corinth was Corinthian bronzeware. In the 1st century B.C. and in the early Empire Corinthian bronzes became collectors' items and were avidly sought after; on the bronzes see pp. 79-80, 117.

This section on what might be called the "Age of Plunder" may be appropriately brought to an end with Cicero's neat and very Roman summary of the period.

Cicero, Verr. II, I, 55: What should I say of M. Marcellus, who captured Syracuse, the city which was richest of all in art? What of L. Scipio who waged war in Asia and conquered a most mighty king? What of Flamininus who subjected King Philip and Macedonia? What of L. Paulus who overcame King Perseus by his strength and virtue? Or what of L. Mummius who destroyed Corinth, a city of the greatest beauty and artistic richness, and who brought many cities of Boeotia and Achaia under the power and sway of the Roman people? The homes of these men, when they flourished with virtue and honor, were void of statues and paintings. And yet we see the whole city and the temples of the gods and likewise all the other parts of Italy ornamented with the gifts and monuments of these men.

The City of Rome and Its Monuments

The following is a colorful if irreverent picture of the Roman Forum and its environs during the period under discussion given by the comic playwright Plautus (c. 254-184 B.C.):

Plautus, Curculio 470-483: If a man wants to meet a perjurer, let him go to the Comitium, and if he wants to meet a liar or a braggart, he should go to the temple of Venus Cloacina; for married men who waste their money let him ask at the Basilica.[83] There too he will find "mature" prostitutes and men who are accustomed to quoting a price, while at the Forum fishmarket he'll find those who are devotees of public feasts. In the lower Forum good and well-to-do men stroll up and down; in the middle forum near the Canal,[84] the mere show-offs; above the

[83] Basilica = the Basilica Aemilia begun in 179 B.C. The shrine of Venus Cloacina stood near its northwest end. On the remains of the buildings and sites mentioned in this and the following passages, cf. E. Nash, Pictorial Dictionary of Ancient Rome (New York 1961), hereafter cited as Nash, Pictorial Dictionary.
[84] Canal = the main channel of the Cloaca Maxima.

lake [85] are those insolent, garrulous, and nasty types who audaciously slander others for no reason and who themselves have plenty that one could quite truthfully criticize. Beneath the Old Shops are those who loan and borrow money at interest. Behind the temple of Castor, there you will find those whom you shouldn't believe too quickly. In the *Vicus Tuscus* [86] are the men who sell themselves. . . .

In 207 B.C., following a series of grim prodigies and omens, the Romans undertook to appease the apparent anger of the gods by an expiatory sacrifice to Juno. An elaborate procession to the temple of Juno on the Aventine was organized.

Livy XXVII, 37, 11-15: From the temple of Apollo two white cows were led through the *Porta Carmentalis* into the city; behind these two statues in cypress wood of Juno *Regina* were carried. Then came twenty-seven virgins dressed in long robes, singing a hymn in honor of Juno *Regina* as they went. . . . From the gate they came along the *Vicus Iugarius* into the Forum. Here a processional line was formed, and after being given a rope to hold in their hands the virgins went forward, modulating the sound of their voices in time with the steps of their feet. Thence they went through the *Vicus Tuscus*, the *Velabrum*, the *Forum Boarium*, up the *Clivus Publicus* and on to the temple of Juno *Regina*.[87] There the two victims were sacrificed by the *decemviri*,[88] and the cypress wood statues were brought into the temple.

During the course of the 2nd century B.C. the aediles and the censors carried out extensive building projects which added new monuments to the city and continually changed its appearance. The following passages illustrate the types of changes which took place.

Livy XXXV, 10, 11-12: The aedileships of M. Aemilius Lepidus and L. Aemilius Paullus in that year [193 B.C.] were outstanding. They fined many of the *pecuarii* [see note 49 above], and with the money which resulted from these fines they placed gilded shields on the gable of the

85 Lake = the *Lacus Curtius,* a sacred enclosure in the Forum (it was perhaps originally a swamp, but by the time of Augustus was dry) into which coins were thrown for various ritual purposes.

86 *Vicus Tuscus* = "Tuscan street." It ran between the later *Basilica Iulia* and the temple of Castor and was perhaps the area where the Etruscan workmen hired by Tarquinius *Superbus* had settled.

87 The *Porta Carmentalis* was a gate in the "Servian" wall near the southwest corner of the Capitoline. The *Velabrum* was the low area between the northwest slope of the Palatine and the Capitoline. The *Clivus Publicus* was a street which ran across the Aventine from the *Forum Boarium*.

88 *Decemviri*, "ten men," priests of Apollo who had charge of the Sibylline books and organized public games and sacrifices.

temple of Jupiter. They built one portico outside the *Porta Trigemina*, and added an *emporium* to it along the Tiber; [89] they also built a second portico running from the *Porta Frontinalis* to the altar of Mars, which was to serve as a path into the *Campus Martius*.

Livy XL, 2, 1-3: The spring of that year [182 B.C.] was very stormy. On the day before the *Parilia*,[90] at about midday, a tempest with violent winds was stirred up and wreaked havoc in many places, both sacred and profane; it knocked down bronze statues on the Capitoline, tore the door off the temple of Luna, which is on the Aventine, and dashed it against the side walls of the temple of Ceres; then it overturned other statues in the *Circus Maximus* together with the columns on which they were standing; after that, tearing off the crowning members from the rooves of some temples, it scattered them about in a chaotic manner.

It was perhaps the damage caused by this storm that prompted a series of extensive building projects in 179 B.C. under the direction of Aemilius Lepidus, who was now a censor, and his colleague in the censorship, M. Fulvius Nobilior.

Livy XL, 51, 2-6: Lepidus had a mole constructed at Tarracina, a work which won him no favor, because he owned private property there and hence had charged a private expense to the public treasury. He further contracted for the building of a theatre and stage near the temple of Apollo, and for the embellishing of the temple of Jupiter on the Capitoline and the columns around it in white [stucco]. He removed from in front of these columns those statues which made one's view of them untidy, and also took down from the columns the shields and military insignias of all sorts which had been attached to them. M. Fulvius contracted for works which were both more numerous and also more useful. He constructed a port on the Tiber and the piers for a bridge across it (it was on these piers that the censors P. Scipio Africanus and L. Mummius had spanning arches built some years later [142 B.C.]), a basilica behind the new bankers' quarters [known as the *Tabernae Novae* or *Argentariae*], and a fishmarket [*forum piscatorium*] surrounded by shops, which he sold for private use; he also built a forum and a portico outside the

89 The building which formed the major element in this portico-wharf complex was known as the *Porticus Aemilia*. It was rebuilt in 174 B.C. (while Aemilius Lepidus was the leader of the Senate) by the censors Q. Fulvius Flaccus and Aulus Postumius, who also constructed new bridges and paved many parts of the city with stone (cf. Livy XLI, 27, 1 ff.). The *Porticus Aemilia* was one of the earliest buildings in Rome with concrete arches and vaults; cf. Crema, *L'Architettura Romana* (*Enciclopedia Classica* III, xii, 1; Torino 1959), pp. 59-61; F. E. Brown, *Roman Architecture* (New York 1961), p. 23, figs. 30-31; Nash, *Pictorial Dictionary*, II, 238-40.

90 *Parilia* (or *Palilia*), the feast of the *Pales*, two shepherd gods, celebrated on the date of the founding of Rome.

Porta Trigemina, another behind the shipyards, and another by the shrine of Hercules, and behind the temple of Spes [Hope] on the Tiber he built the temple of Apollo *Medicus.*[91]

Painting

Livy XXIV, 16, 19: [The consul T. Sempronius Gracchus, after defeating a Carthaginian force near Beneventum in 214 B.C., was pleased at the sight of his victorious soldiers dining in the streets of Beneventum.] The scene was so impressive that, after he returned to Rome, Gracchus ordered that a representation of that day's celebration be painted in the temple of Liberty, which his father had built and dedicated on the Aventine with money from fines

Pliny, *N.H.* XXXV, 22-25: The dignified reputation of painting at Rome was increased by M. Valerius Maximus Messala, who first displayed a painting of a battle—the one in which he had defeated the Carthaginians and Hieron in Sicily—on a side wall of the *Curia Hostilia* in the 490th year from the foundation of the city [264 B.C.]. L. Scipio did the same thing; he placed a picture representing his Asiatic victory [190 B.C.] on the Capitoline, an act which, they say, annoyed his brother Africanus, and not without reason, since his [Africanus'] son had been taken prisoner in that battle. L. Hostilius Mancinus, who first broke into Carthage, committed a not dissimilar offence against Aemilianus by placing in the Forum [a painting depicting] the site of the city and his own assaults upon it, and also by being present himself and explaining the details to the onlooking public (for which affable behavior he was elected to the consulship in the next assembly). [Pliny then mentions some later paintings set up by Claudius Pulcher and also the anecdote, already given, about Mummius and Attalos II; see pp. 88 and 47.] . . . After this I see that paintings were quite commonly displayed even in the Forum. For the Forum was the setting for the witticism of the orator Crassus [92] which came about when he was pleading a case beneath the Old Shops. When a witness who had been summoned insisted on replying "Tell me, Crassus, what sort of a person do you take me for?", Crassus replied

91 The temple mentioned at the beginning of this passage is probably the original temple of Apollo in Rome in the *Campus Martius.* It was first dedicated in 431 B.C. and restored many times. The "basilica" referred to is the *Basilica Aemilia* in the Forum, which was rebuilt and rededicated during the time of Julius Caesar and Augustus (see p. 110). The temples of Spes and Apollo *Medicus* were apparently in the *Forum Holitorium,* the vegetable market situated between the Capitoline and the Tiber. The text is sometimes emended to mean that the censors built "another portico behind the temple of Spes and another near the temple of Apollo *Medicus.*" Cf. S. Platner, T. Ashby, *A Topographical Dictionary of Ancient Rome* (London 1929), s.v. "Apollo, aedes." (Hereafter referred to as "Platner and Ashby.")

92 Presumably L. Licinius Crassus, 140-91 B.C.

"That sort," pointing to a picture of a Gaul sticking out his tongue in a very crude manner. In the Forum too there was that picture of an old shepherd with his crook, about which an ambassador of the Teutones said, when he was asked what its value might be, that he would prefer not to be given such a thing even if it were living and real.

Livy XLI, 28, 10: [After subduing a revolt in Sardinia in 177 B.C., the younger Tiberius Sempronius Gracchus set up a tablet with an inscription commemorating his achievements in the temple of the Mater Matuta: Near this tablet or on it] there was a representation of the island of Sardinia and on it were painted representations of the battles.[93]

A few painters of this period are known by name.[94]

Pliny, *N.H.* XXXV, 19: Next [to the work of Fabius Pictor] in renown was the painting of the poet Pacuvius [c. 220-130 B.C.] in the temple of Hercules in the *Forum Boarium*. He was the son of a sister of Ennius [95] and made this art more distinguished in Rome through the glory of the stage.[96] After his time painting was not looked upon as a suitable pastime for hands of distinction. . . .

Pliny, *N.H.* XXXV, 115: It would not be proper to omit mention of the painter of the temple at Ardea [in Latium], especially for the fact that he was granted citizenship there and for the poem which was written on the picture, containing these verses:

A worthy man decorated this place with paintings worthy of it,[97]
The temple of Queen Juno, consort of the supreme one.
He was Marcus Plautius, the famed scion of wide Asia [98]
Whom Ardea, now and forever, praises for his art.

[93] This passage is of considerable importance for the history of Roman art, since it seems to reflect a type of topographical landscape painting found in later Roman wall-paintings and mosaics. This style was perhaps originated by the Alexandrian painter Demetrios "the *topographos*" who lived in Rome around this time; cf. *The Art of Ancient Greece*, p. 178.

[94] In addition to the Roman painters mentioned here and to Demetrios and Metrodoros, the Greek painters who have already been mentioned, another painter named Theodotos is mentioned in a fragment of the Roman poet Naevius (c. 270-201 B.C.) which is quoted by Festus; cf. Vessberg, *Studien*, p. 36, no. 143.

[95] Roman epic poet, 239-169 B.C.

[96] "Glory of the stage" = *gloria scaenae*. The phrase probably means that Pacuvius' prestige as a playwright contributed to the prestige of his own paintings and of painting in general; it may mean, however, that he did some impressive scene paintings for the theaters in which his plays were performed.

[97] Reading *dignis dignu' loco*. Some would read *dignis digna*, "to those who deserve it, a worthy reward" (which is supported by the manuscripts) and substitute *Lyco* for *loco*, interpreting the former as the original Greek name of Marcus Plautius; cf. Vessberg, *Studien*, p. 37.

[98] Several variant readings for the words in this line are given in the manuscripts. The artist may have been one of the Asians who came to Rome from Asia after the victory of L. Scipio over Antiochos; see p. 42.

Portrait Sculpture

The development of naturalistic portrait sculpture was one of the most conspicuous and characteristic achievements of Roman art. During the late Republic and throughout the Empire this naturalistic tradition in portraiture was fused with and sometimes gave way before a conscious Hellenizing classicism, but it was always present in Roman portraits to some degree. Developed Roman portrait sculpture reflects the stylistic influence of a number of earlier artistic traditions—classical and Hellenistic Greek, Etruscan, and possibly even Saitic Egypt—but its psychological appeal is probably to be found in a native Roman tradition described by Polybios and Pliny.

Polybios VI, 53: [When a prominent Roman died he was taken, in the course of his funeral procession, to the *Rostra* in the Forum where a son or other relative then gave a public eulogy recounting the virtues of the deceased.] After this, having buried him and performed the customary rites, they place a portrait of the deceased in the most prominent part of the house, enclosing it in a small wooden aedicular shrine. The portrait is a mask which is wrought with the utmost attention being paid to preserving a likeness in regard to both its shape and its contour. Displaying these portraits at public sacrifices, they honor them in a spirit of emulation,[99] and when a prominent member of the family dies, they carry them in the funeral procession, putting them on those who seem most like [the deceased] in size and build. . . . [The men so dressed also wore the togas and carried the insignias of the magistracies which had been held by the person whom they were impersonating.] One could not easily find a sight finer than this for a young man who was in love with fame and goodness. For is there anyone who would not be edified by seeing these portraits of men who were renowned for their excellence and by having them all present as if they were living and breathing? Is there any sight which would be more ennobling than this?

Polybios, writing in the mid 2nd century B.C., *is our earliest source for this custom. How long it had been in existence before his time is an unanswerable question. The portraits themselves, as Pliny tells us in the next passage, were made of wax, and hence it is not surprising that none has survived.*[100]

99 "Honor them in a spirit of emulation" = *kosmousi philotimōs*. The phrase might mean "adorn them with a competitive spirit" or perhaps simply "they decorate" or "honor them zealously."

100 A marble statue now in the Museo Nuovo Capitolino in Rome represents a Roman noble holding what are apparently ancestral funeral portraits (but not, it would seem, masks). The date of the statue itself is not certain, but it probably belongs to the early 1st century A.D.; cf. the frontispiece of this volume.

Pliny, *N.H.* XXXV, 6-7 [Pliny has been commenting on lack of an appreciation of portraiture in his own day]: But conditions were different in the *atria* of our ancestors where it was portraits which were looked at, and not statues by foreign artists, either in bronze or marble. Wax impressions of the face were set out on separate chests, so that they might serve as the portraits which were carried in family funeral processions, and thus, when anyone died, the entire roll of his ancestors, all who ever existed, was present. Genealogical lines of descent, in fact, used to be indicated, running back and forth between painted portraits. The family archive rooms were filled with scrolls and other records commemorating deeds done [by members of the family] during their magistracies. Outside the doors around the lintels there were also portraits of these great spirits along with spoils of the enemy fixed in position near them; not even one who bought the house was permitted to remove these spoils; and so the house celebrated perpetual triumph even though the masters changed.

Ancestral portraits of very famous Romans were sometimes kept in public buildings, from which their families had the right to remove them during public processions.

Valerius Maximus VIII, 15, 1-2: [Scipio Africanus] was honored by a portrait which was placed in the cella of Jupiter in the temple of Jupiter *Optimus Maximus;* this portrait was taken from there whenever a funeral service was held by the Cornelian *gens;* [101] for him alone did the Capitolium serve as an atrium . . . [and likewise] the image of Cato the Elder in the *Curia* is brought out for the ceremonies of his *gens.*

Honorific public portrait statues, authorized by the state, naturally continued to be made during the 3rd and 2nd centuries B.C. The texts given here refer to statues about which something beyond their mere existence is known.

Pliny, *N.H.* XXXIV, 24: This [erecting public statues] was customary for those who had been put to death unjustly, as were, among others, P. Junius and T. Coruncanius, who were killed by Teuta, queen of the Illyrians [c. 230 B.C.]. And it would seem that one should not omit a fact which the annals make note of—namely, that the statues of these men in the Forum were three feet high; this quite obviously was a respectable scale in those days.

Livy XXIII, 19, 18 [In 216 B.C. a Roman garrison at Casilinum surrendered to Hannibal after a long siege. Most of the men in the garrison

[101] *Gens* is the term for a clan, or large grouping of families (e.g., the Fabii, Valerii, Cornelii).

were from Praeneste, and to commemorate the brave stand of these men, a statue of their commander, M. Anicius, was set up in the forum at Praeneste]: . . . A statue of him was set up in the forum, wearing a breastplate and a full-dress toga and having his head covered. . . .

Cicero, *Pro Rabirio Postumo* X, 27: You see, in fact, a statue on the Capitoline of L. Scipio, who waged war in Asia and defeated Antiochos, [representing him as dressed] not only in a *chlamys* [102] but also in sandals.

The setting up of commemorative portrait statues in public places may have gotten out of control in the 2nd century B.C. *The Senate's attempt to curb the practice is mentioned by Pliny.*

Pliny, *N.H.* XXXIV, 30-31: L. Piso has recorded that in the second consulship of M. Aemilius and C. Popilius [158 B.C.] all the statues around the Forum of men who had served as magistrates were removed by the censors P. Cornelius Scipio and M. Popilius, except for those which were authorized by a decree of the people or the Senate; in fact, the statue which Spurius Cassius, who had aspired to be king, set up in honor of himself near the temple of Tellus was even melted down by the censors. Quite clearly those men used to take steps against ambition even in this matter [that is, statuary]. Some vociferous denunciations are extant made by Cato during his censorship [184 B.C.] against the setting up of statues of women in the provinces. He was not able, however, to prevent them from being set up even in Rome; there is, for example, a statue of Cornelia, the mother of the Gracchi, who was the daughter of the elder Scipio Africanus. This statue, which represents her as seated and is unusual in that it has sandals which have no strap, was in the Portico of Metellus and is now in the buildings of Octavia.[103]

Plutarch, *Life of the Elder Cato* 19 [On Cato's term as censor]: It would seem that the people reacted marvelously to his censorship. For after they had set up a statue of him in the temple of Health [Salus], they added an inscription commemorating not his military commands nor his triumph, but rather—as one might paraphrase the inscription—"that, on becoming censor, he set the Roman state aright again through noble principles of guidance and wise prescriptions for customary behavior, and through education at a time when it was declining and sinking into degeneracy." And, indeed, prior to this honor, Cato used to laugh at those who loved such things, and said that in making so much of the works of bronze-workers and painters they overlooked the fact that citizens carry around the best portraits of themselves in their souls. To people who marveled that, while many unknown people had statues, he

102 A *chlamys* was a light traveling cloak worn by Greek soldiers. The statue was thus another reflection of the philhellenic tastes of the Scipii.
103 On these buildings see pp. 45 and 105, 109.

had none, Cato would reply, "I should rather be asked why there is no statue of me than why there is one."

Plutarch, *Life of Titus Flamininus* 1: Those who wish to form an impression of what Titus Quintius Flamininus looked like may do so from the statue of him in Rome (which stands next to the huge Apollo from Carthage opposite the racecourse and which has an inscription in Greek letters)—his temperament is said to have been intense, both in anger and in graciousness.

Livy XL, 34, 5-6 [On the temple of Pietas in the *Forum Holitorium* in Rome]: M. Acilius Glabrio, a *duumvir* [104] dedicated this temple [in 181 B.C.]. In it he placed a gilt statue of his father, the first of all the gilt statues to be set up in Italy. This [the father] was the man who vowed the temple on the day when he defeated King Antiochos at Thermopylae [as consul in 191 B.C.] and who contracted for the building of it after authorization by the Senate.

Pliny, *N.H.* XXXV, 14: The Carthaginians used to make shields and portraits of gold to carry around with them. In any case, Marcius,[105] who was the avenger of the Scipii in Spain, found such a shield with a portrait of Hasdrubal when he captured his camp; this shield was to be found above the doors of the Capitoline temple down to the time of the first burning of the temple [83 B.C.].

The following portrait statues dating from 264 to 133 B.C. are mentioned but not described:

C. Duillius, the admiral who defeated the Carthaginians in a naval battle in 260 B.C. (Pliny, N.H. XXXIV, 20).

L. Caecilius Metellus, consul in 251 B.C. and later priest, who rescued some sacred objects from a fire which destroyed the temple of Vesta in 241 B.C. (Dionysios of Halikarnassos, Ant. Rom. II, 66).

M. Claudius Marcellus, the conqueror of Syracuse, in the temple of Athena at Lindos (Plutarch, Life of Marcellus 30).

Q. Fabius Maximus, after taking Tarentum; an equestrian statue on the Capitoline (Plutarch, Life of Fabius 22).

Quintia Claudia, one of the Roman matrons who received the sacred stone of Cybele (the Magna Mater) in Rome in 204 B.C. (Valerius Maximus I, 8, 11).

Scipio Africanus the Elder; portrait on sepulchral monuments at

104 *Duumvir*, "one of two men," was the name given to two magistrates who held a variety of administrative offices at Rome and in the colonies. Glabrio was one of the *duo viri aedi dedicandae,* officers who were specially elected to oversee the building of a temple.

105 L. Marcius was one of the consuls who succeeded Gnaeus and Publius Scipio (the father of Africanus), who were killed by the Carthaginians in Spain in 212-211 B.C. On the origin of the *imago clipeata*, the shield portrait, see p. 22.

Liternum and outside the Porta Capena (*Livy XXXVIII, 56, 3-4*). *The latter also included statues of the poet Ennius and of Publius and Lucius Scipio. On the portrait of Ennius see also Cicero,* Pro Archia Poeta *IX, 22; Valerius Maximus VIII, 14, 1; Pliny, N.H. VII, 114.*

Gnaeus Octavius, consul in 165 B.C. (*Cicero,* Philippics *IX, 4; Pliny,* N.H. *XXXIV, 24*).

On the statue of C. Mancinus, consul in 137 B.C., see Pliny, N.H. *XXXIV, 18.*

Statues of Gods and Heroes

Here again a substantial number of cult images and votives are mentioned in the literature, but very few descriptive details are given. The following is a list, in chronological order, of the statues mentioned.

C. 241 B.C.

A statue of Janus, the god of gateways, with four faces, taken when the Romans captured Falerii, a Faliscan city in Etruria (Servius, *Commentary on the Aeneid* VII, 607 ff.).

A statue of Minerva, called the "Minerva *Capta*" ("Captured Minerva") seems to have come from the same city (Ovid, *Fasti* III, 843).

217 B.C.

Statues of Mars and some wolves in the temple of Mars on the *Via Appia*, which were seen to sweat at the time of Hannibal's invasion (Livy XXII, 1, 12).

216 B.C.

A golden statue of Victory weighing 220 pounds presented by the Syracusans to the Roman Senate (Livy XXII, 37, 2-5).

C. 211 B.C.

Statues of *Honor* and *Virtus* set up in separate temples in Rome by Marcellus (Valerius Maximus I, 1, 8).

A statue of Victory on the roof of the temple of Concord which was struck by lightning (Livy XXVI, 23, 4).

209 B.C.

A statue of Jupiter on the Alban Mount (Livy XXVII, 11, 2).

197 B.C.

Bronze statues of Ceres, Liber, and Libera set up by the praetors Acilius Glabrio and Caius Laelius (Livy XXXIII, 25, 2-3).

193 B.C.

An image of the god Veiovis in cypress wood dedicated on the *arx* [106] (Pliny, *N.H.* XVI, 216).

189 B.C.

A statue of Hercules and a gilded six-horse chariot group dedicated in the temple of Hercules; set up by P. Cornelius Scipio Nascia Corculum (Livy XXXVIII, 35, 4-5).

186 B.C.

A statue of the goddess Pollentia [107] in the *Circus Maximus;* it was struck by a pole which had not been firmly fastened in place (Livy XXXIX, 7, 8-9).

180 B.C.

Gilt statues dedicated to (and perhaps representing) Apollo, Aesculapius, and Salus by the command of Caius Servilius, the *Pontifex Maximus* (Livy XL, 37, 2).

C. 146 B.C.

Statue of a Carthaginian deity (Melkart?) identified with Hercules set up in the *Porticus ad Nationes* [108] in Rome (Pliny, *N.H.* XXXVI, 39).

A few details of art historical interest may be gleaned from these passages. The fact that the four-faced Janus type was derived from a statue captured in Falerii indicates that the artistic influence of Etruria on Rome continued down into the 3rd century B.C. *The rise of Hellenistic Greek influence later in the century may be noted in the two personificatory statues* (Honor *and* Virtus) *dedicated by Marcellus, and by the fact that a statue of Victory, presumably a Greek Nikē type, was placed on the roof of the temple of Concord.*

THE DECLINE OF THE REPUBLIC: 133-31 B.C.

The acquisition of a large foreign empire brought changes into the social organization of the Republic which eventually proved to be its undoing. The first of these to make itself seriously felt was the disappearance of the Italian

[106] The *arx*, "citadel," was the northwest summit of the Capitoline.
[107] Pollentia was the Roman goddess of power.
[108] See p. 113.

peasant farmer who had been both the political and military backbone of the state for centuries. The rigors of the military draft, the competition of foreign goods, and the glamour of the big cities all played a role in luring or driving the small farmer off the land and into the growing urban masses. At the same time the land which was being abandoned was bought by wealthy nobles who reshaped it into large plantations worked by the slave labor which was one of the fruits of foreign conquests.

In 133 B.C. the tribune Tiberius Gracchus, a man of distinguished lineage who was influenced to some degree by Stoic political philosophy, proposed a land reform bill based on the old Licinian Laws of 367 B.C. (see p. 23), whereby a maximum limit was set on the amount of public land [109] which could be held by any one person. Tiberius bypassed the Senate, which consisted mostly of wealthy land holders, and presented his bill directly to the popular assembly, which eventually passed it. In order to have a hand in carrying out the details of his bill he took the almost unprecedented step of attempting to have himself elected to the tribunate for a second consecutive year; this effort provoked a riot in which he was murdered by a group of irate senators. In 123 B.C. Gaius Gracchus, Tiberius' younger brother, revived the land reform bill, and added to it several new proposals—among them the foundation of new colonies, stabilization of grain prices, and reforms in the courts—all calculated to aid the poorer classes and antagonize the Senate. At first, Gaius had considerable public support, but when he made the radical proposal that all the Italian allies should receive Roman citizenship, even his support among the Roman populace began to wane. The Senate took quick advantage of this change of mood by declaring martial law and instituting a persecution which resulted in the death of Gaius and several hundred of his followers.

The social and political issues which had been raised during the "revolution of the Gracchi" were not forgotten after the death of Gaius. One problem in particular—that of recruiting, maintaining, and providing for the retirement of soldiers—required almost immediate solution, and the solution, when achieved, was to have far-reaching consequences in Roman history. In 118 B.C. the king of Numidia (the northeastern part of modern Algeria) died, and a struggle for power ensued between his two legitimate sons and an illegitimate son named Jugurtha. The latter soon seized control and when the Senate tried to intervene and impose its own settlement, it was rebuffed by Jugurtha, who proceeded to defeat a series of incompetent Roman commanders sent out against him. In 107 B.C. the popular assembly, finally becoming disgusted with the inefficiency and questionable honesty of the senatorial administration, elected Gaius Marius consul and made him military commander. Marius, a man of relatively humble lineage who had no place in the senatorial establishment, proceeded to recruit new troops by tapping, for the first time, the urban masses, and inculcated strict discipline and a sense of unity into this new army. Marius landed in Africa in 107 B.C., and by 105 B.C. he had captured Jugurtha and brought the war to an end. In successfully completing this campaign he received invaluable aid from one of his lieutenants, a young aristocrat named Lucius Cornelius Sulla, who was the antithesis of Marius both socially and politically.

During the Jugurthine War a group of migrant Germanic tribes, led by the Cimbri and the Teutones, had been encroaching on Roman territory in northern Italy and had defeated several consular armies sent out to discipline them. In 105 B.C. at Arausio (modern Orange) in southern France they com-

[109] That is, land in Italy which belonged to the Roman state by right of conquest and which it could allot to Roman citizens at its discretion.

pletely annihilated a large Roman force, and it even appeared that they might undertake a full scale invasion of Italy. Marius was immediately called to take charge of the army and was re-elected to the consulship for five successive years (104-100 B.C.). During this time he reformed the Roman military system by forming new tactical divisions and changed the basic make-up of the army by recruiting his troops on the basis of voluntary long-term enlistments, again from the urban masses rather than from the peasant farmers. These reforms were of the greatest consequence for later Roman history. The citizen militia commanded by military amateurs who changed annually, or, at most, every several years, now yielded to the professional army commanded by a professional general. That the loyalty of such an army was more strongly directed to its commander than to the abstract concept of "the state" is not surprising, and that its military efficiency was greater than that of the old citizen militia is undeniable. By 101 B.C. Marius had completely defeated the Cimbri and the Teutones.

The military reforms of Marius gave new importance to the social reforms of the Gracchi. He needed land which could be allotted as pensions to his retiring veterans, and he needed a cheap and stable grain supply both to feed his army and to sustain the urban population from which his troops were drawn. To achieve these ends he allied himself in 101-100 B.C. with Saturninus, an unscrupulous demagogic tribune who nursed a private grudge against the Senate. Marius supported Saturninus' proposals for new land allotments and colonies and in turn was promised the command of the new army which was being raised to clear pirates out of the eastern Mediterranean and to make war against King Mithridates of Pontus.[110] But in 99 B.C., when Saturninus, after a career of violence, connived at the murder of a political opponent, he was deserted by Marius and lynched by a mob. The Senate annulled his legislation, and Marius retired into temporary obscurity.

One of the proposals of Saturninus which the Senate annulled would have conferred Roman citizenhip on certain of Rome's Italian allies. By 91 B.C. these allies had become so impatient for enfranchisement that they were on the brink of revolt. In that year the tribune M. Livius Drusus sought to stave off the rebellion by introducing a complex series of reforms among which was the full enfranchisement of all the Italian allies. When Drusus was murdered by his political opponents, the allies finally did revolt, and the ensuing "Italic" or "Social" War (90-88 B.C.) was one of the Republic's worst crises. It took the skill of Rome's most experienced military men, Marius and Sulla, to overcome the rebels who had established a new nation of their own, which they called "Italia." In the end, the war need not have been fought, for Rome concluded it by granting enfranchisement to all the Italian allies.

After the war the Senate, always distrustful of Marius, conferred the command of its long-projected campaign against Mithridates on Sulla, who had been elected consul in 88 B.C. As a reaction to this insult Marius lent his support to another reform-minded tribune, Sulpicius Rufus, who was proposing, among other things, that senators who were in debt should be unseated. Sulpicius showed his gratitude for the support by having Sulla's eastern command transferred to Marius. Sulla, however, retained the personal loyalty of the legions which he had commanded during the Italic Wars. Rallying these in Campania, he marched on Rome, took control of the city, and drove out Marius,

[110] Mithridates VI *Eupatōr* (c. 120-63 B.C.). Pontus was the name of a region in northern Asia Minor on the Black Sea east of the River Halys. Mithridates was Rome's major rival for control of central and western Asia Minor. During the "First Mithridatic War" he occupied Asia Minor and much of Greece.

who now fled to Africa with a price on his head. Sulla then set out for his campaign in Greece and Asia Minor, where (after achieving the dubious distinction of sacking Athens) he subdued Mithridates and imposed a heavy fine on the cities of Asia Minor.

In his absence Rome returned to chaos. In 87 B.C. Marius returned to Italy with an army and joined forces with the consul Cornelius Cinna, who favored the interests of the newly enfranchised Italians against the senatorial aristocracy. Together they besieged and took Rome. The aging Marius then instituted a reign of terror which ended only with his (apparently natural) death in 86 B.C. For the next three years Cinna and his chosen colleague Papirius Carbo kept the consulship for themselves and ruled by virtue of military authority. When Sulla returned from the East in 83 B.C., however, Cinna was killed by his own troops and Carbo was easily defeated.

Upon his return to Rome Sulla became dictator in perpetuity (thus being the first "monarch" to rule Rome since the period of kings) and effected a series of proscriptions which dwarfed Marius' reign of terror. He then undertook to reform the constitution of the Republic by enlarging the Senate and concentrating more power in it, by limiting the power of the tribunes, and by fixing prescribed intervals between the iteration of magistracies so as to prevent successive consulships and the consequent concentration of power in the hands of one man. Finally, and most remarkable of all, Sulla voluntarily laid down his dictatorship in 79 B.C. and retired from public life. In the following year the consul M. Lepidus, one of Sulla's officers, attempted to undo his commander's reforms and gain personal power by making the usual appeals for popular support—land reform and the promise of a cheap grain dole. After he was suppressed by a force commanded by another of Sulla's lieutenants, Gnaeus Pompeius ("Pompey the Great"), the focus of Roman politics shifted to external problems. In the west a pro-Marian general, Q. Sertorius, seized Spain and continually defeated Roman armies until he was murdered by a subordinate in 72 B.C. In the east pirates operating from Cilicia on the southern coast of Asia Minor harassed Roman shipping, and Mithridates, again restive, w鿚ested Bithynia from Roman control. A large army commanded by L. Lucullus was sent to the East. Lucullus drove Mithridates out of Asia Minor, conquered Armenia (74-68 B.C.), and was generally so successful that he aroused the envy of Pompey, who arranged with the Senate to have him removed from his command. Pompey himself had had little military success against Sertorius, but after the latter's death he managed to settle affairs in Spain. He also received some residual credit for Rome's defeat of a bitter slave revolt led by a Thracian gladiator, Spartacus (73-71 B.C.). The major credit for this victory, however, went to M. Crassus, another of Sulla's officers.

Although he was qualified for the position by neither age nor experience, Pompey, along with Crassus, obtained the consulship in 70 B.C. The Senate was inhibited from offering any resistance by the presence of Pompey's legions stationed outside the city. By restoring the power of the tribunes which Sulla had curtailed, Pompey obtained a base of popular support which enabled him in 67 B.C. to obtain a command with broad powers in the East. He proceeded to clean out the Cilician pirates and to follow up the victories of Lucullus (whom he replaced) in Asia Minor and Armenia. He then moved into Syria, which he took from the last of the Seleukid kings in 64 B.C. and made into a province, and finally into Judaea, where he quelled a civil dispute and forcefully reaffirmed Roman influence. In 62 B.C. he returned to Rome where he was granted a spectacular triumph.

In Pompey's absence Crassus tried various political maneuvers which would concentrate power in his hands, but these were blocked by the influ-

ence of Marcus Tullius Cicero, consul in 63 B.C. and the greatest orator of the time. Cicero attained particular prominence by thwarting a potential revolt led by Catiline, an ambitious noble who had failed to win the consulship and had won the favor of various discontented elements in Italy by suggesting the abolition of debts. By this action Cicero, although only of equestrian rank [111] by birth, had won the favor of the aristocratic senators. When Pompey returned to Rome Cicero tried to arrange a compromise government in which the Senate would retain its power, with Pompey as a figurehead chief of state. The Senate, however, refused to accept this arrangement, and Pompey did not for the moment force the issue. But the folly of the Senate's intransigence became apparent when Julius Caesar, a dynamic young noble who had risen through the *cursus honorum,* was elected consul in 59 B.C. When the Senate tried to prevent Caesar from receiving the provincial proconsulship which would customarily have followed his year in office, he joined with Pompey and Crassus to form the "First Triumvirate." Pompey was assured approval of his settlement in the east and of support for his veterans; Crassus, already fabulously wealthy, received financial advantages; and Caesar received the proconsulship in Gaul for five years (later renewed for another five). By personal influence and military power these men dominated Roman politics for the next decade. During this period Caesar enhanced his prestige through his famous conquest of Gaul (which brought what was later to be France into the orbit of Roman power and culture) and made forays into Britain and Germany. The Triumvirate was never an easy one, and it began to break up in 54 B.C. with the death of Caesar's daughter, who was married to Pompey and had therefore been helpful in securing his loyalty. Crassus was killed in the following year while conducting a disastrous campaign against the Parthians in Mesopotamia.

During the years 53-50 B.C. food shortages and personal rivalries led to civil chaos in Rome to such an extent that street riots threatened the safety of the Senate itself. Pompey, who had cunningly remained in the background, now appeared as the Senate's champion and restored order. Realizing that his new position gave him the opportunity to obtain sole power, he joined with the Senate in an attempt to remove Caesar from his command and prosecute him for misconduct. In 49 B.C. Caesar took up the challenge, crossed the Rubicon, and civil war began. While Pompey retreated to Greece, Caesar rapidly took control of Italy, subdued Pompey's forces in Spain, and followed him across the Adriatic. After preliminary skirmishes, Caesar's hardened Gallic legions defeated Pompey at Pharsalos in 48 B.C. Pompey fled to Egypt where he was murdered by agents of King Ptolemy XIII.

Caesar spent the next three years settling affairs in the East, amusing himself with Cleopatra (co-regent of Egypt with her brother Ptolemy), and destroying the remnants of Pompey's forces in Africa and Spain. In 45 B.C. he returned to Rome and assumed the office of dictator. His rule as dictator was marked by clemency toward his former enemies, constructive administrative and fiscal reforms, and public works. Although there can be no doubt that these actions benefited Rome, Caesar was still an anathema to a hard core of aristocrats led by C. Cassius and M. Brutus who saw him as a "tyrant" suppressing liberty. In March of 44 B.C. they assassinated him.

Public support never rallied to the assassins, however, and Caesar's power fell at first to Marcus Antonius, one of the dictator's loyal lieutenants and

[111] The *Equester Ordo,* "Order of the Knights," was one of the permanent classes of the Roman population, originally the class which supplied the cavalry for the army. By the 1st century B.C. the *Equites* had assumed many of the functions of a mercantile middle class. After the time of the Gracchi they became the tax-farmers of the empire.

consul in 44 B.C. When public resentment toward them began to grow, the assassins, who were initially tolerated by Antony, thought it best to leave Rome for provincial governorships. At this point Caesar's eighteen-year-old grand-nephew and heir, C. Octavius, appeared on the scene to collect his inheritance from Antony. When Antony refused, Octavius organized several of the legions which were loyal to Caesar and became a power in his own right. Octavian, as he came to be called,[112] at first allied himself with the senatorial party led by Cicero and with them made war on Antony who had gone to northern Italy to fight one of Caesar's assassins. But when the Senate refused to show Octavian the respect which he thought he deserved, he changed his allegiance, reconciled his differences with Antony, and joined with him and Lepidus, the governor of Transalpine Gaul and eastern Spain, in forming the "Second Triumvirate" in 43 B.C. The reign of the triumvirs opened with a series of vengeful proscriptions in which the principal victim was Cicero, who now paid the price for his acerbic orations against Antony (the *Philippics*). The death of Cicero, whose peculiar combination of high principles with inconsistent vacillation characterized the Republic as a whole, symbolizes the Republic's end. In 42 B.C. Antony, with some help from Octavian, avenged Caesar by defeating Cassius and Brutus at Philippi in Macedonia. After the battle Octavian was given charge of Italy and Spain while Antony took Gaul and the East; Lepidus, deprived of most of his power, went to Africa. The beginning of Octavian's governorship was not auspicious. His attempt to pension off veterans by confiscating land produced a revolution (inspired in part by members of Antony's family). After a new settlement had been made with Antony,[113] he then had to face a war with Sextus Pompeius, a son of Pompey the Great, who had taken over Sicily and was harassing Rome's food supply. Owing largely to the military skill of Octavian's loyal admiral and friend, Marcus Agrippa, Sextus was overcome in 36 B.C., and the west was secure. In the meantime Antony indulged himself in an expensive but inconclusive campaign in the East against the Parthians and in his famous and equally expensive romance with Cleopatra. The facts of Antony's life in the East provided excellent propaganda for Octavian, who now gratified his understandable, long-standing dislike of Antony by stirring public feeling against him at Rome. The two leaders met for their final struggle in a naval battle off Actium in western Greece in 31 B.C. Octavian's victory and the subsequent suicides of Antony and Cleopatra mark the beginning of a new phase in Roman history. Four years later he officially received the name "Augustus" and became the first emperor (*imperator*) of Rome.

Triumphs and Plunder

Although Rome was continuing to develop an artistic tradition of its own, most of the new works of art which appeared in the city still came, as in previous centuries, from foreign conquests.

THE TRIUMPH OF SULLA (81 B.C.)

Valerius Maximus II, 8, 7: Now when L. Sulla, who was a partisan in many civil wars and whose victories were extremely cruel and vindictive,

112 When Octavius was recognized as Caesar's adopted son he received the name Gaius Julius Caesar Octavianus. Hence until the time when he becomes "Augustus" he is usually referred to as "Octavian."

113 The pact was cemented by Antony's marriage to Octavia, the sister of Octavian.

conducted a triumph (after his power was concentrated and at its height) he did not display any town of Roman citizens among his conquests, as he did with many of the towns of Greece and Asia.

For the elaboration of this triumph Sulla took from Athens the famous painting of a Centaur Family *by Zeuxis.*[114] *He also brought from Athens several Corinthian columns from the temple of Zeus* Olympios. *This temple, it should be noted, was paid for by the Syrian king Antiochos IV* Epiphanēs *but was constructed by a Roman architect named Cossutius.*[115] *Sulla apparently intended to use the columns in rebuilding the temple of Jupiter* Optimus Maximus *on the Capitoline, which had been destroyed by fire in 83* B.C.

Pliny, *N.H.* XXXVI, 45: And finally marble was used for the columns of temples. . . . This was the case, for example, with the unfinished temple of Zeus *Olympios* in Athens, from which Sulla brought some columns for his buildings on the Capitoline.

THE TRIUMPH OF L. LUCULLUS [116] (63 B.C.)

Plutarch, *Life of Lucullus* 37: . . . He adorned the Flaminian Circus with all kinds of weapons of war and with military machines that had belonged to the king [Mithridates]. Nor was there anything despicable about the sight of this. A few cavalrymen in full armor rode in the triumphal procession, and also ten chariots equipped with scythes, and sixty companions and generals of the king; 110 warships with bronze prows were carried in it and also a large gold statue of Mithridates himself, six feet high, a long shield set with stones, twenty loads of silver vessels. . . .

THE ASIATIC TRIUMPH OF POMPEY (61 B.C.)

Pliny, *N.H.* XXXIII, 151: The opinion that the use of silver was first transferred to sculpture for making statues of the divine Augustus, as a result of the flattery characteristic of those times, is false. For in the triumphal procession of Pompey the Great we find that a silver statue of Pharnaces I,[117] king of Pontus, was carried, and likewise one of Mithridates *Eupatōr,* and also some gold and silver chariots.

Pliny, *N.H.* XXXVII, 12-14: It was the victory of Pompey, however,

[114] For Lucian's description of this painting cf. *The Art of Ancient Greece,* pp. 151-53.
[115] Cf. *ibid.,* pp. 213-14 (Vitruvius VII, praef. 15 and 17).
[116] On L. Lucullus see the preceding historical summary. He should be distinguished from his brother, M. Lucullus, who, as governor of Macedonia, had a colossal statue of Apollo by the Greek sculptor Kalamis transported to Rome; cf. *The Art of Ancient Greece,* p. 48.
[117] Ruled c. 185-169 B.C.

that first inclined our taste toward pearls and gems, just as that of L. Scipio and Cn. Manlius had turned it toward engraved silver, Attalic [118] clothing, and bronze dining couches; and that of L. Mummius at Corinth had turned it toward painted panels. In order that this may be understood more clearly, I offer here statements taken from the actual records of Pompey's triumph. To proceed then, in the third triumph, which was over the pirates, Asia, Pontus, and the peoples and kings mentioned in the seventh volume of this work [*N.H.* VII, 98], and which was held during the consulships of M. Piso and M. Messala, on his own birthday, the day before the kalends of October,[119] a gaming table with dice was carried in the procession, the table being made from two gem-stones and having a width of three feet and a length of four. And lest anyone should doubt that our resources are now exhausted (since today there are no gems which even approach this in size), there was placed on the gaming table a golden moon weighing thirty pounds. There were also three [golden] dining couches, vessels made of gold and gems set out on nine sideboards, three golden statues representing Minerva, Mars, and Apollo, thirty-three crowns made of pearls, a square golden mountain, on which stood stags, lions, and fruit trees of all kinds and which was entwined with a golden vine. There was also a portrait of Pompey made of pearls—that portrait, which was so pleasing with its impressive swept-back hair and the honest face of this man who was venerated by many nations, that portrait, I emphasize, was made of pearls; what was really celebrated was the triumph of luxury and the conquest of restraint.

Appian, *Mithridatic War* **XVII, 116-117:** In his triumphal procession he [Pompey] exhibited team-drawn wagons and litters carrying gold and other elaborate decorative objects, including the couch of Darius the son of Hystaspes,[120] as well as the throne of [Mithridates] *Eupatōr,* his scepter, and a gold portrait statue measuring eight cubits from the base. . . . [Painted?] portraits of those who were not present [in the procession] were also carried, notably of Mithridates and Tigranes [of Armenia], fighting, being conquered, and fleeing. The besieging of Mithridates, the night when he fled, and the silence were represented. And finally how he died was represented; the virgins who chose to die with him were depicted standing by, and there were paintings of the sons and daughters who died before him and also images of the barbarian gods adorned in the fashion of the fatherland.

THE TRIUMPH OF CAESAR (46 B.C.)

Appian, *Civil Wars* **II, 101:** He refrained from inscribing the names of Romans in his triumph, on the grounds that the killing of kinsmen was

[118] Attalic clothing: a type of fabric woven with gold threads which seems to have originated in and/or been characteristic of Pergamon.

[119] September 29th.

[120] Darius the son of Hystaspes was king of Persia from 521 to 486 B.C.

both an unseemly thing for him and was shameful and ill-omened for the Romans; but he did display, nevertheless, in twenty varied paintings, all their sufferings in these wars and the men [who had done the fighting], with the exception of Pompey. The latter alone he refrained from representing, because he was still remembered with great fondness by many. The people, though fearful, mourned their domestic sufferings, especially when they saw Lucius [sic] Scipio, the commanding general, wounded in the chest by his own hand, casting himself into the sea, or Petreius destroying himself at a banquet, or Cato slashing himself with his own hand like a beast. But they commended the death of Achillas and Pothinus, and laughed at the flight of Pharnaces.[121]

The most notorious plunderer of art objects in the history of the Republic was Gaius Verres. legate to the governor of Cilicia in 80 B.C. and propraetor of Sicily in 73-70 B.C. Verres pillaged Sicily so badly that the Sicilians appealed to the Senate, which proceeded to put him on trial for misconduct and extortion. The prosecuting attorney was Cicero, whose Verrine Orations [122] *presented such a damaging case against Verres that he went into voluntary exile. The* Verrines *describe in detail what sort of art objects Verres stole, especially in Sicily, and how he went about it. Some selections follow.*[123]

We begin with an example of Verres' early career in Greece and Asia Minor.

Cicero, *Verr.* II, I, 49-51 and 61: And as for the arrival of this man in Asia, to which he came after this [i.e., after plundering Delos] why should I recount his lunches and dinners, his horses and presents? I have no intention of going over with Verres his day-by-day crimes. At Chios, I tell you, he took three beautiful statues by force, and likewise from Erythrai and Halikarnassos. At Tenedos—and this is in addition to the money he stole—he carried off Tenes himself, who is the most sacred deity among the people of Tenedos. (It is he who is said to have founded the city, and it is from him that Tenedos gets its name.) The same Tenes, a very beautifully made work, which you once saw in the *Comitium,* he robbed amidst the groanings of the city. And then there was that assault

121 Q. Metellus Scipio, M. Petreius, and the Younger Cato were all on the Pompeian side in the Civil Wars, and each committed suicide rather than be captured by the Caesarian forces. Pothinus and Achillas were Egyptian guardians of Ptolemy XII who were responsible for the death of Pompey and who opposed Caesar. Pharnaces II, the king of whose force Caesar said *veni, vidi, vici,* was the son of Mithridates the Great.

122 The *Verrines* are divided into two *actiones* (trial briefs). Only the first was delivered, since, following it, Verres went into exile. The second, which is considerably longer, was published by Cicero to reinforce his case and demonstrate his rhetorical skill.

123 Among the works which Verres stole there were some pieces of sculpture by famous Greek artists; for these see *The Art of Ancient Greece,* pp. 51, 78-9, 93, 217. The complete references may be found in Vessberg, *Studien,* nos. 187-217, pp. 48-55.

upon the most ancient and renowned shrine of Hera at Samos, which was such a sorrow to the Samians, which was bitter to all of Asia, which is infamous among all, which none of you can have failed to hear about. . . . What paintings, what statues this man carried off from there! I examined them myself in his house just recently, when I came there for the purpose of sealing an accusation against him. . . .

[Sec. 61] . . . That you [addressing Verres] have brought home many extremely beautiful statues, many excellent paintings—this you cannot deny. Would that you could deny it! Point out one of these in your own accounts or in those of your father that you have bought, and you have won your case. Those two very beautiful statues, for example, which now stand by the *impluvium* in your house and which for many years stood before the doors of the temple of Hera at Samos—you have no way of showing how you bought them, the two statues which now stand alone in your halls, deserted by the other statues, and await a buyer of confiscated goods.

Cicero begins his description of Verres' career in Sicily with this general statement:

Cicero, *Verr.* II, IV, 1: I affirm that in the whole of Sicily, in a province which is so wealthy and old, which has so many towns and so many rich family estates, that there is no silver vase, neither Corinthian nor Delian, no gem or pearl, no object of gold or of ivory, no bronze, marble, or ivory statue, no picture either painted on a tablet or woven in a tapestry, which he [Verres] has not sought out, inspected, and, if it pleased him, stolen.

One of Verres' typical operations was at the expense of Sthenius, a citizen of the Sicilian city of Thermae.

Cicero, *Verr.* II, II, 83-85: Sthenius, who sits here before you, is a citizen of Thermae. Prior to this he was known to many for his high character and great nobility, but now on account of his personal calamity and the conspicuous injury which he has suffered at the hands of this man, he is known to all. For Verres, although he had often availed himself of Sthenius' hospitality and although he had not only visited him on many occasions at Thermae but had even lived with him, nevertheless stole from his house everything which could in the least attract his attentions or hold his glance. For Sthenius from the time of his adolescence had procured perhaps a little too zealously the following things: elegant wares of bronze (both Delian and Corinthian), paintings, and even, by the standards of wealth which apply to a man of Thermae, a good quantity of finely worked silver. These things, as I said, he procured with zeal when he was in Asia as a youth, not so much, however, for his own delectation as for that of our citizens, who received his invitations

and visited him there, and also for that of his friends and guests. After Verres took away all these possessions, asking for some, demanding others, and simply taking others, Sthenius bore it as best he could. Naturally he felt anguish in his spirit because Verres had left his house, once so tastefully decorated, almost completely stripped and empty. Nevertheless, he did not communicate his sadness to anyone. He decided that the injuries which he suffered at the hands of the praetor should be borne tacitly and peacefully. In the meantime Verres, driven by that cupidity of his which was now famous and known to all, when he saw certain ancient and very beautiful statues set up in a public place in Thermae, fell in love with them. And so he began to demand from Sthenius that he offer his services and lend him a hand in getting possession of these statues. Sthenius not only refused but pointed out to him that it was impossible to take these very ancient works, monuments of Publius Africanus, out of the city of Thermae and to insure at the same time that the city and the Roman power remain safe and unharmed.

Cicero contrasts Verres' rapacity to the enlightened custom of other Roman magistrates, who frequently borrowed works of art from private citizens for public display but returned them afterward (cf. Verr. II, IV, 6). Verres would sometimes buy the works of art which he wanted, but before doing so, he would assess their value and set the proper sale price himself. Cicero's remarks on this practice give us an insight into the "art market" of the 1st century B.C.

Cicero, *Verr*. II, IV, 12-14: Let us look, then, at what the great price was which enabled Heius, a man of vast wealth and not at all greedy, to be led astray from the path of humanity, piety, and religion.[124] It was by your order, I believe, that he has recorded in his accounts that all these statues of Praxiteles, Myron, and Polykleitos were sold to Verres for 6,500 [125] sesterces. This is the way he has recorded it. Read from the records. It delights me that the renowned names of these artists, which the experts praise to the heavens, fall so low in the estimation of Verres. A Cupid by Praxiteles for 1,600 sesterces! It must be from this that the saying was born: "I would rather buy than ask." Someone might object "What? Do you set so high a price on such things?" The fact is, I do not evaluate them on the basis of my own reason and experience. But I think you should take a look at how much such works would be assessed for in the judgment of those who are zealous connoisseurs, how much they usually sell for, how much these very works which we are discussing

[124] Heius was a Sicilian from Messina whose fabulous art collection included works by Myron, Polykleitos, and Praxiteles. One of the gems of his collection was a Cupid (Eros) by Praxiteles which he sold, under duress, to Verres.

[125] Roughly $450.00 in modern American currency. One thousand sesterces was worth around $70.00. A *denarius* was worth four sesterces.

would sell for if they could be sold openly and freely, and finally how much Verres himself would really say that they are worth. For never, if he really thought that this Cupid was worth only 400 denarii, would he have allowed himself for the sake of it to become the subject of so much censure in the conversation of men. Who of you, then, is ignorant of how much these works are really worth? Did we not see in a recent auction a bronze of no great size go for 40,000 sesterces?

Among Verres' prime targets were the venerable Greek temples of Sicily, which, in addition to being works of art themselves and containing cult images, housed many votive offerings which had accumulated over the centuries.

Cicero, *Verr*. II, IV, 122-124: There is on the island [126] a temple of Minerva [Athena] of which I was speaking before. Marcellus did not touch it but left it full and complete with all its decorations. It was, however, so pillaged and torn to pieces by Verres that it seemed to have been sacked, not by an enemy who would still retain some sense of religion and the laws of propriety even in war, but by piratical robbers. There were outstanding paintings there showing a battle of the cavalry of King Agathokles [of Syracuse, ruled 317-289 B.C.]. The walls of the interior of the temple used to be decorated with these. Nothing in Syracuse was more famous; nothing was considered more worthy of a visit. . . . Verres, who owed his vows not to Honor and Virtue, like Marcellus,[127] but rather to Venus and Cupid, was the man who dared to despoil the temple of Minerva. The one [Marcellus] did not wish to adorn the gods with spoils taken from [other] gods, but the other [Verres] transferred the ornaments of Minerva the Virgin to the house of a prostitute. In addition he carried off from the same temple twenty-seven beautifully painted tablets on which there were portraits of the kings and tyrants of Sicily, portraits which were not only pleasing because of the skill of the artists who painted them but also because they commemorated these men and gave an indication of their looks. . . . On the doors [of the temple] there were flawless scenes done in ivory with the greatest precision; he acted as overseer in the removal of these. There was also a very beautiful Gorgon's head ringed with serpents which he tore off and carried away. . . . [To indicate that Verres' motive was greed and not love of art, Cicero goes on to note that the gold nails in the doors of the temple were also stolen.]

Cicero, *Verr*. II, IV, 72-74: There was at Segesta an image of Diana in bronze which was accorded the highest and the most ancient religious veneration, so singular a work was it, and of such perfect artistry. . . .

[126] The island of Ortygia (now a peninsula) which was part of Syracuse.
[127] See p. 57.

[The statue was carried off by the Carthaginians who also worshiped it. After the Third Punic War the younger Africanus returned it to the people of Segesta.] It is reported that at Segesta it was put back in its ancient place with great rejoicing and enthusiasm on the part of the citizens. It was placed in Segesta upon quite a high base, on which the name of P. Africanus was inscribed in big letters, and the inscription also told how it had been restored after it was captured in Carthage. Formal rites of worship for it were instituted by the citizens, and these rites used to be watched by all the visitors who came there. When I was quaestor [in 75 B.C.], nothing was shown to me by them prior to this. The statue, equipped with a long robe, was ample in its proportions and quite tall. Nevertheless, even with this magnitude, it conveyed the age and mien of a virgin girl. From her shoulder there hung [a quiver of] arrows; in her left hand she held a bow, and in her right she held forth a burning torch.

When this enemy and robber of all things sacred and revered saw it, he became inflamed with cupidity and madness, as if set ablaze by that very torch. He commanded the magistrates to pull it down and give it to him.

Cicero, *Verr.* II, IV, 129-130: And as for Jupiter *Imperator,* how great do you think the honor was which he was accorded in his own temple? You would form some idea of it if you would call to mind how much veneration was paid to the statue of the same type and of the same appearance which T. Flamininus brought back from Macedonia, where he captured it, and set up on the Capitoline. For they say that there were three statues of Jupiter *Imperator* in the world, beautifully made works and all in one style; one is the Macedonian statue which we have seen on the Capitoline, the second is that which stands at the mouth of the straits leading into the Black Sea, and the third is that which was in Syracuse prior to the praetorship of Verres. The first of these Flamininus took out of its proper temple so that he could set it up on the Capitoline, which is the terrestrial home of Jupiter. That which is at the entrance to the Black Sea, even though so many wars have issued forth from that sea and even though so many have in turn been carried back to Pontus,[128] has nevertheless been preserved in one piece and inviolate down to this day. The third is that which was in Syracuse, which Marcellus, armed and victorious, saw and which he ceded in the name of religion; which the citizens and residents of Syracuse used to worship; which visitors not only used to see but actually to venerate—this statue Verres carried off from the temple of Jupiter.

Cicero, *Verr.* II, IV, 109-110 [Concerning a group of statues in the

[128] Pontus is the name for the area in northeastern Asia Minor along the Black Sea; it was the center of Mithridates' kingdom. The wars which Cicero has in mind are probably those against Mithridates under Sulla and Lucullus.

Sicilian city of Henna]: This very Ceres, that most ancient and most venerated goddess, the first object of all the sacred rites which are practiced among all races and nations, this goddess was carried off from her seat and her temple by Verres. You who have gone to Henna have seen this image of Ceres in marble and, in another temple, that of Libera. They were of considerable size and distinction, although not very old. And there was another statue, in bronze, of moderate size and very singular workmanship, holding torches, and very ancient—by far the most ancient of all those in the shrine. This too Verres carried off; however, he was not satisfied with it alone. In an open space before the temple of Ceres there were two statues, one of Ceres, the other of Triptolemos, both extremely beautiful and large. Their beauty put them in danger, but their size saved them, because to take them down from their bases and to transport them seemed extremely difficult. But a very beautifully wrought statue of victory stood in the right hand of Ceres. Verres took personal supervision of tearing this off the statue of Ceres and carrying it away.

Sometimes the job of removing the cult images was not so easy, as the following colorful incident indicates.

Cicero, *Verr.* II, IV, 94-95: Among the Agrigentines there is a temple of Hercules not far from the forum which is extremely sacred and highly venerated by them. There is in this temple a bronze image of Hercules himself, than which I could not easily say that I have ever seen a statue more beautiful (though I admit that the extent of my expertise in these matters does not match the number of statues that I have seen). This statue was so venerated that, little by little, its mouth and its chin had become worn down, because in their prayers and their thanksgivings people not only would worship it but even would kiss it. It was against this temple that Verres, when he was in Agrigentum, arranged a sudden approach and an assault during the quiet of night by a band of armed slaves led by Timarchides. A clamor was raised by the guardians and custodians of the shrine. At first, when these people attempted to resist and defend the temple, they were badly beaten with sticks and clubs. Afterward, having pulled down the bars and broken open the doors, they [the attackers] were trying to pull the statue off its base by shaking it with crowbars. In the meantime, from the clamor that was raised, word spread throughout the city that the gods of the country were being stormed, not however by the unexpected arrival of a foreign enemy nor by the sudden attack of pirates, but rather by a band of slaves who had come trained and armed from the house and from the staff of the praetor. No one in Agrigentum was either so weakened by age or so infirm in physical strength that he did not on that night, aroused by the news, leap up and seize whatever weapon chanced to be there. Thus in a short

time they were converging on the sanctuary from all over the city. By that time a good many men had been at work for more than an hour trying to remove the statue from its base. However, it refused to budge at all, even when some tried to move it with crowbars wedged underneath while others attempted to dislodge it with ropes fastened to all parts of it. Then suddenly the Agrigentines converged on the scene. A great shower of stones ensued and the nocturnal soldiers of that distinguished general gave themselves over to flight. They did, however, carry off two rather tiny statues, so that they would not return completely empty-handed to the robber of all things religious. Now things are never so bad among the Sicilians that they do not manage to say something facetious and appropriate, as, for example, in this case, when they said that among the labors of Hercules one should count the extremely vicious Verrine boar as much as the Erymanthian.

Cicero also describes how Verres stole a statue of Mercury from Tyndaris (Verr. II, IV, 84) and an Apollo from Agrigentum (II, IV, 93). He also plundered sanctuaries of the Magna Mater at Engyion (II, IV, 97), of Juno on Malta (II, IV, 103), and of Ceres at Catina (II, IV, 99).

In order to help him assess works for his "collection," Verres hired two advisors.

Cicero, *Verr*. II, IV, 30-31: Now it is worthwhile to know, judges, how he usually went about searching for and discovering all these things. There were certain brothers from Cibyra [in southwestern Asia Minor], Tlepolemos and Hieron by name; of these the former, I believe, usually made his living as a modeler in wax, and the latter was a painter. I believe that when these men were at Cibyra they came to be suspected by their fellow citizens of having plundered the sanctuary of Apollo, and, being afraid of the punishment which would result from a legal trial, they fled from their home. Because it had come to their attention that Verres, who, as you have heard from witnesses, had at that time come to Cibyra with empty contracts,[129] was passionate about their art, these exiles, fleeing their home, betook themselves to him while he was in Asia. He kept them with him during that time and made great use of their help and advice in the thefts and plunderings which were part of his term as legate. It is these men to whom Quintus Tadius [130] refers in the records with the words "given by order of Verres to the Greek painters." Since they were now well known to him and of proven skill, he took them with him to Sicily. After arriving there it was remarkable how (like hunting dogs, you might almost say) they used to pick up every scent and follow every track so that, wherever there was anything to be found, they found it by one means or another. At one time by

129 Or "worthless bonds." The reference is not explained elsewhere.
130 Probably Verres' legate in Sicily.

threatening, at another by promising, sometimes through slaves, sometimes through free men, sometimes through a friend, sometimes through an enemy, they discovered what they were searching for. Whatever was pleasing to them was inevitably lost to its owner. The only hope of those whose silver was requisitioned was that it would displease Hieron and Tlepolemos.

The attempts by Tlepolemos and Hieron to collect works of art in Sicily were not always characterized by subtlety. One of their cruder operations was at Assorus where they attempted to get possession of a statue of the river goddess Chrysas.

Cicero, Verr. II, IV, 96: Her sanctuary was in a field near the road which runs from Assorus to Henna. In it there was a beautifully wrought marble image of Chrysas. On account of the unusually sacred nature of this sanctuary Verres did not dare to demand it from the Assorians. He turned the matter over to Tlepolemos and Hieron. These men came during the night with a band which they had organized and armed, and broke open the doors of the temple. The temple guardians and custodians quickly understood what was happening. The alarm, which was understood by the neighborhood, was sounded with a trumpet. Men converged from the fields; Tlepolemos was driven out of the field and put to flight, and nothing was missing from the shrine of Chrysas except one small bronze.

One of Verres' most remarkable ideas was to create a workshop where the ornaments from plundered plates, vases, etc., could be transferred to objects which he found more pleasing.

Cicero, Verr. II, IV, 54: After he had collected such a huge amount of tableware decorated with relief—it was as if he had not left a single piece to anyone—he established an extremely large workshop in the royal residence in Syracuse. Then he publicly ordered that all artists, engravers, and metal-workers be assembled. These he shut up in the workshop—a great number of men. The work assigned to them required eight straight months to complete, even though nothing was made but gold vases. For those ornaments which he had torn off plates and censers, he now had so tastefully attached to gold drinking cups and so appropriately inlaid in golden bowls that you would have said that they were created for just this purpose. Our praetor, moreover, who says that through his vigilance he brought peace to Sicily, used to spend the better part of the day in this workshop dressed in a dark tunic and a Greek cloak.

Finally, in the following passage Cicero paints a poignant picture of the effect of Verres' robberies in Sicily. It provides us with an interest-

*ing insight into the appreciation of art in this civilized province, which
had more sophisticated cultural traditions than Rome itself.*

Cicero, Verr. II, IV, 132: Accordingly, judges, those who customarily act
as guides to the things which must be seen and who point out each
individual thing, those men who are called *mystagōgoi*, have now altered
their method of indicating things. For, whereas previously they used to
point out where each thing was, now they point out what was taken
from where.

What can I say? Do you think that they have been afflicted with
only moderate grief? It is not so, judges. First because they are all moved
by religious feeling and because they feel that they must maintain and
worship diligently those national gods which they have received from
their ancestors; and second, because Greeks delight in this kind of
ornamentation, in works of art and artistry, in statues and paintings,
more than in anything else. And consequently, from their mournful com-
plaints we are able to understand how these things seem so terribly bitter
to them which to us might seem less serious and hardly so worrisome.

*Cicero sounds the same theme in a more general way when he
speaks of the Roman Forum in the 1st century* B.C. *and its effect on
foreign visitors.*

Cicero, Verr. II, I, 59: It was at this time that the allies and foreign
nations first abandoned all hope for their interests and fortunes; because
there were then by chance many ambassadors from Asia and Achaia, who
used to see with veneration the images of the gods in the Forum which
had been carried off from their own shrines, and who, when they also
recognized other statues and ornaments, some in one place, some in
another, used to contemplate them with tears.

Collecting and Connoisseurship

*The passion for building an art collection, which in Verres had
reached a maniacal and violent degree, was shared by many Roman
nobles of the 1st century* B.C. *Works of Greek art quite naturally formed
the basis of these collections.*

*Public displays of art were often set up for special festivals in public
buildings or places of assembly.*[131] *When not derived from foreign plunder,
the objects so displayed usually came from the private collection of some
individual or were borrowed from various places by a magistrate. The*

[131] Cicero mentions specifically the temple of Today's Fortune and the Portico of
Metellus as prominent places for the display of works of art (*Verr.* II, IV, 126); for works
of Greek art in the former structure see the geographical index of *The Art of Ancient
Greece*, geographical index, s.v. "Rome."

latter procedure is mentioned by Cicero in connection with the collection of Heius in Sicily.

Cicero, *Verr*. II, IV, 6: C. Claudius, whose aedileship [in 99 B.C.] was, as we know, so magnificent, made use of this Cupid [132] during the time when he decorated the Forum in honor of the immortal gods and the Roman people, and since he was a close friend of the family of Heius and patron of the people of Messina, he was as scrupulous about returning what he borrowed as they were courteous in lending it. It is only recently that men of noble rank have behaved in this way. In fact, why do I say recently? Rather, it has been for only the briefest time that we have seen those who decorate the Forum and the basilicas do so not with spoils from the provinces but with the art objects of their friends, loaned by their hosts, and not with the thefts of criminals. . . .

The outstanding individual collector of the 1st century B.C. was Gaius Asinius Pollio (76 B.C.-A.D. 5), friend of Caesar, Antony, and later of Augustus, scholar, poet, literary critic, politician, promoter of cultural activities in Rome, and conspicuous philhellene.

Pliny, *N.H.* XXXVI, 33: Asinius Pollio, being a man of great enthusiasm, naturally wanted his art collection to be seen. In it are Centaurs carrying Nymphs by Arkesilaos, Thespiades [Helikonian Muses] by Kleomenes, Oceanus and Jupiter by Heniochos, Appiades [133] by Stephanos, the Hermerotes by Tauriskos (not the engraver, but rather an artist from Tralles), a Jupiter *Hospitalis* by Papylos, the pupil of Praxiteles, and a Zethos and Amphion, along with Dirke, the bull and the rope—a work by Apollonios and Tauriskos which was brought from Rhodes. . . . In the same place there is a praiseworthy Liber Pater by Eutychides.[134]

Other public exhibitions of art in the 1st century B.C. are mentioned by Pliny.

Pliny, *N.H.* VII, 34: Pompey the Great set up among the ornaments of [his] theater images representing miraculous events, wrought with considerable refinement just for this purpose by the inspiration of great artists, among which we read of Eutychis, who after giving birth thirty times in Tralles, was borne to her funeral pyre by twenty children, and Alkippe who gave birth to an elephant. . . .

132 A work of Praxiteles.

133 The Appiades were nymphs associated with *Aqua Appia*, one of the Aqueducts of Rome. The sculptures by Stephanos decorated a fountain in the *Forum Iulium;* cf. Nash, *Pictorial Dictionary*, I, 33.

134 For the Greek artists listed here consult the index to *The Art of Greece: 1400-31 B.C.;* see also under "Asinius Pollio."

Pliny, N.H. XXXV, 173: During their aedileship [probably in 59 B.C.] Murena and Varro, for the purpose of decorating the *Comitium*, had transported from Sparta to Rome some examples of *opus tectorium*,[135] which, on account of their excellence, were cut away from certain brick walls and encased in wooden frames. Although the work itself was much admired, the transference was praised even more.

Pliny, N.H. XXXV, 127: But eventually all the pictures were confiscated from public ownership [in Sikyon] and were transferred from there to Rome during the aedileship of Scaurus [58 B.C.].

Pliny, N.H. XXXIV, 36: During the aedileship of M. Scaurus there were as many as three thousand statues on the stage of a temporary theater.

 Our best insight into the attitudes and interests of art collectors in the 1st century B.C. *comes from the private correspondence of Cicero, who was a moderately intense collector himself. Cicero was particularly interested in procuring works of Greek art which would serve as appropriate decorations for his villa in Tusculum. Most of his letters on this subject are written to his friend Titus Pomponius Atticus (109-32* B.C.) *who resided in Athens and purchased works of art on behalf of his friends.*

Cicero, ad Atticum I, 6, 2, (68 B.C.): I implore you [Atticus, who is in Athens], if you are able to find any artistic decorations which are *gymnasiōdē* [136] and would be suitable for that place, which you are not ignorant of, do not let them get away.

Cicero, ad Atticum I, 8, 2, (67 B.C.): I have paid L. Cincius 20,400 sesterces [137] for the Megarian statues in accordance with what you wrote me. As for those herms [138] of yours in Pentelic marble with heads of bronze, about which you wrote me, they are already providing me in advance with considerable delight. And so I pray that you send them to me as soon as possible and also as many other statues and objects as seem

[135] *Opus tectorium,* "plaster work," can refer either to fresco-painting or stucco relief.

[136] *Gymnasiōdē,* "suitable for the decoration of a gymnasium," a Greek word.

[137] Since the value of money must be gauged in terms of purchasing power it is impossible to give exact equivalents for ancient and modern currencies; 20,400 sesterces was roughly equivalent to $1,700.

[138] "Herm" is the modern archaeological term for a particular type of quadrangular shaft surmounted by a sculptured head. Such shafts were made of both bronze and marble. The heads on the earliest Greek herms appear to have represented Hermes, but in time other deities were represented in this form. The Romans adopted the practice of placing portraits on herm shafts. The *Hermerakles* and *Hermathena* mentioned by Cicero in the letters which follow may have been either simple herm shafts surmounted by heads of Herakles and Athena or possibly double herms in which heads of Herakles and Athena were combined with heads of Hermes.

to you appropriate to that place, and to my interests, and to your good taste—above all anything which seems to you suitable for a gymnasium or a running track. For I am in such an emotional transport owing to eagerness for this subject that I am deserving of help from you, if also perhaps of censure from others. If there is no ship belonging to Lentulus, have them loaded at any port you wish.

Cicero, *ad Atticum* I, 9, 2: I am awaiting eagerly the Megarian statues and the Herms about which you wrote me. Anything which you have in any category which seems to you worthy of the "Academy," [139] do not hesitate to send, and have confidence in my treasure chest. This sort of thing is my voluptuous pleasure. I am enquiring into those things which are most *gymnasiōdē*. Lentulus promises his ships. I beg you to see to this project diligently.

Cicero, *ad Atticum* I, 10, 3: As for my statues and the *Hermerakles*, I implore you in accordance with what you have written, to ship them at the first opportune moment which appears, and also anything else which seems to you suitable for this place, with which you are not unacquainted, and especially for a wrestling court and gymnasium. As a matter of fact, I have been writing to you while seated in that very location, so that the place itself informs me of what it needs. In addition I commission you to procure some reliefs [140] which I could insert into the wall of my *atriolum* [141] and also two well-heads ornamented with figures.

Cicero, *ad Atticum* I, 4, 3, (66 B.C.): What you wrote me about the *Hermathena* is certainly pleasing. This is the sort of decoration which is appropriate for my Academy, since Hermes is characteristic of all gymnasia and Minerva in particular is a distinguishing mark of mine.[142] Naturally I would like you, in accordance with what you have written, to decorate this place with as many works of art as possible. As for those statues which you sent me previously, I have not yet seen them. They are in Formiae, to which I am just now intending to set out. I shall transport them all to the villa in Tusculum. I shall decorate Caieta when I begin to get rich.[143]

139 The "academy" was the name of Cicero's gymnasium; it was undoubtedly intended to call to mind Plato's Academy.

140 "Reliefs" here translates the Latin accusative *typos* = Greek *typous*. On this term see *The Art of Ancient Greece*, p. 104.

141 An *atrium* was the hall of a Roman house adjacent to the main entrance. It usually contained a pool (*impluvium*) to collect rain water which came through an open space in the roof above it (*compluvium*). The *atriolum* was a small version of the same type of room placed farther to the rear of a large house or villa.

142 Ancient Greek gymnasia served as schools as well as places to exercise. Cicero is emphasizing the intellectual aspect of his gymnasium by putting in a herm of Minerva (Athena), who was recognized as the goddess of wisdom.

143 Formiae and Caieta were adjacent towns on the coast in southern Latium, near which Cicero owned additional property.

Cicero, *ad Atticum* **I, 1, 5,** [65 B.C. Cicero has finally received his sculptures from Atticus]: Your *Hermathena* delights me greatly, and it is placed so beautifully that the whole gymnasium looks like a votive offering.[144]

In a considerably later letter written to M. Fadius Gallus in c. 61 B.C. Cicero's early ardor has cooled to tasteful interest.

Cicero, *ad Familiares* **VII, 23, 1-3** [Gallus has purchased some statues on Cicero's behalf at an exorbitant price. Cicero does not want the statues and complains about having to pay for them]: . . . But everything would have been easy, my dear Gallus, if you had bought only those statues which I wanted, and at the price which I was willing to pay. All the same, those purchases which you say that you have made will be not only validated by me but also received with gratitude. For I quite understand that you bought up things which pleased you (a person, I have always felt, of the most cultured taste in all matters) and which you thought were worthy of me, acting not only on the impulse of your native zeal but also out of affection.

But I would be happy if Damasippos would adhere to his stated intention.[145] For the truth is that out of all those purchased there is not one which I really want. You, however, in ignorance of my principles, bought these four or five statues for more than I would pay for the complete corpus of all the world's statuary. You compare these Bacchantes [146] with the Muses of Metellus [see p. 95]. What is similar about them? To begin with, I never would have thought that even those Muses were worth so much, and I would probably have secured the Muses' approval on this point. But they, at least, would have been appropriate for my library and would have been in keeping with my interests. But these Bacchantes, where could I ever put them in my house? They are, of course, pretty little figures. I know them very well and have seen them often. I would have commissioned you to buy these specific works, which were known to me, if I had approved of them. For I customarily buy statues which, by their decorative effect, would create for me a place in the palaestra which had the appearance of the gymnasia.[147] But what good is a statue of Mars to me, the author of peace? I rejoice that there was no statue of Saturn. For I might have thought that these two statues had gotten me into debt. My preference would have been for some sort of statue of Mercury.[148] For then, I think, I would be better able to do

144 "Votive offering"—Cicero uses the Greek *anathēma.*
145 Damasippos seems to have been an art dealer who decorated gardens with statuary and then sold them. Cf. Cicero, *ad Att.* XII, 29, 33; Horace, *Satires* II, 3, 16. He had apparently offered to buy the statues in question from Cicero.
146 Latin *Bacchas,* in Greek *Bacchai* (= Maenads).
147 Statues of Bacchantes were presumably inappropriate for gymnasia.
148 Saturn was traditionally the god who conferred ill-fortune and debt; Mercury brought success in commerce.

business with Avianius. As for the *trapezophoron* [table support][149] which you must have intended for yourself, if it pleases you, keep it. If however you have changed your mind, I will of course keep it. For the sum involved I would much more gladly have bought a lodge at Tarracina, so as not always to be a bother to my host there. In general, I see that the blame should go to my freedman, whom I clearly commissioned to buy certain things, and also to Junius, who I think is known to you, the friend of Avianius [see p. 89]. I have installed some new sitting rooms in a little portico in [my villa in] Tusculum. I would like to decorate these with paintings. As a matter of fact, if there is any type of art which really pleases me, it is painting.

Another enthusiastic collector was the orator Hortensius (114-50 B.C.) who was the defense counsel for Verres.

Pliny, *N.H.* XXXIV, 48: Many people are so charmed with the statuettes which they call "Corinthian" that they carry them around with them, as, for example, the orator Hortensius, who during the Verres affair had received a sphinx [from Verres]; it was on account of this that, when, in the course of an altercation during that trial, Hortensius was objecting that he was not good at riddles, Cicero responded, "You ought to be, because you have a sphinx of your own."

Pliny, *N.H.* XXXV, 130: Active at the same time [as Euphranor] was Kydias, whose picture of the Argonauts was bought for 144,000 sesterces by the orator Hortensius, who made a temple for it on his estate in Tusculum.[150]

Corinthian bronze, of which Hortensius' Sphinx seems to have been made, became a collector's item in Rome, where it first became known after the sack of Corinth by Mummius (see pp. 46-48). Pliny offers the following somewhat disenchanted observations on collecting Corinthian bronzes.

Pliny, *N.H.* XXXIV, 5-7: . . . The technique of casting precious works in bronze has degenerated to such a point that for a long time now not even chance [*Fortuna*] has had the privilege of producing this kind of artistry. But among the ancient glories of that art Corinthian bronze is praised most highly. This is a mixture which occurred by accident at Corinth during the time when it was captured and burned, and the attraction which this metal has had for many people has been indeed remarkable. In fact there is a tradition that, for the sake of this metal

[149] Probably a statue which could support a flat disc and serve as a table.

[150] 144,000 sesterces = about $10,000. On this passage see also *The Art of Ancient Greece*, p. 175.

and no other, Verres, whom M. Cicero convicted, was proscribed by Antony along with Cicero; for Verres had refused to surrender to Antony his collection of Corinthian bronzes. And it seems to me that the great part of these collectors more often merely pretend to have real knowledge about this bronze, so that they may stand out from the common run of men, and that less·often do they really have a very subtle understanding of the subject.[151] I will briefly illustrate what I mean. Corinth was captured in the third year of the 158th Olympiad, which was the 608th year of our city [146 B.C.], by which time there had not been any outstanding sculptors in metal for ages, yet even so these collectors today call all statues "Corinthian." . . . There do exist, then, a certain number of real Corinthian vases, which these "men of taste" sometimes have converted into dishes and sometimes into lamps or even into wash basins with no consideration for the subtle points of their style.[152]

Objets d'art *made of silver seem to have been collected almost as eagerly as Corinthian bronzes.*

Pliny, *N.H.* XXXIII, 147: Not only are men mad for silver in great quantity, but they are perhaps even madder for it in the form of works of art, and this has been true for so long a time now that we today pardon ourselves. Gaius Gracchus had some figures of dolphins which he bought for the price of five thousand sesterces per pound, and the orator Lucius Crassus [c. 140-91 B.C.] had two cups chased by the hand of the artist Mentor [153] which cost him 100,000 sesterces; it is admitted, however, that, out of a sense of shame, he never dared to use them.

Pliny, *N.H.* XXXIII, 130: Silver mirrors have come to be preferred. Pasiteles, during the time of Pompey the Great, was the first to make these.[154]

For the use of silver on furniture before and during the time of Sulla cf. Pliny, N.H. XXXIII, 144 and 146.
The collecting mania of the 1st century B.C. also turned to gems.[155]

Pliny, *N.H.* XXXVII, 11: The first person at Rome to collect a great many gems—the sort of collection which they refer to by the foreign name

151 Some liberty has been taken with the grammar of this sentence in order to bring out its real meaning.
152 With no consideration for the subtle points of their style = *nullo munditiarum dispectu.*
153 On Mentor see *ibid.,* pp. 216-17, 233-4.
154 On Pasiteles, *ibid.,* pp. 120, 220, 234.
155 The Roman gems which are preserved from this period show a marked rise in quality. See Vessberg's remarks, *Studien,* pp. 61-62 and also A. Furtwängler, *Die Antiken Gemmen* (Leipzig 1900), III, 299 ff.

dactyliotheca [156]—was Sulla's stepson Scaurus. There was for a long time no other until Pompey the Great dedicated among his offerings on the Capitoline those which had belonged to King Mithridates; his collection, as Varro and other authors of that era confirm, was much inferior to that of Scaurus. His example was followed by the dictator Caesar, who consecrated six *dactyliothecas* in the temple of Venus *Genetrix,* and by Marcellus [42-23 B.C.], the son of Octavia [and nephew of Augustus], who consecrated one in the temple of Apollo on the Palatine.

Pliny, *N.H.* XXXVII, 9: The dictator Sulla, according to tradition, always wore a signet ring taken from Jugurtha.

Julius Caesar, if we may believe Suetonius, was one of the most avid of the Roman collectors.

Suetonius, *The Divine Julius* XLVII: It is said that he attacked Britain in the hope of finding pearls, and that when comparing the size of pearls he would sometimes gauge their weight with his own hand; it is also said that he was always an extremely avid collector of gems, engravings, statues, and paintings of ancient workmanship. . . .

Private and Public Buildings

On the whole, collecting and connoisseurship in the 1st century B.C. *were more devoted to enriching the private world of the collector than the public domain. In time this came to be true even of architectural elements in marble, which as already noted was first used in Rome on buildings constructed by Metellus (see p. 45). Pliny speaks of this development with disapproval.*

Pliny, *N.H.* XXXVI, 4-8: There are on the books laws passed by Claudius the censor [c. 169 B.C.] forbidding that dormice and other things too trivial for mention be served at meals; but no law has ever been passed which would forbid the importation of marble and the crossing of oceans for the sake of it. Someone might object, "But none was being imported." This however is false. For in the aedileship of M. Scaurus [58 B.C.] people saw 360 columns, which were to be used for scarcely a month, transported to the stage of a temporary theater while the laws were silent. But it was for the delight of the public, of course, that the laws were being indulgent. But why should this be? For by what route do vices more commonly make inroads than the route of public interest? By what other path has the use of ivory, gold, and gems entered into private life? Is there anything that we have left exclusively to the gods? Well and good, then, that they will have made some allowance for the

[156] *Dactyliotheca* (Greek) = "a place where rings are kept."

delights of the public. But were the laws not also quiet when the largest of these columns, as large as thirty-eight feet in length and of Lucullean marble, were set up in the atrium of Scaurus' house? Nor was this done secretly and covertly. A contractor of sewers compelled Scaurus to give him a guarantee against damaging them [the sewers] while the columns were being dragged to the Palatine. But would it not have been more useful, in the face of such a bad example, to take some precaution for the preservation of our morals? Yes, the laws were silent while such massive pieces [of marble] were dragged past the terracotta roof ornaments of the [temples of] the gods. Nor is it possible to assume that Scaurus, with a sort of primary probe at vice, took by surprise a city which was naïve and unable to see its potential evil. For it was some time before that the orator L. Crassus, who first had columns of foreign marble in his house on the Palatine (they were, however, of Hymettos marble and not more than six in number nor more than twelve feet long), was, in the course of an argument about it, given the name "Palatine Venus" by M. Brutus [c. 95 B.C.]. Naturally, with morals already defeated, people ignored these things, and discerning that they were vainly forbidding things which had already been prohibited, they decided that it was better to have no laws at all than to have useless ones. These facts and the events which followed prove that we are better men. For who today [157] has such columns in his atrium?

Pliny, *N.H.* XXXVI, 48-50: The first man in Rome reputed to have covered walls with marble revetments throughout his whole house, which was on the Caelian, was, according to Cornelius Nepos, Mamurra, a Roman knight born at Formiae, who was C. [Julius] Caesar's prefect in charge of construction in Gaul; lest the indignity of the practice be minimized, I hasten to point out that it was such a man as this who invented the practice. For it is this Mamurra whom Catullus of Verona rakes over with his poems, and whose house, as a matter of fact, proclaimed more clearly than Catullus that "he now had whatever shaggy Gaul had had." [158] Nepos also adds that he was the first to have nothing but marble columns throughout his whole house and that they were all either solid Karystian or solid Luna marble.[159] M. Lepidus, who was consul along with Q. Catulus, was the first to use marble from Numidia for the door frames of his house but did so in the face of great criticism. He was consul in the 676th year of the city [78 B.C.]. This is the first record that I find of the importation of Numidian marble; it was not imported, however, in the form of columns or revetments, like the Karystian marble mentioned

[157] That is, during the time of the Emperor Vespasian (A.D. 70-79), when Pliny was writing the *Natural History*.

[158] A paraphrase of Catullus XXIX, 3-4: *Mamurram habere quod comata Gallia/ Habebat* . . . ; cf. also Catullus LVII.

[159] Karystian marble was from Karystos, a Greek city on the southern tip of Euboea; Luna is an Italian site on the border between Etruria and Liguria.

above, but rather in rough blocks for the most commonplace of uses—
that is, for door frames. Four years after the consulship of Lepidus, L.
Lucullus was consul, the man who gave his name, as is quite obvious
from the fact of it, to Lucullean marble. He was quite delighted with it
and first brought it to Rome, although as a rule it is the black marbles
and those with speckled patterns or colors which receive commendation.
This [Lucullean marble], however, is found on the island of Melos [160]
and is just about the only marble to have been named after an admirer.
Among these men the first, I believe, whose stage had marble walls was
M. Scaurus, but I could not easily say whether these were done with revet-
ments or with solid polished blocks, like the present temple of Jupiter
Tonans ["the Thunderer"] on the Capitoline [see pp. 104, 108-109]. For
at this early date I do not find any trace of marble revetments being
used in Italy.

*Perhaps the most famous of all the Roman voluptuaries was L.
Lucullus. Plutarch gives a picture of the private splendor to which
Lucullus retired after the end of his military career.*

Plutarch, *Life of Lucullus* **39:** The life of Lucullus, as is the case in Old
Comedy, is characterized at the beginning by politics and military affairs
and toward the end by drinking, feasting, all-night parties, torchlight
processions, and all kinds of sportive play. For it is under the heading of
play that I would classify his expensive buildings, his porticoes for
strolling, and his baths, and likewise his paintings and statues and his
enthusiasm for all these arts, which he collected with great outlays of
money. He lavishly spent on these things the great and shining wealth
which came from his campaigns, to such a degree, in fact, that even at the
present time, when there has been such an increase in luxury, the
Lucullean gardens are counted among the most costly of the imperial
possessions. And as for his buildings along the coast around Naples—
where he suspended the hills on great tunnels, surrounded the dwellings
with moats fed by the sea and inlets full of fish, and built living quarters
on the seaside—Tuberon the Stoic, when he saw them, referred to
Lucullus as "Xerxes in a toga." He also had country quarters in the area
of Tusculum which had lookout points with conspicuous views and struc-
tures combining open banqueting halls and porticoes. Pompey, when he
chanced to be in these, found fault with Lucullus for having designed
quarters which were perfect for the summer but which would be un-
inhabitable in the winter. But Lucullus, laughing, replied, "Do I seem
to you to be worse off than the cranes and storks, so that I cannot change
my dwelling with the seasons?"

[160] "Melos" is the reading adopted by Sillig, Mayhoff, and others. The manu-
scripts have such unintelligible forms as *heǫ* (Chios?), *millo, ilo,* and *nilo.*

Although the luxury of Lucullus' estates may have exceeded that of any others in the 1st century B.C., it was, as Pliny indicates, not unique.

Pliny, *N.H.* XXXVI, 109-110: In the consulship of M. Lepidus and Q. Catulus [78 B.C.], as is agreed among our most precise authorities, there was no more beautiful house at Rome than that of Lepidus himself, but, by Hercules, within thirty-five years the same place was not even rated as the hundredth most beautiful house. Whoever wishes to may compute from this estimate the value of the vast mass of marble, the paintings, the regal expenses—the value, in fact, of a hundred houses which competed with the most beautiful and praiseworthy [of their time] and afterward were surpassed by innumerable others right up to the present day. Fires, to be sure, punish luxury; nevertheless, it is impossible to make people understand that there is anything more perishable than man himself.

Although the principal outlet for the taste in grandiose architecture may have been in private dwellings, public monuments, too, especially when they were the gift of a particular wealthy individual, were sometimes characterized by an extravagant splendor.

Pliny, *N.H.* XXXVI, 113-115: . . . And I shall indicate that even their insanity [that of the Emperors Caligula and Nero] was outdone by the privately financed works [161] of M. Scaurus, whose aedileship [58 B.C.] did more to undermine morals than any that I know of; in fact, it may be that so much power in the hands of Sulla's stepson [Scaurus] did more harm than Sulla's proscription of so many thousands. In his aedileship he constructed the greatest of all works ever made by human hand, surpassing not only those planned to last for a limited period but even those planned to last for eternity. This was his theater. Its stage rose three storeys in height and had 360 columns—and this in the very city which had not been able to bear the presence of six columns of Hymettos marble without abusing its most distinguished citizen [L. Crassus; see p. 82]. The lower storey of the stage was made of marble, the middle of glass (an unheard of luxury, even later on), and the highest storey was covered with gilded panels. The columns of the lower storey, as I have said,[162] were thirty-eight feet high. The bronze statues between the columns numbered, as I have indicated, three thousand in all. The auditorium [*cavea*] itself held 80,000 people, even though the auditorium of the theater of Pompey, which seats 40,000, is now more than sufficient in spite of the fact that the city has increased so much in size and the population is so much greater. The rest of the theater's apparatus con-

[161] Reading *privatis operibus;* another reading is *privatis opibus,* "by the private wealth."

[162] See p. 81. Some of the columns were later moved to Scaurus' own house.

sisted of so many Attalic [163] drapes, so many paintings, and other theatrical accoutrements that, when the luxurious objects which were superfluous for the theater but which could be of some daily use were transported to the villa [of Scaurus] in Tusculum, and the villa was burned down by irate servants, the loss amounted to thirty million [164] sesterces.

Scaurus' theater was so splendid that no later building could rival it. Later builders seem to have veered away from costly extravagance in the direction of inventiveness. Pliny claims that Gaius Curio, tribune in 50 B.C., built two wooden theaters, which revolved on pivots. When set face to face the two theaters could be used to stage two separate shows simultaneously. Cf. Pliny, N.H. XXXVI, 116-120.

On the new temple of Jupiter Optimus Maximus *built during this period see pp. 160-161.*

The Buildings and Monuments of Julius Caesar

When Caesar made his triumphant return to Rome in 46 B.C. after the defeat of Pompey, he undertook an ambitious program of public works which was to serve as a pattern for many later emperors.

Dio Cassius XLIII, 22, 2-3: For he constructed the forum which is named after him.[165] This was considerably more beautiful than the *Forum Romanum,* but it enhanced the reputation of the latter to the point where it came to be called the "Great Forum." After constructing this forum, then, and also the temple of Venus (because she was the founder of his family),[166] he dedicated them immediately. He also arranged for all kinds of contests in honor of their dedication, and he built a sort of wooden hunting theater with benches, which was called an "amphitheater" from the fact that the seats ran all the way around it and that there was no stage.

Dio Cassius XLIV, 4, 4 ff.: [In addition to other triumphal honors, the Senate and the people] granted him the title "father of his country" and had the title stamped on coinage and decreed that his birthday should be marked by public sacrifices; moreover, they ordered that a statue of

163 See p. 65.

164 The number given in the manuscripts varies, and the reading given by Mayhoff is adopted here. The amount would be in excess of $2,000,000.

165 The *Forum Iulium,* the first of the imperial forums, lies to the northwest of the Roman Forum. It was completed by Augustus (see p. 119); cf. Nash, *Pictorial Dictionary,* I, 424-32. According to Suetonius the cost of the forum was over one hundred million sesterces (*The Divine Julius,* XXVI, 2).

166 The temple of Venus *Genetrix* dominated the west end of the *Forum Iulium.* The Julian *gens* claimed to be descended from Iulus, the son of Aeneas; Aeneas was the son of Venus and Anchises.

him should be set up in all the cities and in the temples of Rome, and they set up two others on the *Rostra,* one representing him as the man who had saved the citizens and the other as the man who had lifted the siege, both having the crowns which are customary with statues of this sort. They also made the decision to build a temple of *Concordia Nova,* because they were now experiencing peace as a result of Caesar's efforts, and to hold an annual festival in honor of it [Concord]. And when he received these honors, they turned over to him the task of draining the Pomptine marshes, of digging a canal through the Peloponnesian isthmus,[167] and of building a new Senate House, since the *Curia Hostilia,*[168] even though it had been repaired, was destroyed. The proffered reason for its destruction was that a temple of Felicitas was to be built there (which, in fact, Lepidus did construct when he was *magister equitum* [45-44 B.C.]), but the real reason was so that the name of Sulla should not be preserved on it, and that another, newly constructed, could be called the *Curia Iulia.* . . .[169]

Suetonius, *The Divine Julius* LXXVI, 1: But he also allowed honors to be voted to him which were greater than those normally accorded to the highest human level of achievement: a golden chair which was in the Senate House in front of the tribunal, a carriage and a litter for the procession in the Circus, temples, altars, images placed next to those of the gods. . . .

After his assassination many monuments were created to honor the memory of Caesar.

Suetonius, *The Divine Julius* LXXXIV, 1: When his funeral was proclaimed, a pyre was constructed in the *Campus Martius* next to the tumulus of Julia, and a gold shrine, the form of which was modeled on the temple of Venus *Genetrix,* was placed before the *Rostra;* within it was a bier covered with gold and purple, and at the head of this was a trophy supporting the cloak in which he had been killed.

Dio Cassius XLVII, 18, 4: [In 42 B.C. the triumvirs] laid the foundations of a *heroön* to him on the spot where he had been cremated, and they sent an image of him, along with another of Venus, to be used in the processions in the Circus.

167 The Pomptine marshes: a marshy stretch along the Appian Way about thirty-five miles southeast of Rome. Caesar did not live long enough to undertake the excavation of the isthmus. Caligula and Nero later attempted to carry out the project but eventually abandoned it.

168 On the *Curia Hostilia* see p. 4. It was repaired by Sulla and finally burned down in 52 B.C.

169 Suetonius, *The Divine Julius* XLIV, 1, also mentions a theater and a temple of Mars among the projected buildings of Caesar and records that the *Circus Maximus* was rebuilt by him (*ibid.* XXXIX, 2; cf. also *infra* p. 154).

Painting

As in the earlier periods only a few painters are known by name.[170]

Pliny, N.H. XXXV, 147-148: Iaia of Kyzikos,[171] who remained a virgin all her life, painted at Rome during the time when M. Varro [116-27 B.C.] was a youth, both with a brush and with a *cestrum* [172] on ivory, specializing mainly in portraits of women; she also painted a large panel in Naples representing an old woman and a portrait of herself done with a mirror. Her hand was quicker than that of any other painter, and her artistry was of such high quality that she commanded much higher prices than the most celebrated painters of the same period, Sopolis and Dionysios, whose paintings fill the picture galleries.

The workshop of Sopolis was still active in 54 B.C., *as is indicated in a letter of Cicero to Atticus.*

Cicero, *ad Atticum* IV, 18, 4: After Gabinius [173] was acquitted, the other judges were so irritated that, about an hour later, they condemned on the basis of the *lex Papia* [174] a certain Antiochos Gabinius who was a freedman among the painters of Sopolis and an assistant to Gabinius.

Pliny, *N.H.* XXXV, 119: The painter Arellius, active shortly before the time of the Divine Augustus, was also esteemed highly, or at least would have been had he not corrupted his art with one shameful practice—that of always paying court to the woman he fell in love with, and, as a result of this, always painting goddesses, but making them look like his mistresses. For this reason there was a number of prostitutes to be found in his paintings.

Another painter who was a contemporary of Julius Caesar and may have worked in Rome was Timomachos of Byzantium, on whom see The Art of Greece: 1400-31 B.C., *p. 211.*
The subjects of a few anonymous paintings are also known.

Pliny, *N.H.* XXXV, 23: A stage built for public spectacles arranged by

170 Vessberg, *Studien*, pp. 69-70, no. 267, dates the painter Serapion (mentioned by Pliny, *N.H.* XXXV, 113) in this period on the grounds that he might have been a contemporary of Varro, whom Pliny cites as his source. But Varro provides only a *terminus ante quem* for Serapion.

171 Kyzikos = a Greek city on the coast of Asia Minor.

172 The *cestrum* was a small spatula used mainly in encaustic painting.

173 Aulus Gabinius, a legate of Pompey and consul in 58 B.C., was tried in 54 B.C. for taking bribes while he was governor of Syria.

174 The *lex Papia* was a law of 64 B.C. which made it possible to evict from Rome all persons who were not Roman citizens.

Claudius Pulcher [aedile in 99 B.C.] won great praise for its painted decoration, because some crows, deceived by a painted representation of roof-tiles, tried to alight on them.

Plutarch, *Life of Pompey* 2: And indeed they say that this Flora [a courtesan and former mistress of Pompey] was so radiantly beautiful and so renowned for her looks that Caecilius Metellus, when he was decorating the temple of the Dioscuri with statues and paintings, also set up a painted portrait of her because of her great beauty.

Varro mentions seeing a painted map of Italy on the wall of the temple of Tellus [175] *in Rome (de Re Rustica I, 2, 1) and a picture of some light-armed cavalrymen in the temple of Aesculapius on the island in the Tiber (de Lingua Latina VII, 57). The date of these paintings is not certain. The former, however, is probably connected with the "topographic" paintings of the 2nd century* B.C. *(see p. 52).*

Sculpture

The most important sculptors active in Rome during the 1st century B.C. *were Pasiteles and Arkesilaos. On Pasiteles, his school, and his influence cf.* The Art of Ancient Greece, *pp. 4, 120, 220, and 234. Arkesilaos seems to have been active around the middle of the century.*

Pliny, *N.H.* XXXV, 155-156: The same writer [Marcus Varro] gives high praise to Arkesilaos, the close friend of L. Lucullus, and says that his *proplasmata* [176] were wont to sell at a higher price, even to artists themselves, than the finished works of others; also that the Venus *Genetrix* in the Forum of Caesar was made by him and, owing to the haste with which it had to be dedicated, was set up before it was finished; [Varro also says that] the same artist was hired by Lucullus for one million sesterces [177] to make a statue of Felicitas, but the death of both of them begrudged it completion; and that when the Roman knight Octavius wanted him to make a krater [bowl for mixing wine], he made a model out of plaster for the price of a talent.

Pliny, *N.H.* XXXVI, 41: Varro also gives high praise to Arkesilaos and states that he possessed a work by him representing a lioness and winged

[175] Built on the Esquiline c. 268 B.C. and restored in 54 B.C.
[176] *Proplasmata* = clay or plaster sketch-models.
[177] Perhaps in this case the son of the more famous Lucullus is referred to; the latter died in 56 B.C., and Arkesilaos certainly lived beyond this time because the temple in the Forum of Caesar, for which he made the Venus *Genetrix*, was not dedicated until 46 B.C. The reading "one million sesterces" (about $70,000) is that of Detlefsen.

Cupids playing with her; some of the Cupids, having tied the lioness up, were holding her, others were compelling her to drink from a horn, and still others were providing her with slippers as footwear—all made from one piece of stone.

Pliny (N.H. XXXVI, 33) also mentions a group of "Centaurs carrying Nymphs" by Arkesilaos in the collection of Asinius Pollio.

The names of a few other sculptors of less import are also known.

Pliny, N.H. XXXVI, 41: Varro also says that the artist who made the fourteen figures of Nations which are placed around the theater of Pompey [built c. 55 B.C.] was Coponius.

Pliny, N.H. XXXV, 155: M. Varro records that he knew at Rome an artist by the name of Possis, by whom apples and grapes [178] were made which were so realistic that you could not, simply by looking at them, tell them from the real thing.

Pomponius Porphyrio, *On the Satires of Horace*, ad. Sat. I, 3, 90: "On account of this he knocked from the table with his hands a well-worn dish by Evander." Those who have written about the people in the writings of Horace say that this Evander was an engraver and modeler of statues, for which reason Marcus Antonius brought him from Athens to Alexandria. And being brought from there to Rome among the captives, he made many remarkable works.

Pliny, N.H. XXXVI, 32: There is a Diana [Artemis] by Timotheos [179] in Rome on the Palatine in the sanctuary of Apollo, the statue for which Avianius Evander replaced the head.[180]

If this Avianius Evander is the same as the artist mentioned by Cicero in his letter to Fadius Gallus (see p. 79), he must have been active in Rome in the mid 1st century B.C. and from there have gone to Athens and Alexandria where he was taken prisoner. His restoration of the statue by Timotheos suggests that he is to be classified among the neo-Attic sculptors who specialized in copying and imitating classical Greek statuary and whose works were produced primarily for the Roman art market in the 1st century B.C.

The Artemis of Timotheos was only one of several important Greek cult statues which were transferred to Rome during this century.

178 Probably of wax or terracotta. The section of the *Natural History* in which this passage occurs deals mainly with modelers in clay.

179 A Greek sculptor of the 4th century B.C.; cf. *The Art of Ancient Greece*, pp. 104-5, 196.

180 "Replaced the head" = *caput reposuit;* that is, he either made a new head or replaced the old one after some sort of damage.

Others were an Athena by Euphranor,[181] *an Apollo by Kalamis,*[182] *and a colossal head by Chares of Lindos (the sculptor of the Colossus of Rhodes).*

Pliny, *N.H.* XXXIV, 44: There are also on the Capitoline two much admired heads, which P. Lentulus, the consul [in 57 B.C.] dedicated; one is by Chares, who was mentioned above, and the other is by [Pytho]dikos,[183] who by comparison comes off so badly that he seems the least praiseworthy of artists.

Another important Greek statue in Rome was the Herakles in a tunic which was set up in the Forum.

Pliny, *N.H.* XXXIV, 93: In mentioning statues, there is one that should not be overlooked, even though its sculptor is uncertain, and that is the Hercules *tunicatus* next to the *Rostra,* the only statue in Rome which represents him wearing this type of dress; there is a grim look on his face as he becomes conscious of the moment of death from the tunic.[184] There are three inscriptions on this statue: one says that it is "from the booty taken by the general L. Lucullus"; another says that Lucullus' ward and son dedicated it after authorization by the Senate, and the third says that T. Septimius Sabinus, the curule aedile, restored it from private to public ownership. So great was the contention over this statue and so great was the value attached to it.

Locally made statues achieved less renown, but Cicero does mention a large statue of Jupiter which stood in a prominent spot in Rome. It was set up in 63 B.C. at the behest of a group of Etruscan soothsayers, who were called to Rome following a great storm which had destroyed many public monuments in 65 B.C.

Cicero, *in Catilinam* III, 20: Likewise they [the Etruscan soothsayers] advised them to make a larger image of Jupiter and set it up in a prominent spot facing the rising sun, which was the opposite of the way it had faced before. And they said that they hoped, if this statue, which you see, should look upon the rising of the sun and the Forum and the *Curia,* that those stratagems which secretly worked against the health of the city and the empire would be clarified to the extent that they could be perceived by the Senate and the Roman people. Thereupon those consuls contracted for the setting up of this statue. But such was the slow-

181 Cf. *The Art of Ancient Greece*, pp. 93-4.
182 *Ibid.,* p. 59.
183 The manuscripts preserve only the last five letters of this name. Prodikos is another conjecture.
184 The reference is to the fatal poisoned tunic given to Herakles by Deianeira.

ness of the work that neither by the subsequent consuls nor by us was the work set up before the present day.

Dio Cassius, XLVIII, 14, 5-6, [in 41 B.C. following the sack of Perugia, which had sided with the pro-Antony party in Italy and served as a fortress for L. Antonius]: . . . The city itself, except for the temple of Vulcan and the statue of Juno, was completely consumed by fire. The statue (for chance had somehow preserved it) was brought to Rome because of a vision which Caesar [Octavian] had seen in a dream, and it provided the city [Perugia] with the boon of being allowed to be resettled by people who were willing to do so. . . .

Portraiture

Portraits were another form of art which the connoisseur of the 1st century B.C. collected and studied with avidity. Varro, Asinius Pollio, and Cicero's friend Atticus all made useful contributions to this study.

Pliny, *N.H.* XXXV, 9-11: Nor must we pass over a rather new invention, that of setting up portraits in libraries, if not of gold or silver at least of bronze, of those immortal spirits who speak to us in these places; in fact, even portraits of those whose looks were never modeled are made, and our sense of longing gives birth to faces which have not been recorded, as happens to be the case with Homer. From my point of view at least there is no greater type of felicity than that everyone should always have the desire to know what sort of a person a certain individual was. At Rome this practice was the invention of Asinius Pollio, who, by dedicating a library, was the first to make the works of human genius available to the public. Whether the kings of Alexandria and Pergamon, who competed with one another extensively in founding libraries, began this custom [of setting up portrait statues in libraries] at an earlier time, I cannot easily say. Those who testify that there was once a great love for portraits are Atticus, the friend of Cicero, in the volume he published about them, and Varro, who, by a most benign invention, was able to insert into the fertile output of his volumes seven hundred portraits of people who were in some way illustrious, thereby not allowing human appearances to be forgotten nor the dust of ages to prevail against men; he [Varro] was thus the inventor of a gift envied even by the gods, since he not only conferred immortality but also sent it all over the world, so that the men represented could be present everywhere just like the gods. And he performed this service, moreover, for people he never knew.

Public portrait statues, as in the preceding centuries, continued to be set up in great numbers. Many statues from apparently all periods were destroyed in the storm of 65 B.C. (see above).

Cicero, in Catilinam III, 19: For certainly you still remember how during the consulships of Cotta and Torquatus many things on the Capitoline were struck by lightning; at that time the images of the gods were dislodged, statues of men of earlier times were knocked down, the bronze tables of laws were liquefied, and even the statue of him who founded this city, Romulus, was hit—that statue which you remember was on the Capitoline and represented him as a small boy opening his mouth eagerly to suck milk from the dugs of the wolf.

Portrait statues of most of the important figures in Roman politics of this period were set up at one time or another. Some of the more interesting examples follow.

PORTRAITS OF MARIUS

Plutarch, Life of Marius 2: As far as Marius' looks are concerned, I have seen a stone statue of him at Ravenna in [Cisalpine] Gaul which successfully conveys his reputedly morose and bitter character.

Plutarch, Life of Caesar 6: . . . During his aedileship [65 B.C.] while he was at the peak of his popularity, he [Caesar] secretly had statues made of Marius and Victory, both bearing trophies, which he set up after transporting them to the Capitoline during the night. At daybreak, when people saw these statues—their gold glittering and their exquisite workmanship being manifest (he also made open reference by inscriptions to the successes over the Cimbri)—there was amazement at the daring of him who had set them up (nor was there any doubt as to who it was).[185]

PORTRAITS OF SULLA

Plutarch, Life of Sulla 6: His [Sulla's] struggle with Marius flared up again, gaining a new impetus from the ambition of Bocchos, who, to flatter the Roman people and to please Sulla, set up figures of Victory bearing trophies on the Capitoline and, next to them, a gold figure of Jugurtha being handed over for justice by Sulla himself.

As a young man Caesar had defied Sulla by setting up a statue of Marius; as an older man, he defied public opinion and exercised his own famous clemency by restoring a statue of Sulla.

Suetonius, The Divine Julius LXXV, 4: Finally, toward the end of his life, he gave permission for all those whom he had not yet pardoned to return to Italy and allowed them to hold magistracies and military com-

[185] Marius had married Caesar's aunt, and hence Caesar had a certain affection for the Marian party. Since the faction controlled by the followers of Sulla was in power in Rome at this time, it was risky to set up statues of Marius.

mands; and he even restored statues of Lucius Sulla and Pompey which had been thrown down by the populace.

PORTRAITS OF CAESAR (SEE ALSO P. 86)

Dio Cassius XLIII, 14, 6: [On Caesar's return from Africa the Senate decreed] . . . that a certain chariot of his should be set up on the Capitoline opposite the statue of Jupiter and that a bronze statue of him, striding over an image of "the inhabited world" [*oikoumenē*], should be set up, with an inscription saying that he was a demigod.

Dio Cassius XLIII, 45, 3 [After Caesar's victory over Sextus Pompeius in Spain in 45 B.C.]: They then decided that a statue of him in ivory, and later an entire chariot, should be sent into the Circus along with the images of the gods. They set up another statue of him in the temple of Quirinus, adding to it an inscription which read "to the unconquered god," and still another in Rome on the Capitoline next to those of the former kings.

Pliny, *N.H.* XXXIV, 18: In the old days they used to set up statues of people wearing just a toga. They also liked to set up nude figures holding spears, figures which are modeled on the statues of ephebes in Greek gymnasia and which are called "Achilles." The Greek custom is to cover nothing, whereas the Roman custom is to add a military breastplate. In fact, the dictator Caesar permitted a statue of himself wearing a cuirass to be dedicated in the Forum.

After Caesar's death the belief that he had been deified and placed among the stars was fostered by Octavian, who set up a statue of him in Rome which would convey the deification theme.

Dio Cassius XLV, 7, 1: When, however, throughout those days a certain star appeared, moving from north to west, some called it a comet and said that it presaged the sort of things which usually followed, but many did not believe this, and associated it with Caesar, holding that he had transcended death and been placed among the stars; so, taking courage, he [Octavian] set up a bronze statue of him, with a star above its head, in the temple of Venus.

Caesar's assassins, Brutus and Cassius, were not completely without honors either.

Dio Cassius XLVII, 20, 4: The Athenians gave them a glowing reception. For, although they were honored by almost everyone for the deeds which they had done, the Athenians voted bronze statues in their honor, which were set up next to those of Harmodios and Aristogeiton [the

tyrant-slayers], thus implying that they [Brutus and Cassius] had emulated them.[186]

CLEOPATRA AND ANTONY

Appian, *Civil Wars* II, 102: [Caesar] built a temple to Venus *Genetrix*, as he had vowed when he was about to go into battle at Pharsalos . . . and next to the goddess he placed the beautiful portrait of Cleopatra, which stands there even now.

Dio Cassius L, 5, 3: [Antony] was represented along with her in paintings and by modeled statues, he claiming that he was Osiris and Dionysos and she that she was Selene and Isis.

Cf. also Dio Cassius XLIX, 18, 6, where Octavian is said to have set up portraits, presumably of Antony, in the temple of Concord at the time of their temporary reconciliation in 35 B.C.

OCTAVIAN

Appian, *Civil Wars* V, 130: From the honors which were voted to him, he accepted a triumph . . . and a gold statue, representing him dressed as he was when he entered the city, was set up on a column in the Forum, with prows of the [captured] ships placed all around the column. The portrait statue which stood there bore the inscription: "After prolonged strife he established peace on land and on sea."

The use of portrait statues by Roman politicians for personal glorification, a practice evident in several of the preceding passages, was, as one might expect, carried to a ruthless and sometimes ridiculous extreme by Verres in Sicily.

Cicero, *Verr.* II, 2, 154: There was an arch set up by him [Verres] in the forum of Syracuse, upon which stood a nude figure of his son and also a statue of Verres himself on horseback looking out over the province which he had denuded. In addition, there were statues of him in every location, a fact which seemed to demonstrate that he was able to set up in Syracuse just about as many statues as he took away. In Rome too we see on the bases of statues to him in large letters: "Given by the federation of Sicily."

Cicero, *Verr.* II, 2, 50: What is more, because in the senate house—the place which they call the *Bouleutērion* and which is among them a place of great honor and renown, the place in fact where there is a bronze

[186] The statues of Harmodios and Aristogeiton, who slew the Athenian tyrant Hippias, were revered as symbols of democracy by the Athenians; on these statues cf. *The Art of Ancient Greece*, pp. 41, 43.

statue of M. Marcellus (who preserved the building and restored it to the Syracusans when, by the law of war and victory, he might have torn it apart)—they were required to set up a gilded statue of Verres and another of his son, because of this I say, at least while the memory of that man remained, the Syracusan senate was not able to meet in the senate house without tears and groaning.

Cicero also related that on one occasion Verres compelled the Sicilian censors to collect two million sesterces to pay for some statues of himself (cf. Verr. II, 2, 137-141).
 Clipei, portrait shields, which have been discussed earlier (see pp. 22 and 56) continued to be made in the 1st century B.C. *Pliny offers his own view on the origin of their name.*

Pliny, N.H. XXXV, 13: After him [Appius Claudius; see p. 22] M. Aemilius [Lepidus], who was the colleague of Quintus Lutatius in the consulship [78 B.C.], set up portrait shields (not only in the *Basilica Aemilia* [in the Forum] but also in his own house) for which there was also a Mars-inspired prototype. For on these shields, which were of the type used in the war at Troy, there were portraits, whence their name *clupei*, which is not derived, as the perverse subtlety of linguistic scholars would like us to believe, from the word meaning "be famous" [*clueo*].[187] It is a source of great virile courage that the face of a man who once used a shield should be put upon it.

Other portrait statues mentioned briefly in the sources: An equestrian statue of Sulla before the Rostra *in Rome (Appian,* Civil Wars *I, 97); a funeral portrait of Sulla made out of spices (Plutarch,* Life of Sulla *38); a statue of the poet L. Accius (c. 170-84* B.C.*) in the temple of the Muses in Rome (Pliny, N.H. XXXIV, 19); a statue in Rome of the praetor (85* B.C.*) Marius Gratidianus (Pliny, N.H. XXXIV, 27); statues on the Capitoline and Palatine of the aedile (74* B.C.*) M. Seius (Pliny, N.H. XVIII, 16); a gilded statue of Cicero set up by the people of Capua (Cicero, in Pisonem XI, 25); portraits of Gaius Marcellus, praetor in 99* B.C.*, and his ancestors at Tyndaris in Sicily (Cicero, Verr. II, 4, 86); an equestrian statue of Octavian (Velleius Paterculus II, 61, 3); statues of L. Antonius, Marc Antony's brother (Cicero, Philippics VI, 12-15).*
 In a letter written to Atticus in 50 B.C. *Cicero expresses amusement at the fact that his contemporary Q. Caecilius Metellus Scipio, reputedly a connoisseur of sculpture, had had the name of his great-grandfather Scipio Nasica Serapio (consul in 138* B.C.*) inscribed on three statues which in fact really represented Scipio Africanus the younger (Cicero, ad Att. VI, 1, 17).*

187 The word in fact may be of Etruscan origin. Pliny seems to be attempting to derive it from the Greek *glypho,* "carve."

2

The
Roman Empire
from 27 B.C. to 192 A.D.

THE JULIO-CLAUDIAN EMPERORS, 27 B.C.-A.D. 68

After the battle of Actium Octavian pursued Antony and Cleopatra to Egypt, where, for a short time, the remnants of their forces offered him feeble resistance. When their subsequent suicides brought the civil war to an end, he converted Egypt into a Roman province and made a triumphant return to Rome in 29 B.C. Since the time of the Gracchi, over a century before, Rome had been involved in almost unceasing warfare. The institutions of the Republic had lost all efficiency, and there is little doubt that Octavian could now have imposed upon the Romans, at least for a time, any sort of government he chose, including a military dictatorship. That he forswore the more obvious forms of autocracy in favor of a complex constitutional principate based on the institutions of the Republic must have seemed surprising to those who had followed his early career in the Second Triumvirate. But it seems to be a fact that, as he matured, Octavian developed into a sincere if highly pragmatic political idealist, who recognized Rome's need for peace, efficient government, economic rehabilitation, and a sense of moral order after a century of chaos. In the four decades following his return from Egypt he answered all these needs and filled the reconstructed city with monuments which symbolized his achievement.

In 27 B.C. Octavian went before the Senate and offered to lay down all the powers which he had held as one of the triumvirs. The Senate refused to accept his resignation and instead encouraged him to continue as consul, gave him proconsular *imperium* for ten years in what were, from a military standpoint, the most important provinces, and conferred upon him the honorific title "Augustus." The name seems to have implied that he possessed divinely based authority to inaugurate a new state and the personal majesty necessary for such a task.

The essence of the new Augustan government was that the institutions of the Republic should be preserved but that the executive power of the magistracies should be conferred, by consent of the Senate and the popular assemblies, upon Augustus personally or upon men whom he sanctioned. While it may be that Augustus' ultimate source of power at this early stage lay in the legions which he had commanded during the civil wars, it is also clear that he genuinely preferred a formalized constitutional government to arbitrary military rule and that he took his constitutionally granted offices seriously. From 27 to 23 B.C. he personally held the consulship. After a serious illness in 23 B.C., he instituted a "second settlement" of the government whereby he became more of a paternal supervisor than an active participant. He gave up holding the consulship regularly and received instead *tribunicia potestas*, the tribune's power to convene the Senate and to introduce and veto legislation in the popular assemblies. He also was given the right to nominate candidates for the magistracies and to make recommendations to the Senate. His proconsular *imperium* in the "imperial" provinces—principally Spain, Gaul, Syria, and Egypt—was renewed for a five-year period and continued to be renewed for five- or ten-year periods for the rest of his life. In 12 B.C. Augustus also took over the office of *Pontifex Maximus* which made him the religious leader of the state and rounded out the scope of his authorities. His influence, direct or indirect, was now felt in every area of Roman political and social life. *Princeps*, "first citizen," was the title which he himself most favored to express his complex constitutional position. The fact that he was also the *imperator* (from which "emperor" is derived) by virtue of his control over all the military forces of the empire received less emphasis.

The membership of the Senate and the qualifications for such membership had been revised by Augustus in 29-28 B.C., and in this revised form it continued to be the most important governing body in Rome. It administered its own "senatorial provinces" [1] and was normally consulted by the emperor on all important matters of state.

The power to make treaties and to conduct foreign policy was left completely to Augustus. He was on the whole more interested in internal rebuilding than in foreign conquests, and, although his generals fought a number of vigorous campaigns, the history of his reign does not hinge on great military achievements. It was, in fact, by skilled diplomacy rather than force that Augustus made peace with Parthia and recovered the standards which had been lost by the Roman legions under Crassus (in 53 B.C.). Spain was pacified in the west, while in the east Judaea and Galatia came under direct control of Roman governors. The two most active fronts were on the Rhine and in Pannonia (Austria and Hungary) which had been conquered between 12 and 9 B.C. by the Romans under Tiberius, stepson of the emperor. German tribes continually crossed the Rhine to pillage Gaul, and Tiberius, at first with his brother Drusus (died 9 B.C.) and later with his nephew "Germanicus," waged what were generally successful although inconclusive campaigns against them. Some of their success was marred in A.D. 9 when P. Quintilius Varus, the inept legate of the army on the Rhine, led an expedition against the German general Arminius and was annihilated. Tiberius and Germanicus were also called upon to quell a serious revolt which broke out in Pannonia in A.D. 6.

Of far more lasting value, however, was the cultural efflorescence at Rome which the "Augustan Peace" made possible. Augustus recognized the value of the arts in promoting the themes of his administration—peace, abundance, devotion to duty, and reverence for tradition. Some of the greatest works of Roman literature—the *Aeneid* and *Georgics* of Vergil, the history of Livy, and many of the poems of Horace—were written with the encouragement of Augustus and to some extent subsidized by him. Gaius Maecenas, a wealthy nobleman of Etruscan descent who was a close friend of the emperor, informally played the role of cultural minister and did much to encourage new talents. The fertility of the Augustan period in literature is paralleled in the visual arts by the monuments of the great Augustan building program which will be described in subsequent passages.

The most difficult, perplexing, and potentially dangerous problem of Augustus' reign was the question of succession. He seems to have resolved at an early stage that a member of his own family selected by himself and approved by the Senate should succeed him. The candidate first designated for the succession was M. Marcellus, the son of Augustus' sister Octavia by her first husband. When Marcellus died prematurely in 23 B.C. the imperial favor seemed to pass to Marcus Agrippa who had been compelled to marry Augustus' daughter and only child, the notoriously profligate Julia. There was also an understanding that the line of succession would eventually go to Agrippa's two infant sons by Julia, Gaius and Lucius (born in 20 and 17 B.C. respectively). When Agrippa's death in 12 B.C. upset this plan, Augustus' favor turned for a time to his stepsons, Drusus and Tiberius, the children of his second wife Livia by an earlier marriage. When Drusus died in 9 B.C., the hopes of Tiberius seemed bright, especially in 6 B.C. when he was given *tribunicia potestas*. But as Gaius and Lucius grew older, Augustus' favor swung back to them, to the extent, in fact, that Tiberius was obliged to withdraw as an unofficial but

[1] By a special *maius imperium* Augustus could, if he chose, interfere in the affairs of the senatorial provinces, but he very seldom did.

resentful exile to the island of Rhodes. Both Lucius and Gaius, however, died prematurely, the former in A.D. 2 and the latter in A.D. 4, and by a process of elimination the succession veered back again to Tiberius. After the death of Gaius, Augustus adopted Tiberius and restored the tribune's power to him. In A.D. 13 Tiberius became virtual co-regent and upon the death of Augustus in AD. 14 he became the second emperor. Augustus was officially deified by the Senate, and the cult of *Divus Augustus*, the divine Augustus, was formally inaugurated on the Capitoline. The apotheosis of the emperor was a practice which had oriental prototypes and served not only as an expression of respect for the deceased but also as a way of putting the final stamp of legitimacy on the chosen successor.

In spite of the obviously sensational anecdotes of Suetonius and the tendentious account of Tacitus, Tiberius seems to have been one of the most capable and dedicated men ever to hold the principate. The reputedly morose side of his character is probably to be explained as a reaction to Augustus' off-and-on treatment of him during his early career. The efficiency of his administration in economic and foreign affairs, however, was eclipsed by a series of domestic quarrels and plots which kept Tiberius' private life in chaos. The first of these occurred when Germanicus, the son of Tiberius' brother Drusus, died in A.D. 19 while traveling in the eastern provinces. Germanicus had married Agrippina, the daughter of Agrippa and Julia, and had been designated as Tiberius' successor by Augustus. As an affable personality, a gifted general, and husband of Augustus' granddaughter, Germanicus was popular in Rome and therefore probably a source of anxiety to the aging Livia, who seems always to have fought for the Claudian branch of the family against the Julian. Rumors to the effect that Germanicus had been poisoned by agents of Tiberius and Livia, unproven and probably untrue, were not discouraged by Agrippina and continued to circulate among those who favored the Julian side of the family. A second and much worse crisis in Tiberius' reign was fostered by L. Aelius Sejanus, the commander of the Praetorian Guard,[2] who had won his way into the favor of the emperor and apparently aspired to the principate himself. Sejanus seems to have set about to eliminate rivals for the imperial favor by first poisoning Tiberius' own son Drusus, and then by arousing the emperor's suspicions against Agrippina and her children, whom Tiberius eventually banished. In A.D. 26 Sejanus managed to convince the emperor that he would find some peace of mind by retiring for an indefinite period to the imperial villa on the island of Capri. With Tiberius out of Rome, Sejanus felt he could concentrate enough power in his own hands either to succeed Tiberius or perhaps even to overthrow him. But these intrigues were eventually revealed to Tiberius, and a skillfully organized counterplot in A.D. 31 resulted in the execution of both Sejanus and a number of genuine or assumed confederates. Tiberius' last six years on Capri seem to have been characterized by physical illness and senile paranoia. In A.D. 33 he effected the deaths of Agrippina and her two eldest sons but spared a younger son Gaius, who continued to live with the emperor at Capri. Gaius, better known as "Caligula," [3] had won the favor of Macro, the new commander of the Praetorian Guard, and when Tiberius finally died in A.D. 37, Macro's influence induced the Senate to confirm Gaius as emperor at the age of twenty-five.

[2] The Praetorian or Palace Guard was a body of troops stationed just outside Rome which was responsible for the safety of the emperor. It consisted originally of nine cohorts (nine thousand men) and was normally commanded by two *praefecti*, although Sejanus held this command alone.

[3] *Caligula* is the diminutive of *caliga*, a soldier's boot. "Little boot" was the name given to Gaius by the troops of his father Germanicus.

For a few months it seemed that Caligula might be a model emperor; but an insane streak, perhaps the result of his grim childhood, suddenly revealed itself. He began to squander the imperial treasury recklessly, to construct megalomaniac monuments, and to bring charges of treason (whether founded or unfounded is difficult to say) against some of his closest associates. He executed Macro and Tiberius Gemellus, grandson of the Emperor Tiberius, as well as some prominent senators, and produced a chain reaction of conspiracies and persecutions which so alienated any support he might have had that in A.D. 41 a tribune of the Praetorian Guard assassinated him in his palace on the Palatine.

Caligula was succeeded by Claudius, brother of Germanicus and uncle of Caligula. Claudius suffered from some congenital malady which caused him to stammer and at times made his mind wander. His predecessors seem to have viewed him as an amusing imbecile, and until the time when the Praetorian Guard proclaimed him emperor, no one ever seems to have taken seriously the possibility of his ascending to the office. Yet when not afflicted by his illness, Claudius demonstrated a scholarly intelligence, surprising ability as an orator, and a painstaking devotion to the duties of his office. He was, on the whole, not ineffective as an emperor, although much of the credit for his administrative success undoubtedly belongs to his unscrupulous but able freedmen, Narcissus, Pallas, and Callistus. The greatest achievement of Claudius' foreign policy was the conquest of Britain, during which the emperor himself took personal command of the army for a time. He also added Thrace and Mauretania (Morocco and part of Algeria) to the list of Roman provinces.

Claudius' downfall came not from administrative incompetence but from his unfortunate choice of wives. In A.D. 48 Messalina, his beautiful but openly profligate first wife, conspired with her paramour to overthrow Claudius and had to be put to death. The emperor then married Agrippina the younger, who inherited her mother's titanic and ambitious nature. Agrippina prevailed upon Claudius to pass over Britannicus, his own son by Messalina, and to designate Nero, Agrippina's son by an earlier marriage, for the succession. Claudius died in A.D. 54 (poisoned, some said, by Agrippina to prevent him from reversing his decision on the succession), and Nero, aged sixteen, became emperor.

The young emperor was by nature an aesthete and dilettante, and was easily swayed by the will of others. The early years of his reign were marked by a furious struggle for influence over him between Agrippina on the one hand and Burrus, the Praetorian prefect, and Seneca, Nero's tutor, on the other. When Nero's affections seemed to be turning away from Agrippina, she reacted by showing a new fondness for Britannicus, who, she hinted, had a more rightful claim to be emperor. Britannicus was immediately poisoned (A.D. 55). Three years later Agrippina again tried to assert her influence over her son by denouncing his paramour, Poppaea Sabina, and urging the emperor to be faithful to his wife Octavia, daughter of Claudius and Messalina. Nero retaliated against this interference by having his mother murdered by the admiral of the fleet at Naples. Tacitus' brilliant description of the murder (*Annals* XIV, 1-9) is too good to summarize. For the next few years Nero indulged his dilettantism while Burrus and Seneca administered the empire. The death of Burrus in A.D. 62, however, and the forced retirement of Seneca shortly thereafter, marked the end of this era of restraint and the beginning of a new and riotous period in which Nero's worst qualities were exploited by a new Praetorian prefect, Tigellinus, a man more in the tradition of Sejanus than of Burrus. While Nero diverted himself by giving operatic performances, which culminated in a grand tour through Greece in A.D. 67-68, Tigellinus attempted to replenish the dwindling imperial treasury by instituting a series

of prosecutions for treason, the victims of which were mostly prominent and wealthy Romans whose fortunes could be confiscated. The lower classes also found cause to hate Nero after the great fire of A.D. 64 (*vide infra*), which some thought Nero was responsible for, and the subsequent cruel persecution of the Christians in Rome, whom the emperor used as scapegoats. In A.D. 65 a conspiracy to overthrow Nero and to raise a Roman noble of ancient lineage, C. Calpurnius Piso, to the principate was exposed. The executions and forced suicides which followed claimed among their victims the Stoic philosopher, dramatist, and former imperial tutor, Seneca; the epic poet Lucan; and the emperor's *arbiter elegantiae*, Petronius (*vide infra*).

The provincial and foreign affairs of the empire during Nero's reign were essentially successful, thanks to the efforts of competent governors and generals. But when he forced the suicide in A.D. 67 of his foremost general, Gnaeus Domitius Corbulo, who had pacified the eastern frontier of the empire, the regional governors began to abandon him. The first to revolt was C. Julius Vindex, a governor of one of the regions of Gaul. Shortly thereafter Servius Galba, the governor of Nearer Spain, declared himself at the disposal of the Roman people. Vindex was suppressed by the legions of Verginius Rufus, governor of Upper Germany, but the tide of disaffection had already spread to Rome, where the Praetorian Guard abandoned Nero and proclaimed Galba emperor. The Senate quickly condemned Nero to death by cudgeling, and the emperor, confused, in panic, and out of touch with reality, only escaped execution by a reluctant suicide.

Augustus: 27 B.C.-A.D. 14

The Fruits of Actium

In the period between the battle of Actium and the time when he first assumed the title of Augustus and established the Empire, Octavian commissioned a number of buildings and statues to commemorate his triumph.

Dio Cassius LI, 22, 1-3: When he completed this [his triumphal celebration] he dedicated the temple of Minerva called the *Chalcidicum* [4] and the *Curia Iulia,* which was in honor of his father [Julius Caesar]. In this last building he set up the image of Victory which still exists, indicating, as seems likely, that through her help he had gotten control of the empire. The Victory belonged to the Tarentines, and after being taken from Tarentum to Rome, was set up in the council chamber and decorated with spoils from Egypt. This was also the case with the shrine of Julius Caesar which was consecrated at that time [29 B.C.]. For many of the spoils were also set up in this shrine, and likewise others were offered to Jupiter *Capitolinus* and to Juno and to Minerva; on the other hand, all the objects which either seemed to have been once set up there [5] as votives or which were still actually in place were by decree

[4] A *Chalcidicum* was a monumental porch, sometimes having a courtyard attached to it, which led to a larger building, usually a basilica. The *Chalcidicum* of Minerva was perhaps a shrine of this form attached to the *Curia Iulia.*

[5] The reference presumably is to the Temple of the Capitoline triad.

taken down at this time on the grounds that they were polluted. And thus Cleopatra, even though she had been defeated and captured, was accorded glory, because her personal ornaments now lie in our temples and a golden statue of her may be seen in the temple of Venus.

Another fruit of the victory at Actium was the founding of the city of Nikopolis ("City of Victory") on the peninsula opposite Actium.

Dio Cassius LI, 1, 2-3: [After the battle Augustus dedicated some of Antony's defeated ships to Actian Apollo] and built a larger temple. . . . He also founded a city on the site of his camp by gathering together a part of the surrounding population and by transplanting others, and he gave it the name Nikopolis. Moreover, on the spot where his tent had stood he laid a foundation with squared stone blocks and decorated it with captured prows, and on this base he established an open-air shrine to Apollo.[6]

Suetonius, *The Divine Augustus* XCVI, 2: At Actium as he was descending to the battle he came upon an ass and its driver. The name of the man was Eutychus ["Good Luck"] and of the beast Nicon ["Victor"]. When he became the victor he set up bronze images of both of them in the sacred shrine into which the site of his camp had been converted.

The Augustan Building Program [7]

Suetonius, *The Divine Augustus* XXVIII, 3 ff.: He [Augustus] so improved the city, which had previously lacked the trappings which befitted the dignity of its empire and had been subject to floods and fires, that his boast to have "left in marble that which he found made of brick" was quite justified. And he made it safe for posterity, at least to the degree that it is possible for human reason to have foresight in such matters.

He built many public works, among which the following are conspicuous: his forum with the temple of Mars *Ultor,* the temple of Apollo on the Palatine, the temple of Jupiter *Tonans* on the Capitoline. The reason for constructing his forum was the greatness of the population and the number of judicial cases; these made a third forum necessary,

[6] Traces of emplacements for such prows as well as a dedicatory inscription can still be seen at Nikopolis.

[7] A complete archaeological commentary on the remains of all the monuments mentioned in the passages which follow is beyond the scope of this book. For a summation of all the evidence on the buildings in Rome which are mentioned in this chapter and those which follow cf. S. B. Platner, T. Ashby, *A Topographical Dictionary of Ancient Rome,* and E. Nash, *Pictorial Dictionary of Ancient Rome.* The literary and archaeological evidence for Augustan and later imperial temples is in some cases supplemented by numismatic evidence; cf. D. F. Brown, *Temples of Rome as Roman Coin Types (Numismatic Notes and Monographs,* no. 90, New York 1940).

since the two already in existence were not sufficient.[8] For this reason it was opened for public business rather quickly, before, in fact, the temple of Mars was finished, and the order was given that public trials and the selection of jurors by lot should be held in it away from other affairs. He had vowed to build the temple of Mars at the battle of Philippi, which he had undertaken for the sake of avenging his father. He ordained therefore that the Senate should consult here concerning wars and triumphs, that the escort of those who were about to set out for the provinces with *imperium* should begin from it, and that those who returned as victors should bring the insignias of their triumphs to it. He built the temple of Apollo on that part of his house on the Palatine which the soothsayers declared was desired by the god since it had been hit by lightning. To it he added porticoes with a Greek and Latin library, in which, as he grew older, he often convened the Senate and worked at revising the divisions of jurors. He consecrated the temple of Jupiter *Tonans* because he had escaped danger during a night march on his Cantabrian expedition when a bolt of lightning flashed by his litter and killed a servant who was going before him with a torch. There were also certain works which he constructed in the name of others—for instance, the names of his nephew, his wife, and his sister—such as the portico and basilica of Lucius and Gaius, the porticoes of Livia and Octavia, and the theater of Marcellus. But he also often exhorted other leading citizens to adorn the city, according to the resources of each of them, either by building new monuments or by restoring and improving old ones. There were many such monuments, constructed by many people—as, for example, the temple of Hercules and the Muses constructed by Marcius Philippus [29 B.C.], the temple of Diana by Lucius Cornificius, the Atrium of Libertas by Asinius Pollio, the temple of Saturn by Munatius Plancus [42 B.C.],[9] the theater by Cornelius Balbus [13 B.C.], the amphitheater by Statilius Taurus [29 B.C.], and many outstanding structures by Marcus Agrippa.

He divided the area of this city into regions and districts,[10] and arranged that the former should be supervised by magistrates chosen by lot annually, while the latter should have *magistri* elected by the people of each neighborhood. To combat fires he created night alarm posts manned by watchmen; to control floods he widened and cleared the channel of the Tiber which had been filled for some time with rubble and con-

8 The two forums already in existence were the *Forum Romanum* (the Forum) and the *Forum Iulium.* Augustus' own forum was the third. The plan of Augustus' forum and substantial remains of the temple of Mars *Ultor* are still visible in Rome. Cf. Nash, *Pictorial Dictionary*, I, 401-10. According to Dio Cassius LIV, 8, 3, Augustus built another temple of Mars *Ultor* on the Capitoline.

9 The temples mentioned here were all older temples which were restored in the time of Augustus.

10 The *regiones* and *vici* were formal divisions of Rome resembling the boroughs and wards of a modern city.

gested by the projection of buildings into it. And in order that the city could be reached more easily from every direction, he personally took on the task of rebuilding the *Via Flaminia* as far as Ariminum [Rimini], and he assigned the task of paving the rest of the roads to men who had celebrated triumphs and could pay the cost with money from the sale of their military booty.

He restored sacred temples which had collapsed through age or had been consumed by fire, and he adorned both these and others with very costly donations, as was the case with the cella of Jupiter *Capitolinus* where he offered as a single donation sixteen thousand pounds of gold and also gems and pearls worth fifty million sesterces.

Among the most impressive of the monuments which Suetonius itemizes in the preceding passage were the complura et egregia *buildings of Marcus Agrippa. Dio Cassius elaborates on these.*

Dio Cassius LIII, 27, 1-3: . . . In the meantime Agrippa adorned the city at his own expense. At one time he erected in honor of his naval victories the stoa called the "Stoa of Poseidon," the splendor of which he enhanced by adding to it a painting representing the Argonauts; and at another time he constructed the "Laconian" baths. He called the gymnasium [11] "Laconian" because at that time the Lacedaemonians were the people best known for exercising and anointing themselves with oil. He also completed the building which is called the Pantheon.[12] It is perhaps given this name because, among the statues which are set up in it there are images of many gods, including one of Ares [Mars] and one of Aphrodite [Venus], or, as I believe, it may be so called because, being round and domed, it resembles the heavens.[13] It was Agrippa's wish to set up a statue of Augustus there and to name the building after him. But when Augustus would accept neither honor, he [Agrippa] set up a statue of the former Caesar [Julius Caesar] there and put statues of Augustus [14] and himself in the *pronaos*.

[11] An ancient Roman bathing establishment consisted of a series of rooms heated to different temperatures which served as steam baths (like a modern Turkish bath). The larger baths also contained swimming pools and an open court (or courts) surrounded by porticoes which served as a gymnasium in the ancient sense of the word—that is, a place where one stripped and exercised, and where reading and lecture rooms were also available. *Laconicum* was the general term for a sweat bath.

[12] This structure burned down in A.D. 80; see p. 157. The present Pantheon was built on the site of Agrippa's building by Hadrian, who reproduced Agrippa's original dedicatory inscription on the porch of the new building. Cf. Nash, *Pictorial Dictionary,* II, 170, fig. 895.

[13] "Round and domed" = *tholoeides,* "like a *tholos,*" which is the generic term in Greek for all round buildings. Dio Cassius seems to have assumed that Agrippa's Pantheon (which Dio, living in the late 2nd and early 3rd centuries A.D., never would have seen) had the same shape as the Hadrianic Pantheon.

[14] According to Dio Cassius LIV, 1, 1, this statue held a spear in its hand; in 22 B.C. a lightning bolt dislodged the spear.

Pliny elaborates on the Pantheon and the baths of Agrippa.

Pliny, N.H. XXXIV, 13: The capitals on the columns in the Pantheon built by Marcus Agrippa are of Syracusan bronze.

Pliny, N.H. XXXVI, 38: Diogenes the Athenian did the decorations on the Pantheon of Agrippa. Among the columns of this temple there are Caryatids which are praised as are few other works, and likewise the statues placed in the pediment,[15] which, however, because of the height of the place in which they are situated, are less well known.

Pliny, N.H. XXXVI, 189: Mosaic floors had already begun during the time of Sulla; at least there exists today a floor made of tiny inlaid pieces which he had made for the sanctuary of Fortuna at Praeneste.[16] Afterward these pavements were driven from the floor to vaulted ceilings and began to be made of glass.[17] This too is a rather recent invention. At any rate Agrippa, in the baths which he built at Rome, painted the terracotta work in the hot-rooms in encaustic and decorated the remaining parts with white paint; no doubt he would have made vaulted ceilings inlaid with glass if this technique had already been invented or if it had been adapted from the walls of the stage of Scaurus' theater, which I have mentioned [see pp. 81, 84], for use on ceilings.

Among other architectural projects undertaken by Agrippa were the building of the Diribitorium *(finished in 7 B.C.) where ballots were sorted, and the decoration of the* Saepta *(26 B.C.), an enclosure in the Campus Martius in which the* Comitia Tributa *voted.*[18]

Dio Cassius LV, 8, 3-4: The *Campus Agrippae*,[19] except for the portico, and the *Diribitorium* were opened to the public by Augustus. This building (it was the largest structure with a single roof ever made, but the roof is now completely destroyed,[20] and because it could not be reconstructed, the building is open to the sky) Agrippa had left still in the process of construction, and it was completed at this time [7 B.C.]. On the other hand, the portico in the *Campus [Agrippae]*, which was being built by Agrippa's sister Polla, who also undertook to decorate the racecourse, had not yet been completed.

15 "In the pediment" = *in fastigio*. The phrase could also mean "on the roof" as it certainly does when used in connection with early Roman temples; but by the time of Augustus pedimental sculptures on the Greek model were also used.

16 Pliny may be referring to the famous Barberini Mosaic from the temple of Fortuna at Praeneste. Cf. G. Gullini, *I Mosaici di Palestrina* (Rome 1956).

17 Reading *vitro* as restored by Mayhoff.

18 On the scant remains of these structures cf. Nash, *Pictorial Dictionary*, II, 291-93.

19 A section of the *Campus Martius*.

20 This destruction also occurred during the fire in the time of Titus; cf. p. 157; Dio Cassius LXVI. 24. 2.

Dio Cassius LIII, 23, 1-2: [In 26 B.C.] . . . Agrippa dedicated the building called the *Saepta*. For Agrippa, rather than promising to undertake the repair of a road, adorned this structure, which was in the *Campus Martius* and had been built and equipped with surrounding porticoes by Lepidus for the meetings of the *Comitia Tributa,* with stone stelae and with paintings. Agrippa called this complex the *Saepta Iulia* in honor of Augustus.

Still another of Agrippa's great achievements was the building of the Aqua Virgo, *an aqueduct which entered the city near the Pincio hill and supplied water for his baths.*

Pliny, *N.H.* XXXVI, 121: During his aedileship [21] Agrippa added the *Aqua Virgo,* repaired the other channels, and made seven hundred reservoirs, as well as five hundred fountains, and 130 distribution towers, many of which were decorated with refined magnificence; on these structures he placed three hundred bronze and marble statues and four hundred marble columns. He accomplished all these works within the space of one year.

The following passages shed further light on some of the works listed in Suetonius' summary of the Augustan building program.

THE FORUM OF AUGUSTUS

Pliny, *N.H.* XXXIV, 48: There is also a tradition that statues were commonly used to support a tent of Alexander the Great; two of these are now dedicated in front of the temple of Mars *Ultor,* and the others before the *Regia.*

THE THEATER OF MARCELLUS (DEDICATED 13 B.C.) [22]

Dio Cassius XLIII, 49, 2: "Desiring to build a theater, as Pompey had before him, he [Julius Caesar] laid the foundations for one but did not complete it. Afterward Augustus, who did finish it, named the theater after his nephew Marcus Marcellus. But Caesar took the blame for tearing down the houses and the temples in that area, and also for burning the images which, with a few exceptions, were of wood. . . .

THE TEMPLE OF JUPITER TONANS (22 B.C.)

Dio Cassius LIV, 4, 2-4: He also dedicated the temple of Jupiter who is called "the Thunderer." Concerning this temple two anecdotes have

[21] Agrippa's aedileship occurred in 33 B.C. According to Dio Cassius, however, the *Aqua Virgo* was not completed until 19 B.C.; cf. Dio Cassius LIV, 11, 6-7.

[22] Portions of the theater are still very well preserved. Cf. Nash, *Pictorial Dictionary,* II, 418-23.

been handed down. One is that during the dedicatory ritual peals of thunder occurred; the other is that afterward the following dream came to Augustus: It seemed that the Roman people were approaching Jupiter *Tonans* and worshiping him, partly because of the strangeness of his name and of his appearance, partly because his temple had been founded by Augustus, but mostly because his was the first temple which people going up the Capitoline came to; it seemed, moreover, that the Jupiter in the great temple [the Capitolium] was angry at being made to take second place; in reply to this Augustus claims to have told that Jupiter that he [Jupiter *Optimus Maximus*] had Jupiter *Tonans* as his watchman and vanguard; and when the next day came, he attached an alarm bell [to Jupiter *Tonans*], thereby affirming his dream. For those who guard communities at night carry a bell, so as to be able to give the alarm whenever the need arises.

 The Portico of Octavia mentioned by Suetonius was really a large complex of buildings which replaced the earlier Porticus Metelli *and surrounded the temples of Jupiter* Stator *and Juno* Regina *which had been built by Metellus after 148* B.C. *(see p. 45). The Porticus Octaviae contained a library in which the Senate sometimes convened and which hence was called the* Curia Octavia *(cf. Dio Cassius XLIX, 43, 8; LV, 8, 1), and also many important works of art.*[23] *Dio Cassius (XLIX, 43, 8) relates that the* Porticus Octaviae *was completed as early as 33* B.C., *but Plutarch (Life of Marcellus 30) claims it was not completed until after the death of Marcellus in 23* B.C.

 The dedication of the Portico of Livia was assigned by Augustus to Tiberius, while the latter was consul in 7 B.C. *(Dio Cassius LV, 8, 2).*

 The fully developed triumphal arch was another architectural product of the Augustan era.[24]

Dio Cassius LI, 19, 1: [When Octavian returned from Egypt in 30 B.C. the Romans] granted him an arch decorated with trophies at Brindisi and another arch in the Forum in Rome.

Dio Cassius LV, 2, 3: [Upon the death of Drusus, the brother of Tiberius, in 9 B.C., Augustus granted in his memory] these honors: statues, an arch, and a cenotaph on the banks of the Rhine itself.

Suetonius, *The Divine Claudius* **I, 3-4:** In addition to many other honors the Senate voted him [Drusus] a marble arch decorated with trophies on the Appian Way. . . .

 [23] Cf. *The Art of Ancient Greece,* geographical index, s.v. "Rome."
 [24] Simple arches commemorating triumphal processions were erected during the Republic at least as early as the beginning of the 2nd century B.C. (cf. p. 43). The arch of Augustus set up in the Forum was originally of this type and was later remodeled and enlarged by having two smaller side arches added to the original span. On the Augustan arch cf. H. Kähler, *The Art of Rome and her Empire* (New York 1963), pp. 61-66; Nash, *Pictorial Dictionary,* I, 92-101.

On an arch dedicated to Augustus in the Alps cf. Dio Cassius LIII, 26, 5.

Still another novel type of monument by which Augustus (and his successors) embellished Rome was the Egyptian obelisk (cf. Pliny, N.H. XXXVI, 70-75). Two of the obelisks which the emperor had transported from Egypt may still be seen in Rome—one originally set up in the Campus Martius *in Monte Citorio, the other originally in the* Circus Maximus, *now in the Piazza del Popolo.*[25]

In addition to constructing many new buildings in Rome, Augustus also undertook to restore a number of the older structures which had been damaged during the civil wars.

Suetonius, *The Divine Augustus* **XXXI, 5:** Next to the immortal gods, he bestowed honor upon the memory of those leaders who had raised the *imperium* of the Roman people from insignificance to greatness. Consequently he restored the works of these men with the original dedicatory inscriptions of each and set up statues of all of them in triumphal dress in each of the porticoes of his forum, and professed in an edict: "This display has been devised by the *princeps,* so that he himself while he lives, and also the leaders in succeeding ages, will be compelled by the citizens to use the lives of these men as their exemplars." He also had an image of Pompey transferred from the *curia* [the *Curia Pompei*] in which Gaius [Julius] Caesar had been killed and placed it on a marble archway opposite the grand doorway of his [Pompey's] theater.

Dio Cassius LIII, 2, 4: On the one hand he did not allow the Egyptian religious rites within the *pomerium,*[26] but on the other he took care to see that there were temples for them. As for those which had been built by private citizens, he ordered their sons and descendants (if any survived) to refurbish them, and the remainder he restored himself. He did not, however, take the credit for rebuilding them himself, but bestowed it rather on those who had constructed them originally.

Dio Cassius LIV, 24, 3: The *Basilica* [*Aemilia,* in the Forum] was afterward built in the name of Aemilius, the reason for this being that he was descended from the same family as the man who originally made it; the building was actually carried out, however, by Augustus and the friends of Paullus.[27]

25 Cf. Nash, *Pictorial Dictionary,* II, 134-37. The obelisk from the *Circus Maximus* dates from the XIXth dynasty; that from the *Campus Martius* from the XXVIth dynasty.

26 The *pomerium* was a sacred area within Rome defined by a boundary which was sanctified by religious ritual. The *pomerium* originally seems to have been the boundary of the earliest settlement. As the city expanded this sacred boundary was also extended, but the extension did not keep pace with the actual growth of the city and important monuments were often outside it.

27 The *Basilica Aemilia* was originally built c. 179 B.C. by the censor M. Aemilius Lepidus. It was completed by L. Aemilius Paullus Lepidus, who was censor in 22 B.C.

Dio Cassius LIV, 19, 4: Before setting out [for Gaul in 16 B.C.] Augustus dedicated the temple of Quirinus [burned down in 49 B.C.], which he had rebuilt. I have mentioned this because he decorated it with seventy-six columns, as many as the total number of years which he lived, which fact has given some people reason for thinking that he did this deliberately and not by chance alone.

In spite of the lavish and extensive nature of Augustus' building program, his personal tastes are reputed to have been simple.

Suetonius, *The Divine Augustus* LXXII, 1-3: In the other aspects of his life it is agreed that he was moderate and above even the suspicion of fault. He lived at first near the *Forum Romanum* above the Ringmakers' Stairs, in a house that had belonged to Calvus the orator. Afterward he lived on the Palatine in the house of Hortensius, which was no less modest, being conspicuous neither for its size nor for its decoration, since the porticoes in it were short and had columns made of Alban stone [*"Peperino"* 28] while the rooms lacked marble or any kind of distinguished pavement. Furthermore, for forty years he kept the same bedroom, both in winter and in summer, and although he found by experience that the city in wintertime was rather bad for his health, he nevertheless continuously spent the winter in town. If ever he proposed to do something in secret or without interruption, there was a solitary place at the top of the house which he called "Syracuse" 29 and the *technyphion* ["little workshop"]; it was either here that he used to retire, or to the suburban home of one of his freedmen. When he was ill, however, he used to go to the home of Maecenas.30 As retreats he used to frequent primarily the coastal area and islands of Campania or the towns near Rome, such as Lanuvium, Praeneste, and Tibur, where he often administered justice in the colonnade of the temple of Hercules. He was annoyed by large and sumptuous country palaces. He even went so far as to raze to the ground a residence of his granddaughter Julia, which had been constructed by her with great extravagance; he decorated his own villas not so much with statues and paintings as with open walks and woods and with objects which were remarkable for their age or their rarity—as, for example, at Capri the huge bones of enormous monsters and beasts, which are called "the bones of the giants," and also the military arms of heroes.

28 *Peperino*—a grey volcanic stone quarried from the Alban Mount. It came into use in the 3rd century B.C.

29 Possibly so called because Syracuse's success in withstanding the siege of Marcellus resembled Augustus' efforts to avoid being interrupted.

30 Maecenas (d. 8 B.C.), Augustus' informal cultural minister, had a sumptuous house and gardens on the Esquiline.

Sculpture

Augustus' buildings, as already pointed out, contained many important works of Greek art. The passages which describe works by known and datable artists have been given in The Art of Greece: 1400-31 B.C.[31] *In the case of the two following passages the dates of the Greek artists in question are not known, but it is probably safe to place them in the Hellenistic period.*

Pliny, *N.H*. XXXVI, 34-36: . . . And near the Portico of Octavia there is a statue of Apollo by Philiskos of Rhodes, which stands in his [Apollo's] own shrine, and also a Latona [Leto], a Diana [Artemis], the nine Muses, and another statue of Apollo. . . . The Pan and Olympos wrestling, which is in the same building[32] and is the second best known *symplegma*[33] in the world, is by Heliodoros. . . . The standing Venus is by Polycharmos. It is apparent from the honor given to it that the work of Lysias, which the Divine Augustus dedicated in honor of his father Octavius in an *aedicula* adorned with columns upon the arch on the Palatine, was held in great esteem. This work consisted of a four-horse chariot group and an Apollo and a Diana [Artemis], all carved from one piece of stone.

Pliny, *N.H*. XXXVI, 28-29: Similarly, the question of authorship is raised[34] about the Cupid holding a lightning bolt in the *Curia Octavia;* one thing at least can be affirmed with certainty—that is, that it represents Alcibiades, who was the best looking person of that age. There are many works in the same place of leisure[35] which are pleasing even though anonymous: for example, the four Satyrs, of whom one carries Father Liber [Dionysos], dressed in a tragic costume, on his shoulders, another carries Libera [Ariadne?][36] in the same manner, a third is attempting to stop the wailing of an infant, and a fourth is quenching the thirst of another [child (or Satyr?)] from a mixing bowl; and also the two Aurae [Breezes] spreading their garments like sails. There is no less dispute about who made the Olympos and Pan and the Cheiron with Achilles in the *Saepta,* especially since their reputation has decreed for them a value which merits giving one's life as security for their safety.

31 See the geographical index under "Rome."

32 The temple of Jupiter within the Portico of Octavia.

33 *Symplegma* = a group of intertwined figures; cf. *The Art of Ancient Greece*, p. 111.

34 Just prior to the passage here cited Pliny has been discussing the question of whether certain works should be attributed to Skopas or Praxiteles (cf. *ibid.*, p. 141).

35 Pliny here uses the term *schola*. The *Curia Octavia*, it will be remembered, was actually a library.

36 Liber and Libera were Italic deities connected with the growth of vines, etc. Liber was identified with Dionysos. Libera was usually associated with Persephone, but occasionally with Ariadne.

In addition to the images of deities which were imported from Greece, Augustus also had many new figures made for the different buildings which he constructed. A number of these have already been mentioned in connection with his building program. Many of the new statues obviously were Greek or imitated Greek prototypes—for example, the "very expensive statues which he bought and dedicated in each ward, such as the Apollo Sandalarius and the Jupiter Tragoedus and others" which Suetonius mentions (Divine Augustus LVII, 1). Other new images, however, were essentially personifications which expressed themes of Augustus' new political order.

Dio Cassius LIV, 35, 2: When the Senate and the people once again contributed silver for statues of him [Augustus], he set up a statue not of himself but rather of *Salus Publica* [the Health of the State] and also to *Concordia* and *Pax*.

The unity of the peoples within the Roman empire was also expressed by symbolic statuary.

Servius, *Commentary on Vergil, Aeneid* VIII, 721: For Augustus made a portico in which he assembled images representing the different peoples, on which account it is called the *Porticus ad Nationes*.[37]

Strabo IV, 192: The sanctuary [at Lugdunum (now Lyons)] which was dedicated to Augustus Caesar by a league of all the Gauls was built before the city at the junction of the two rivers. There is a notable altar with an inscription naming the tribes, which are sixty in number, and also images of these, one for each tribe, as well as another large statue.

Portrait statues of all types, including, in spite of his apparent reluctance, a fair number of Augustus himself, abounded in Augustan Italy. A number of these have already been cited (see pp. 94, 106).

Suetonius, *The Divine Augustus* LIX: To honor the physician Antonius Musa, through whose ministrations he [Augustus] had recovered from a dangerous illness, money was contributed and a statue of him was set up next to that of Aesculapius.

Suetonius, *Gaius Caligula* VII [Concerning the children of Germanicus and Agrippina]: Death carried off two of these while they were infants and another as he was reaching boyhood—a boy of remarkable gaiety, of

[37] The location of the *Porticus ad Nationes* is uncertain, but it may have been near the theater of Pompey. Pliny, quoting Varro, refers to fourteen figures "of nations by the sculptor Coponius" set up "around" the theater of Pompey (*N.H.* XXXVI, 41). The same statues are mentioned by Suetonius (*Nero* XLVI). The date of Coponius is not known, and it is not certain that the statues mentioned by Pliny and Suetonius are the same as those in the *Porticus ad Nationes*.

whom Livia dedicated a statue in the guise of Cupid in the temple of Venus *Capitolina;* Augustus set up another in his bedroom and used to kiss it fondly every day when he entered.

Pliny, N.H. XXXVI, 196: We have often seen statues of Augustus in solid obsidian, since this stone comes in sufficiently large pieces for this purpose; Augustus also dedicated as a sort of marvel four obsidian elephants in the temple of Concord.

Dio Cassius LIII, 22, 2-3: The road [the *Via Flaminia*] was finished just at this time [27 B.C.], and for that reason statues to Augustus were made for the arches of the bridge over the Tiber and also at Ariminum [Rimini]. The other roads were finished later, either at public expense (for none of the senators would willingly spend money on them) or at the expense of Augustus, whichever way one likes to describe it. For I am unable to find any distinction between the two treasuries, even if I allow for the fact that Augustus had converted into coins silver statues of himself which had been offered by some of his friends and by certain subject peoples, in order to make it seem that everything he claimed to spend [on the roads] came from his private resources.

Suetonius, *The Divine Augustus* LII: As for temples, although he knew that it was customary to decree temples even for proconsuls, he would not allow any to be dedicated to him unless the name of Rome appeared along with his. Even in the city he tenaciously abstained from this honor. In fact, he even melted down silver statues which had once been set up in his honor, and with the total proceeds from these he dedicated gold cauldrons to Apollo on the Palatine.

Dio Cassius LVI, 29, 4: [In 14 B.C., just prior to Augustus' death] a lightning bolt struck a statue of him which stood on the Capitoline, and the first letter of the name "Caesar" disappeared. As a result of this the soothsayers said that on the one hundredth day from that time he would partake of some divine destiny. . . .[38]

Painting

Pliny, N.H. XXXV, 21: There was also a famous conference about painting of which mention should not be omitted, held by the foremost men of the state because Quintus Pedius (the grandson of the Quintus Pedius who had held the consulship, won a triumph, and been made co-heir along with Augustus by Julius Caesar) was born a mute. In this conference the orator Messala, from whose family the grandmother of the boy had come, expressed the opinon that the lad should be instructed in the art of painting, and even the divine Augustus approved of this plan. But the boy, after making great progress in the art, died young.

[38] C is the Roman numeral for one hundred.

Pliny, N.H. XXXV, 26-28: But it was the dictator Caesar who most enhanced the reputation of painting by dedicating pictures of Ajax and Medea in front of the temple of Venus *Genetrix*.[39] After him it was Marcus Agrippa, a man whose taste tended toward rustic simplicity rather than refined elegance. There exists, in any case, a magnificent oration by Agrippa, worthy of the greatest of citizens, on the subject of making all statues and paintings public property, which would have been a more satisfactory solution than banishing them as exiles to country villas. Nevertheless, that same grim personage bought two pictures, an Ajax and a Venus [Aphrodite] from the people of Kyzikos for 1,200,000 [sesterces].[40] Moreover, he had small painted panels worked into the marble in even the hottest part of his baths; these were removed a short time ago, when they were being restored.

The Divine Augustus surpassed all others when he placed two paintings in the most frequently visited part of his forum; depicted in one of these was the "Visage of War" [41] and also "Triumph," while the other represented the Castors and Victory. He also placed [two] pictures, which we shall discuss in connection with the names of their artists, in the temple of his father Caesar. Furthermore, he had imbedded into the wall in the *Curia,* which he consecrated in the *Comitium,* a Nemea seated on a lion and carrying a palm branch, by whom stands an old man with a staff, over whose head hangs a picture of a two-horse chariot—a picture on which Nikias [42] wrote that he did it in the encaustic technique; such was the expression used by Nikias. The admirable point about the other picture is the way in which it shows the resemblance between an aged father and his grown-up son without obscuring the difference in their ages. Philochares [43] has provided evidence to show that this work is by him; and if one were to reckon the effect of this painting alone, it would be proof of the immense power of this art, since thanks to Philochares the Senate of the Roman people has gazed upon Glaukion and his son Aristippos, who would otherwise be unknown, for so many centuries.

Pliny, N.H. XXXV, 116-117: Nor must Spurius Tadius,[44] active during the time of the Divine Augustus, be cheated of the praise he deserves. It was he who first instituted that most delightful technique of painting

[39] These paintings were by Timomachos of Byzantium; cf. *The Art of Ancient Greece*, pp. 178-9.

[40] As so often, the reading of this number is uncertain in the manuscripts; the reading adopted here is that of Ian.

[41] "Visage of War" = *Belli faciem pictam.* This was presumably a personificatory figure.

[42] On Nikias, cf. *The Art of Ancient Greece*, pp. 169-71.

[43] This is perhaps Philochares, the brother of Aeschines (c. 390-330 B.C.), who is identified as a painter by Demosthenes, *de falsa legatione* 237.

[44] The manuscripts give the readings *studio* and *ludio. Tadio,* which is at least a known Roman name, was first suggested by L. Urlichs and Ian.

walls with representations of villas, porticoes and landscape gardens, woods, groves, hills, pools, channels, rivers, coastlines—in fact, every sort of thing which one might want, and also various representations of people within them walking or sailing, or, back on land, arriving at villas on ass-back or in carriages, and also fishing, fowling, or hunting or even harvesting the wine-grapes. There are also specimens among his pictures of notable villas which are accessible only through marshy ground, and of women who, as the result of an agreement, are carried along on the shoulders of men who totter along beneath the restless burdens which are being carried,[45] and many other lively subjects of this sort indicative of a sharp wit. This artist also began the practice of painting representations of seaside towns on [the walls of] open galleries, thus producing a charming view with minimal expense.

The remains of ancient Roman wall-painting found at Rome itself and at Pompeii, Herculaneum, and other sites in Campania seem to confirm the impression given by Pliny that landscape painting was particularly important during the time of Augustus. The description of "Tadius' " painting calls to mind many examples of Romano-Campanian painting of the later "second style" and the "third style"—for example, the "Odyssey Landscapes" and many small vignettes from walls at Pompeii.[46]

Augustus' enthusiasm for painting was tempered, if we may believe Suetonius, by a wry sense of humor.

Suetonius, *The Divine Augustus* LXXV: It was also his custom at banquets to try to sell chances on objects of the most unequal value and also to sell paintings of which one could see only the back, thereby, through an uncertain twist of fortune, either frustrating or fulfilling the hope of the buyers. . . .

The Minor Arts

The Augustan era was an exceptionally fertile period for the creation of gems, silverware, pottery, and other objects which might be said to belong to the realm of private as opposed to public art. The particular excellence of gem-carving in this era is emphasized by Pliny.

Pliny, *N.H.* XXXVII, 8: After him [Pyrgoteles, the gem-carver of Alexander the Great] in renown were Apollonides and Kronios and

45 The text of the clause "women . . . carried" is corrupt, and we give here a free rendering of what its meaning may have been.

46 For illustrations cf. A. Maiuri, *Roman Painting* (Geneva 1953), pp. 32-34, 117-24; G. Rizzo, *La Pittura Ellenistico-Romana* (Milan 1929), p. 72, plates CLXV-CLXXIX. On the general question of Roman landscape painting see C. M. Dawson, *Romano-Campanian Mythological Landscape Painting* (New Haven 1944). On Tadius (or Ludius) cf. *ibid.*, pp. 78, 120-24.

the man who cut with the utmost exactness that portrait of the divine Augustus which later emperors use as a seal—namely, Dioskourides.

A number of Augustan seals with the signatures of the artists who carved them have survived. Dioskourides is prominent among these. Cf. A. Furtwängler, Die Antiken Gemmen *(Leipzig 1900), plates XLIX and L; and text, Vol. II, pp. 232-46.*

Pliny, *N.H.* XXXVII, 10: The divine Augustus at the beginning of his career used a seal engraved with a sphinx. He had found among his mother's rings two which were remarkably similar. During the civil war whenever he himself was absent his friends used one of these as a seal on letters and edicts which the conditions of the times made it necessary to issue; and it was a standing wry joke among those who received them to say that the sphinx had come bearing its riddles. And naturally the seal of Maecenas engraved with a frog was an object which caused great terror because it signified that a contribution of money would be demanded.

Suetonius, *The Divine Augustus* L: On letters of recommendation, documents, and personal letters he at first used a sphinx as his seal design, later a portrait of Alexander the Great, and finally his own portrait, cut by the hand of Dioskourides; the last of these continued to be used by the succeeding emperors.

On gems in the Augustan period see also Pliny, N.H. XXXVII, 4, where we are told that the famous ring of Polykrates had come into the possession of Livia and had been dedicated in the temple of Concord, and also p. 81 above, where a collection dedicated by Marcellus is mentioned.

The craze for Corinthian bronzes which had infected the last century of the Republic apparently lived on in Augustus.

Suetonius, *The Divine Augustus* LXX, 2: He was also censured for being overly fond of expensive articles of furniture and of Corinthian bronzes, and likewise for being addicted to gambling with dice. In fact, at the time of his proscriptions the following graffito was added to a statue of him:

"My father was an *argentarius*, and I a *Corinthiarius*," [47]

since it was thought that he had had some men placed among the proscribed on account of their Corinthian vases.

[47] *Argentarius* = "money changer." Augustus' father, C. Octavius, was said to have been involved in this profession. Cf. Suetonius, *The Divine Augustus* III, 1. *Corinthiarius,* "keeper of Corinthian vases," is a playful analogy.

*For other references to vases, cups, etc., in the Augustan period
see Pliny, N.H. XXXIV, 141 (iron goblets in the temple of Mars Ultor);
XXXIII, 83 (an amusing anecdote of how the pious Augustus was served
food on gold plates made from a cult image of the goddess Anaitis which
had been melted down by one of his veterans).*

The Death, Interment, and Testament of Augustus

Suetonius, *The Divine Augustus* **C, 4 and CI, 4:** . . . He was borne on
the shoulders of the senators to the *Campus Martius* and cremated. There
was even one man, a former praetor, who swore that he had seen an
image of him who was cremated rising to heaven. His remains were
gathered up by the foremost men of the Equestrian Order, who, in ungirt
tunics and barefoot, conveyed them to his Mausoleum.[48] He had con-
structed this work between the *Via Flaminia* and the bank of the Tiber
during his sixth consulship [28 B.C.] and at the same time had thrown
open the surrounding woods and pathways for public use.

. . . Of the three rolls [of his will], one consisted of instructions
for his funeral, the second gave an account of the things which he had
accomplished and wished to have inscribed on bronze panels which were
to stand before his Mausoleum, and the third was a summary of the
state of the entire empire. . . .

*The "things accomplished," Res Gestae, which Augustus had in-
scribed on bronze panels outside his Mausoleum was widely copied on
monuments dedicated to his memory throughout the empire. Fragments
of it are preserved on the inner walls of the pronaos of a temple of Rome
and Augustus at Ankara. This inscription is conventionally known as
the* Monumentum Ancyranum. *It consists of a Greek translation as well
as the original Latin text. The following excerpts relate to Augustus'
artistic achievement and to some of his personal honors.*

Monumentum Ancyranum [49] **II, 12:** When I returned to Rome from
Spain and Gaul after having successfully attended to affairs in the prov-
inces, during the consulship of Tiberius Nero and Publius Quintilius
[13 B.C.] the Senate, in honor of my return, decreed that an altar of the
Augustan Peace [*Ara Pacis Augustae* [50]] be consecrated in the *Campus
Martius,* and ordered that the magistrates, priests, and Vestal Virgins
should perform annual sacrifices on it. . . .

[48] The shell of Augustus' Mausoleum, which was a large earth-covered tumulus
possibly inspired by Etruscan prototypes, can still be seen; cf. Nash, *Pictorial Dic-
tionary*, II, 38-43; Kähler, *The Art of Rome and her Empire*, pp. 41-47.

[49] An excellent modern text is that edited by J. Gagé, *Res Gestae Divi Augusti*
(Paris 1950).

[50] The *Ara Pacis* is one of the best known works of Roman art. It was recon-
structed in the 1930s in the *Campus Martius* near the Mausoleum of Augustus; cf.
Nash, *Pictorial Dictionary*, I, 63-73; G. Moretti, *Ara Pacis Augustae* (Rome 1948).

IV, 19-21: I built the *Curia [Iulia*, 29 B.C.] and the *Chalcidicum* connected to it; the temple of Apollo on the Palatine with its porticoes [36-28 B.C.]; the temple of the Divine Julius [29 B.C.], the *Lupercal*,[51] the Portico in the *Circus Flaminius* which I permitted to be called the "Octavia"[52] after the name of him who first constructed it on the same ground; the seat of honor in the *Circus Maximus;* the temples on the Capitoline of Jupiter *Feretrius* [31 B.C.] and Jupiter *Tonans* [22 B.C.], the temple of Quirinus [16 B.C.], the temples of Minerva, Juno *Regina*,[53] and Jupiter *Libertas* on the Aventine; the temple of the Lares on the highest rise of the *Via Sacra,* the temple of the Di Penates[54] on the Velia, the temple of Iuventas and the temple of the Magna Mater on the Palatine.[55]

I rebuilt the Capitolium and the theater of Pompey, each work requiring great expense, without any inscription of my name. I rebuilt the channels of the aqueducts which were falling apart in many places through age, and I doubled the capacity of the aqueduct called the *Aqua Marcia* by diverting a new spring into its channel. I completed the *Forum Iulium* and the *Basilica [Iulia]* which was between the temple of Castor and the temple of Saturn, the works having been begun and almost finished by my father; and when the same basilica was consumed by fire I undertook its reconstruction on an enlarged site in the name of my sons,[56] and gave orders that, if I did not live to complete it, it should be finished by my heirs. I rebuilt eighty-two temples of the gods in the city during my sixth consulship [28 B.C.] in accordance with a decree of the Senate, ignoring none which at that time needed to be repaired. In my seventh consulship [27 B.C.] I built the *Via Flaminia* from the city to Ariminum, and I built all the bridges except the Mulvian and Minucian.

On [my] private land I built the temple of Mars *Ultor* and the Forum of Augustus from the spoils of war. Adjacent to the temple of

[51] The *Lupercal* ("cave of the wolf") was the cave on the Palatine where tradition held that Romulus and Remus were suckled by the wolf. Augustus seems to have made it into a picturesque grotto with fountains.

[52] The *Porticus Octavia* (which should be distinguished from the *Porticus Octaviae,* the complex on the site of the *Porticus Metelli* named after Augustus' sister) was first built by Cn. Octavius in 168 B.C.; see p. 45.

[53] The temple was first dedicated by Camillus in 392 B.C.

[54] The Lares and Penates were tutelary deities of the Roman household and of the state as a whole. The Lares also protected fields and roads. The temple of the Lares was on the *Via Sacra* near where the arch of Titus was later built. That of the Penates was on the Velia on the site previously occupied by the house of King Tullus Hostilius.

[55] The temple of the Magna Mater was originally built c. 204 B.C. to house the black stone which was brought from Pessinus (in Phrygia) to Rome. It burned down twice before receiving its final restoration by Augustus in A.D. 3. Its foundations are still visible; cf. Nash, *Pictorial Dictionary*, II, 27-31.

[56] Gaius and Lucius Caesar, the sons of M. Agrippa and Augustus' daughter Julia; they were adopted by Augustus.

Apollo, on land bought for the most part from private owners, I built the theater which was to bear the name of my son-in-law M. Marcellus. I dedicated offerings from the spoils of war in the Capitolium and in the temple of the Divine Julius and in the temple of Apollo and in the temple of Vesta and in the temple of Mars *Ultor,* which cost me around one hundred million sesterces. . . .

VI, 35: While I was serving my thirteenth consulship [2 B.C.] the Senate and the Equestrian Order and the whole Roman people gave me the title *pater patriae* ["father of the country"] and decreed that this title should be inscribed in the vestibule of my own house and in the curia and in the Forum of Augustus, beneath the quadriga which was set up in my honor by the authority of the Senate. When I wrote this I was in my seventy-sixth year.

Vitruvius

Vitruvius Pollio was a military architect in the service of Julius Caesar and later of Augustus. After Actium and the reestablishment of internal order in Italy, he became aware of the new emperor's interest in rebuilding Rome and set out to write a treatise on architecture in order that Augustus should be better informed about its principles and problems. These and a few other biographical facts given to us by Vitruvius himself are all that is known about the author of the de Architectura, *the sole extant treatise by an ancient artist and a work which has had incalculable influence on the course of European architecture.*

Vitruvius was eager to impress upon Augustus (and upon the general reader) the fact that architecture was a dignified and intellectually demanding profession. He therefore sets out in the first of the ten books of the treatise to describe the extensive learning which the architect must possess in order to practice his profession adequately. He also attempts to relate his own treatise to an intellectual tradition which went back to the great architects of Classical and Hellenistic Greece. Direct reference is made to a sizable number of Greek treatises on architecture and proportion, and extensive if occasionally confusing use is made of their terminology.[57] *Throughout the work the theoretical principles derived from Greek sources appear side by side with examples of the practical know-how of an experienced Roman architect. Book II, for example, contains a very down-to-earth summary of building materials but also*

[57] Cf. *The Art of Ancient Greece,* pp. 203-4, 233. Vitruvius' use of Greek sources has been widely discussed, although few unchallengeable conclusions have ever been drawn; cf. F. W. Schlikker, *Hellenistische Vorstellungen von der Schönheit des Bauwerks nach Vitruv* (Berlin 1940); C. Watzinger, "Vitruvstudien," *Rheinisches Museum,* LXIV (1909), 203-23; P. Tomei, "Appunti sull' Estetica di Vitruvio," *Bollettino del Reale Istituto di Archeologia e Storia dell'Arte,* X (1943), 57-73.

includes a short summary of the pre-Socratic philosophers' quest for the primal substance. Books III and IV discuss the Greek architectural orders and the theoretical problems involved in laying out and proportioning Greek temples. Book V deals with public buildings, both Greek and Roman; Book VI concerns houses, and VII deals with the stucco-work and painting within houses. Book VIII deals with the collection, storage, and drainage of water. In Book IX Vitruvius discusses astronomy and the various devices for telling time. His purpose in this book is once again to emphasize the degree of learning required of a good architect. Finally, Book X deals with various mechanical devices, especially military machines, which a Roman architect might be called upon to construct.

The selections included here have been chosen to show Vitruvius' essential Romanitas. *The first two describe buildings which are characteristically Italic, while the third sheds light on certain aspects of art criticism and taste in the age of Augustus.*[58]

ON "TUSCAN" TEMPLES

Vitruvius IV, 7, 1-5: When the area in which the temple is to be built is divided into six units, subtract one unit and let what remains serve as the latitude. The length should then be divided into two even parts, with the part which is to serve as the interior designated for the spaces of the cellas, and the part which will be adjacent to the front façade reserved for the placement of the columns. Likewise, the width is to be divided into ten parts. From these let three parts on the right and the left be allotted to the smaller cellas, or to the *alae* [wings] if there are to be any. Let the four remaining parts be used for the middle of the temple. The space which will be left in front of the cella, in the *pronaos*, should have its columns arranged so that the corner columns are aligned with the antae on the line of the exterior walls. The two middle columns are to be so placed as to be on a line with the inner cella walls which are between the antae and the central cella. Between the antae and the front columns another row of columns should be placed running through the middle on the same lines. These should have a base diameter which is one-seventh of their height. The height is to be one-third the width of the temple. The top of the column [shaft] should diminish by one-fourth of the base diameter. Their bases should be half a column diameter in height. The bases should have circular plinths which have a height equal to half of their [the bases'] total height, with the *torus* above and the *apophysis*[59] having a thickness equal to that of the plinth. The abacus

[58] For an excellent translation of the whole of Vitruvius, accompanied by useful illustrations and diagrams, cf. M. H. Morgan, *Vitruvius, The Ten Books on Architecture* (Cambridge, Mass., 1914; reprint New York 1960).

[59] The *torus* was a disc with convex edge which was placed directly on the plinth of a Tuscan column. The *apophysis* was the curving element, usually concave, which joined the column shaft to its base.

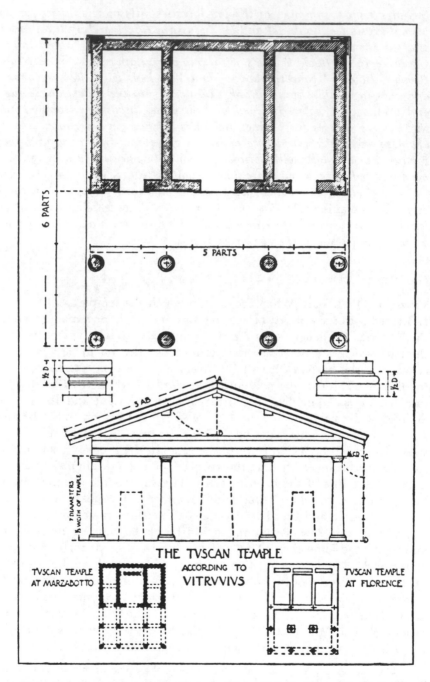

This diagram is taken from Vitruvius, The Ten Books on Architecture, *trans. Morris Hicky Morgan, illustrations prepared under the direction of Herbert Langford Warren (New York: Dover Publications, Inc., 1960), p. 121.*

should have a width equal to the lower diameter of the column. The height of the capital is to be divided into three parts of which one is to be allotted to the plinth (which is the abacus), another to the echinus, and the third to the *hypotrachelium* [necking] at the top of the column, and they should be joined with mortices and tenons in such a way that they have a gap two fingers in width at the point of joining. For when they touch one another and do not have provision for ventilation slits through which air can circulate, they become overheated and quickly begin to rot. Above the beams and above the walls the projection of the mutules should come to one-fourth of the height of the column. Next casings should be fastened to the fronts of these. Above this the tympanum of the gable should be constructed either with masonry or wood. Above the gable the ridge pole, the main rafters, and the purlins should be so placed that the overhang of the eaves amounts to one-third of the finished roof.[60]

ON THE FORUM AND THE BASILICA

In addition to providing interesting insights into problems of siting and design which the Romans recognized in their civil architecture, this passage is of particular interest because Vitruvius describes one of his own works.

Vitruvius V, 1, 1-10: The Greeks lay out their forums on a square plan with very ample double porticoes having close-set columns; they also adorn them with entablatures of stone or marble and construct walkways above in the upper storeys. But in the cities of Italy one should not make them on this plan because there is the custom, handed down from our ancestors, of presenting gladiatorial performances in the forum. Therefore, rather wide intercolumniations should be allowed around the place where the spectacle is held; in the surrounding porticoes there should be bankers' offices [*argentariae tabernae*], while on the upper floors balconies should be installed which are properly disposed for usefulness and for bringing in public revenue.

The dimensions of a forum should be determined on the basis of the number of people using it, so that the space should neither be too small to serve its function nor seem like a wasteland owing to the small number of people using it. The width of the forum should be so determined that, when the length is divided into three parts, two of these are allotted to the width. For in this way its plan will be oblong, and the

[60] The general features of the Tuscan temple described by Vitruvius—the frontal orientation, the deep porch, the wide overhang of the eaves—were characteristic of the early temples of both Etruria and Rome. The type with three cellas may have been a Roman invention and perhaps appeared for the first time in Tarquinius Superbus' temple for the Capitoline triad. Vitruvius' canon for the Tuscan temple seems in its specific details to be more Roman than Etruscan; cf. Crema, *L'Architettura Romana*, pp. 37-42; Richardson, *The Etruscans*, pp. 182-88.

arrangement will be practical for its function as a place of spectacles. The upper columns should be established as smaller than the lower ones by one-fourth, the reason for this being that, when it comes to bearing weight, the lower section must be stronger than that which is above. And a reason no less important is that one ought to imitate the way nature makes things grow, as in the case of trees with smooth trunks—the fir, the cypress, and the pine—of which there is none which is not thicker at its base and does not diminish as it gets higher, thus growing according to a natural and even pattern of contraction right to the top. Therefore, if nature demands that things should grow in this way, things are properly constituted both with regard to height and thickness when the upper parts are more contracted than the lower.

The sites of basilicas should be laid out adjacent to the forums in the warmest possible areas, so that in the wintertime businessmen can confer with one another in them without being disturbed by storms. Their width should be constituted as not less than a third nor more than a half of their length, unless the nature of the site poses an impediment and forces a change to a different set of proportions. If the site is unusually large in longitude, porches [*chalcidica*, see p. 103] should be placed at the ends, as in the *Iulia Aquiliana*.[61] It would seem that the columns of basilicas should be made as high as the aisles formed by the inner columns are wide. An aisle should be limited to one-third of the width which the central space [nave] will occupy. The upper columns should be smaller than the lower columns, in accordance with what I have written previously. The balustrade, which is to be placed between the upper and the lower columns, should be, it seems, lower by one-fourth than the upper columns, so that those walking around above, on the second storey of the basilica, should not be seen by the businessmen. The [dimensions of the] architraves, friezes, and cornices should be derived from the proportions of the columns, as we have specified in the third book.

But the components of basilicas can have no less a degree of dignity and beauty when built in the manner of that in the Julian colony at Fanum,[62] of which I planned and supervised the building. Its measurements and proportions are arranged as follows: The central roof between the columns is 120 feet long and sixty feet wide. The aisle which runs around the area covered by the roof, between the outer walls and the columns, is twenty feet wide. The columns have an unbroken height of fifty feet including the capitals, and a diameter of five feet; behind these columns are pilasters, twenty feet high, 2½ feet wide, and 1½ feet thick,[63] which support the beams on which the floors of the aisles [in the upper storey] are carried. Above these there are other pilasters, eighteen

61 The site of this building—Rome, Aquileia, or elsewhere—is a matter for conjecture.

62 Modern Fano, on the Adriatic coast of Umbria, between Rimini and Ancona.

63 That is, projecting 1½ feet from the wall to which they are attached.

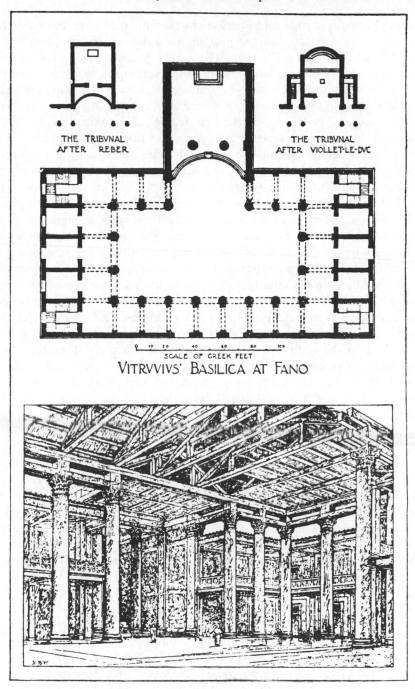

THE TRIBVNAL
AFTER REBER

THE TRIBVNAL
AFTER VIOLLET-LE-DVC

SCALE OF GREEK FEET

VITRVVIVS' BASILICA AT FANO

This diagram is taken from Vitruvius, The Ten Books on Architecture, *trans. Morris Hicky Morgan, illustrations prepared under the direction of Herbert Langford Warren (New York: Dover Publications, Inc., 1960), p. 135.*

feet high, two feet wide and one foot thick, which take the beams carrying the main raftering and the roof of the aisles, which are placed at a lower level than the main roof. The spaces between the pilasters and the beams which the columns support are left open to serve as intercolumnar windows. There are four columns, counting the angle columns on the right and left, at each end of the area covered by the main roof; on the long side of this space, the side facing the forum, there are eight columns, counting the same angle columns, while on the opposite side there are six, again counting the angle columns. The two middle columns on this side are omitted, lest they obstruct the view of the *pronaos* of the shrine of Augustus, which is situated in the middle of the side wall of the basilica facing the middle of the forum and the temple of Jupiter. The tribunal, which is in this temple, is laid out on a hemicyclical plan of which the curve is less than a semicircle. The width of this hemicycle is forty-six feet across the front, and its depth is fifteen feet, so that those who stand before the magistrates do not interfere with the businessmen in the basilica. Around the building above the columns are beams composed of three two-foot timbers bolted together. These return from the third [from each end] of the columns which are on the inner side [of the basilica] to the antae, which project from the *pronaos* and touch the hemicycle on the right and left. Above the beams piers three feet high and four feet square are disposed on supports directly over each capital. Above these, well-jointed [64] beams made of two two-foot timbers are carried all around the building. Upon these the crossbeams with the connecting struts, lined up with the column shafts and the antae and the walls of the *pronaos*, support a single continuous gabled roof covering the [main body] of the basilica, and also another projecting from the main roof over the *pronaos*. The arrangement of the roof with two ridges which thus arises gives a beautiful appearance to the outside of the roof and to the high interior ceiling. Furthermore, since the ornaments of the entablature and the placement of both the balustrades and an upper row of columns are dispensed with, a burdensome annoyance is avoided and the expense is diminished by a very substantial degree. But, at the same time, having the columns themselves rise in an unbroken span up to the beams which support the roof seems to enhance the feeling of grandiose richness and impressiveness.

Vitruvius also gives equally practical and equally thorough prescriptions for constructing baths (V, 10, 1-5), houses (VI, 3, 1-11) and theaters (V, 6, 1-9). As with the foregoing description, these passages combine general principles with his personal experience as a builder and shed some light on his personal taste and the tastes of his age. A more direct

[64] "Well-jointed" = *everganeae*. This is the only occurrence of the word. It is usually connected with the Greek *euergos*, "well-worked," but could be connected with the Latin *evergo* and mean "projecting."

revelation of these tastes, however, occurs in his chapter on stucco-work and painting.

The passage which follows is of great interest both as a description of a decisive stage in the stylistic development of Roman painting and as a record of one aspect of Roman art criticism. In condemning the imaginative extravagance of decorative elements in the "third style" of Romano-Campanian wall painting and in praising what he seems to have considered the natural logic of the "second style," Vitruvius presents what seems to be a conservative classicist's theory of painting. The theory holds that since art's function is to imitate the "real" world, it should not represent anything which does not and cannot really exist. The critical approach to painting embodiéd in it seems to represent a fundamentally Greek way of thinking,[65] and is probably derived by Vitruvius from one of his Greek sources.

ON FRESCO WALL PAINTING

Vitruvius VII, 5, 1-7: For other apartments, that is, those used for spring, autumn, and summer, and also in atriums and peristyles, clearly defined principles for depicting objects were derived by the ancients from prototypes which really existed in nature.[66] For a picture is an image of something which either really exists or at least can exist—for instance, men, buildings, ships, and other things from whose clearly-defined and actually existent physical forms pictorial representations are derived by copying. Following this principle, the ancients, who first undertook to use polished wall surfaces, began by imitating diffcrent varieties of marble revetments in different positions, and then went on to imitate cornices,[67] hard stones, and wedges [68] arranged in various ways with relation to one another.

Later they became so proficient that they would imitate the forms even of buildings and the way columns and gables stood out as they projected from the background; and in open spaces, such as exedrae, because of the extensiveness of the walls, they depicted stage façades in the tragic, comic, or satyric style. Their walks, because of the extended length of the wall space, they decorated with landscapes of various sorts, modeling these images on the features of actual places. In these are painted harbors, promontories, coastlines, rivers, springs, straits, sanc-

[65] On the Greek conception of the function of painting see *The Art of Ancient Greece*, pp. 155-6, 230-3.

[66] Reading . . . *constitutae sunt ab antiquis ex certis rebus certae rationes picturarum.* Here and at other points I have allowed myself considerable freedom in translating the very condensed language of this passage.

[67] *Coronarum,* which could also mean "garlands."

[68] Reading *coronarum, silicum, cuneorum.* For *silicum,* my own suggestion, Krohn reads *silicorum,* "husks," and suggests *speculorum,* "mirrors," as another possibility. Another reading is *silaceorum,* "ochre colored," modifying *cuneorum.* None of the suggestions, including my own, is completely satisfying.

tuaries, groves, mountains, flocks, and shepherds. In places there are some designs done in the megalographic style representing images of the gods or narrating episodes from mythology, or, no less often, scenes from the Trojan war, or the wanderings of Odysseus over the landscape backgrounds, and other subjects, which are produced on the basis of similar principles from nature as it really is.

But these, which were representations derived from reality, are now scorned by the undiscriminating tastes of the present. For now there are monstrosities painted on stuccoed walls rather than true-to-life images based on actual things—instead of columns the structural elements are striated reeds; instead of gables there are ribbed appendages with curled leaves and volutes. Candelabra are seen supporting figures of small shrines, and, above the gables of these, many tender stalks with volutes grow up from their roots and have, without it making any sense whatsoever, little seated figures upon them. Not only that, but there are slender stalks which have little half-figures, some with human heads and some with beasts' heads.

Such things do not exist, nor could they exist, nor have they ever existed. Consequently it is the new tastes which have brought about a condition in which bad judges who deal with incompetent art have the power to condemn real excellence in the arts. For to what extent can a reed actually sustain a roof or a candelabrum the ornaments of a gable, or a tender, soft stalk support a seated figure, or at one time flowers and at another time half-figures be produced from roots and stalks? And yet upon seeing these false images they do not disapprove of them, but on the contrary they delight in them, nor do they give any attention to the question of whether any of these things could really exist or not. Minds obscured by weak powers of criticism are not able to make a valid judgment, with authority and with a rational understanding of what is proper, about what can exist. For pictures should not be given approbation which are not likenesses of reality; even if they are refined creations executed with artistic skill, they still should not, simply on the basis of these facts, immediately be judged as correct, unless their subjects demonstrate conceptual principles which are based on reality and are put into practice without deviations. . . . [At this point Vitruvius tells the story, probably Hellenistic in origin, about a small theater which the architect named Apaturius of Alabanda made for the people of Tralles (in southern Asia Minor). Apaturius had decorated the stage façade of the theater with such imaginative conceptions as centaurs holding up the entablature, and above the stage he placed painted representations of porticoes, rotundas, and half-pediments. When the people of Tralles were about to lavish praise on the theater, a local mathematician named Licymnius pointed out to them how completely at variance the decoration was with what could really exist. Buildings he told them rose from the ground, not from tiled rooves, and whoever thought differently was guilty of the foolish-

ness which was characteristic of the people of Alabanda. Licymnius carried public opinion with him, and Apaturius was forced to alter his design. Vitruvius applies this lesson to the problems of his own age.] Would that the immortal gods would make it possible for Licymnius to come to life again and correct the madness and the erroneous practices of the fresco painters. But it will not be beyond the scope of our discussion to explain why a false method wins out over the truth. The reason is that what the ancients sought to achieve by laborious, painstaking diligence in their arts, the present age seeks to attain by colors and their alluring effect; and the impressiveness which the subtle skill of the artist used to contribute to works, is now brought about by lavish expenditure on the part of the client, lest loss of subtlety be noted.

Tiberius: A.D. 14-37

Buildings and Monuments

Tiberius was primarily interested in completing unfinished projects begun by Augustus and in restoring even older buildings. Glorifying his own reign through architectural monuments seems not to have interested him.

Suetonius, *Tiberius* XXVI, 1: Tiberius prohibited the decreeing of temples, *flamines*,[69] and priests in his honor, or even statues and portraits unless they were set up not among the images of the gods but rather among the ornaments of temples.

Dio Cassius LVII, 10, 1-3: [Tiberius glorified the memory of Augustus] . . . in that after completing the buildings which Augustus had begun but had not finished, he inscribed Augustus' name on them; and likewise in the case of the images and *heroa* [70] of Augustus, both those which were being made by the populace and those by private citizens, he either dedicated them himself or instructed one of the priests to do so. This policy with regard to dedicatory inscriptions he applied not only to those buildings undertaken by Augustus but also to any other buildings which were in need of repair. For although he restored all the buildings which had suffered damage (he himself built no completely new building, except the temple of Augustus), he claimed none of them as his own, but rather he bestowed the names of the original builders on all of them. And while he spent very little money on himself, he spent it freely for

69 A *flamen* was a special Roman priest who served a particular deity. There were originally fifteen such priests in Rome, each serving a different deity on behalf of the state. Later new *flamines* were appointed to serve the cults of certain of the emperors.

70 *Heroa* = shrines dedicated to a *hero*—that is, a human being who, like Augustus, had been apotheosized.

the public good, rebuilding or decorating just about all public installations and giving considerable aid to both cities and private citizens.

FURTHER DETAILS ON THE TEMPLE OF AUGUSTUS

Dio Cassius LVI, 46, 3-4: A *heroön* to Augustus, decreed by the Senate and built by Livia and Tiberius, was established in Rome, and [others were made] in many other places, some people building them willingly and others not so willingly. In addition to these the house at Nola in which he had passed away was made into a sacred place. Moreover, during the time in which the *heroön* in Rome was under construction, they placed a golden portrait of him on a couch in the temple of Mars, and to this portrait they directed all the details of worship which they were later to apply to his cult image. These honors were voted to him, and it was also decreed that his portrait should not be carried in anybody's funeral procession. . . .

Tiberius was also responsible for certain restorations carried out during the later years of Augustus' reign, principally the temple of Concord and the temple of Castor and Pollux in the Forum.[71]
 Tiberius even seems to have followed Augustus' lead in his choice of building stones.

Pliny, *N.H.* XXXVI, 55: [Many colored building stones are rare and valuable] as, for example, Augustan marble, and the Tiberian, which came in use later; these were first discovered in Egypt during the reigns of Augustus and Tiberius. There is a difference between these and serpentine, since the latter has patterns which resemble snakes (whence its name), whereas these have patterns of a different sort; the Augustan has a wavy pattern of circles arranged in coils, while the Tiberian has widely spread grey markings which are not coiled up.

The apparent self-effacement of Tiberius' architectural monuments was contradicted in the case of only one monument—the Domus *Tiberiana on the northern end of the Palatine. This was the first of the imperial palaces on the Palatine (Augustus, as we have seen, lived in a modest rented house) and marks the first stage in the process which drew the Julio-Claudian emperors away from Augustus' conception of the emperor as a modest "first citizen" toward the conviction that he should be an aloof autocrat in the tradition of the Hellenistic kings of Syria and Egypt.*

[71] On both of these temples Tiberius inscribed the name of his deceased brother Drusus as well as his own. The Castor and Pollux temple was dedicated in A.D. 6 (Dio Cassius LV, 27, 4); the temple of Concord was undertaken in 7 B.C. and finished in A.D. 11 (Dio Cassius LV, 8, 1 and LVI, 25, 1). Suetonius, *Tiberius* XX, also mentions the temples but is slightly inaccurate in his dating of them.

Substantial portions of the substructure of the Domus Tiberiana *can still be seen,*[72] *but little is known of its plan and there is little information about it in the literature. It is known, however, that the Emperors Antoninus Pius and Marcus Aurelius used it as a residence* (Historia Augusta, Antoninus Pius *X, 4;* Marcus Antoninus *VI, 3).*

The two sides of Tiberius' enigmatic personality as it is displayed by ancient historians are summed up in the following two passages.

Dio Cassius LVII, 21, 5: It happened around this time [A.D. 23] that, when one of the porticoes in Rome began to lean to one side, it was set upright again in a marvelous manner. A certain architect, whose name nobody knows (because Tiberius, jealous of the man's remarkable ability, would not permit it to be recorded in the annals), this architect, I say, whoever he was, reinforced the foundations all around the structure so that they would not buckle, and after wrapping all the rest of the building in fleeces and thick tunics, he bound it together everywhere with ropes. Then, by employing many men and pulleys, he righted it to its original position. For this reason Tiberius marveled at the architect but also envied him; as a result of the former emotion he honored the man with money, but as a result of the latter he drove him out of the city. Later the man approached Tiberius and made supplication to him [to be allowed to return from exile] and, while doing so, he purposely dropped some kind of glass cup, which thereupon was either crushed or shattered; next, having rubbed it with his hand, he immediately exhibited it in one piece again. The purpose of this was to win a pardon from Tiberius; but Tiberius, on the contrary, put him to death.[73]

Velleius Paterculus II, 130, 1: How many buildings he [Tiberius] constructed in his name or that of his family! With what pious munificence, above and beyond human faith, has he built a temple to his father! With what magnificent moderation of spirit has he restored the public works of even Cn. Pompey which were consumed by fire! For whatever monument anywhere was graced with distinction, this he has decreed should be protected as if it belonged to his own family.

Sculpture

During the reign of Tiberius sculpture, like the construction of public buildings, was characterized by respect for the immediate past and a general lack of innovation. Tiberius, as we have seen, discouraged

72 Cf. Nash, *Pictorial Dictionary,* I, 365-74.

73 This story has all the earmarks of a popular "yarn," and there may be no truth in it at all. A version of the second part of the anecdote is also given by Pliny, *N.H.* XXXVI, 195, and Petronius, *Satyricon* 51. As they tell it, the man had invented some kind of unbreakable but remoldable plastic-glass, which Tiberius feared might replace gold and bankrupt the state.

the Romans from setting up statues of himself [74] but insisted on respect for the images of Augustus (Suetonius, Tiberius LVIII). In one famous case a Roman knight named Falanius had been tried on a charge of treason for including a statue of Augustus in the sale of his estate, and it was only through the reasoned clemency of Tiberius that he was spared (Tacitus, Annals I, 73). This clemency was perhaps partly prompted by a desire to discourage the politically ambitious from using images of Augustus as an emotional rallying point. We are told, for example, that when Livia was dedicating an image of Augustus in her house and had invited many of the most important men in Rome to the ceremony, Tiberius put a stop to the whole project (Dio Cassius LVII, 12, 5).

 In most respects Tiberius emulated the traditionalism of Augustus, as is evident, for example, in the statues exhibited at the funeral of his son Drusus in A.D. 23.

Tacitus, Annals IV, 9: The funeral ceremony with the procession of portrait busts was extremely impressive, since Aeneas, the founder of the Julian family, all the Alban kings, Romulus the founder of Rome, and after them the Sabine nobles, Attus Clausus, and portrait busts of all the other Claudii were exhibited in a long procession.[75]

 The story that Tiberius removed the famous Apoxyomenos of Lysippos to his bedroom because he had fallen in love with it [76] is no doubt scurrilously exaggerated but probably does reflect the fact that Tiberius, like Augustus, had a fondness for Greek art.

 Very few works are known to have been set up on the initiative of Tiberius himself. After the conspiracy of Sejanus [77] was thwarted, a figure of "Liberty" was set up in the Forum (Dio Cassius LVIII, 12, 5), and an obsidian statue which had apparently been plundered by Sejanus' father was restored to its place in Egypt (Pliny, N.H. XXXVI, 197).

 The basically withdrawn personality of the emperor is perhaps most truly reflected by the following passage.

Suetonius, Tiberius LXX, 2: He also made Greek poems in imitation of Euphorion and Rhianos and Parthenios, poets in whose writings he took the greatest delight, and dedicated portraits of them in the public libraries among the venerable and outstanding authors.

[74] When Tiberius had fallen out of favor during the reign of Augustus and was in exile on Rhodes, the citizens of Nemausus (Nîmes) had thrown down all their statues of him (Suetonius, Tiberius XIII). This may partly account for Tiberius' lack of enthusiasm about self-portraits.

[75] The same sort of honors had been awarded to Tiberius' brother Drusus, who died in 9 B.C., but were, according to Tacitus, denied to Germanicus (Annals III, 5).

[76] Pliny, N.H. XXXIV, 62; cf. The Art of Ancient Greece, p. 98.

[77] Sejanus himself seems to have been honored by a number of statues in Rome before his fall. According to Dio Cassius LVIII, 7, 1-2, various omens appeared in connection with these statues at the time of the conspiracy.

Painting

There is only scant literary information preserved about painting during the reign of Tiberius. Pliny records the fact that Tiberius dedicated a picture of Hyakinthos *by the Greek painter Nikias in the temple of Augustus. He also tells us that Tiberius fell in love with a picture of an* Archigallus *by Parrhasios, just as he had with the Apoxyomenos of Lysippos, and kept it in his bedroom.*[78] *We are also told by Suetonius (Tiberius XLIII, 2) that, after his retirement to Capri, Tiberius had the rooms of his villa decorated with paintings and reliefs of a "most lascivious" sort.*

The Minor Arts

Here again little information is preserved. An attempt by Tiberius to set limits on the spiraling prices of Corinthian bronzes is mentioned by Suetonius, Tiberius XXXIV. Some changes in fashion in house furnishings are recorded by Pliny.

Pliny, *N.H.* XXXIII, 146: Fenestella, who died in the latter part of the principate of Tiberius Caesar,[79] says that sideboards made of tortoise shell came into use at that time, whereas shortly before that they were made of wood and were round, solid, and not much bigger than a table; but even while he was a boy, he says, they started to make square ones composed of pieces of maple wood or citrus wood fastened together and covered over; he also says that subsequently silver was added on the corners and along the lines which marked the joins; these were called "drums" when he was a young man; at this time too those platters which the ancients had called *magides* came to be called *lances* after the balances of a scale.

Caligula: A.D. 37-41

Buildings and Fancies

Suetonius' biography of Caligula depicts him first as a young aspiring emperor and then as a wild, inhuman but comical lunatic, and discusses the monuments which reflected each side of the emperor's nature.

Suetonius, *Gaius Caligula* XXI-XXII: He completed works which had been left half-finished in the reign of Tiberius—the temple of Augustus

78 Pliny, *N.H.* XXXV, 131 and 70; cf. *The Art of Ancient Greece*, pp. 170 and 154.

79 A Roman historian who, according to one tradition, died in A.D. 19, hence early rather than late in the reign of Tiberius.

and the theater of Pompey. He also began an aqueduct in the area of Tibur [Tivoli] and an amphitheater next to the *Saepta;* of these works the former was finished by Claudius, his successor, while the latter was abandoned. The fortification walls at Syracuse, which had collapsed through age, were repaired, as were the temples of the gods. He had determined to restore the royal palace of Polykrates at Samos, to complete the Didymaion at Miletus,[80] to found a city on a peak of the Alps, but, before anything else, to dig a canal through the isthmus in Achaia [the Isthmus of Corinth], and he had already sent out a chief centurion to mark out the course.

So much about the emperor; the remainder of what must be told concerns the monster . . . [Caligula at first intended to change the constitutional principate into a monarchy.] But being reminded that he had risen above the level of princes and kings, he on that account began to claim for himself divine majesty. And after having made the arrangements so that certain images of unusual holiness and outstanding artistic merit, among which was the Jupiter of Olympia,[81] be brought from Greece and that their heads be removed and replaced with his own, he extended a portion of the Palatine [Palace] as far as the Forum; after transforming the temple of Castor and Pollux into a vestibule, he would often take his place among his divine brothers and, standing between them, would exhibit himself for worship by those who came forward. And some saluted him as Jupiter *Latiaris.* He also established a temple to his own divinity and supplied it with priests and the most ingeniously selected sacrificial victims. In this temple there stood a golden portrait-statue [of Caligula], and it used to be dressed every day in the sort of clothing which ,he himself wore. The richest men used to compete for positions in the priesthood of his cult by canvassing for votes and by outbidding one another. The sacrificial victims were flamingoes, peacocks, grouse, African and other types of guinea hen, and pheasants, which were offered species by species, day by day. And during the nights he constantly used to invite the full and shining moon to enter into his embrace and lie with him, while by day he would converse in secret, with Jupiter *Capitolinus,* sometimes whispering and then in turn offering his ear, and sometimes speaking more audibly; in fact, their conversation was not without its quarrels. For his voice was even heard to say threateningly, "Either you throw me or I'll throw you"; [82] but eventually, being won over by [the god's] entreaties, as he reported, and even being invited to share the god's quarters across the way, he joined the Palatine and the Capitoline by a bridge which ran over the temple of the Divine Augustus.

80 Cf. *The Art of Ancient Greece*, pp. 202-3 and 204.

81 The famous gold and ivory image by Pheidias in the temple of Zeus at Olympia; cf. *ibid.*, pp. 70-74 and geographical index under "Olympia." On the fate of Caligula's project see the following passage.

82 *Iliad* XXIII, 724. The line is spoken by Ajax to Odysseus during their wrestling match at the funeral games of Patroklos.

Subsequently, in order that he could be still nearer, he laid the foundations of a new house in an open space on the Capitoline.

Essentially the same information, but with interesting variations of detail, is given by Dio Cassius.

Dio Cassius LIX, 28, 1-5: Gaius ordered that a precinct in the province of Asia, at Miletus, should be set aside for his worship. The reason he gave for choosing this city was that Artemis had already occupied Ephesos, Augustus Pergamon, and Tiberius Smyrna; but the truth was that he desired to adopt for his own worship the great and extremely beautiful temple which the Milesians were making for Apollo. Then he was led on to ever more grandiose projects, so that even in Rome he built a temple for himself which had been authorized by the Senate and also another on the Palatine which he authorized personally. He also constructed some sort of guest quarters on the Capitoline in order that, as he said, he might live with Jupiter. But deeming it beneath his dignity to take second place to the god in this neighborhood, and even going so far as to accuse the god of having unfairly pre-empted the Capitoline, he proceeded in haste to build another temple on the Palatine, and wanted to install in it the statue of Olympian Zeus, the features of which he proposed to change to make it look like himself. But when this turned out to be impossible (for the ship which had been built to transport it was struck by lightning, and as often as anyone came forward to lay hands upon its base, peals of laughter were heard), he made threats against the statue but set up another one [of?] himself. By cutting the temple of the Dioscuri, which stood in the Forum in Rome, right through the middle he made an entrance way running between the two images to his palace on the Palatine.

Caligula also indulged his fancies in Campania.

Suetonius, *Gaius Caligula* XXXVII, 2-3: He also constructed Liburnian galleys equipped with ten banks of oars, sterns studded with gems, multicolored sails, with ample space for baths, porticoes, and dining rooms, and with a great variety of vines and fruit bearing trees; [83] reclining on these ships throughout the day he would sail along the Campanian shores amid choral dancing and singing. In building country palaces and villas all reckoning of expense was ignored, and there was nothing he loved so much as to build that which others felt could not possibly be built. And

83 The Liburnians were an Illyrian people. Remains of two large pleasure ships, dating from the reign of Caligula, were recovered from the bottom of Lake Nemi in the early 1930s. They were destroyed in World War II. It is not impossible that these were the ships described by Suetonius. Cf. G. Ucelli, *Le Navi di Nemi* (Rome 1940); for a short summary in English, cf. P. MacKendrick, *The Mute Stones Speak* (New York 1960), pp. 178-82.

so he built moles in rough and deep areas of the sea, made cuttings in cliffs of the hardest flint, built up plains to the levels of mountains, and by digging away at mountain peaks, brought them to the level of the plains—all with incredible speed, since the price paid for delay was the loss of one's head.

Sculpture

If we may believe Suetonius, Caligula's urge to set up statues of himself was counterbalanced by a desire to efface those of others.

Suetonius, *Gaius Caligula* XXXIV: With no less envy and malignity than arrogance and ferocity he raged against the human race in almost every epoch. He overturned the statues of famous men which had been moved by Augustus to the *Campus Martius* from the Capitoline, where the space had been cramped, and he broke them in pieces to such an extent that it has not been possible to restore them with their inscriptions intact. Afterward he decreed that no statue or portrait should be set up in honor of any living man unless it had his consent and authorization. He even thought of abolishing the poems of Homer, asking why that should not be permissible for him which was permissible for Plato, who had excluded Homer from the [ideal] state which he designed. In fact, he came very near to removing the writings and portraits of Vergil and Titus Livius from all the libraries; the former he used to carp at on the grounds that he had no inspiration and minimal learning, the latter because he was verbose and careless in his history.

When Caligula did set out to honor another person, however, he did so with the expected éclat, *as was the case with the monuments commemorating his sister Drusilla, who died in* A.D. *38.*

Dio Cassius LIX, 11, 2-3: . . . And so many honors as had been given to Livia were also voted to her, and [there were also decrees stating] that she should be made an immortal and that a golden statue of her should be set up in the *Curia,* and likewise that in the temple of Venus in the forum [84] an image should be set up which was the same size as that of the goddess and that she should be honored with the same rites. . . .

Claudius: A.D. 41-54

Public Works

Pliny, *N.H.* XXXVI, 122-125: The aqueduct which only quite recently was begun by Gaius and completed by Claudius [the *Aqua Claudia*]

[84] Presumably the *Forum Iulium.*

surpassed all other aqueducts in cost, since the Curtian and Caerulean springs and the *Anio Novus* [85] were made to flow into the city from [as far out as] the fortieth milestone at such a height that all the hills of the city were supplied with water; the amount expended on this work was three hundred million sesterces. Now if one were to reckon accurately the plentiful amount of water in public buildings, baths, pools, channels, private houses, gardens, suburban villas, and if he were to consider the distance traversed by the water, the arches raised to support it, the mountains which had to be tunneled through, the valleys which had to be traversed with level courses, he would have to admit that there is no work more worthy of admiration in the whole world. A work by this same Claudius, which I, for my part, would also class among those most worthy of being remembered (even though it was abandoned by his odious successor), was the channel dug through a mountain in order to tap the water of the Fucine Lake,[86] a work which required almost indescribable expense and occupied a large number of workmen for so many years, either because the material dug out of the water channel, in that part of the mountain which consisted of loose earth, had to be raised aloft by pulleys, or because solid rock had to be cut. How vast was the work which they carried out in the dark interior! It was so vast, in fact, that it cannot be conceived in the mind except by those who have seen it, nor is it capable of being described by human speech. At this point I must pass over the work done on the port at Ostia, and likewise the roads cut through mountains, the moles by which the Tyrrhenian sea was shut out from the Lucrine Lake, and the great number of bridges which were made at such great cost.

The three great public works undertaken by Claudius—the building of the Aqua Claudia, the draining of the Fucine Lake, and the building of harbor installations—are also described by Suetonius (The Divine Claudius XX), who tells us that the work on the Fucine Lake took eleven years and required thirty thousand men.

Further details on the rebuilding of the harbor at Ostia are given by both Suetonius and Dio Cassius.

Suetonius, *The Divine Claudius* XX, 3: He constructed the port at Ostia by enclosing it with curving breakwaters on the right and left, and at the entrance he placed a single mole in deep water. In order to make the mole as stable as possible, he sank the ship, in which the great obelisk had been brought from Egypt,[87] and after securing it with piles, he

[85] The *Anio Novus*, which brought water from the river Anio, a tributary of the Tiber, was begun by Caligula in A.D. 38 and finished by Claudius in A.D. 52.

[86] A large lake in central Italy about fifty miles east of Rome. Claudius' intention was to draw the waters of the lake into the bed of the river Liris. The project was never completely successful.

[87] See also Pliny, *N.H.* XXXVI, 70.

constructed on top of it a very high tower modeled after the *Pharos* [88] at Alexandria, in order that the beacon fires in it at night could guide the course of ships.

Dio Cassius LX, 11, 2-3: Just about all the grain used by the Romans was imported, and the area at the outlets of the Tiber had neither safe landing-places nor suitable harbors, and consequently the Romans' control of the sea was rendered useless to them. . . . Seeing this situation he undertook to construct a harbor, nor was he deterred even by the architects who said to him, when he asked how great the cost was likely to be: "You don't really want to build it!" For they hoped that he would be discouraged by the extent of the expense, if he knew beforehand what it would be.[89] But he had conceived a project worthy of the reputation and grandeur of Rome, and he brought it to completion.

Claudius carried out restorations and improvements on a number of monuments in Rome itself, including the theater of Pompey, which had been damaged by fire, and the Circus Maximus *(Suetonius,* The Divine Claudius *XXI, 1-3). He also seems to have removed some of the architectural eccentricities of Caligula and to have furthered a revival of respect for Tiberius.*

Dio Cassius LX, 6, 8: He returned to the cities from which they had come certain statues which Gaius had demanded, and he restored to the Dioscuri their temple and restored Pompey's name to his theater. In the same theater he also had the name of Tiberius inscribed on the stagefront, since Tiberius had rebuilt it after it burned down.

Suetonius, *The Divine Claudius* XI, 3: He completed the marble arch to Tiberius next to the theater of Pompey, which had been decreed by the Senate a long time before but which had never been finished.

Expensive and exotic building stone continued to be used in Claudius' reign.

Pliny, *N.H.* XXXVI, 60: There were also developments in the history of this stone [onyx marble] afterward, for when Cornelius Balbus set up four rather small columns in his theater [13 B.C.], it was considered an outstanding marvel; yet we have seen thirty even larger columns in the dining room which Callistus, the freedman of Claudius Caesar who was renowned for his power, built for himself.

[88] The great lighthouse at Alexandria; cf. Pliny, *N.H.* XXXVI, 83.
[89] To a modern reader this lack of enthusiasm on the part of the architects may seem strange. The architects in question, however, seem to have been civil servants and did not stand to make any great profit from this difficult project.

Sculpture

Claudius, like Tiberius before him, had had some unhappy experiences with portrait statues before he rose to the principate.

Suetonius, *The Divine Claudius* IX, 1: . . . In his own consulship [A.D. 37 under Caligula] he came very near to being removed from office, because he had been rather slow about contracting for and setting up statues of Nero and Drusus, [Gaius] Caesar's brothers.

Again like Tiberius, Claudius was hesitant about letting statues of himself be set up.

Dio Cassius LX, 5, 4-5: . . . He forbade that anyone should worship him or sacrifice to him. . . . At first he accepted only one portrait, and that merely of silver, and two statues, one of bronze and one of stone, which were voted to him. Expenses of this sort, he said, were futile and, in addition to that, they provided the city only with great loss and annoyance. In fact, the public buildings were so filled with statues and votives that he said he would give some thought to the problem of what was to be done with them.

On the other hand, Claudius respected the images of Augustus and Livia. He set up an image of Livia in the temple of Augustus and commanded the Vestal Virgins to worship it (Dio Cassius LX, 5, 2) We also hear that he had an image of Augustus removed from an amphitheater because he felt that the slaughter of slaves and freedmen which had been going on there might disgrace the statue of his distinguished forebear (Dio Cassius LX, 13, 3).

A few more random details about sculpture during the reign of Claudius are mentioned by Pliny. We are told that the emperor set up a colossal statue of Jupiter in the Campus Martius *which was dwarfed, in spite of its size, by the neighboring theater of Pompey (N.H. XXXIV, 40) and also that he expressed disapproval when one of his procurators brought back some statues in porphyry from Egypt (N.H. XXXVI, 57).*

Gems and Jewelry

Pliny, *N.H.* XXXIII, 23: Luxury has brought it about that some gems are set into the gold [on gold rings] even in that area which is hidden by the finger, and the gold has thus been rendered cheaper than thousands of little stones.[90] But on the other hand many people do not allow

[90] Reading *milibus lapillorum.*

any gems to be put on a signet ring, and they do their sealing with the gold itself. This fashion was invented during the principate of Claudius Caesar.

Pliny, N.H. XXXIII, 41: At present men are beginning to wear representations of Harpokrates and the Egyptian deities on their fingers. There was also another unusual distinction during the principate of Claudius among those men who had free access to the imperial presence —namely, the right [91] to wear a gold portrait of the emperor on their rings. . . .

Nero: A.D. 54-68

The Great Fire, the Golden House (*Domus Aurea*), and Other Architectural Projects

Tacitus, Annals XV, 38-43: A disaster followed (whether as the result of the emperor's treachery or not is uncertain, for there are authors who give both versions) which was more serious and more dreadful than any which had ever befallen the city through the violence of fires. It started in that part of the Circus which is contiguous with the Palatine and Caelian hills, where it first swept through the shops in which the sort of goods upon which a flame could feed were stored, and, being immediately fanned to great intensity by the wind, it spread throughout the whole length of the Circus. For here there were neither houses closed off by defensive barriers nor temple precincts surrounded by walls nor any other obstacle which might stand in the way [of the flames]. The onrush of the blaze first swept over the level areas, and, by eventually surging up the hills and by returning again to ravage the areas below, it defied any remedy, owing to the swiftness with which the evil came and the hazardous susceptibility of any city having the winding passageways and irregular streets which were characteristic of old Rome. . . . Nor did anyone dare to fight the fire, owing to the frequent threats posed by a number of people against those who might have extinguished the flames and because there were others who were openly hurling torches and shouting (either in order that they could go on looting more freely or because they were under orders) that there was an authority for their action.

 Nero was at that time at Antium [Anzio] and did not return until the fire began to approach his own house, which stretched between the Palatine and the Gardens of Maecenas. He was not able, however, to stop the fire from devouring the Palace, the house,[92] and everything around

 91 The text of the phrase "who . . . right" is problematical, but the meaning is sufficiently clear.

 92 The house referred to here was the *Domus Transitoria* between the Palatine palace and the Esquiline; cf. Suetonius' description, p. 142; Nash, *Pictorial Dictionary,* I, 375-79.

it. As a comfort for the people who had been driven out of their homes and were wandering aimlessly he opened up the *Campus Martius,* the buildings of Agrippa, and even his own gardens, and constructed temporary shelters which would receive the helpless multitude. The necessities of life were brought up from Ostia and from the neighboring towns, and the price of grain was reduced to three sesterces a peck. These relief measures, although popular, were in vain in the long run because the rumor had spread about that, at the very time when the city was in flames, Nero appeared on a private stage and sang [93] about the destruction of Troy, thus comparing the present afflictions to the disasters of old.

At last, on the sixth day after it began, the fire was put out on the lower slopes of the Esquiline by demolishing a large number of buildings so that the continuing violence of the blaze came upon an open field with the same effect that it would have had if it had come upon the open sky. But hardly had fear been put aside when it broke out again and attacked once more with no less intensity and this time did more damage in the open areas of the city, although the loss of life was less than before. The shrines of the gods and the porticoes which were dedicated to pleasant diversion suffered more widespread destruction. And even greater infamy was attached to this conflagration because it broke out on the Aemilian property of Tigellinus; and also because Nero seemed to be seeking the glory of founding a new city and naming it after himself. Rome, of course, is divided into fourteen regions, of which four remained undamaged, three were razed to the ground, while in the remaining seven there were only a few vestiges of houses, mangled and half burned-out, which remained standing.

As for the houses, blocks of apartments, and temple areas which were lost, one could not arrive at an accurate reckoning of them with any ease. But among them were those which had the oldest cults attached to them: the temple of Luna which was consecrated by Servius Tullius; the great altar and shrine which Evander the Arcadian consecrated to Hercules, who was present; the temple of Jupiter *Stator* decreed by Romulus; the *Regia* built by Numa; the shrine of Vesta which contained the Penates of the Roman people—all were burned down. Also destroyed were the wealth acquired through so many victories, the beautiful examples of Greek art, and, after these, the ancient and unspoiled monuments of men of genius, so that, in spite of the beauty of the rebuilt city, there are old men who will remember many things which could not be restored. . . .

"Nero, all the same, made use of the ruin of his country and built a palace in which the gems and gold were scarcely as much a cause for

[93] Nero's belief in his own operatic talents became legendary; cf. Suetonius, *Nero* XX-XXII. It is this story which is ultimately at the root of the popular image of Nero fiddling while Rome burned. According to Seutonius (*Nero* XXXVIII) Nero sang his aria about the fall of Troy from a tower in the Gardens of Maecenas.

wonder (for they are familiar, and have long been vulgarized by luxury) as the fields and pools and, in one part, woods to provide solitude, and, in an adjacent area, open spaces and vistas. The controllers and contrivers [of these projects] were Severus and Celer who had both the inventiveness and the audacity to attempt through art what even nature denied and to amuse themselves with the resources of an emperor. They, in fact, had even vowed their intention to dig a navigable canal from Lake Avernus to the outlets of the Tiber at Ostia, running either along the parched shoreline or through the mountains. . . .

The portion of the city which was not taken up by the palace was not, as after the fire which occurred during the Gallic invasion, constructed at random and without any conception of order; on the contrary, it was provided with measured rows of streets and wide, spacious avenues; a limit was set on the height of buildings, open spaces were provided, and porticoes were added which would serve to protect the front of the apartment blocks.[94] Nero promised that he would construct these porticoes at his own expense and would turn over the areas which had been cleared [of rubble] to the landlords. He also offered rewards according to the rank and private resources of each person and defined a period within which they could earn the rewards by finishing houses or blocks of apartments. He designated the Ostian marshes for the reception of rubbish and arranged that the ships, which carried grain up the Tiber, should sail down it again loaded with rubble. The buildings themselves were to be made, up to a specified height, of solid Gabinian or Alban stone (without any wooden beams), since this type of stone is impervious to fire. And to insure that the water, which had been drawn off owing to the unlawful behavior of private individuals, should flow more copiously into several centers, guards were appointed, and everyone was to have a reserve tank in the open court of his dwelling for controlling fires. Nor were there to be any common walls [between buildings], but each structure was to be enclosed by walls of its own. These changes, which were accepted for their utility, also brought a certain orderly comeliness to the newly built city. There were some, however, who believed that the old arrangement of the city was more conducive to health, because the narrow passageways and the high houses were not penetrated by the heat of the sun, whereas now the open space, protected by no shade at all, is burned much more severely by the heat.

Suetonius, *Nero* XXXI: There was nothing, however, in which he was more ruinously extravagant than in building. He built a palace running from the Palatine to the Esquiline which he at first called the *Domus Transitoria,* but when it was subsequently consumed by fire and again restored, the *Domus Aurea.* The following description will suffice to

94 Suetonius, *Nero* XVI, adds that these porticoes had flat rooves from which fires could be fought.

convey its spaciousness and elaborateness. It had a vestibule, in which stood a colossal statue of Nero himself, 120 feet high; the area it covered was so great that it had a mile-long portico with three colonnades; it also had a pool [95] which resembled the sea and was surrounded by buildings which were to give the impression of cities; besides this there were rural areas varied with ploughed fields, vineyards, pastures, and woodlands, and filled with all types of domestic animals and wild beasts. All the structures in the other parts of the palace were overlaid with gold and were highlighted with gems and mother-of-pearl; there were dining rooms whose ceilings were equipped with rotating ivory panels and with pipes so that flowers could be strewn and unguents sprayed on those below; the foremost of the dining rooms was a rotunda, which rotated day and night like the heavens; there were baths through which flowed sea water and medicinal spring water.[96] When the palace was completed in the mode which has been described, he dedicated it and expressed his approval only by noting that he was "at last beginning to live like a human being."

Pliny, *N.H.* XXXIII, 54: . . . Nero had the theater of Pompey covered with gold for a single day's use, the day on which he proposed to show it to King Tiridates of Armenia. Yet this was a mere fraction of the gold on the *Domus Aurea,* which winds all around the city!

Pliny, *N.H.* XXXVI, 111: Twice we have seen the whole city girdled by the palaces of the Emperors Gaius and Nero, the latter's, lest it be inferior to any other, being made of gold.

Pliny also tells us that Nero looted many pieces of Greek sculpture and placed them "in the sitting rooms of the Domus Aurea" *(N.H. XXXIV, 84). On the sculptor Zenodoros and the painter Famulus, both of whom worked on the* Domus Aurea, *see pp. 144 and 146, respectively.*
The architectural and engineering projects in Campania which Tacitus attributes to the architects Severus and Celer, are further described by Suetonius.

Suetonius, *Nero* XXXI, 3: He also undertook to build a pool stretching from Misenum to Lake Avernus, covered by a roof and enclosed by porticoes, into which he intended to turn all the hot springs which existed throughout the whole of Baiae. Then he intended to build a canal from Lake Avernus all the way to Ostia, so that one could make the journey on ship but not by sea; its length was to be sixty

[95] This pool seems to have been in the area now occupied by the Flavian Amphitheater (the "Colosseum").
[96] "Medicinal spring water" = *albulis . . . aquis.* The *Albulae Aquae* were springs near Tivoli.

miles and its width was to be great enough to allow quinquerimes,[97] going in opposite directions, to pass.

Pliny, *N.H.* XXXVI, 163: During the principate of Nero a stone was discovered in Cappadocia which had the hardness of marble and was white and translucent even where yellow veins occurred; because of this characteristic, it was called *phengites* ["the shining stone"]. With this stone Nero built the temple of Fortuna, which they call the "shrine of Sejanus," a building originally consecrated by King Servius and incorporated [by Nero] into the *Domus Aurea*. Owing to this material it was as light as day in the temple, even when the doors were closed; the light, however, was of a different sort from that normally given by translucent stone in that it seemed to be shut in [the temple] and not transmitted [through the stone into it].

Other less important architectural projects of Nero were a Macellum *(Market) and a wooden amphitheater in Rome (Dio Cassius LXI, 19, 1; Suetonius, Nero XII, 1).*

Sculpture

The most renowned sculptor of the age of Nero was Zenodoros, who did the colossus of Nero which stood in the vestibule of the Domus Aurea.

Pliny, *N.H.* XXXIV, 45-47: But it was in our own age that all other statues of this sort [colossal statues] were surpassed in size by the Mercury of Zenodoros, which was made in the city of the Averni in Gaul, took ten years to complete, and cost forty million[98] sesterces. After he had given sufficient proof of his artistic ability, he was summoned to Rome by Nero and there made that colossal image, 120[99] feet in height, which was intended to be a representation of that emperor but which now, since the infamous acts of the emperor have been condemned, is dedicated to and revered as an image of the Sun.[100] In his studio we used to marvel not only at the remarkable model [of the colossus] made out of clay but also at the substructure made of rather small branches[101] which marked the first stage in the construction of the work. This statue provides an

97 Ships with five banks of rowers.

98 The manuscripts read four hundred. Ian's emendation, which is given here, is almost certainly correct.

99 The manuscripts give confused readings here, and many emendations have been suggested. In view of the difficulty, we give here the dimension reported by Suetonius in his description of the Golden House.

100 A free translation of the reading *qui dicatus Solis venerationi.*

101 "Branches" = *surculis. Surculus* was the word for the shoot of a plant or for a very young tree. Exactly what Pliny means here is difficult to say. Perhaps he is referring to green, flexible timbers or perhaps to pipes which resembled branches but were made of some other material.

indication of the extent to which the technique of casting bronze has died out, since Nero was prepared to supply gold and silver on a lavish scale [but Zenodoros refused it]; and it also indicates that Zenodoros was inferior to none of the artists of old in the technique of casting and chasing bronze. When he was making the statue of the Averni, at the time when Dubius Avitus was governor of the province, he also made copies of two cups engraved by the hand of Kalamis, which Germanicus Caesar had treasured and had given to his teacher, Cassius Salanus, the uncle of Avitus; the work was so fine that there was scarcely any difference in artistic skill between the original and the copy. To the degree that one recognizes the preeminence of Zenodoros in this art, to that degree one can comprehend how much the art of casting bronze has degenerated.

Zenodoros' colossus was later moved by Hadrian; cf. p. 175.
Besides the colossus, Nero apparently commissioned a good many other images of himself.

Suetonius, Nero XXV, 2 [Aspects of Nero's triumphant return to Rome after "competing" in the Olympic games in A.D. 67]: . . . Thence, passing by the arch, which had been demolished, in the *Circus Maximus*, he went through the *Velabrum* and the Forum and made for the Palatine and the temple of Apollo. As he paraded by, victims were sacrificed to him here and there, saffron was repeatedly spread along the street, and song-birds, ribbons, and confections were showered upon him. He placed sacred crowns in his bedrooms around the beds, and also statues of himself in the dress of a *kitharoidos* [lyre player]; furthermore, he had a coin struck representing him in that way.

Pliny, N.H. XXXVII, 118: There is also a form of jasper which resembles Megarian salt and is characterized by a pattern which resembles smoke, and is, for that reason, called *capnias* ["smokey"]. I have seen a statue sixteen inches high made from this stone representing Nero wearing a breastplate.

We also hear of golden images of Minerva and Nero being set up in the Curia after the murder of Agrippina and the supposed exposure of a plot against the emperor's life (Tacitus, Annals XIV, 12).
Nero shared the passion for Greek art which had characterized his predecessors. He personally undertook to have a portrait of Alexander gilded and demanded that a statue of an Amazon by the 5th century Greek sculptor Strongylion be carried around in his courtly retinue.[102]

102 Cf. *The Art of Ancient Greece*, pp. 71-2 and 98. He also carried off from Olympia a statue of Odysseus by the sculptor Onatas; cf. *ibid.*, p. 39.

Nero's concern for the arts also had a highly negative and destructive side.

Suetonius, Nero XXIV [Concerning the emperor's activities in Greece while he was competing in the Olympic games]: And so that no memory or trace of any victor in the games other than himself should remain, he ordered that all their statues and portraits should be overturned, dragged off with hooks, and thrown into latrines.

There is also evidence that Nero was not above robbing temples and melting down sacred images when he needed money (Suetonius, Nero XXXII, 4), and Tacitus tells us that the people of Pergamon rioted to stop one of the emperor's freedmen from plundering the city (Annals XVI, 23).

Painting

Pliny, N.H. XXXV, 120: More recently there was the serious and severe, but at the same time overly florid [103] painter Famulus. By his hand there was a Minerva which continued to face the viewer no matter from what angle he looked at it. He used to paint for only a few hours a day, but this was done with great gravity, since he always wore a toga, even when he was in the midst of his painter's equipment. The *Domus Aurea* was the prison for his artistry, and for that reason there are not many other examples of his work extant.

Pliny, N.H. XXXV, 51-52: And in our own age there was one example of lunacy in painting which I ought not to omit. The Emperor Nero ordered that a colossal portrait of him, 120 feet high, should be painted on linen, a thing unknown up to that time. When this picture, after being completed, was in the Gardens of Maius, it was struck by lightning and consumed by fire along with the best part of the gardens. One of his [Nero's] freedmen, when he was giving a gladiatorial exhibition at Antium, filled the public porticoes, it is agreed, with paintings in which there were life-like portraits of all the gladiators and attendants. This type of portraiture has been a subject of passionate interest in painting for many centuries now, but it was C. Terentius Lucanus who first began to have gladiatorial shows painted and to exhibit the paintings in public. This man, in honor of his grandfather, who had adopted him, sponsored

103 Most of the manuscripts read *floridis* or *floridus* followed by *umidis, umidus, humilis, humidis,* or *humidus.* Many emendations have been suggested, of which the most reasonable are Urlichs' *floridissimus* ("extremely florid") or Ian's *floridis tumidus* ("puffed up with floridity"). The reference must, in any case, be to the ornate and theatrical aspects of the "fourth style" of Romano-Campanian painting of which Famulus may well have been one of the inventors. Traces of such painting can still be seen in the extant subterranean rooms of the Golden House; cf. A. Boethius, *The Golden House of Nero* (Ann Arbor 1960); Nash, *Pictorial Dictionary,* I, 339-48.

thirty pairs of gladiators, [who fought] in the Forum over a period of three days, and set up a picture of them in the grove of Diana.

The following passages on painting are from the bawdy, satirical prose narrative known as the Satyricon *which is traditionally thought to have been written by Gaius Petronius, the "arbiter of elegance" at Nero's court. His luxurious forced suicide following the Pisonian conspiracy is described by Tacitus,* Annals XVI, *18 ff. Although fictional, these passages provide an insight into the type of painting which could be found in Italy during the reign of Nero. They also shed light on the attitudes toward and taste in painting which characterized both Petronius' own class and the south Italian* nouveau riche *class which he satirizes.*

At the beginning of the Satyricon *its "hero," Encolpius, launches into a diatribe against the bombastic and florid "Asiatic" style of rhetoric which his contemporaries had adopted enthusiastically.*

Satyricon 2: Nor has there been any poetry which glowed with a healthy color; on the contrary, all the arts, nourished by this same diet, have been unable to muster enough vigor to produce the gray hairs that come with old age. Even painting has come to the same end since the time when the audacity of the Egyptians invented a method of abbreviating [104] so great an art.

Encolpius later visits the house of Trimalchio, a fabulously wealthy former slave who lives in a boorish and garrish splendor which perhaps apes that of the court of Nero. In the following passage Encolpius studies a cycle of frescoes which illustrate Trimalchio's career. The description is perhaps intended as a satire on actual cycles of paintings which depicted the careers of the emperor, important senators, generals, etc.

Satyricon 29: While I was staring in astonishment at everything, I almost fell back and broke my leg. For on the left of the entrance, not far from the doorman's room, there was a painting on the wall of a huge dog, tied by a chain, above which was written in neat letters "*Cave Canem*" ["Beware of the Dog"]. My companions, naturally, laughed at me; gathering up my courage, however, I did not pass up the opportunity

[104] "Method of abbreviating" = *compendiariam*. This controversial term is also used by Pliny in connection with the style of the 4th century Greek painter Philoxenos of Eretria (Pliny, *N.H.* XXXV, 110). *Compendiaria* is sometimes translated as "shortcut." Whether these shortcuts were simplified technical procedures or whether they denoted an aspect of style is not certain. The theory that an impressionistic style of painting came to Rome from Egypt is not supported by any archaeological evidence. Egyptian motifs in Roman wall-painting and mosaics, however, are not uncommon. It is possible that Petronius had in mind the type of abbreviated landscape vignettes with Egyptian subject matter which is found in the "Nilotic landscapes" and similar Roman monuments and which may have some connection with the painter Demetrios the *topographos;* cf. *The Art of Ancient Greece*, pp. 169 and 178.

to inspect the whole wall. There was a picture of a slave market with identifying titles [for all the people represented]. In it was Trimalchio with the long hair of a slave holding the wand of Mercury [105] and entering Rome with Minerva leading him by the hand. The way in which he subsequently learned to keep accounts and was eventually made a steward—all this the painstaking painter had rendered with great detail and explained with inscriptions. At the point where the portico came to an end Mercury was taking Trimalchio by the chin and was raising him on high to the tribunal.[106] Fortune stood by with a richly laden cornucopia, and the three Parcae [Fates] were spinning the golden threads [of Trimalchio's life]. . . . I began to ask the doorman what paintings they had in the atrium. "The *Iliad* and the *Odyssey*," he replied, "and also the gladiatorial games sponsored by Laenas." . . .[107]

Later in the narrative Encolpius visits a picture gallery in another Italian town.

Satyricon 83: I came upon a picture gallery with a marvelous collection of all kinds of painting. For I saw a work by the hand of Zeuxis which was not yet worn away by the injuries of age, and I beheld not without a certain awe the sketches [*rudimenta*] of Protogenes which were so real that they vied with nature herself. And when I came upon the work of Apelles [108] which the Greeks call the *monoknēmon*,[109] I actually worshiped it. For the outlines of the figures gave a rendering of natural appearance with such subtlety that you might believe even their souls had been painted. In one picture the eagle was carrying aloft the shepherd of Ida [Ganymede] to the heavens, and in another fair Hylas was repelling the importunate Naiad. Apollo was cursing his guilty hands and was adorning his bow with a newly born type of flower.[110] Amid these faces of painted lovers, as if in a lonely place, I cried out, "So love touches even the gods!"

That a gallery with such precious paintings actually existed in some south Italian town is open to question. Possibly Petronius was thinking of paintings which he had seen at the imperial court.

105 Mercury was the patron god of commerce.

106 Trimalchio had become a *Sevir Augustalis*, one of the officials in charge of the worship of the deified emperor in the Italian municipality in which this scene of the *Satyricon* takes place.

107 The inappropriate juxtaposition of subjects is intended to characterize Trimalchio's artistic sensitivities.

108 For the literary testimonia concerning these famous Greek painters cf. *The Art of Ancient Greece*, pp. 149-53, 158-63, 171-3.

109 *Monoknēmon* = "the one-legged." The reference is possibly to Apelles' Aphrodite *Anadyomenē* of which the lower portions were at one time damaged (cf. Pliny, *N.H.* XXXV, 91).

110 The reference is to Hyakinthos, the youth whom Apollo loved and accidentally killed. The flower of that name was supposed to have sprung from his blood.

The Minor Arts

Pliny, *N.H*. XXXVII, 20 [In connection with Nero's fondness for Myr-
rhine ware, a type of tableware made from agate or a similar stone]:
When T. Petronius, a man of consular rank, was about to die owing to
the enmity of Nero, he broke a Myrrhine ladle, which he had bought
for three hundred thousand sesterces, in order to cheat the emperor's
table of its inheritance. But Nero, as was proper for an emperor, outdid
everyone by paying one million sesterces for a single bowl. That it cost
so much for one who was an emperor and father of his country to have
a drink is a fact which must be recorded.[111]

Pliny, *N.H*. XXXVII, 29: Nero [during the *coup d'état* which pre-
ceded his death], when he received the news that things were hopeless,
broke, in a last supreme fit of rage, two crystal goblets by dashing them
on the ground. This was the revenge of a man who was punishing the
men of his time—he made sure that no one else could drink from them.

*Cf. also Pliny, N.H. XXXVII, 17, on Nero's fondness for studding
various objects with pearls.*

Nero the Artist

Tacitus, *Annals* XIII, 3 [Commenting on how earlier emperors, in con-
trast to Nero, had all been gifted speakers]: But Nero from his earliest
boyhood years turned his lively spirit to other pursuits: to being a
sculptor, to painting, and to the practice of singing and of caring for
and training fine horses; and sometimes even to composing verses by
which he demonstrated that he had the rudiments of learning.

Suetonius, *Nero* LII: Some writing tablets and little books have come
into my possession in which some of his best-known verses are written
in his own handwriting, and it is quite obvious that these were neither
copied down nor recorded from someone's dictation, for they are scribbled
just as they would be by one who was thinking and creating, so that they
contain many deletions and additions and words written above the line.
He also had a zeal, which was in no way half-hearted, for painting and
sculpture.

The End of Nero

Suetonius, *Nero* XLV, 2: When he had incurred the hatred of every-
one, there was no form of insult to which he was not subjected. A curly

111 The numerals in this passage are based on restorations by Sillig and Ian.
T. (Titus) Petronius is presumably the same as G. (Gaius) Petronius, the *arbiter
elegantiae* of Nero. There is no way of determining for certain which is the correct
version of the first name, although Tacitus is perhaps more reliable than Pliny on
such details.

lock of hair was placed on the head of his statue along with an inscription in Greek which said that now at last games were being held in which he would eventually have to yield.[112] On the neck of another statue a sack was fastened along with the inscription "I have done what I could. But you have earned the sack." [113]

Suetonius, *Nero* L: Egloge and Alexandria, Nero's nurses, along with Acte, his concubine, deposited his remains in the tomb of the Domitian family, which is situated on the Hill of the Gardens [Pincio] and is visible from the *Campus Martius*. Within that monument is his porphyry sarcophagus, with an altar of Luna marble placed above it and a barrier of Thasian marble surrounding it.

Suetonius, *Nero* LVII: People were not lacking, however, who, for a long time afterward, decorated his tomb with spring and summer flowers, and who, at one time, brought forth images of him in a fringed toga to the *Rostra,* and, at another time, brought forth his edicts, as if he were alive and would shortly return to wreak vengeance on his enemies.

THE FLAVIANS

At the age of seventy-one, the new emperor Galba lacked the flexibility required for survival in his shaky position, and his short reign was marked by repeated tactical blunders. Upon his arrival in Rome, he connived at the assassination of several military officers who might have been potential rivals for the principate. At first he held the support of the Praetorian Guard, which sided with Galba when one of its commanders, Nymphidius Sabinus, claimed to be a son of Caligula and tried to displace the emperor. But when Galba attempted to cancel reckless donatives to the troops on the grounds that such payments were bankrupting the imperial treasury, his military support began to wane. The army of Upper Germany, whose commander, Verginius Rufus, had imprudently been recalled by Galba, seemed on the brink of revolt. In January Galba decided he needed a co-regent, and chose a little known member of an old Roman family, M. Piso Licinianus. In doing so he passed over and offended M. Salvius Otho, the former governor of Lusitania, who had been the first to support Galba's claim to the throne. In quick retaliation, Otho bribed the Praetorian Guard to take up his cause, marched to the Forum, murdered Galba, and was proclaimed emperor. Otho, whose background and interests had much in common with those of Nero (he was, in fact, the first husband of Nero's wife Poppaea), was an unlikely candidate to succeed as emperor. Almost immediately the legions of the Rhine, which had already been incited by two ambitious officers, A. Caecina and Fabius Valens, to revolt

112 When Nero competed in the Olympic games he wore long hair and, of course, had no need to worry about being defeated.

113 A person guilty of parricide was sewn up in a sack with a dog, a snake, a cock, and a monkey and was thrown into the sea (cf. the *Corpus Iuris Civilis, Digesta,* 48, 9, 9). The reference must be to the murder of Agrippina.

from Galba, proclaimed the commander of the army of the lower Rhine, A. Vitellius, as emperor. In the early spring, Caecina and Valens, leaving Vitellius behind, made a remarkable passage through the Alps, while they were still covered with snow, and entered northern Italy. The surprised Othonians, after a series of tactical blunders, met the Vitellians at Cremona and were defeated. When news of the defeat of his army reached Otho he committed suicide; the opposing forces then quickly came to terms, and Vitellius was declared emperor.

While Vitellius sought, through a life of Neronian luxury, to forget the chaotic financial condition of the state and his own tenuous hold on the principate, a group of officers in the eastern provinces, led by C. Licinius Mucianus, the governor of Syria, proclaimed T. Flavius Vespasianus, commander of the Roman army in Palestine, as the new emperor. While Vespasian moved to secure Egypt, Mucianus began a slow march to Italy. He was anticipated, however, by the legions of the Danube, which, under the command of a minor officer named Antonius Primus, made a sudden descent into Italy and defeated a Vitellian army at the second battle of Cremona. In December of A.D. 69 Mucianus offered to let Vitellius escape total disaster by abdicating. Vitellius was willing, but when his troops went out of control and attacked Flavius Sabinus, Vespasian's brother and mediator, his chance for clemency was lost. The Vitellian troops drove Sabinus to the Capitoline where he was besieged, captured, and put to death. It was during this siege that the temple of Jupiter on the Capitoline went up in flames. The death of Sabinus brought on an attack upon Rome by the Danubian legions under Antonius Primus. Vitellius was quickly put to death and his followers slaughtered. Mucianus arrived soon after to bring order to the city. Vespasian was acknowledged as emperor by the Senate, and the Flavian dynasty was established.

Vespasian's parents were of the equestrian rank, and hence, for an emperor, his social background was relatively humble. Both his personality and his policies were characterized by a hardheaded, generous practicality which offered an intentionally sharp contrast to the elegant infatuations of the later Julio-Claudians. His parsimonious approach to the economic affairs of the empire, although it was sometimes the butt of jokes, restored the solvency of the imperial treasury in a remarkably short time. By effective use of the emperor's right of *adlectio* (nomination) of new members for the Senate, he replenished its ranks, which had been decimated by the civil wars, with experienced and capable administrators drawn largely from the Equestrian Order. The reestablishment of internal order which these moves promoted made it possible for the Romans to once again assert a united front in foreign affairs. In A.D. 70 Vespasian's son Titus was appointed to the command of the Roman army in Judaea where a revolt of Jewish nationalists had been in progress since A.D. 66. Titus' epic siege of Jerusalem, and the great triumph which followed, helped to win great popularity for the Flavians in Rome. Revolts in Gaul and along the Rhine in the same year were suppressed with equal effectiveness, and the Roman boundaries in England were extended to the north and west under the leadership of the generals Cerialis, Frontinus, and Agricola.

While the borders of the empire were expanded and solidified, Vespasian enhanced the grandeur of Rome itself with a series of magnificent structures (*vide infra*) which were designed to erase the vestiges of Nero's buildings and to repair the damage resulting from the civil war.

But in at least one respect, adherence to the idea of hereditary succession, Vespasian followed the example of the Julio-Claudians. Titus was made a virtual co-regent during his father's lifetime, and when Vespasian died in A.D. 79 he succeeded to the principate without friction. As a military hero who also

possessed charm and good looks, he was immensely popular. His unexpected death in A.D. 81 ended a reign which was too short to lose its glamour, in spite of the fact that it saw two major disasters—the eruption of Vesuvius which buried Pompeii and other Campanian towns in A.D. 79, and a great fire in Rome in A.D. 80.

Titus was succeeded by Vespasian's younger son Domitian, who had always stood in the shadow of his magnanimous father and popular brother. Domitian was an efficient administrator, but his morose and arrogant personality won none of the affection and loyalty which had been easily given to Vespasian and Titus. He particularly antagonized the Senate by ignoring its decisions, seldom consulting it, and rigidly controlling its membership through his power as censor and his right of *adlectio*.

Domitian was not a gifted military man and had mixed fortunes in foreign affairs. In A.D. 83 he led a successful expedition against the Chatti, a German tribe which had impinged upon Roman territory by occupying the Taunus region. A few years later, however, when he attempted to crush a coalition of German tribes which were supporting incursions by Decebalus, the king of Dacia (Roumania), into the Danubian provinces, he was defeated and eventually felt constrained to sign a humiliating peace treaty with Decebalus (A.D. 89). It may have been this military failure, combined with Domitian's reputed personal arrogance, which touched off a revolt led by L. Antonius Saturninus, the governor of Upper Germany in A.D. 88-89. Although it was suppressed without great difficulty, this revolt marked the beginning of a series of conspiracies over the next six years. In the violent recriminations which followed each of these, Domitian made an increasing number of bitter enemies, and with the execution of his own cousin, the consul Flavius Clemens, in A.D. 95, he lost his last shred of support. In A.D. 96, as the result of a plot which was formulated, at least in part, by his own wife Domitia, the emperor was assassinated by the Praetorian Guard.

The significance of Domitian's reign lies not so much in its successes and failures as in the trend which it clearly shows toward absolutism in the principate. In ignoring the Senate, withdrawing to his grandiose palace on the Palatine, and insisting that he be addressed as *Dominus et Deus*, Domitian is a forerunner of the emperors of the 3rd and 4th centuries A.D. It is not surprising that after his death, the Senate condemned him with a *damnatio memoriae*, and his name and face were removed from public monuments.

The Year of Galba, Otho, and Vitellius: A.D. 69

The most significant event in this chaotic year from the standpoint of art history was the burning of the temple of the Capitoline triad by Vitellius' men.

Suetonius, *Vitellius* XV, 3: [By a sudden attack Vitellius drove the Flavian forces on to the Capitoline] and, after setting fire to the temple of Jupiter *Optimus Maximus,* he crushed them; he himself watched both the battle and the fire from the *Domus Tiberiana* while he feasted.

Pliny, *N.H.* XXXIV, 38: [The art of making sculpture in bronze] rose to a peak of success, and subsequently of daring, which was beyond human expectation. As an illustration of this success I will offer one example which concerns neither images of gods nor those of men. Our

own age saw in the Capitolium, before it was recently consumed by the fire started by Vitellius, a bronze statue in the cella of Juno of a dog licking its wound. Its miraculous excellence and extremely realistic appearance can be appreciated not only by the fact that it was dedicated in that place, but also by the method of insuring its safety. For, since no amount of money seemed equal to its value, it was publicly decreed that the caretakers should answer for its safety with their lives.

The creative side of the "year of the three emperors" was somewhat limited. Suetonius tells us that Galba was honored after his death by a statue set up on a column (Galba XXIII, 1) and that Otho restored a statue of Nero which had previously been removed (Otho VII, 1). Vitellius, whose voluptuous nature became a legend, is said to have paid one million sesterces for an earthenware dish which caught his fancy (Pliny, N.H. XXXV, 163) and to have felt that even the Golden House of Nero was not sufficiently comfortable for a man of his taste (Dio Cassius LXIV, 4).

Vespasian: A.D. 70-79

Suetonius, *The Divine Vespasian* XVIII: He was the first to establish an annual salary of one hundred thousand sesterces from the imperial treasury for professors of Latin rhetoric and professors of Greek rhetoric. He honored not only the foremost poets but also artists—for example, the restorer of the Venus of Kos and the restorer of the Colossus [114]— with outstanding donations and large rewards. To an engineer who was promising to transport some large columns to the Capitoline for a very small cost, he gave no small reward for the device he had invented, but he did not use the device, explaining that he [the inventor] must allow him [Vespasian] "to feed his people."

Buildings and Restorations

Suetonius, *The Divine Vespasian* VIII, 5-IX, 1: The city was disfigured from old fires and ruined buildings. He permitted anyone who wished to occupy vacant areas and to build on them to do so if the owners neglected [them]. He himself undertook the restoration of the Capitoline, was the first to turn his hand to the job of cleaning away the rubble, and carted off some of it on his own back. And he took on the task of restoring three thousand bronze tablets which had been consumed by the fire at the same time [as the temple of Jupiter]. . . . He also under-

114 The "Venus of Kos" could refer either to a statue of Aphrodite by Praxiteles or to a painting of her by Apelles; cf. *The Art of Ancient Greece*, pp. 84 and 161. The colossus referred to is that of Nero, which, as already noted (p. 144), was converted into a statue of the Sun.

took new works including the Temple of Peace next to the Forum and a temple to the Divine Claudius on the Caelian hill (this had, in fact, been begun by Agrippina but was almost completely destroyed by Nero); also an amphitheater in the middle of the city, since he had learned that it had been Augustus' intention to build one.

The new temple of Jupiter Optimus Maximus, the Flavian Amphitheater (the "Colosseum"), and the Temple of Peace were the three major products of Vespasian's building program. The last of these was actually a large complex which included porticoes and a library as well as a temple. Pliny, who was a contemporary of Vespasian, sums up the beauties of the restored city as he knew it, and classes the Temple of Peace [115] among the most beautiful buildings in Rome.

Pliny, N.H. XXXVI, 101-102: This is surely the proper time to pass on to the marvels of our own city, to examine the assets which have accrued from eight hundred years of experience, and to show that in this category too [that is, buildings] we have conquered the world. . . . Even if we were to ignore among the great works of architecture the *Circus Maximus* built by Julius Caesar, which is three stades long, one stade wide, and has four *iugera* [116] of buildings with seats for 250,000 people, even so, would we not still have among our magnificent structures the Basilica of Paullus,[117] which is so marvelous for its columns from Phrygia, the Forum of Augustus, and the Temple of Peace of the Emperor Vespasian Augustus—buildings which are among the most beautiful works the world has ever seen?

Sculpture

Pliny tells us that Vespasian placed in the Temple of Peace many of the works of Greek sculpture which had been looted by Nero (N.H. XXXIV, 84) and also mentions a statue of Venus in it which he describes as being "worthy of the ancients" (N.H. XXXVI, 27). The most remarkable work in the Temple of Peace seems to have been a large figure in Egyptian stone representing the river Nile.

Pliny, N.H. XXXVI, 58: Egypt is also the source of a stone found in Ethiopia which they call *basanites;* it has the color and hardness of iron,

[115] Small portions of the Temple of Peace have been excavated. Its plan has been reconstructed from traces of it on the *Forma Urbis,* the great map of Rome engraved on stone and placed on a wall within the Temple of Peace during the time of Septimius Severus; cf. A. M. Colini, "Forum Pacis," *Bollettino della Commissione Archeologica Communale di Roma,* LXV (1938), 7-40; for a summary in English cf. MacKendrick, *The Mute Stones Speak,* pp. 224-30.

[116] A *iugerum* measured 120 x 280 feet or ⅝ of an acre.

[117] The Basilica of Paullus is another name for the *Basilica Aemilia,* first built in 179 B.C. and later restored by Augustus; cf. pp. 50-51 and 110.

for which reason this name has been given to it.[118] There has never been a larger specimen of it found than that from which the statue representing the Nile,[119] dedicated by the Emperor Vespasian Augustus in the Temple of Peace, was made; playing around the Nile were sixteen figures of children, through which are conveyed the total number of cubits which the river rises at its high flood-point.

It should be remembered that Pliny was a contemporary of Vespasian and that in a sense all the passages in books XXXIII-XXXVII of the Natural History *reflect the attitudes toward and interests in the arts which characterized this era. Pliny, as the previous passage indicates, admired the architectural achievements of his own age, but he seems to have viewed the sculpture and painting of his time as, at least in their technical aspects, degenerate. His opinion about the art of bronze-casting in his own age has already been presented in connection with the sculptor Zenodoros (see pp. 144-145). In the following passage he expresses it in a more general way.*

Pliny, *N.H.* XXXIV, 5: There was a time when bronze used to be alloyed with gold and silver, and even so the artistry was considered more precious [than the metal]. But nowadays it is uncertain which is worse, the artistry or the material, and it is a marvel that, while the prices of works have increased *ad infinitum,* real competence in the art has died out. And now, like everything else, this art is practiced for the sake of profit, while, when it originated, it was practiced for the sake of glory; for this reason, the art was even ascribed to the gods, and the foremost men of all nations used to seek fame through this path; but now the art of casting precious works of bronze has so declined, that for a long time not even luck has been able to produce artistic merit.[120]

Painting and Decoration

Pliny, *N.H.* XXXV, 20: After him [Pacuvius; see p. 52] painting was not looked upon as a suitable occupation for respectable hands, unless perhaps one wishes to make note in our own time of Turpilius, a man of equestrian rank from Venetia, whose beautiful works may be seen in Verona. This man painted with his left hand, a fact which is recorded

[118] Pliny connects *basanites* with *basanos,* "touchstone." It is identified as a kind of velvety jasper by K. C. Bailey, *The Elder Pliny's Chapters on Chemical Subjects* (London 1932), II, 157, but it may be a translation of the Egyptian "bekhen," "graywacke"; cf. A. Lucas, *Ancient Egyptian Materials and Industries* (4th ed., London 1962), pp. 419-20.

[119] The appearance of the statue must have been similar to the famous figure of the Nile in the Vatican; cf. M. Bieber, *The Sculpture of the Hellenistic Age* (rev. ed., New York 1961), fig. 407.

[120] ". . . has been able to produce artistic merit" = *ne fortuna quidem in ea re ius artis habeat,* literally "not even luck has the right of art in this matter."

of no previous artist. Titedius Labeo, a former praetor who died recently in extreme old age and who once even served as the proconsul of the province of Gallia Narbonensis, used to take great pride in his own miniature paintings, but the ridicule directed at him for this bordered on invective.

Pliny, *N.H.* XXXV, 120: After him [Famulus; see p. 146] in esteem were Cornelius Pinus and Attius Priscus, who painted the temples of Honor and Virtue when they were restored by the Emperor Vespasian Augustus; Priscus was rather similar [in style] to the ancient painters.

In spite of these artists Pliny felt that both decorative and portrait painting in his own time were degenerate.

Pliny, *N.H.* XXXV, 2-5: . . . First let us say what remains to be said about painting, an art which was once renowned—at the time when it was zealously sought after by kings and nations—and conferred renown on others whom it considered worth transmitting to posterity; but now it has been completely driven out by marbles, and recently, indeed, even by gold, not only to the extent that entire walls are covered [with these materials] but even to the extent that there is engraved marble and marble inlaid with wavy patterns which form figures of objects and animals. Panels or stretches of wall in the bedroom which represent an expanse of mountains are no longer pleasing. Now we begin even to paint the stone. This custom was invented during the principate of Claudius, while during the time of Nero the technique of varying the monotony by implanting markings which did not exist in the natural surface of the stone developed, so that Numidian marble was given oval-shaped markings, and Synnadic [Phrygian] marble was characterized by purple, just as the taste for luxury would have wanted them to be by nature. These are the reserves we have when the mountains fail to sustain us, and luxury never ceases to arrange it so that as much as possible may perish when there are fires.

The painting of portraits, by which the closest possible likenesses of deceased persons used to be handed down from age to age, has also died out completely. Bronze shields with silver surfaces and with only the vague outlines of human faces are now set up. The heads of different statues are substituted for one another, a practice about which sarcastic poems were common in the past. To such an extent do they prefer to draw attention to the material rather than to be recognized themselves! And amidst all this they fill up [121] their picture galleries with old pictures and they collect portraits of total strangers, while as far as they themselves are concerned, they reckon that there is no honor unless it has a price, since their heir would break up [their own statue] and drag

[121] Reading *complent,* as suggested by Mayhoff.

it out of the house with a rope.[122] Consequently, since nobody's portrait lives on, they leave behind portraits of their money, not of themselves. The same people also decorate their wrestling-courts with portraits of athletes and likewise their anointing rooms; [123] moreover, they display throughout their bedrooms and carry around with them the portrait of Epicurus.[124] They even sacrifice on his birthday, and they celebrate a festival in honor of him which they call the *eikas* [twentieth day]—and this is most true of those who supposedly wish to be unnoticed while they live. This then is the way things are: idleness has sent the arts to perdition, and because there are no portraits of our spirits, our bodies are neglected.

Titus: A.D. 79-81

During the short reign of Titus a second great fire caused destruction on a scale which rivaled that of the great fire during the time of Nero.

Dio Cassius LXVI, 24, 1-3: In the following year [A.D. 80] another fire on the surface of the earth [125] spread over much of Rome while Titus was away from the city dealing with the disaster which had occurred in Campania. The fire destroyed the temple of Serapis, the temple of Isis, the *Saepta*, the temple of Neptune, the baths of Agrippa, the Pantheon, the *Diribitorium*, the theater of Balbus, the stage-front of the theater of Pompey, the buildings of Octavia with their books, and the temple of Jupiter on the Capitoline along with the surrounding temples.[126] The disaster thus was apparently not of human but of divine origin. For from the buildings which I have enumerated, anyone can form a notion of how many were destroyed.

Suetonius, *The Divine Titus* VIII, 4: During the burning of the city Titus made no public statement other than a comment to the effect that he was ruined, and he set aside the ornaments of his country houses for

122 The language of this sentence is obscure and open to a variety of interpretations. The final part may also mean "they themselves value portraits for nothing except their price, and the result is that their heir breaks them up . . . etc."

123 Or, according to Mayhoff, "they decorate their anointing place with portraits of athletes of the wrestling-court" (reading *palestrae* for *palestras*).

124 The Greek philosopher Epicurus (c. 342-270 B.C.) held that happiness was to be found by retiring from the world as much as possible and, as he put it, "living unnoticed." This of course contradicted the venerable Roman view that the proper end of life was to achieve an honorable fame which would be remembered by posterity. Pliny associates the decline of an interest in ancestor portraits with the rise of the Epicurean attitude.

125 As opposed to the eruption of Vesuvius in 79 B.C. which could be considered an underground fire.

126 With the exception of the Jupiter temple, the buildings in question were all in the *Campus Martius*.

use on the [reconstructed] public buildings and temples; he also put several men from the Equestrian Order in charge of the rebuilding, by which appointments he was insured that everything would be done with unusual promptness.

Titus also completed the Colosseum and built new baths near it.

Suetonius, *The Divine Titus* VII, 3: He yielded to none of his predecessors, however, in munificence; when, for example, he dedicated the amphitheater and the baths which he had hurriedly built near it, he gave a gladiatorial show which was of the utmost magnificence and lavishness. He also put on a naval battle in the old *Naumachia*,[127] and again, in the same place, a gladiatorial combat and, in a single day, [a show with] five thousand wild animals of every variety.

The dedication and opening of the Flavian amphitheater by Titus in A.D. *80 was celebrated by the poet Martial with a little book of poems about the spectacles which were given in the arena. One of these conveys the appearance of Rome after the Flavians had finished obliterating most of the monuments of Nero.*

Martial, *de Spectaculis* II: Here where the glittering solar colossus views the stars more closely and where in the central road lofty machines [128] grow up, the hateful hall of the beastly king used to radiate its beams, at the time when a single house used to occupy the whole city. Here where the mass of the conspicuous and revered amphitheater rises up, the pools of Nero once stood.[129] Here where we marvel at that swiftly built donation, the baths,[130] an arrogant field had deprived the poor of their homes. Where the Claudian portico [131] spreads its shade afar, the farthest part of the palace came to an end. Rome is restored to herself, and under your direction, O Caesar, those delights now belong to the people which once belonged to the master.

The most famous monument connected with the name of Titus today is the arch on the Via Sacra *at the east end of the Forum. The arch of Titus (which actually seems to have been built by Domitian in*

127 An amphitheater built by Augustus near the Tiber on its north side. It could be flooded for sea battles.

128 "Machines" = *pegmata*, could also refer either to mechanical devices which were part of the standard equipment of the amphitheater or to cranes, etc., which were being used for the erection of new buildings.

129 The *stagna*, "pools" or "marshes," on the grounds of the Golden House were filled with concrete to form the foundations of the amphitheater.

130 The baths of Titus.

131 The *Porticus Claudia* seems to have been part of the temple of the Divine Claudius on the Caelian; on the latter cf. Nash, *Pictorial Dictionary*, I, 243-48.

memory of Titus) is not mentioned in the literature, but the event which it commemorated, the triumphal procession of Titus and Vespasian following the sack of Jerusalem, is described by the Jewish historian Josephus.

Josephus, *Jewish War* **VII, 5, 132 ff.:** It is impossible to give a worthy description of the great number of splendid sights [which were in the procession] and of the magnificence which occurred in every conceivable form, be it works of art, varieties of wealth, or natural objects of great rarity. For almost all the wondrous and expensive objects which had ever been collected, piece by piece, from one land and another, by prosperous men—all this, being brought together for exhibition on a single day, gave a true indication of the greatness of the Roman Empire. For a vast amount of silver and gold and ivory, wrought into every sort of form, was to be seen, giving not so much the impression of being borne along in a procession as, one might say, of flowing by like a river. Woven tapestries were carried along, some dyed purple and of great rarity, others having varied representations of living figures embroidered on them with great exactness, the handiwork of Babylonians. Transparent stones, some set into gold crowns, some displayed in other ways, were borne by in such great numbers that the conception which we had formed of their rarity seemed pointless. Images of the Roman gods, of wondrous size and made with no inconsiderable workmanship, were also exhibited, and of these there was not one which was not made of some expensive material. . . . [Animals and several groups of captives followed. After these came a series of very large floats in the form of stages, upon which scenes from the Jewish War were illustrated either by human actors or by statues of some kind.] The rest of the spoils were borne along in random heaps. The most interesting of all were the spoils seized from the temple of Jerusalem: a gold table weighing many talents, and a lampstand, also made of gold, which was made in a form different from that which we usually employ. For there was a central shaft fastened to the base; then spandrels extended from this in an arrangement which rather resembled the shape of a trident, and on the end of each of these spandrels a lamp was forged. There were seven of these, emphasizing the honor accorded to the number seven among the Jews.[132] The law of the Jews was borne along after these as the last of the spoils. In the next section a good many images of Victory were paraded by. The workmanship of all of these was in ivory and gold. Vespasian drove along behind these and Titus followed him; Domitian rode beside them, dressed in a dazzling fashion and riding a horse which was worth seeing.

[132] The seven-branched candlestick and other objects from the temple in Jerusalem may still be seen depicted on one of the reliefs on the inside of the arch of Titus. Cf. Nash, *Pictorial Dictionary*, I, 133-35; Kähler, *The Art of Rome and her Empire*, p. 125.

*The connection of the arts with the more personal aspects of Titus'
life is conveyed by the following passage:*

Suetonius, The Divine Titus II: [When Britannicus drank the poison
prepared for him by Nero] it is believed that Titus, who was reclining
next to him at the table also tasted it, and hence he was afflicted by
serious illness for a long time. Later on, mindful of all these things, he
set up a golden statue in his [Britannicus'] honor on the Palatine; he also
dedicated another statue, an equestrian figure in ivory, which even today
is carried in procession through the Circus, and followed it in procession.

Domitian: A.D. 81-96

Public and Private Buildings

Suetonius, Domitian V: He restored many of the grandest buildings
which had been destroyed by fire, among which was the Capitolium,[133]
which had been burned again [A.D. 80], but all the buildings bore his
name alone, and there was never any mention of the original builder.
He also built a new temple on the Capitoline in honor of Jupiter *Custos*
["the Guardian"] and also the forum which is now called the "Forum of
Nerva"; likewise a temple of the Flavian family, a stadium,[134] an odeum,
and a *naumachia;* the stone used on this last was later used to rebuild the
Circus Maximus when both of its sides were destroyed by fire.

*Domitian's reconstruction of the temple of Jupiter Optimus Maxi-
mus on the Capitoline was the last major restoration of the ancient
shrine. Its history is neatly summarized by Tacitus.*

Tacitus, Histories III, 72: This was the most lamentable and disgrace-
ful crime to affect the Roman state since the founding of the city. There
was no external enemy; the gods, had it only been made possible by our
morals, were ready to be propitious; and yet the seat of Jupiter *Optimus
Maximus,* founded with the proper auspices by our ancestors as a pledge
of empire—a temple which neither Porsenna, when the city was sur-

133 Cf. also Suetonius, *Domitian* VIII, 5, where Suetonius relates that Domitian,
in order to avoid a sacrilege, destroyed a tomb built by one of his freedmen from
stone which had been intended for the temple of Jupiter.

134 The temple of the Flavian family is perhaps the temple of Vespasian and
Titus, of which three columns still stand at the west end of the Forum, although
Suetonius tells us that Domitian also converted the house of the Flavian family into
a temple (*Domitian* I). Domitian's stadium stood on the site of the present Piazza
Navona, which still preserves the shape of the stadium. Remains of the substructure
of the stadium are still visible in some of the surrounding buildings. On the stadium
cf. A. M. Colini, *Stadium Domitiani* (Rome 1943); on the temple of Titus and
Vespasian cf. Nash, *Pictorial Dictionary,* II, 501-4. On the temple of Jupiter *Custos*
cf. *ibid.,* I, 518-20.

rendered to him, nor the Gauls, when they captured it, were able to desecrate—was destroyed by the madness of emperors. The Capitolium had indeed been burned down before in a civil war, but then it was a crime perpetrated by private individuals. Now it was openly besieged and openly burned—and what were the causes for this clash of arms? What was the price of so great a disaster? The temple continued to stand as long as we fought for our country. Tarquinius Priscus had vowed it during the Sabine war and had laid foundations in the hope that there would be a great expansion in the future, rather than on the basis of what the Roman people, still having only moderate means, could then provide. Subsequently Servius Tullius, aided by the zeal of the allies, continued the construction, and, after him, Tarquinius *Superbus,* having captured Suessa Pometia, used the spoils taken from the enemy to carry on the building. But the glory of the work was reserved for liberty. After the kings were driven out, Horatius Pulvillus dedicated the temple in his second consulship [traditionally 508 B.C.] with such magnificence that the huge wealth which the Roman people later accumulated simply decorated it rather than increased its grandeur. This temple was built again on the old foundations, when, after an interval of 415 years, it was burned down in the consulship of L. Scipio and C. Norbanus [83 B.C.]. The victorious Sulla undertook the task [of rebuilding it], but it was not he who dedicated it. This alone was denied to him by his consistently good luck. The name of Lutatius Catulus [135] held a place among the great works of [Augustus] Caesar down to the time of Vitellius. Then this temple too was burned to ashes.

Domitian's greatest architectural project, however, was a grandiose new palace complex on the Palatine, the Domus Flavia,[136] *which continued to serve as the imperial residence until the seat of the Empire was moved from Rome. There is no precise description of the palace, but some of its grandeur is conveyed by the poet Statius.*

Statius, *Silvae* **IV, 2, lines 18-31** [prose translation]: An august building, and a huge one, distinguished not for a hundred columns but for as many as would be required to support the heavens if Atlas became negligent. The neighboring palace of the Thunderer [Jupiter] stares at it with awe, and the holy powers rejoice that you dwell in a seat of equal dignity. Nor do you make haste to ascend into the great sky. It looms

135 Q. Lutatius Catulus, a conservative senator and opponent of Julius Caesar, dedicated the new temple in 69 B.C. Augustus later carried out extensive repairs on this temple but retained Lutatius' dedicatory inscription (see p. 119).

136 The names *Domus Augustiana* or *Domus Palatina* are applied to the Flavian palace plus all later accretions and alterations. The *Domus Tiberiana* was considered a separate structure. On the *Domus Flavia* cf. G. Lugli, *Roma Antica* (Rome 1946), pp. 486-93, 509-16; P. H. von Blanckenhagen, *Flavische Architektur und ihre Dekoration* (Berlin 1940), pp. 66ff.; H. Kähler, *The Art of Rome and her Empire,* pp. 115-20.

up in such great massiveness, and the effect of its expansive hall is freer than a plain, while its embrace encloses a vast airy space—but all this has less grandeur than its lord. He fills the household and delights it with his mighty spirit. There the Libyan mountain becomes a rival as does the shining stone of Ilium; likewise the great amounts of stone from Syene and Chios become rivals, as do the stones which rival the blue-gray realm of Doris,[137] while Luna is deemed sufficient to support the columns. Far upward goes the view. You would scarcely reach the top with your vision, and when you did, you would think you had come to the ceiling of the golden sky.

Rabirius, the architect of Domitian's palace, is praised in an epigram of Martial.

Martial, *Epigrams* **VII, 56:** Heaven and the North pole,[138] O Rabirius, you have conceived in your pious mind, you who have constructed with miraculous art the palace of the Palatine. If Pisa shall be prepared to give a worthy temple to Pheidian Jupiter, she will seek from our own Thunderer these hands of yours.[139]

Martial also lavishes praise on the palace itself.

Martial, *Epigrams* **VIII, 36:** Laugh, Caesar, at those kingly wonders, the pyramids; now barbaric Memphis is silent about the great work of the East: for the Mareotic [Egyptian] labor constitutes only a small part of the great Palatine halls. The day looks over the whole earth and sees nothing more brilliant. You might believe that the seven hills were rising up together. Ossa when it carried Thessalian Pelion was not so high.[140] It pierces so far into the atmosphere that, concealed among the twinkling stars, its apex, above the tempest, resounds with the thunder of the cloud below, and is satiated with the mysterious force of Phoebus before Circe sees it on the boundary of the world where her father rises.[141] Yet this palace, Augustus,[142] which forces back the stars with its peak and is equal to the heavens, is nevertheless less than its lord.

137 Doris, the wife of Nereus; in other words, "the sea."

138 Apparently a reference to a domed roof within the palace.

139 The Pisa referred to here is the town in Elis which included Olympia within its territory; the "Thunderer" refers to Domitian.

140 Ossa and Pelion are mountains in Thessaly. During the war between the gods and the giants, the giants piled one mountain on top of the other in order to reach the heavens.

141 For those unaccustomed to ancient hyperbole: "The palace was so high that the sun's rays reached it before they reached the realm of Circe, daughter of the Sun, who lived near the easternmost boundary of the world."

142 "Augustus" = Domitian. The title of "Augustus" was held by every Roman emperor except Vitellius.

For other epigrams in a similar vein cf. Martial, Epigrams *I, 70,*
IX, 13; IX, 79; XII, 15.

The names of certain portions of the palace are known from other
brief references. For example, the rooms at the southwest corner, ad-
jacent to the large peristyle courtyard, are probably to be identified with
the Sicilia *and the* coenatio Iovis, *"dining room of Jupiter" (Historia*
Augusta, Pertinax XI, 6).

According to a questionable anecdote preserved by Suetonius,
Domitian had the porticoes of the palace lined with the shiny stone
called phengites (see p. 144) which was intended to provide a mirror-like
surface by which he could see any potential assassins who might steal
up behind him (Suetonius, Domitian *XIV, 4).*

Sculpture

A large equestrian statue of Domitian in the Forum is described
in an effusive poem by Statius. The statue, erected in A.D. *91, stood in*
the Forum between the Basilica Aemilia *and the* Basilica Iulia *opposite*
the temple of the Divine Julius.[143]

Statius, *Silvae* **I, 1** [excerpts] **(lines 1-16):** What is this massive form,
doubled by the colossus surmounting it, which stands in and embraces
the Latin [Roman] Forum? Did the work fall in finished form from
heaven? Was the statue shaped in Sicilian furnaces, and did it leave
Steropes and Brontes exhausted? Or did the hands of Pallas model your
statue for us, O Germanicus, holding the reins as you did when the
Rhine and the steep home of the astonished Dacian saw you?[144]

Now let fame of an earlier time marvel at the Dardanian [Trojan]
horse, renowned through the ages, for which Dindymon gave up its
sacred crown and Ida was shorn of its foliage. This [Domitian's] horse
Pergamon [Troy] would never have received within the walls which
were torn open nor could that mixed crowd of boys and unwedded girls,
nor even Aeneas nor mighty Hector have drawn it. Besides, that [Trojan]
horse caused harm, for it contained the raging Achaeans. But a gentle
horseman has control of this horse. That visage is a joy to behold which
blends the marks of war with the quiet peace which it oversees.

(Lines 32-51) You yourself, however, with your lofty head surrounded
by the pure air, shining resplendently above the temples, seem to be
looking into the distance to see if the new Palatine palace, showing its
contempt for the flames, is rising with even greater beauty, or to see if

143 On its remains, cf. Nash, *Pictorial Dictionary*, I, 389-90.

144 Brontes and Steropes were Cyclopes who served as assistants to Vulcan in his
workshop. Cf. Vergil, *Aeneid* VIII, 425. The statue commemorated Domitian's military
expeditions against the Chatti and against Decebalus and the Dacians.

the Trojan fire keeps the silent watch with its torch, or if Vesta is now praising her ministrants who have been put to the test.[145] Your right hand forbids battles; the Tritonian maiden [146] is not too great a burden for your left hand as she holds out the severed head of Medusa. As if a goad, she urges the horse onward. Never, anywhere, was the chosen resting place of the goddess sweeter; nor would it be even if you, O Father [Jupiter] held her. Your chest is such as might be able to solve the problems of the world, the chest on which Temese exhausted herself by giving all the metals of her mines; a *chlamys* [147] hangs down over your back; great Orion, with a blade as large as this, makes threatening gestures throughout the winter nights and terrifies the stars. And the steed, imitating the true equine stance and spirit, tosses its head rather sharply and threatens to break into a run. The mane on its neck is standing on end, a vital force pulses through its shoulders, and its flanks swell to a width sufficient for such great spurs; instead of a clod of empty earth the bronze hoof treads upon the hair of the captive Rhine.[148]

(Lines 84-94) Let that horse yield which stands opposite the temple of Latian Dione [149] in Caesar's Forum, the one which you, Lysippos, with great daring, are said to have made for the ruler at Pella and which later bore the admired face of Caesar on its neck,[150] for scarcely would you discover with your wearied vision how far down one must look to that statue from this. Who is there who is so crude as to deny, when he will have looked upon both, that the distance between the rulers is as great as that between the horses? [151]

This work fears not the rainy storms of winter, nor the triple fire of Jupiter, nor the onrushing forces of the prison of Aeolus, nor even the passage of years. It will stand for as long as the earth, and the heavens, and the Roman day endure.

[145] Domitian at one time punished one of the Vestal Virgins for immoral behavior (Suetonius, *Domitian* VIII). The "Trojan fire" is the hearth fire of Rome, which was thought to have been brought to Rome from Troy by Aeneas. It was tended by the Vestal Virgins.

[146] The Tritonian maiden is Athena, or, in Roman terms, Minerva.

[147] Temese: a place mentioned in the *Odyssey* (I, 184) which had productive copper mines. It is possibly to be identified with Temesa on the west coast of Bruttium. A *chlamys* is the short traveling cloak worn by a Greek soldier. The presence of obviously Greek elements in the statue suggests that it was perhaps modeled on the equestrian statue by Lysippos which Statius later refers to.

[148] Presumably a statue personifying the Rhine was placed beneath the hoof of the horse. The motif was not uncommon in Roman art; cf. R. Brilliant, *Gesture and Rank in Rôman Art* (New Haven 1963), pp. 96-97.

[149] Latian Dione = Venus *Genetrix*.

[150] *Caesaris ora mirata cervice tulit*. The ruler at Pella is Alexander the Great. Presumably Caesar brought an equestrian statue of Alexander by Lysippos to Rome and put his own head on the statue.

[151] The point of this innocuously repulsive sycophancy is that Domitian's greatness as a ruler exceeds that of Caesar in the same proportion as his statue is larger than (or stands higher than) that of Caesar.

Martial, in a pair of epigrams, mentions a statue of Domitian as Hercules in a temple on the road between Rome and Aricia.

Martial, *Epigrams* IX, 64: Having deigned to descend to the face of great Hercules, Caesar gives a new temple on the Latian Way, where, as he goes toward the wooded realm of the goddess of the Three Ways [Diana], the traveler reads the eighth marble milestone from the ruling city. . . .

IX, 65: Alcides, now acknowledging the rule of the Latian Thunderer, after taking on the fair face of Caesar the god . . .[152]

Suetonius, *Domitian* XIII, 2: He permitted no statues to be set up in his honor unless they were of gold and silver and were of a certified weight. He also built so many arcades and arches, complete with the insignias of triumphs, throughout all the regions of the city that on one of them someone added the following inscription in Greek: *"Arci."* [153]

Domitian suffered a damnatio memoriae after his death, and most of his statues were defaced or destroyed. Procopius, Anecdota ("Secret History") VIII, 18-21, tells a story to the effect that the only statue of Domitian left in Rome was one which his wife had set up after his death; in order to provide the sculptors with a model for the statue, she was forced to piece together again the emperor's dismembered body. Domitia was one of the moving forces behind the emperor's assassination, and the anecdote is undoubtedly fantastic.

THE "FIVE GOOD EMPERORS" AND COMMODUS

After the death of Domitian the Senate, for the first time since the founding of the Empire, was in a position to make a free choice of a new *Princeps*. It chose one of its own elder and highly respected members, M. Cocceius Nerva. The high-mindedness and moderation of Nerva's reign, symbolized by the theme *libertas publica* on his coinage, ushers in an era of civil harmony, prosperity, and imperial expansion, an era which saw both the high-point of the Empire and the incipience of its fall.

Nerva had the confidence of the civilian population but exercised almost no effective control of the military, and when the Praetorian Guard demanded revenge upon Domitian's assassins, it seemed for a time as if the chaos of A.D. 69 might repeat itself. But Nerva, with wisdom and political adroitness, forestalled a military coup by adopting as co-regent M. Ulpius Traianus, the governor of Upper Germany and a respected military commander. After the death

152 Alcides = Hercules; Latian Thunderer = Jupiter.
153 Presumably a pun on *arkei*, "it is sufficient," in Greek, and on *arcus*, "arch," in Latin.

of Nerva in A.D. 98, Trajan succeeded him without incident, and the deceased emperor, his reputation untarnished and his memory revered, was deified by decree of the Senate.

Trajan was born in Spain, and although his father had held the consulship, his family, like that of Vespasian before him, was relatively unknown. He seems to have possessed a unique combination of personal forcefulness, by which he controlled the army, and humane moderation, which endeared him to the Senate. Together they won him the title *Optimus Princeps*. His civil and provincial administrations were marked by an enlightened efficiency, the spirit of which can be appreciated from his letters to the younger Pliny. But it was as a conqueror, the commander who extended the borders of the empire to their outermost limits, that Trajan was and is primarily remembered. His two great campaigns against Decebalus and the Dacians in A.D. 101-102 and 105-106 resulted in the acquisition of Dacia as a Roman province. The booty from the Dacian Wars not only financed Trajan's building program in Rome but even made possible large contributions of money *(congiaria)* to the citizenry. Even more ambitious, but only temporarily successful, was his campaign in the East, beginning in 113, against the Parthians. In the process of punishing the Parthian king for having interfered with the Roman vassal in Armenia, he not only reasserted control over Armenia but also invaded Mesopotamia and seized the Parthian capital at Ctesiphon. His death in Cilicia in A.D. 117, however, occurred before these gains could really be consolidated.

Trajan himself had risen to the principate on the basis of personal merit rather than familial relationship, but whether or not this principle was applied in the choice of his successor, P. Aelius Hadrianus, is uncertain. Hadrian was a distant relative as well as the ward of Trajan and had held important military and civil posts under the emperor, but there is some doubt as to whether he was ever formally designated as the successor. His adoption by Trajan was announced only after the latter's death, but the fact of it was confirmed by Trajan's wife Plotina, who had always favored Hadrian over Trajan's leading generals and advisors. Shortly after Hadrian's accession had been ratified by the Senate a plot against the new emperor's life was formulated by four of Trajan's generals, but it was discovered, and the conspirators were quickly put to death by the Senate. Returning to Rome from the East, Hadrian won the favor of a wary populace by public gifts and shows; then, in A.D. 120, feeling that his position was secure, he set out for an extensive tour of the provinces which lasted until 127. Following a second brief stay in Rome he set out again in A.D. 128 for another tour of Athens and the eastern and African provinces. In the later years of his reign, from A.D. 131 until his death in 138, he spent most of his time at his villa at Tibur (Tivoli) surrounded by buildings which recalled his travels in the provinces. No previous emperor had ever paid less attention to Rome. As a Spaniard by birth and a Greek by emotional and intellectual disposition, Hadrian appears to have identified himself with the empire as a whole more than with the founding city. It was perhaps for this reason that he abandoned the aggressive expansionism of Trajan and concentrated on strengthening and solidifying the imperial boundaries against barbarian aggression. In drawing a definite line between civilization and barbarism and decreeing that there should be a limit to outward expansion, Hadrian introduced a new attitude toward foreign policy. The function of Rome's military power now became not so much to conquer as to defend. It may be that to this most complex of emperors—a good soldier, an efficient administrator, but at the same time a poet, architect, and philosopher, a man imbued with a sense of historical nostalgia and a consciousness of the virtues of many cultures—the Roman imperialism of the past five hundred years seemed a little naïve and crude.

Hadrian at first adopted L. Aelius Verus as his successor, but when Aelius died in A.D. 138 shortly before the emperor himself, he adopted a senator named T. Aurelius Antoninus, later surnamed "Pius." Antoninus in turn was to adopt one of Aelius' sons, Lucius Verus, and one of his own nephews, Marcus Aurelius, as his successors. Descended from an old Roman family, modest by nature, beneficent in his intentions, deferential to the Senate, efficient and conscientious in administration—Antoninus was in every way suited to rule Rome during the period of repose and prosperity which preceded the coming storm of the 3rd century. His principate marked the last period in which Rome and Italy can still be said to be the focal points of power in the empire. The economic and military resources of Italy were in a state of euphoric decay, and it was essentially by tradition rather than by strategic importance that it ruled the empire. The harbingers of future troubles could be seen in the revolts which broke out in Africa, Judaea, and Dacia, as well as in the general restlessness along the frontiers, especially in Germany. But when Antoninus died in A.D. 161, Italy still enjoyed an unparalleled stability, and no emperor was ever mourned with greater sincerity.

Antoninus had felt that Marcus Aurelius alone should succeed him in the principate, but upon his accession, Marcus immediately had Lucius Verus, his adoptive brother, made co-regent. This act of ill-advised charity was characteristic of the austere, ascetic, dedicated emperor who took on the burdens of the principate as a Stoic philosopher was required to take on all the burdens of life—with detachment and self-effacement but also with an unflinching sense of duty. Lucius Verus, by contrast, was fond of ease and looked forward to the pleasures which his position could provide him. Until his death in A.D. 169 from apoplexy, he proved to be only one more among Marcus' many burdens.

Rebellion and chaos in the provinces blighted Marcus' principate from the beginning. In 162 there was a revolt in Britain, the Chatti once again invaded Germany, and the Parthians again took control of Armenia. While his generals were controlling the situation in Europe, Marcus sent an army commanded by Verus against the Parthians. Verus dallied incompetently in Antioch, but gifted subordinate generals, Avidius Cassius and Statius Priscus, pushed the campaign forward. Priscus recovered Armenia while Avidius drove into Mesopotamia and burned Ctesiphon (A.D. 165-166). But this campaign, which had momentarily brought glory to Marcus' reign by restoring the Trajanic boundaries of the empire, ended in tragedy. On its return the army brought with it a pestilence which decimated every province along its route, including Italy. In the wake of this plague new invasions of German tribes—principally the Chatti, Quadi, and Marcomanni—swept across the Danube, overturned the Danubian provinces, and even entered northern Italy (A.D. 167). Between 170 and 174 Marcus personally led an arduous but successful campaign against these tribes and had all but quelled them when the campaign was cut short by the news that Avidius Cassius, whom Marcus had put in control of all the eastern provinces, had revolted and declared himself emperor. With characteristic self-effacement, Marcus offered to yield in favor of Avidius if it should be the will of the Romans, but the assassination of Avidius by a subordinate brought the revolt to a close. Marcus then made a brief visit to the east and an even briefer return to Rome. In 177 he again set out to fight the Marcomanni and other German tribes along the upper Danube. Prior to his departure he had indicated that his son Commodus, now endowed with proconsular and tribunician power, was to succeed him. This abandonment of the principle of adoption followed by his immediate predecessors in favor of hereditary succession was Marcus' last but worst mistake. When he died on campaign in A.D. 180, Commodus immediately abandoned his father's objectives in the provinces, concluded an easy peace, and returned to Rome.

The ancient historians depict Commodus as a maniacal monster who viciously persecuted the Senate and looked to his Praetorian prefects, his freedmen, and even his mistress to implement what little policy he had. Under the delusion that he was Hercules incarnate, he is said to have given performances in the amphitheater in which he wore the costume of Hercules and mimicked the hero's labors. When Rome was temporarily rededicated as *Colonia Commodiana,* even its name had become a temporary victim of his monomania. Whether some elements of a serious policy underlay the seeming lunacy depicted by the historians is now difficult to determine. His personal arrogance, at any rate, eventually became too much even for his closest advisors and his mistress. In A.D. 192 they conspired to have a professional athlete strangle Commodus in his bath.

Nerva: A.D. 96-98

The only monument which commemorated the short reign of Nerva was the Forum Transitorium [154] *between the Forum of Augustus and Vespasian's Temple of Peace. As we have already seen, the forum was actually built by Domitian, but Nerva's name was later attached to it (see p. 160).*

An interesting work dating from the reign of Nerva which is of at least marginal interest for the history of art is the De aquis urbis Romae *of Sextus Julius Frontinus (c. A.D. 40-103), a lengthy technical discussion of the aqueducts of Rome. Frontinus, who had previously served as consul and as governor of Britain, was appointed* curator aquarum *by Nerva in A.D. 97. His exhaustive analysis of the history, dimensions, and capacities of Rome's water supply offers an impressive illustration of the Romans' competence in civil engineering. It is difficult to extract excerpts from such a technical treatise, but the following passage will convey the spirit of efficiency and confident competence which pervades the whole work.*

Frontinus, *De aquis urbis Romae* I, 16-17: With so many indispensable structures for so many water channels compare, for what it's worth, the inert pyramids or the vainly useless but renowned works of the Greeks.

It seemed to me not foreign to my purpose to include also the lengths of the streams of each aqueduct, classed according to the type of structure which it was. For since the greater part of the responsibility of this office consists in taking care of them, the person in charge ought to know which of them require the greater expense. It did not satisfy our own solicitude simply to subject single details to scrutiny. We also took care to have plans of the aqueducts drawn up, from which it is clear where the valleys are and how many there are; also where rivers are traversed, and where underground channels placed on the sides of mountains require more assiduous care for the protection and shoring up of their course. The useful advantage which results from this is that we are

[154] Cf. Nash, *Pictorial Dictionary,* I, 433-38 (s.v. *Forum Nervae*).

able to deal with any problem immediately, as if it were actually before our eyes and we were deliberating while standing beside it.

Trajan: A.D. 98-117

Building Projects

Although Trajan commissioned a number of important architectural projects in Rome, the literary evidence for the monuments of his reign is. limited. The best summary of Trajan's building program is given by Pausanias while describing the statues in the pronaos *of the temple of Zeus at Olympia.*

Pausanias V, xii, 6: There are also statues of emperors, one of Hadrian in Parian marble set up by the cities which form the Achaean confederacy, and one of Trajan, set up by all the Greeks. This latter emperor was victorious over the Getae who live north of Thrace and waged war against Osroës, the descendant of Arsaces, and the Parthians. Of the public buildings which were constructed during his reign, the most worthy of note are the baths [155] which are named after him, the great theater which is completely circular,[156] the building for horse races which stretches out to a length of two stades, and the forum which he built for the Romans; the last is worth seeing on account of its ornamentation and that sort of thing, particularly its roof which is made of bronze.

The Forum of Trajan was the most splendid of all the imperial forums. Further details about it are given by Dio Cassius.

Dio Cassius LXVIII, 16, 3: He also built libraries, and he set up in his forum an extremely large column which both served as his tomb and also provided an indication of the amount of work which had been done on the forum. For since the whole area was hilly, he dug into it to a depth which was equal to the height of the column, and as a result of this operation he was able to build the forum on level ground.[157]

155 Remains of the baths can still be seen on the Oppian built over the subterranean rooms of the Golden House of Nero; cf. *ibid.*, II, 472-77; Crema, *L'Architettura Romana*, pp. 403-5.

156 Identity uncertain. Trajan did build a theater in the *Campus Martius*. This reference was formerly associated with the amphitheater known as the *Amphitheatrum Castrense* (e.g., by Platner and Ashby), but the construction of this building is now put in the 3rd century A.D.; cf. Crema, *L'Architettura Romana*, pp. 548 ff.; Nash, *Pictorial Dictionary*, I, 13-16.

157 Dio Cassius probably derived his information about the excavation of the forum by reading the inscription on the column of Trajan. The libraries in question stood on either side of the column behind the great central *Basilica Ulpia*. On the forum and its buildings, cf. Nash, *Pictorial Dictionary*, I, 450-56; Kähler, *The Art of Rome and her Empire*, pp. 127-38 and 221 (bibliography). On the column cf. K. Lehmann-Hartleben, *Die Trajanssäule* (Berlin-Leipzig 1926); P. G. Hamberg, *Studies in Roman Imperial Art* (Uppsala and Copenhagen 1945), pp. 104-41; 162-72.

The architect of the forum and several other Trajanic buildings was Apollodoros of Damascus, who later worked for and was put to death by Hadrian (see pp. 175-176).

The most vivid impression of the grandeur of the Forum of Trajan is given by Ammianus Marcellinus while describing the Emperor Constantius' visit to Rome in A.D. *357.*

Ammianus Marcellinus XVI, 10, 15-16: But when he came to the Forum of Trajan, a structure which, in my opinion, is unique under the heavens, and a marvel which even wins the acceptance of the divine powers, he stopped in his tracks, astonished, while his mind tried to grasp the gigantic complex, which cannot be described by words and could never again be attempted by mortal men. He abandoned all hope of ever constructing anything of this sort but said that he only wanted to copy, and was able to do so, Trajan's horse which was situated in the middle of the open court of the forum, and which carried the emperor himself. Ormisda, the [Persian] royal pretender, happened to be standing by . . . and responded with a studied remark characteristic of his people: "Before you do that, O Emperor, you should give the command, if you are able, to have a stable built just like this one. For the horse which you intend to make would thus have as much room to move around as this horse which we see here."

Cassiodorus, *Variae* VII, 6, 1: The Forum of Trajan is a wonder to look upon, even after continual viewing.

Dio Cassius neatly sums up the spirit of Trajan's building program.

Dio Cassius LXVIII, 7, 1-2: He spent great sums on wars and equally great amounts on the works of peace, and although he carried out a great many very necessary repairs on the roads and harbors and public buildings, he did not bleed anyone dry for any of these. He was so generous and magnanimous that, when the Circus had fallen into decay, he restored it on a greater scale and in a much more beautiful fashion and then added an inscription saying only that he had made it adequate for the Roman people.

The Younger Pliny's Villa at Laurentum

The life of cultured ease led by upper class, urbanized Romans during the reign of the Optimus Princeps *and their fondness for the picturesque, soothing aspect of the Latian countryside are vividly captured in two letters written by the younger Pliny* [158] *describing his coun-*

[158] C. A.D. 61-114. He was the nephew of the elder Pliny and served as legate in Bithynia (c. 110-12) for Trajan; his correspondence with the emperor is preserved in the tenth book of his letters.

try villas near Rome. One of these (II, 17) describes his villa at Laurentum on the coast of Latium; the other (V, 6) describes a villa in Tuscany. The former is presented here. For reconstructions of both villas and the problems involved in Pliny's descriptions see H. Tanzer, The Villas of Pliny the Younger (New York 1924).

Pliny, Epistulae II, 17 [to Gallus]: You marvel at the extent to which my Laurentinum, or, if you prefer, my Laurens delights me. But you will cease to marvel when you come to know the charm of the villa, the advantageous nature of the place, and the extent of the seacoast. It is situated seventeen miles from Rome, so that after accomplishing those tasks which must be attended to and having passed a constructive day [in Rome], you could come here to stay. It may be approached by more than one road. Both the Via Laurentina and the Via Ostiensis get you to the place, but on the Laurentina you must turn off at the fourteenth milestone, and on the Ostiensis at the twelfth. Both roads are sandy for a certain part of the way and are hence difficult and long for those in a coach but brief and easy for one on horseback. The aspect of the country varies from place to place. In one area the road is hedged in by woods and in another area it opens up and spreads out in broad meadows. There one finds many flocks of sheep and many herds of horses and cattle, which, after being driven from the mountains by winter, grow sleek from grazing and from the vernal warmth.

My villa is roomy enough for the uses to which I put it, but the maintenance of it is not costly. The atrium at the entrance of it is simple but not vulgarly so; leading from there is a portico laid out in the form of the letter D, which encloses a rather small but cheerful area. This provides a remarkable little refuge against storms; for it is protected by transparent windows and even more effectively by the overhanging eaves of the roof. Opposite the middle of the portico is a cheerful inner court [cavaedium], and after this there is a quite beautiful dining room [triclinium] which runs out to the seashore; and if ever the sea is stirred by the African wind, the dining room is lightly washed by the final breaking of the waves. On all sides it has folding doors or windows no smaller than the doors, so that from the sides and the front the effect is as if one were looking out over three seas; from the back the view consists of the open court, the portico, the open area, the portico at the rear [in the D-shaped area], and finally the atrium, after which it is closed by the distant mountains.

On the left of this room, a short distance away from it, there is an ample-sized living room [cubiculum] [159] and, after that, another smaller room which has one window looking east and another facing west; this also has a view of the sea but is somewhat farther from it and hence

[159] Cubiculum most often means a bedroom, but its general meaning is simply "chamber," and it can also refer to a drawing room or living room.

more secure. An angle of exposure to the sun is formed by this living room with the dining room mentioned previously, an angle which holds and intensifies the most wholesome sunlight. This is my winter retreat and also serves as a gymnasium for my household. There all the winds are silent except those which bring on clouds and must carry away the fair weather before they destroy the usefulness of the place. An apsidal drawing room, which, by its windows, follows the course of the sun, is joined to the angle. Inserted into its wall is a chest in the form of a bookcase which contains books which must not simply be read but must be lived with.[160] Attached to this is a bedroom which is reached by a transitional passageway which, being constructed so that it is suspended over pipes, directs and administers healthfully moderated heat to one place and another. The remaining part of this wing of the house is designated for the use of my slaves and freedmen, but many are presentable enough so that they can be used for receiving guests.

In the other wing of the villa there is another very refined drawing room, after which comes another such room which serves as either a large drawing room or a small dining room. This room is brightly illuminated by the sun, and equally brightly by the sea. After this there is a drawing room with an antechamber which makes a good summer room because of its altitude, and a good winter room because it is protected. For it is sheltered from all winds. To this drawing room and its vestibule another similar unit is joined by a common wall. Thence you go into the bath by entering the spacious and lavish cold-water room [*frigidarium*], on the opposing walls of which two cold plunge-baths curve outward as if they were being pushed; these are more than sufficient, if you keep in mind that the sea is nearby. Adjoining this is the anointing room [*unctorium*], the heating installation [*hypocauston*], and adjacent to the regulating room [*propnigeion*] are the two bathing rooms which are refined rather than sumptuous. Connecting with these is a warm pool which is marvelously constructed; from it those who are swimming have a view of the sea. Not far from this is the *sphaeristerium*,[161] which is turned so as to catch the sun at the hottest time of day. Here a tower rises, beneath which are two living rooms, with a similar number in the tower itself, as well as a dining room [*cenatio*] which looks out on the vast extent of the sea, a great stretch of the coast, and the extremely delightful villas upon it. There is also another tower. In this there is a drawing room in which both the rising and the setting of the sun may be witnessed. Behind this there is an extensive storeroom and a granary, beneath which is a dining room [*triclinium*] which does not experience the pounding of the turbulent sea except in a languid and stifled form. It looks out on the garden and the promenade which the garden encloses.

160 *non legendos libros, sed lectitandos.*
161 *Sphaeristerium,* a place for playing ball. One is reminded of Trimalchio's amusements at the baths (Petronius, *Satyricon* 27).

The promenade is lined with boxwood and, where the boxwood has failed, with rosemary. For the boxwood, in the part where it is protected by the buildings, blooms abundantly; but where it is open to the sky and the wind and, even though far away from it, to the spray of the sea, it withers up. A shady arbor of delicate vines borders on the promenade and forms a secluded passageway, which is soft and yielding even if you walk barefoot. The fig and the mulberry tree grow thickly together in the garden; for this soil is as fruitful for these trees as it is unproductive for other kinds. Here there is a dining room which, though remote from the sea, enjoys a view which is not less impressive than that of the sea. It is bordered at the back by two living quarters, from the windows of which one gets a view of the forecourt of the villa and another fertile and rustic garden.

From here a closed gallery [*cryptoporticus*], which one might almost take for a public monument, stretches out. It has windows on both sides—many on the seaward side and fewer on the side facing the garden, where single windows are paired with every other window on the seaward side. These are all open on days when the weather is fair and calm, but when the wind is blowing on one side [those windows are closed while] those on the side where the winds are quiet remain open without any disturbance. Before the *cryptoporticus* there is an open walk [*xystus*] fragrant with the scent of violets. The *cryptoporticus* increases the warmth here by reflecting the rays of the sun; for as it retains the sun's heat it also slows down and turns away the north wind, to the extent that the warmth is as marked before the wall as the cold is behind it. In the same way it serves as a barrier against the African wind and likewise breaks the force of all the other winds, no matter from what side they come. This is the pleasant effect of the structure in winter; in summer it is even more pleasant. For in the morning it casts its shade upon the *xystus* and in the afternoon upon the nearest part of the promenade and garden; the shadow which it casts is either shorter or longer depending on whether the day is waxing or waning. Moreover, the *cryptoporticus* itself is most free from sunlight when the sun beats most fiercely on its roof. In addition, by means of the open windows, it receives and circulates the western breezes and thus never grows heavy with stifling, stagnant air.

Culminating the *xystus* and *cryptoporticus* complex is a garden-house, my *Amores*; in truth, it is a love affair for me. I placed it where it is myself. In it there is a sunroom [*heliocaminus*], one side of which faces the sea, the other the *xystus* (both sides catch the sun) and also a drawing room which looks out both at the *cryptoporticus* through folding doors and at the sea through a window. Against the middle of the wall there is a very elegantly recessed private chamber [*zotheca*] which, by either drawing back or closing the transparent panes and curtains is either added to or shut off from the *cubiculum*. It holds a couch and two

chairs; at your feet you have the sea, behind are the villas, and from the head [of the couch] are the woods.[162] This many views can both be seen separately through a like number of windows and can also be combined [into one view]. Connected with this is a bedroom for sleeping at night. This room is not disturbed by the voices of the servants, nor the murmur of the sea, nor the commotion of tempests, not even by the flash of lightning; not even, in fact, by the very daylight, unless the windows are open. The explanation for such profound and undisturbed solitude is to be found in an intervening passageway which divides the wall of the chamber from that of the garden, and thus every sound is consumed by the empty space in between. Connected with this *cubiculum* is a very small heating installation which, through a narrow window, either produces or maintains the level of heat, as the occasion demands. From here another *cubiculum* and antechamber are laid out toward the sun so as to catch it just as it rises and to continue to have sunlight, however obliquely, until beyond noon. When I withdraw to this garden-house, I seem to be far from my villa, and I count this as a great delight, especially during the *Saturnalia,* when the remaining part of my estate resounds, owing to the license of those days, with gaiety and clamor. For thus I do not interfere with the sportive diversions of the people of my household nor do they interfere with my studies. . . .

Hadrian: A.D. 117-137

Personality and Tastes

Historia Augusta, Hadrian I, 5: He became so imbued with and earnest about the study of things Greek, and his nature inclined to these subjects to such a degree that he was called by some people the "Greekling" [*Graeculus*].

Historia Augusta, Hadrian XIV, 8-11: He had a passionate interest in poetry and letters. In arithmetic, geometry, and painting he was an accomplished expert. He openly displayed his knowledge of lyre-playing and singing. In his taste for the voluptuous he went to excess, and consequently he composed many verses about the things which delighted him. He also wrote love poems. He was likewise an expert on questions of arms, was extremely well-versed in military affairs, and could even handle gladiatorial weapons. Alternately aloof and friendly, serious and playful, a delayer and a hastener, miserly and generous, cruel and merciful, he was at all times changeable in all things.

Historia Augusta, Hadrian XV, 10: And although he was very gifted in both prose and poetry and was accomplished in all the arts, he never-

162 These are apparently the views one would have reclining on the couch and leaning on one elbow.

theless used to laugh at the professors of all these arts, as if he himself were much more learned, and to treat them with contempt and to disparage them.

Aurelius Victor, *de Caesaribus* **(epitome) XIV, 2:** He devoured the interests and the customs of the Athenians and was a master not only of the literary arts but also of other disciplines, such as singing, playing the lyre, the sciences of medicine, music, and geometry; as a painter, and as a sculptor both in bronze and marble, he approached Polykleitos and Euphranor.

The Hadrianic Building Program in Rome

Historia Augusta, Hadrian **XIX, 9-13:** Although he constructed a vast number of buildings everywhere, he never inscribed his own name on any of them except the temple of his father Trajan. In Rome he restored the Pantheon, the *Saepta,* the basilica of Neptune, a great many sacred structures, the Forum of Augustus, and the baths of Agrippa.[163] All these he dedicated with the names of their original builders. He also constructed a bridge in his own name, a sepulcher on the banks of the Tiber, and a temple of the Bona Dea.[164] Through the skill of the architect Decrianus he raised, while still in a standing position, the colossus [of Nero] and moved it from the spot where the temple of the City [165] now stands; its weight was so enormous that he even had to supply twenty-four elephants for the work. This statue, after removing from it the face of Nero, to whom it had formerly been dedicated, he consecrated to the Sun. He also undertook, with the help of the architect Apollodoros, to make a similar statue of Luna [the Moon].

Dio Cassius elaborates on Hadrian's interesting but unfortunate association with the architect Apollodoros.

Dio Cassius LXIX, 4, 1-5: Hadrian first drove into exile and then put to death the architect Apollodoros who had carried out several of Trajan's building projects—his forum, the odeum, and the gymnasium. The pretext given for Hadrian's action was that Apollodoros had been guilty of some serious offense, but the truth is that when Trajan was at one time consulting with Apollodoros about a certain problem connected with his buildings, the architect said to Hadrian, who had interrupted them with

163 The buildings mentioned date from the time of Augustus (see pp. 104-109) and were burned in the great fires during the reigns of Nero and Titus.

164 Hadrian's sepulcher was the great structure now usually called the Castel Sant'Angelo; cf. Kähler, *The Art of Rome and her Empire,* p. 163; Nash, *Pictorial Dictionary,* II, 44-48. His bridge, the *Pons Aelius,* survives in part as the Ponte Sant'Angelo. The temple of the Bona Dea was on the Aventine.

165 The temple of the City = the temple of Venus and Rome; cf. Nash, *Pictorial Dictionary,* II, 496-99; Kähler, *The Art of Rome and her Empire,* pp. 23, 156-57.

some advice, "Go away and draw your pumpkins.[166] You know nothing about these problems." For it so happened that Hadrian was at that time priding himself on some sort of drawing. When he became emperor he remembered this insult and refused to put up with Apollodoros' outspokenness. He sent him the plan for the temple of Venus and Rome, in order to demonstrate that it was possible for a great work to be conceived without his [Apollodoros'] help, and asked him if he thought the building was well designed. Apollodoros sent a reply saying that, as far as the temple was concerned, it should have been placed in a higher position and that the area beneath it should have been dug out, both so that the temple would have had a more imposing effect on the *Via Sacra* by being raised above it and so that the hollow space beneath the temple could have received the machines. (There they could be put together out of sight and brought into the theater without anyone knowing about it beforehand.) With regard to the cult images he said that they were made on a scale which was too great for the height of the cella. "For if the goddesses should wish to stand up and leave the temple," he said, "they would be unable to do so." [167] When he wrote all this so bluntly, Hadrian was both irritated and deeply pained because he had fallen into an error which could not be rectified; nor did he attempt to restrain his anger or hide his pain; on the contrary, he had the man slain.

THE PANTHEON [168]

This most prominent of all preserved Roman temples, built on the site of the earlier structures of Agrippa and Domitian, is scarcely mentioned in ancient literature.

Ammianus Marcellinus XVI, 10, 14: [Constantius on his visit to Rome in A.D. 357 also saw] the Pantheon, rounded like the boundary of the horizon,[169] and vaulted with a beautiful loftiness. . . .

Hadrian's favorite retreat in Italy was his villa at Tibur (Tivoli), because it was there that he could indulge most freely his artistic and intellectual fancies.

Historia Augusta, Hadrian XXVI, 5: He built up his villa at Tibur in a marvelous manner, and even went so far as to apply the highly renowned

166 Pumpkins = *kolokuntas*. The word implies any kind of ribbed melon or gourd. Apollodoros was referring to Hadrian's fondness for domes. Some of the domes which Hadrian later built at his villa in Tivoli (especially that of the Serapeum in the "Canopus") did, in fact, look as if they might have been molded from some great pumpkin. Cf. S. Aurigemma, *Villa Adriana* (Rome 1961), figs. 80-83.

167 The notion that a cult image should be scaled in a naturalistic way to the dimensions of the temple in which it was placed may derive from the same tradition of "realistic" criticism which Vitruvius applies to painting; cf. pp. 127-129. Strabo (VIII, 353) makes virtually the same criticism about Pheidias' Zeus at Olympia.

168 Cf. Nash, *Pictorial Dictionary*, II, 170-75 (with up-to-date bibliography).

169 *Pantheum velut regionem teretem . . .*

names of provinces and places to [the different parts of] it, such as the Lyceum, the Academy, the *Prytaneum*, the *Poecile* [*Poikilē*], and Tempe.[170] And, in order that he should omit nothing, he even made "infernal regions."

Building Projects in the Provinces

Historia Augusta, Hadrian XX, 4-5: And although he did not like to put his name on his public works, he gave the name Hadrianopolis to many cities, as, for example, Carthage and a part of Athens.[171] He also attached his name to a vast number of aqueducts.

Historia Augusta, Hadrian XI, 2: Thereupon, having instituted reforms in military matters, which was a royal prerogative,[172] he set out for Britain [in A.D. 122], where he corrected many mistakes and was the first to build a wall, eighty miles in length, which divided the Romans from the barbarians.[173]

Historia Augusta, Hadrian XII, 1-3: After arranging affairs in Britain he crossed over to Gaul [in A.D. 122-123]. . . . During this time he constructed a basilica in honor of Plotina at Nemausus [Nîmes], a work of remarkable excellence. After this he proceeded to Spain and wintered at Tarraco [Tarragona], where he restored the temple of Augustus at his own expense.

Historia Augusta, Hadrian XIII, 6: At length, after he had returned to Rome from Africa, he immediately set out for the east by way of Athens, where he finished and dedicated a number of public works which he had already begun for the Athenians, such as the temple of Zeus *Olympios* [174] and an altar to himself; in a like manner, as he made his way through Asia, he consecrated some temples in his own name.[175]

170 The "Lyceum" was named after the gymnasium associated with the philosophical school of Aristotle; the Academy copied, of course, Plato's Academy. The *Prytaneum* and the *Poecile* were modeled on civic buildings in the Agora in Athens. Tempe is the vale between Mount Olympos and Mount Ossa in northeast Thessaly. On these buildings cf. Aurigemma, *op. cit.* (note 166); H. Kähler, *Hadrian und seine Villa bei Tivoli* (Berlin 1950).

171 The area to the east of Hadrian's gate, which still stands in Athens. I. T. Hill, *The Ancient City of Athens* (London 1953), pp. 211-12; W. Judeich, *Topographie von Athen* (2nd ed., Munich 1931), pl. 14.

172 The text for this phrase is problematical.

173 Stretches of the Hadrianic wall, which ran between Newcastle and Carlisle, can still be seen. For a general account of the wall, with illustrations, cf. J. Collingwood Bruce, *Handbook to the Roman Wall* (10th ed., Newcastle upon Tyne 1947); also I. A. Richmond, *Roman Britain* (London 1947), pp. 16-18.

174 On this temple cf. *The Art of Ancient Greece*, pp. 204-5. It was begun in the late 6th century B.C. continued by Antiochos *Epiphanēs* and Augustus (Suetonius, *The Divine Augustus* LX), and finished by Hadrian.

175 These temples were probably dedicated to the imperial cult (hence to Hadrian); the later assertion that they were secretly dedicated to Christ (see p. 199) is fanciful.

Pausanias I, xviii, 9: Hadrian constructed other buildings [in addition to the Olympieion] for the Athenians, including a temple of Hera and Zeus *Panhellenios*, and a sanctuary which was common to all the gods, but most remarkable of all are the hundred columns of Phrygian marble [in the Library of Hadrian]. The walls, as well as the porticoes, are also made of this stone. And there are chambers in it decorated with gilded rooves and alabaster, and also with statues and paintings.[176] In these rooms books are kept. There is also a gymnasium named after Hadrian. And here too there are a hundred columns, this time from the quarries of Libya.

Pausanias VIII, x, 2 [In a sanctuary of Poseidon at the foot of Mt. Alesion, just outside Mantineia]: With regard to this sanctuary, I, like everyone else who has made mention of it, write only what I have heard. The sanctuary which exists today was built by the Emperor Hadrian, who also arranged for overseers to keep an eye on the workmen, so that no one would look into the ancient sanctuary and so that none of its ancient remains should be removed. And he ordered them to build the new temple around [the old one].

Pausanias I, xlii, 5 [at Megara]: The old temple of Apollo was built of brick. Later the Emperor Hadrian built a new one of white marble.

Pausanias I, v, 5: [The Athenians have a tribe named after] the Emperor Hadrian, who in my own time always treated things divine with the utmost respect and who furnished happiness and prosperity in the greatest degree to each of the peoples over whom he ruled. . . . All the sanctuaries of the gods which he built anew, and those which he adorned with votive offerings and furniture, and also those gifts which he gave to the Greek cities as well as those which he gave to some of the barbarians who needed them—all these are inscribed in the sanctuary in Athens which is common to all the gods.

Pausanias also speaks of a temple of Apollo at Abae (X, xxxv, 4) and a portico at Hyampolis (X, xxxv, 6) as being built by Hadrian.

Historia Augusta, Hadrian XIV, 4: He then passed through Arabia and came to Pelusium [in Egypt, in A.D. 130], where he reconstructed the tomb of Pompey on a more magnificent scale.

Dio Cassius LXIX, 11, 1: [Looking at the tomb of Pompey, Hadrian] is said to have uttered this verse:

"For one so weighted down with temples, how great
seems the insufficiency of the tomb!"

And he rebuilt the monument, which was in ruins.

176 On the Library of Hadrian cf. I. T. Hill, *The Ancient City of Athens* (London 1953), pp. 207-9.

Dio Cassius LXIX, 12, 1-2: In Jerusalem [in A.D. 130-131] he founded a city to replace the one which had been razed [by Titus and Vespasian] and named it Aelia Capitolina. Moreover, on the site of the temple of the [Jewish] god, he constructed another temple, this one to Zeus, an action which stirred up a war which was neither small nor quickly terminated. For the Jews deemed it a terrible thing that foreign races of any sort should be established in it. . . .

Sculpture

Among the most prominent examples of Hadrianic sculpture preserved today are the statues of the Bithynian youth Antinoös.[177]

Dio Cassius LXIX, 11, 2: In Egypt [in A.D. 130] he also constructed a city which was named after Antinoös. This Antinoös was from Bithynia, a city in Bithynia which we also call Claudiopolis. He had been an adored favorite of Hadrian and died in Egypt, either by falling into the Nile, as Hadrian writes [in his autobiography], or by being offered as a sacrifice, as the true facts indicate. For Hadrian, as I have said, had among other things an extremely superstitious curiosity and had recourse to all types of divination and prophetic quackery. And so he honored Antinoös, either because of his love for him or because he had willingly gone to his death (the soul had to go willingly in order to achieve what Hadrian had in mind), by founding a city on the spot where he had suffered and by naming it after him [i.e., Antinoöpolis]. He also set up statues of him, or, more properly, cult images [178] of him, throughout what one might almost call the entire inhabited world.

Pausanias VIII, ix, 7-8 [at Mantineia]: Antinoös is also recognized as a god by them. Of all the temples in Mantineia, that of Antinoös is the newest. This person was loved with great ardor by the Emperor Hadrian. I never saw him while he still lived among men, but I have seen him [as a god] in images and in paintings. . . . Mystic rites are observed in honor of him every year, and there is an agonistic festival every four years. There is a chamber in the gymnasium in Mantineia which contains images of Antinoös and is worth seeing, among other reasons, for the stones with which it is adorned and above all for its paintings. There are, among these, portraits of Antinoös, most of them representing him as Dionysos.

Hadrian also set up or collected many other portrait statues.

177 Cf. A. Hekler, *Greek and Roman Portraits* (London 1912), pp. 250-56; for further bibliography cf. *Enciclopedia dell'Arte Antica*, s.v. "Antinoo."
178 One extant statue clearly represents Antinoös as Dionysos, and another perhaps shows him as Osiris; on the former (in the Vatican) cf. A. Hekler, *Greek and Roman Portraits*, p. 255 a, b; on the latter (from Hadrian's Villa) cf. Aurigemma, *op. cit.*, p. 60, fig. 35.

Dio Cassius LXIX, 7, 4: He would often visit his friends when they were ill, would join with them in their celebrations, and would gladly frequent their country estates or their houses. As a result he set up portrait statues in the Forum both in honor of many friends who had died and in honor of many who were still alive.

Historia Augusta, Aelius VII, 1 [after the death of Aelius in A.D. 138]: Hadrian, of course, ordered that colossal statues of Aelius Verus be set up all over the world, and in some cities he even ordered that temples be built.

Suetonius, *The Divine Augustus* VII, 1: That Octavian had the cognomen "Thurinus" I have recorded on the basis of sufficiently reliable evidence, since I once obtained a small bronze portrait of him as a boy with his name inscribed in iron letters, which had almost been worn away with age; this I presented as a gift to the emperor [Hadrian], and it is worshipped among the Lares in his bedroom.

In the provinces which Hadrian visited so often there were many portrait statues of him set up by admiring governments.

Pausanias I, iii, 2: There [in the Agora in Athens] stands a statue of Zeus called *Eleutherios* [Freedom-bringer] and also one of the Emperor Hadrian, who conferred benefits upon all those whom he ruled but especially upon the city of Athens.[179]

Pausanias I, xviii, 6 [statues in the Olympieion in Athens]: Before you go into the sanctuary of Zeus *Olympios*—the Emperor Hadrian was responsible for the temple and also for the image, which is worth seeing; all other cult images, except for the colossi at Rhodes and Rome, fall short of it in size; it is made of ivory and gold and is of very fine workmanship, considering its size—before you enter, as I was saying, there are portrait statues of Hadrian, two in Thasian marble and two in Egyptian stone. In front of the columns stand bronze statues which the Athenians call "the colonies." The whole *peribolos* [circuit of the sanctuary] is about four stades in circumference and is full of statues. For a portrait of the Emperor Hadrian has been set up by each city, and the Athenians have outdone the others by setting up a colossus, well worth seeing, behind the temple.

Pausanias also records seeing a portrait of Hadrian within the cella of the Parthenon (I, xxiv, 7), another in Arcadia set up by the Kynaithaeis

179 The torso of a statue of Hadrian was found during the American excavation of the Agora and is probably identical with the one mentioned by Pausanias; cf. *Hesperia*, II (1933), 178-83, pl. VI.

(VIII, xix, 1), and another in the pronaos of the temple of Zeus at Olympia (see p. 169).

In addition to building temples and other structures in the provinces, Hadrian enriched existing sanctuaries with a variety of votive statues.

Pausanias II, xvii, 6 [at the Argive Heraion]: . . . The peacock dedicated by the Emperor Hadrian is of gold and of gleaming gems. He made the offering because this bird is supposed to be sacred to Hera.

Athenaeus XIII, 574 F [at Melissa in Phrygia]: We too have seen in Melissa a monument of Alcibiades as we approached Metropolis from Synnada. At this place a bull is sacrificed each year; this is done at the command of the Emperor Hadrian, most excellent in all things, who even set up a statue of Alcibiades in Parian marble at the monument.

Antoninus Pius: A.D. 138-161

Public Works

Historia Augusta, Antoninus Pius **VIII, 2-4:** Of his public works, the following still exist: the temple of Hadrian in Rome, dedicated in honor of his father; the *Graecostadium,* which he restored after it burned; the amphitheater which he repaired; also the restoration of the tomb of Hadrian, the temple of Agrippa, the *Pons Sublicius,* and the *Pharus;* [180] the restoration of the ports at Caieta and Tarracina; and the construction of the baths at Ostia, the aqueduct at Antium, and temples at Lanuvium. He also aided many cities with grants of money, so that they could construct new buildings and restore old ones. . . .

Antoninus, like Hadrian, bestowed his benefactions on the provinces as well as on Rome itself. Pausanias describes some of the improvements which he carried out in the sanctuary of Asklepios at Epidauros.

Pausanias II, 27, 6-7: Among the structures which Antoninus, a man of senatorial rank [who later became emperor], built in our own time there are the baths of Asklepios and the sanctuary of the gods whom they call the *Epidōtas* [the Bountiful Ones]. He also made a temple dedicated to Hygieia and to Asklepios and Apollo, who bear the surname "Egyptian."

[180] Parts of the temple of Hadrian still exist; cf. Nash, *Pictorial Dictionary,* I, 457-61; the *Graecostadium* was apparently an open area surrounded by colonnades to the south of the Forum. The amphitheater refers to the Colosseum. The "temple of Agrippa" probably means Hadrian's Pantheon (which carried the dedicatory inscription of Agrippa). The *Pons Sublicius,* the oldest bridge in Rome, crossed the Tiber from the *Forum Boarium.* The *Pharus* refers to the great lighthouse at Ostia built by Claudius; see p. 138.

There was a stoa there called the "Stoa of Kotys," which, when its roof
fell in, went quickly to ruin, since it was made completely of mud-brick.
This building Antoninus also rebuilt. Some of the Epidaurians were
greatly distressed about the sanctuary because their women had no
shelter in which to give birth and because death came to those who were
ill out in the open. He constructed a building to alleviate these problems
too. Here at last was a place where in holy surroundings a man could
die and a woman could give birth.

Above the grove is a mountain called the Titthion and another
called Kunortion, upon which there is a sanctuary of Apollo *Maleas*.
The sanctuary itself is one of the ancient ones. But as for the installations
around the sanctuary of *Maleas*, and particularly the cistern, into which
the water which comes from the god [i.e., rain] is collected, these too
were built for the Epidaurians by Antoninus.

Pausanias, as the preceding passage indicates, was a contemporary
of Antoninus and made the journeys which he records in the Description
of Greece *during Antoninus' reign. In a sense, therefore, his entire work*
may be said to reflect the attitudes and interests of the educated class
of his day. His specific references to contemporary monuments are, how-
ever, relatively few.

Herodes Atticus

One of the contemporaries of Pausanias who did earn a place in the
Description of Greece *was Herodes Atticus (*A.D. *101-177), a wealthy*
Athenian philanthropist who dabbled in literary criticism, rhetoric, and
philosophy. Herodes used his fortune to ornament Greece, and especially
Athens, with monuments which might help to revive her former glory.
The great Odeion (music hall) which Herodes built on the southwest
slope of the Acropolis is still Athens' major outdoor theater.[181]

Pausanias VII, 20, 6: The Odeion [in Patras] in its ornamentation and
in other respects is the most notable in Greece, with the exception, of
course, of the one in Athens. That building, which exceeds all others in
size and in the total number of its fixtures, was built by an Athenian,
Herodes, in honor of his deceased wife. In my book on the monuments
of Attica no mention was made of this Odeion because I had completed
the section on the Athenians before Herodes began his building.

Pausanias I, 19, 6, [in Athens]: A building which is a marvel to those
who see it, but is not equally enticing to those who only hear about it,
is the stadium in white marble. One might infer the size of it from the
following fact: beginning in a crescent shape on a hill above the Ilissos

181 Cf. Hill, *The Ancient City of Athens*, pp. 111-12; P. Graindor, *Hérode Atticus*
et sa famille (Cairo 1920), pp. 92-93; 218-24, figs. 23-26.

it runs in two straight courses down to the bank of that stream. This stadium was built by Herodes, an Athenian, and a great portion of the quarries on Mt. Pentelikon were exhausted in building it.[182]

Pausanias also states that the stadium at Delphi was rebuilt by Herodes in Pentelic marble (X, 32, 1). The fact that this stadium is unusually well preserved and bears not a trace of marble, is one of the foremost enigmas of ancient archaeological literature.[183]

Herodes also dedicated works of sculpture.

Pausanias II, i, 7-8, [in the sanctuary at Isthmia]: There are two images of Poseidon in the *pronaos* [of the temple of Poseidon], a third statue of Amphitrite, and still another of Thalassa [Sea]. The statues in the interior were set up in our own time by Herodes Atticus, the Athenian, including four horses which are gilded except for the hooves. The hooves are of ivory. There are two gold Tritons beside the horses, and in their case, the parts below the waist are made of ivory. Amphitrite and Poseidon stand upon a chariot, and the boy Palaimon is placed upright on the back of a dolphin. These two are made of ivory and gold. In the middle of the base on which the chariot rests there is a relief representing Thalassa holding up the child Aphrodite, and on each side of them are those who are called the Nereids.[184]

Pausanias VI, xxi, 2, [in the sanctuary of Demeter *Chamyne* at Olympia]: In place of the ancient statues of Demeter and Kore new ones in Pentelic marble have been set up by Herodes the Athenian.

Damascius, in Photios, *Bibliotheca* 242, [ed. Hoeschel 1046]: The author says that he once saw an image of Aphrodite set up by Herodes the sophist. He says, when he saw it, "I began to perspire with amazement and shock; I was so overcome in my soul with joy, that I was unable to leave and go to my home. Many times after leaving I would return again to the sight. So great was the beauty which the artist had instilled into the image, a beauty neither sweet nor erotic, but stern and manly."

Marcus Aurelius: A.D. 161-180

The artistic developments of Marcus' reign are poorly documented. We are told that he built a temple to the Divine Antoninus shortly after

[182] This stadium was rebuilt after the ancient plan in 1895 to celebrate the revival of the Olympic games. Pentelic marble was also used in the new stadium, which was once again privately financed (this time by G. Averoff, a latter-day Herodes).

[183] The enigma, of course, invites speculation. Perhaps Pausanias confused his notes on the Athenian stadium with those on the Delphi stadium. Or perhaps he visited Delphi in the heat of the summer and, not wanting to make the arduous uphill climb to the stadium, relied on an exaggerated verbal report.

[184] Pausanias' description does not make clear exactly what was dedicated by Herodes. It may have been the whole group or possibly only the horses and Tritons.

his rise to the principate (Historia Augusta, Antoninus Pius *XIII, 4),*
and that he built another in honor of his wife Faustina after her death
in A.D. 175 (Historia Augusta, Marcus Antoninus *XXVI, 5). Dio Cassius*
LXXI, 34, 3, records that he also built a temple on the Capitoline to a
goddess whose name is given in Greek as Euergesia [185] *and adds that "he*
called her by a name which no one had ever heard before."

 Our information about sculpture during his reign is only a little
more specific.

Historia Augusta, Marcus Antoninus XXII, 7: Many nobles died in this
war, which is called the Germanic, or Marcomannic, or, even more ac-
curately, the "war of all races." He set up statues in honor of all of these
nobles in the Ulpian Forum [the Forum of Trajan].

Dio Cassius LXXI, 31, 1: The Senate voted [in A.D. 176] that silver
portrait statues in honor of Marcus and Faustina [186] should be set up in
the temple of Venus and Rome and that an altar should be established
upon which all the maidens who were married in the city should, to-
gether with the bridegrooms, offer sacrifice. It also decreed that a golden
portrait statue of Faustina should always be carried into the theater on
a chair on every occasion when the emperor was to be a spectator, that
it should be placed in the front box, from which she used to look on when
she was living, and that the women who were of foremost importance
should be seated around it.

 We also hear of a golden statue of Fortuna which Antoninus Pius
kept in his bedroom until shortly before his death, when he passed it
on to Marcus. (Historia Augusta, Antoninus Pius *XII, 5;* Marcus An-
toninus, *VII, 4).*

 When Marcus was a young man, it is recorded that "he also de-
voted some effort to the art of painting under the tutelage of the master
Diognetos" (Historia Augusta, Marcus Antoninus *IV, 9). In his later*
years he continued to admire artists for the steadfast devotion which they
showed for their craft and for their ability to consistently uphold the
principles of their art. A philosopher, Marcus felt, should be able to
apply his reason to the nature of things (physis) *with the same stead-*
fastness and consistency. This Stoic's view of the value of the arts and
artists is derived from a series of personal musings which Marcus wrote
in Greek during his northern campaigns. The ancient title of the work,
if it had one, is not known, but Meditations, *the title which has come to*
be associated with it by later tradition, is apt.

 [185] The Latin equivalent is perhaps *Indulgentia* (Platner and Ashby) or *Liber-*
alitas.
 [186] Faustina the Younger, daughter of Antoninus Pius and wife of Marcus
Aurelius. She died in A.D. 175 while accompanying Marcus on his tour of the eastern
provinces.

Marcus Aurelius, Meditations VI, 35: Do you not see how ordinary craftsmen accommodate themselves, up to a point, to [the opinions of] laymen, but hold fast nevertheless to the rational basis of their art, and cannot endure to deviate from it? Is it not a terrible thing, if the architect and the doctor respect the rational basis of their particular arts more highly than man respects his own reason, which he shares in common with the gods?

In Meditations V, 1, 2, Marcus repeats the same ideas in a more personal vein. He confesses that he has always found it difficult to get out of bed early in the morning and urges himself to show the same intensity in mastering his own nature that artists show in mastering their art. "Others," he notes, "in their devotion to their arts, wear themselves to the bone, and immersing themselves in their tasks, go without washing or eating. But you respect your own nature less than an engraver [torcutēs] respects his engraving."

But in spite of his respect for artists, Marcus elsewhere adheres to the well-established principle of most ancient philosophers that art's principal function is to imitate nature and that it is therefore inferior to nature (Meditations XI, 10).[187]

Commodus: A.D. 180-192

Public Works

Historia Augusta, Commodus Antoninus XVII, 5-7: No public building of his is now in existence, except for the bath which Kleander [the Praetorian prefect] built in his name, but he did inscribe his name on works built by others; the Senate later erased it in each case. In fact, he did not even complete the works begun by his father.

Sculpture and Painting

Dio Cassius LXXII, 22, 3: [Commodus saw himself as a gladiator]. And no one should disbelieve this. For he cut off the head of the colossus [188] and replaced it with another which bore his own features. He also gave it a club and put some kind of bronze lion beneath it so that it would resemble Hercules; then he inscribed on it, in addition to the titles by which he was usually designated, this phrase: "Champion of the *secu-*

187 For the classic statement of this view cf. *The Art of Ancient Greece*, pp. 231-3; on the exceptions, cf. *ibid.*, pp. 223-4.

188 Cf. also *Historia Augusta, Commodus Antoninus* XVII, 9-10, where it is said that the head removed by Commodus had the features of Nero. This is a slight inaccuracy since, as we have already seen, the colossus of Nero was remodeled into a statue of the Sun by Vespasian (or Hadrian, or both); cf. pp. 144, 153 and 175.

tores,[189] the only left-handed gladiator to overcome a thousand" (I believe that was the number) "opponents twelve times."

***Historia Augusta, Commodus Antoninus* IX, 2:** He accepted statues in his honor representing him with the attributes of Hercules,[190] and offerings were made to him as to the god.

***Historia Augusta, Commodus Antoninus* IX, 4:** He observed the sacred rites of Isis, even to the point of shaving his head and carrying an image of Anubis.

***Historia Augusta, Pescennius Niger* VI, 8:** In the curved portico in the gardens of Commodus we see him [Pescennius Niger] depicted in a mosaic, performing the sacred rites of Isis among the most intimate friends of Commodus.

As a recipient of Commodus' favor, Pescennius Niger himself enjoyed a certain private grandeur.

***Historia Augusta, Pescennius Niger* XII, 4:** His house, which is called the *Domus Pescenniana,* can still be seen today in Rome in the *Campus Iovis.*[191] In it there stands an image of him set up in a triangular [192] compartment and made of Theban marble; [193] he received this statue, which was made in his own likeness, from the Theban masses.

189 *Secutores* were gladiators armed with a sword and shield who fought an opponent called a *retiarius,* armed with a net and trident.

190 An impressive bust of Commodus as Hercules is preserved in the Conservatori Museum in Rome; cf. Wheeler, *Roman Art and Architecture,* p. 170, fig. 151; Hekler, *Greek and Roman Portraits,* 270a.

191 Location unknown.

192 *in trichoro.* The meaning may also be in a "tripartite compartment."

193 Egyptian Thebes is referred to here. The stone in question was probably that called *"basanites";* cf. p. 154.

3

Late
Antiquity

The term "Late Antiquity" is somewhat loosely used to characterize Graeco-Roman civilization from around A.D. 200 to the time when its institutions merge into Byzantine civilization in the East or collapse in the West. It is an era which combines a retrospective, nostalgic reverence for the achievements of the Classical past with new religious and mystical sensitivities. The feeling that outer forms—ranging from the human body to the social and political institutions of the Empire—were emanations from and symbols of a higher spiritual world, perceptible only through mystical communion, begins to make itself felt in political and philosophical theory and in the arts. This new attitude was to some degree a natural development of personal religion in the ancient world, but is also partly to be explained as a withdrawal from the problems posed by the chaotic social conditions of the 3rd century.

In politics the new sensitivities gradually took the form of absolutism. The feeling that the emperor, as a direct representative of deity—be it the Christian God of Constantine or the "Unconquerable Sun" (*Sol Invictus*) of Aurelian—should be removed from the vulgar public gaze and treated with the reverence normally shown to that deity culminates in the orientalizing of the imperial court under Diocletian.

In philosophy the new sensitivity is expressed on a serious level by the transcendentalism of Plotinos (*vide infra,* pp. 215-219) and, on a more popular level, in the magical and divinatory preoccupations of Gnosticism.

The late antique style in Roman art, especially as it is revealed in relief sculpture, is characterized by a rejection of the proportions, patterns of composition, and organization of space which had characterized the art of Classical Greece and had served as the basis of the Classical tradition in Roman art. A tendency toward "frontality" comes to dominate scenes in relief. Figures in the narrative panel turn away from the plane of action and stare balefully out at the viewer. Space becomes symbolic rather than real, with the result that figures are stacked above one another in neat tiers or decorative patterns. Where the Classical tradition had emphasized beauty and grace in the form and pose of the human body, the late antique figures become block-like symbolic units, subordinated to a greater pattern and having less importance in themselves. The symptoms of this style can be traced well back into the 2nd century A.D. and perhaps even into the 1st. In the famous column base in the Giardino della Pigna in the Vatican representing the apotheosis of Antoninus Pius and Faustina, the Classical and late antique styles exist side by side.[1] But it is with the reign of Septimius Severus that the new style comes to dominate public monuments,[2] and it is for that reason that we have chosen to begin our examination of the art literature of Late Antiquity with the Severans.

[1] Cf. Kähler, *The Art of Rome and her Empire*, p. 164, add. plates 13, 14; W. Lübke, E. Pernice, B. Sarne, *Die Kunst der Römer* (Vienna 1958), pp. 270-71.

[2] As illustrated by the main relief panels on the Severan arches in the Roman Forum and at Leptis Magna; cf. Kähler, *op. cit.,* p. 175 and add. plate 12; G. Hanfmann, *Roman Art* (Greenwich, Conn. 1964), pp. 210-11, pl. 126, 127; Lübke, Pernice, Sarne, *op. cit.,* pp. 278-79.

HISTORICAL DEVELOPMENTS

The Severans: A.D. 193-235

After the assassination of Commodus, P. Helvius Pertinax, who had served capably as a general under Marcus Aurelius, was proclaimed emperor by the Praetorian Guard. Pertinax conscientiously set about to restore financial solidarity to the imperial treasury by a program of economy which involved denying the soldiers a promised donative. After three months of rule the Praetorians murdered him and put the empire up for auction. The highest bidder was a wealthy but otherwise ungifted senator named Didius Julianus. Although the Senate ratified Julianus' "election," it was totally unacceptable to the military forces outside Rome. Almost immediately three powerful military commanders in the provinces—Clodius Albinus in Britain, Pescennius Niger in Syria, and Septimius Severus in Pannonia (Hungary)—were proclaimed emperor by their troops. Severus, the first to act, was also the nearest to Rome. He made a quick descent into Italy and reached Rome in June of A.D. 193. Didius Julianus was immediately deposed by the Senate and murdered by his personal guard a few weeks later. Severus remained in Rome only long enough to secure his position and then set out to deal with the other pretenders. Albinus was temporarily held in abeyance by being given the title "Caesar," which implied that he was in line for succession, and the emperor's full force was then directed against Pescennius Niger. A relentless drive by Severus' army in 193-194 dislodged Niger's forces from their front line of defense on the Propontis, drove them across Asia Minor, and defeated them at Issus. Pescennius Niger himself was captured in Antioch shortly afterward and put to death. Severus then returned to Europe for a final reckoning with Albinus, who was accused (whether justly or not is uncertain) of a treasonable conspiracy with the Senate. In a great battle at Lugdunum (Lyons) in A.D. 197 Albinus was defeated and killed, and Severus returned to Rome as the sole and undisputed emperor.

With the reign of Septimius Severus it became clear once and for all that the force which made and supported emperors was the provincial armies and not the senatorial aristocracy or even the civilian population of Italy. As an African and a veteran military man, Severus saw the value of treating the provincial armies with patient consideration but felt no special reverence for Italy and its institutions. A variety of military and administrative changes made it clear that although the emperor admired the city of Rome, he viewed Italy as simply another of the provinces of the empire and not as its leader. At the very beginning of his reign he wisely disbanded the old Praetorian Guard, for which Italian birth had been a prerequisite, and formed a new guard from his own troops. Since the new guard was open to provincials, and since service in the guard enabled one to become an officer, this change had the effect of ending the dominance of the higher ranks of the army by Italians. The Senate, always a stronghold of the Italian aristocracy, was normally ignored or treated with perfunctory politeness by Septimius, and important administrative appointments were increasingly given to men of equestrian (rather than senatorial) rank who had a military background.

During the civil war the Parthians had lent at least passive support to Pescennius Niger and had attempted to recover Mesopotamia. In A.D. 197-198 Severus personally led a retaliatory expedition which swept the Parthians out of Mesopotamia, once again destroyed Ctesiphon, and restored the Trajanic province of Mesopotamia.

When he returned to Rome in 202 after consolidating the eastern provinces, Severus seems clearly to have marked out his elder son Caracalla for the succession. Caracalla sensed two threats to his potential position—an immediate one in the person of Plautianus, the Praetorian prefect, and a more distant one in the person of his brother Geta. In 205 he convinced Severus that Plautianus was plotting against both of them, and the prefect was executed. In spite of Caracalla's apparent victory, he seems to have made his father increasingly suspicious of his good intentions. In 208 the emperor took both Geta and Caracalla with him on a campaign against the Caledonian tribes in Scotland which were harassing the Roman borders in Britain. While the campaign was in progress, he attempted to patch up the differences between his two sons and announced that Geta was to be co-heir with Caracalla. But when the emperor died at York in 211, worn out by a relatively unsuccessful British campaign, the hatred between his sons was worse than ever. The pair returned to Rome and, in 212, after unsuccessful attempts at mediation by Severus' second wife, a beautiful and cultured Syrian lady named Julia Domna, Caracalla murdered Geta.

As sole emperor Caracalla followed his father's principle of indulging the army with donatives and with a substantial raise in pay, and hence guaranteeing its allegiance, as well as his policy of ignoring the primacy of Italy. In 212 he issued an edict granting Roman citizenship to all free men in the empire. His motive for the edict may have been to augment the tax rolls and hence increase the revenue needed to back up his lavish treatment of the army, but whatever its motivation, the edict had the effect of bringing Italy to the level of the other provinces.

Caracalla was a capable general. After suppressing another of the increasingly familiar uprisings of German tribes along the Danube and Rhine frontiers, he followed Septimius' footsteps eastward with the intention of conquering Persia itself. By crossing the Tigris and invading Media in 216, he momentarily pushed the eastern border of the empire beyond its furthest extension under Trajan and Septimius; but in 217 he was assassinated by the Praetorian prefect Opellius Macrinus, and the new conquests quickly melted away.

Macrinus, saluted as emperor by his troops and temporarily approved by the Senate, was the first emperor who was not of senatorial rank. Before he could begin to secure his position, however, the legions at Emesa in Syria saluted the fourteen-year-old grandson of Julia Maesa, sister of Julia Domna, as emperor. The boy, who served as high priest of the Syrian god Elagabal (hence the cognomen Elagabalus [3] by which he is usually known) was said to be an illegitimate son of Caracalla. The eastern provinces preferred the new pretender, and Macrinus was quickly defeated and put to death.

During the strange reign of Elagabalus, Julia Maesa and her daughters Julia Soaemias (the emperor's mother) and Julia Mamaea seem to have exercised the real power while the emperor is represented as indulging in the religious fanaticism, debaucheries, and perversions which the Romans felt were characteristic of an Oriental court. Elagabalus' incompetence became alarmingly clear to Julia Maesa, who persuaded him to adopt his cousin Alexianus (son of his aunt Julia Mamaea) and turn over the practical affairs of state to him. When Elagabalus at first agreed to the adoption but later changed his mind, Julia Mamaea bribed the Praetorian Guard to murder both him and his mother (A.D. 222). Alexianus, under the name Alexander Severus, became emperor.

[3] Another version of the name is Heliogabalus. Elagabalus' name at birth was Bassianus. His formally adopted imperial name was Marcus Aurelius Antoninus.

Alexander was as affable and virtuous as his cousin had been objection-able and degenerate. His reign is depicted as a golden age of stability in which the Senate won back its long lost respect and authority. Julia Mamaea, who dominated her son and played a role which approached that of an empress, cultivated the support of the Senatorial Order as a bulwark against the potentially mutinous and always demanding soldiery. A great program of public works, combined with regular doles and generous *congiaria,* were designed to win similar support from the rest of the civilian population. Attempts to discipline the Praetorian Guard, however, proved useless. Among those who tried and failed was the historian Dio Cassius, consul in A.D. 229, whose life Alexander could only protect by dismissing him from service.

A relatively quiet decade in foreign affairs came to an end in 231 when the Parthian rule in Persia was overthrown by a nationalistic revolution which brought a native Persian dynasty, the Sassanians, to power. The new dynasty quickly sought to wrest Mesopotamia from Roman control, and Alexander, accompanied by his mother, left Rome for the East in order to conduct the new border campaign personally. In spite of heavy losses, he won a partial victory, signed a peace treaty with the Persians, and in 233 returned to Rome in triumph. In the following year he set out for a new campaign against the Alamanni, a German tribe on the Rhine. When it became clear that the European and Oriental legions which he had assembled could not work together, he tried to save the situation by buying off the Germans This seeming act of cowardice was used as a pretext for a mutiny by the European legions. C. Iulius Maximinus, one of the legionary officers, was proclaimed emperor, and Alexander and his mother were murdered.

Septimius Severus: A.D. 193-211

SEVERUS' FUNERAL FOR PERTINAX

One of the pretexts for Severus' march on Rome in 193 had been to avenge Pertinax. After disposing of Didius Julianus, he arranged a splendid funeral ceremony both to honor the memory of Pertinax and to give the stamp of legitimate succession to his own rule. The funeral seems to have combined elements of the ancient Republican funeral ceremonies, particularly the use of portrait statues (see pp. 53-54), with aspects of a triumphal procession.

Dio Cassius LXXIV, 4, 1 ff.: After establishing his own regime he built a shrine [*heroön*] in honor of Pertinax and decreed that his [Pertinax's] name should be added to all prayers and oaths. He also decreed that a gold portrait statue should be brought into the Circus on a chariot drawn by elephants and that three gilded thrones should be carried into the other theaters in his honor. The funeral ceremony, even though Pertinax had died quite some time before, had the following features. In the Roman Forum a wooden platform was constructed very near to the stone platform [the *Rostra*], and upon it a peristyle structure, without walls, but embellished with ivory and gold, was placed. In this there was a bier, decorated with the same materials, which was ringed with the heads of both land and sea creatures and adorned with purple drapes embroidered with gold. On this bier there was placed an image of Per-

tinax in wax, neatly laid out with the insignias of a triumph. There was also a handsome boy who brushed away the flies from the image with the feathers of a peacock, just as if it were a sleeping person. As the image lay in state Severus and we senators, along with our wives, approached it dressed in the garb of mourners. The women sat in porticoes whereas we sat in the open air. After this, statues of all the prominent old Romans passed by, followed by a chorus of boys and men singing a sort of dirge in honor of Pertinax. After this came all the subject nations, represented by twenty bronze figures which wore the dress characteristic of each country, and also the guilds which were to be found in the city itself— lictors, scribes, heralds, and others of the same sort. Then came portraits of other men to whom distinction had come as a result of some feat or invention or mode of living; then came the cavalry, the infantry men in their armor, race horses and the funeral offerings which the emperor, we senators, and our wives, the most notable men of equestrian rank, the communities, and the [priestly, etc.,] colleges of the city had sent. These were followed by a gilded altar ornamented with ivory and with gems from India. When all these had passed by, Severus mounted the *Rostra* and read a eulogy of Pertinax. . . . [Ritual mourning followed. With this completed, the funeral procession proceeded to the *Campus Martius*]. There a pyre had been constructed in the form of a tower with three tiers; it was decorated with ivory and gold and with a certain number of statues; on its peak was a gilded chariot which Pertinax himself used to drive. The funeral offerings were thrown into this pyre, and the bier was also placed in it. This done, Severus and the relatives of Pertinax kissed the image. The emperor then mounted a platform while we members of the Senate, except for the magistrates, climbed up on wooden stands so that we could both safely and conveniently view what went on. The magistrates and the equestrians, dressed in a manner befitting their rank, and also the cavalry and the infantry, marched around the pyre deploying themselves in a variety of formations, both civil and military. Then at last the consuls applied flame to the pyre. When this had been done an eagle flew up from it. Thus it was that Pertinax became immortal.

PUBLIC WORKS

Historia Augusta, Severus **XIX,** 5 ff.: The principal public works of his which still exist are the *Septizonium* [4] and the Severan Baths. The Sep-

[4] This was a grandiose structure at the southeast end of the Palatine facing the Appian Way. It served as a monumental façade for the east end of the palace complex. It was about three hundred feet long and seems to have consisted of three superimposed colonnades. Portions of the building survived until the 16th century, when they were destroyed by Pope Sixtus V, and a number of drawings of these remains are preserved. The significance of the name *Septizonium* is not certain. It has been suggested that it is connected with the seven planetary divinities, whose statues may have been placed in the porticoes facing the Appian Way; cf. Crema, *L'Architettura Romana*, pp. 545-48, figs. 718-719.

timian [5] baths in the trans-Tiber region near the gate which is named after him were also his; but when the aqueduct supplying these broke down almost immediately, the public was deprived of the chance to make use of them.

XXIII, 1: There are outstanding works by him in many cities. But the really great achievement of his life was his restoration of all the public shrines in Rome, which were falling to ruin owing to the ravages of time; on scarcely any of these did he inscribe his own name; on the contrary, the names of the original builders were preserved everywhere it was possible.

XXIV, 3-5: When he built the *Septizonium* he had no other intention than that his work should make an impression on those who were coming from Africa.[6] Had it not been for the fact that an image of him was set up during his absence, right in the middle of this area, by the prefect of the city, it is asserted that he would have built there an entrance to the Palatine Palace, that is, the imperial dwelling. Afterward Alexander [Severus] wanted to construct it but was prevented from doing so by a soothsayer; for, when he inquired about this project, he received no favorable omens.

STATUARY

*Portrait statues of a public official during the empire were in many cases symbolic of his status and an index of whether or not he enjoyed imperial favor. A classic example of the interconnection of portraits and politics occurred in connection with Gaius Fulvius Plautianus, who it will be remembered, was the Praetorian prefect and later consul (*A.D.* 203) under Septimius prior to falling from favor and being put to death in* A.D. *205.*

Historia Augusta, Severus XIV, 5: Although at one time Severus was extremely friendly with Plautianus, he became, when he learned the details of the latter's life, so hostile to him that he declared him a public enemy, and by having Plautianus' statues thrown down all over the world, gave him a certain fame owing to the gravity of the punishment; Severus was particularly angry because Plautianus had placed his [Plautianus'] own statue among those of the relatives who were connected with Severus by blood or marriage.

5 "Septimian" is a restored reading. Nothing remains of the baths.

6 Travelers coming from Africa (Septimius' homeland) would disembark at Ostia and approach Rome by the *Via Ostiensis,* which merged, within the city walls, with the *Via Appia,* and curved around the southeast corner of the Palatine. The *Septizonium* may have been inspired by Severus' admiration for the grandeur of the pyramids and other famous monuments of ancient Africa which he is said to have "examined in great detail" (*Historia Augusta, Severus* XVII, 4).

Dio Cassius gives a version of the incident which makes it seem somewhat less serious.

Dio Cassius LXXV, 16, 2: Becoming vexed at one time because of the great number of portrait statues dedicated to Plautianus which were then in existence (and this is an event which is worthy of being recorded), Severus had some of them melted down; as a result of this a rumor ran through the cities to the effect that Plautianus had fallen from power and been destroyed, and some of them smashed his portrait statues, an act for which they were later punished.

Severus cherished the statue of Fortuna which had formerly been in the possession of Antoninus Pius and Marcus Aurelius (see p. 184).

Historia Augusta, Severus XXIII, 5-6: He thereupon decreed that a copy should be made of the statue of Fortuna *Regia,* which used to be carried about with the emperors and placed in their bedroom, so that he might leave this extremely sacred image to both his sons [Caracalla and Geta]; but when he saw that the hour of death was pressing upon him, he ordered, it is said, that the statue of Fortuna be placed in the bedrooms of his sons, the co-emperors, on alternate days.

Historia Augusta, Severus XXII, 3: On the day when the games were held in the Circus, three plaster figures of Victory holding palm-branches were set up in the usual manner. Of these the figure which was in the middle and which held a globe with his [Severus'] name inscribed on it was struck by the force of the wind and fell from the podium in an upright position; it continued to stand upright on the ground. The figure on which the name of Geta was inscribed was thrown down and completely shattered. That which bore the name of Bassianus [Caracalla] had its palm-branch carried off by the wind and just managed to remain standing.

Caracalla: A.D. 211-217

Public Works

Historia Augusta, Severus XXI, 11-12: And finally, Antoninus [Caracalla] was for a long time remembered with hatred by the people (and that holy name was for a long time less beloved), even though he gave clothing to the people (for which reason he was called "Caracallus" [7]) and built baths of the greatest magnificence. There also exists a portico of Severus in Rome which expresses his achievements, and which was constructed, at least this is the opinion of most people, by his son.

[7] A *Caracallus* was a Gallic cloak which reached to the heels (cf. *Historia Augusta, Antoninus Caracalla* IX, 7), Caracalla seems to have made the cloak fashionable and hence received the name by which he is known. The gifts mentioned are probably not directly connected with the name.

Historia Augusta, Antoninus Caracalla IX, 4-10: Among the public works which he left in Rome were the remarkable baths which bear his name; within these baths is the *cella soliaris* which architects declare it is impossible to duplicate in the same manner in which it was built.[8] For latticework grates made of bronze or copper are said to have been raised as supporting arches, and the entire vault rested on these; yet its size is so great that men who have expert knowledge in the field of mechanics deny that it could have been built in this way. He also left behind a portico named after his father and containing a record of his father's achievements, both his triumphs and his wars. . . . He also built a new street which runs next to his baths, that is the *Thermae Antoninianae;* you would not easily find a more beautiful street among all those in Rome. He brought the rites of Isis to Rome and constructed magnificent temples for this goddess everywhere.

Caracalla is also said to have deconsecrated a temple built by Marcus Aurelius to his wife Faustina at the foot of Mount Taurus in Asia Minor (Historia Augusta, Antoninus Caracalla XI, 6-7).

Macrinus: A.D. 217-218

Macrinus attempted to hide the fact that he had been responsible for the death of Caracalla by making a pious speech before the Senate in which he requested honors for the deceased emperor.

Historia Augusta, Opellius Macrinus VI, 8: To Antoninus [Caracalla], moreover, the troops have decreed divine honors; we too decree them and request that you, Conscript Fathers [Senators], do likewise (we are able by our right as emperor to command this, but nevertheless we ask it), dedicating to him two equestrian statues, two statues of him on foot in military dress, and two of him seated in civilian dress; and also two statues to the Divine Severus, dressed in triumphal costume.

Elagabalus: A.D. 218-222

PUBLIC WORKS

Historia Augusta, Antoninus Elagabalus XVII, 8-9: None of his public works is still in existence except the temple of the god Heliogabalus [9] (whom others call the Sun, and still others call Jupiter), the restoration

8 Substantial remains of the baths of Caracalla still exist; cf. Crema, *L'Architettura Romana*, pp. 531-39. The *cella soliaris* was perhaps the great *frigidarium* in the center of the bath complex. Cf. also Nash, *Pictorial Dictionary*, II, 434-41 (with further bibliography).

9 This temple, which stood on the Palatine, was later transformed into a temple of Jupiter *Ultor*. A few remains from it have been found, and there are representations of it on coins; cf. Nash, *Pictorial Dictionary*, I, 537-41.

of the amphitheater after its destruction by fire, and the baths in the *Vicus Sulpicius*, which Antoninus [Caracalla] the son of Severus had begun. These baths in fact were dedicated by Antoninus Caracalla by bathing in them and by admitting the populace into them, but the porticoes [10] were lacking, and these were afterward constructed by this spurious Antoninus and finished off by Alexander.

Historia Augusta, Antoninus Elagabalus XXIV, 6-7: He paved the courts, which he called the *plateae Antoninianae*, in the Palatine palace, with slabs of Lacedaemonian stone [11] and porphyry. These stones lasted down to a time within our own memory but were recently cut out and uprooted. He also had plans to dedicate a single huge column,[12] which could be ascended from the inside, in order that he might place on top of it [an image of] the god Heliogabalus, but he was unable to find such a great quantity of stone, even though he had planned to bring it from [Egyptian] Thebes.

Historia Augusta, Antoninus Elagabalus III, 4: But when he first entered the city [A.D. 219], neglecting all the things which were to be done in the provinces, he consecrated a sanctuary to Heliogabalus on the Palatine mount next to the imperial palace and built a temple to the god; in his zeal he proposed to transfer to this temple the carved stone emblem of the Magna Mater, the fire of Vesta, the Palladium, the *ancilia*,[13] and all objects which were considered sacred by the Romans, doing this so that no god except Heliogabalus would be worshiped at Rome.

Elagabalus is also said to have built a public bath within the imperial palace (Historia Augusta, Antoninus Elagabalus *VIII, 6*).

Herodian, *Historiae ab excessu divi Marci* V, 5, 6-7: [Elagabalus was accustomed to wearing the exotic Syrian dress which went with his role as priest of the Sun God. Julia Maesa was worried about the effect which this barbaric dress would have on the Romans and tried to persuade him to change it before his first arrival in Rome.] But he showed contempt for what the venerable lady said to him, nor could he be persuaded by

10 These were the porticoes which formed a large *peribolos* around the actual bath buildings.

11 Lacedaemonian stone = *serpentine*.

12 Presumably on the model of the columns of Trajan and Marcus Aurelius.

13 The emblem of the Magna Mater was the sacred stone brought to Rome from Pessinus in 205/204 B.C. (Livy XXIX, 10, 4 ff.). The *Palladium* was an image of Athena thought to be of Trojan origin, and the *ancilia* were the shields of the Salii, the priests of Mars who performed an armed dance, apparently a spring fertility rite, every March in honor of the god. Both the *Palladium* and the *ancilia* were kept in the temple of Vesta which Elagabalus desecrated (cf. *Historia Augusta, Antoninus Elagabalus* VI, 6-9). The temple of Heliogabalus is said to have stood on an earlier sanctuary of Orcus; cf. *Historia Augusta, Antoninus Elagabalus* I, 6.

anyone else (for he paid attention to no one except those who were like him and were hence flatterers of his shortcomings). But since he wanted the Senate and the Roman people to become accustomed to the appearance of his characteristic dress, and, while still absent from Rome, to test how they would respond to his appearance, he had a very large full-length portrait painted which showed him taking the lead in performing his priestly duties. Also represented along with him in the painting was the emblem of his native god, to whom he was depicted sacrificing with good omens. He sent this picture to Rome and ordered that it be hung in the middle of the Senate chamber in a lofty spot above the head of the image of Victory, to which each senator, upon coming into the *Curia,* burns incense and offers a libation of wine. And he ordered all the Roman magistrates, if any of them should be in charge of public sacrifices, to call upon the name of the new god Elagabalus before those of all the other gods whom they call upon in performing sacrifice. The result was that when he arrived in Rome the Romans saw nothing unusual in the aforementioned dress, since they had become accustomed to it from the painting.

Alexander Severus: A.D. 222-235

PUBLIC WORKS

Historia Augusta, Severus Alexander XXV, 3-8: He restored many of the works of earlier emperors and constructed many new ones himself, among which were the baths which were named after him and stood next to those which are called the *Thermae Neronianae* and also the aqueduct which is still called *Alexandriana.*[14] He also had a grove of trees planted near his baths in place of some private houses which he had purchased and demolished. He was the first of the emperors to call one of the tubs in his baths "the Ocean," since Trajan had not done this but had simply identified the tubs [in his baths] with particular days. He finished off the porticoes which were added to the baths of Antoninus Caracalla and had them decorated with ornaments. He was the first to make use of the marble work called *opus Alexandrinum,* which combines two types of stone—porphyry and Lacedaemonian stone;[15] it was used in the courtyards of the Palatine which were decorated with a pavement of this type.[16]

14 The *Thermae Alexandrianae* were an extension of the *Thermae Neronianae* in the *Campus Martius.* The *Aqua Alexandriana* supplied water to the baths from springs near Gabii. On the *Thermae* cf. Nash, *Pictorial Dictionary,* II, 460-64; on the *Aqua Alexandriana,* T. Ashby, *The Aqueducts of Ancient Rome* (Oxford 1935), pp. 309-15.

15 The text uses the word *marmor,* although neither of the stones is, strictly speaking, marble.

16 Alexander Severus carried on the work in the palace begun by Elagabalus.

XXVI, 7-11: He had also begun the *Basilica Alexandrina* between the *Campus Martius* and the *Saepta* of Agrippa, a building one hundred feet wide and one thousand feet long, and so constructed that its entire mass was supported by columns. He was not able to complete the building, however; death prevented him from doing so. He appropriately decorated the sanctuaries of Isis and Serapis, supplying them with statues, Delian slaves, and all the apparatus which goes with the mysteries. He behaved toward his mother Mamaea with unique piety, to the extent, in fact, that he constructed living rooms in the palace in Rome which were given the name *diaetae Mamaeae* (which the uneducated crowd today refers to as *"ad Mammam"*), and also constructed a palace with a pool in the region near Baiae, which even today is assessed in the census under the name "Mamaea." He also built other magnificent works in the area of Baiae in honor of his relatives and also amazing pools formed by letting in the sea. Further, he restored the bridges which Trajan had made in almost every place, and he also built some new ones; but on those which he restored, he preserved the name of Trajan.

XXIV, 3: He forbade that the tax on procurers, prostitutes, and juvenile perverts be put into the public treasury, but decreed instead that it should be used for the restoration of public buildings such as the theater [of Marcellus], the Circus, the amphitheater, and the stadium [of Domitian].

XLIV, 7-8: He intended to restore the theater of Marcellus. To many cities which lay in ruins after earthquakes he gave donations from the tax revenues for the restoration of both public and private buildings.

XLIII, 6: He also intended to build a temple to Christ and to admit him to a place among the gods. It is said that this plan was also considered by Hadrian, who ordered that temples without cult images be built in all cities—temples which today, because they are sacred to no particular deities, are called temples of Hadrian and which he [Hadrian] was said to have intended for this purpose.[17] But Alexander was prevented from carrying out his intentions by those who consulted the omens of the sacrificial victims; they ascertained that if he did what he proposed, all men would become Christians and the other temples would of necessity be deserted.

STATUARY

The following descriptions of Alexander Severus' private chapels form together one of the classic illustrations of the eclectic religiosity which characterized the late antique mentality.

17 "this purpose" = as temples of Christ. The temples, in fact, were probably used for the cult of the emperor.

Historia Augusta, Alexander Severus **XXIX, 2:** The routine of his life was as follows: first of all, if it was possible, that is, if he had not lain with his wife, he used to perform worship in the early morning hours in his own *lararium*,[18] in which he had placed statues of deified emperors (although only the noblest of them were chosen) and of very sacred souls, among whom were Apollonios [19] and, as a writer of that era reports, Christ, Abraham, Orpheus, and others of a similar character, and also portraits of his ancestors.

XXXI, 4-5: He used to call Vergil the Plato of poets and kept a portrait of him, along with a likeness of Cicero, in a second *lararium,* where he also had portraits of Achilles and other great heroes. But as for Alexander the Great, he consecrated [his image] among those of the noble souls and deified emperors in his greater *lararium.*

Alexander's urge to identify himself with the great rulers and leaders of the past is also reflected in the statues which he dedicated in public.

Historia Augusta, Alexander Severus **XXVIII, 6:** In the forum of the Divine Nerva, which is called the *Forum Transitorium,* he set up colossal statues, some nude and on foot, and others equestrian, to the deified emperors with all their titles and with bronze columns which contained lists of their achievements; in doing this he followed the example of Augustus, who set up in his forum statues in marble of highly distinguished men and also included a record of their achievements. Alexander wanted it to be recognized that he traced his descent from the Roman race, because he felt shame at being called a Syrian. . . .

XXVI, 4: He set up statues of the most distinguished men in the Forum of Trajan, to which he transferred them from every other place.

XXV, 8-10: He set up colossal statues in many cities, made by artists summoned from all over the world. He also had himself represented in the guise of Alexander [the Great] on many of his coins, some of which were made of electrum, but most of gold.

PERSONALITY AND FINAL HONORS

Historia Augusta, Alexander Severus **XXVII, 7-8:** He was familiar with geometry. He painted marvelously, and he sang excellently, but he never let anyone be a witness [to these skills] except his own slaves. He also wrote a *Lives of the Good Emperors* in verse.

LXIII, 3: [After his death] the Senate elevated him to the level of the

18 A chapel of the Lares, the tutelary deities of a Roman household.
19 Apollonios of Tyana; *vide infra,* pp. 213-215.

gods, and he earned the honor of a cenotaph in Gaul and a sepulcher of the utmost grandeur in Rome.

THE ROMAN EMPIRE FROM A.D. 235-337

In the chaotic fifty years which followed the death of Alexander Severus Rome had at least twenty acknowledged emperors and a horde of pretenders who considered themselves emperors. While the legions made and deposed rulers, the economic and territorial solidarity of the empire gradually fell into decay.

Maximinus was a Thracian peasant who had risen through the ranks as a soldier but had never held a civilian post. In spite of his military ability and a number of successes against the Germans on the frontier, he was unacceptable to the Senate. In 238 it gave its allegiance to the eighty-year-old proconsul of Africa, M. Antonius Gordianus (Gordian I), a man of distinguished lineage who had been induced to revolt and declare himself emperor. Gordian adopted his son (Gordian II) as co-regent. The governor of Numidia, however, almost immediately rebelled against the Gordians, and when Gordian II attempted to suppress the rebellion, he was killed in battle. The aged Gordian I committed suicide after a reign of twenty-two days. The Senate then proclaimed D. Caelius Balbinus and M. Clodius Pupienus, members of a commission which had been formed to protect Italy from Maximinus, as emperors. Maximinus began an invasion of Italy but was murdered at Aquileia by his own troops in June of 238. About a month later the Praetorian Guard murdered Balbinus and Pupienus and installed Gordian III, the fifteen-year-old grandson of Gordian I, as emperor. For several years,- under the capable regency of the Praetorian prefect Timesitheus, Gordian fought successful campaigns against the Goths, who now began to cross the Danube, and against the Persians. But when Timesitheus died while on campaign against Persia in 243, the regency was given to an officer from Arabia named Philippus. In 244 Philip had Gordian assassinated, arranged a peace with Persia, and returned to Rome.

The Period of Maximinus and Gordian I: A.D. 235-238

During this period a tribune of the Moors named Titus (Historia Augusta) or Quartinus (Herodian) became a pretender to the throne. A statue of Titus' wife Calpurnia, a woman of ancient Roman lineage, is described in the Historia Augusta.

Historia Augusta, Thirty Tyrants XXXII, 5: Calpurnia . . . whose statue, *acrolithic* [with the head and extremities done in stone] but otherwise gilded, we have seen still standing in the temple of Venus.

Historia Augusta, The Three Gordians II, 3: He himself [Gordian I] was a consul, and very rich and powerful, being the owner of the *Domus*

Pompeiana [20] at Rome, and in the provinces of more land than any other private person.

III, 6-8: There exists a remarkable *silva* [21] of his, depicted in the *Domus Rostrata* [22] of Gnaeus Pompey, which belonged to him and to his father and to his great-grandfather up until the time of Philip ["the Arab," 244-249] when the imperial treasury took possession of it. In this picture even now there are two hundred stags with palm-shaped antlers, and mixed in with them, stags from Britain, thirty wild horses, one hundred wild sheep, ten elks, one hundred Cyprian bulls, three hundred red Moorish ostriches, thirty wild asses, 150 wild boars, two hundred ibexes, and two hundred fallow deer. All these he gave over to the people to be slain [in the amphitheater] on the day of an exhibition, which was the sixth which he produced [while serving as *quaestor*].

Gordian III: A.D. 238-244

Historia Augusta, The Three Gordians **XXXII, 1-3:** The house of the Gordians is in existence even now; it was very beautifully decorated by this Gordian. There is also a villa of theirs on the *Via Praenestina* which has two hundred columns in its four-sided courtyard, of which fifty are of Karystian marble, fifty of Claudian stone,[23] fifty of marble from Synnada [in Phrygia], and fifty of Numidian marble, all of the same size. In this villa there were also three basilicas one hundred feet long, other structures which are appropriate to villas of that sort, and baths such as could be found nowhere in the world, except in the city as it was at that time.

XXXII, 5-8: No public works of Gordian exist in Rome except for a few fountains and baths. But these baths were for private citizens [24] and for that reason are decorated in a manner befitting private use. He had planned a portico, one thousand feet long in the *Campus Martius* beneath the [Quirinal?] hill, with the intention that another portico, also one thousand feet long, should be built opposite it, and that an open space five hundred feet wide should extend between them. On each side

20 The house of Pompey the Great on the west slope of the Esquiline. It had previously belonged to the Emperor Tiberius.

21 This *silva* was apparently a "woodland scene" put on in the amphitheater. After the exotic beasts of various sorts were displayed in a setting which simulated their natural habitat, hunters were sent into the amphitheater to track them down and kill them.

22 *Domus Rostrata = Domus Pompeiana*. The name was derived from the ships' prows (*rostra*) which Pompey captured from the Cilician pirates and set up in his house.

23 Thought to be red porphyry of the sort which might have been quarried from the *Mons Claudianus* on the east coast of Egypt. Cf. Pauly-Wissowa, *Real-Encyclopädie*, s.v. "Claudianus Mons."

24 The meaning presumably is that these were public baths intended for the common citizen rather than the imperial family. Nothing else is known about these baths.

of this space there were to have been gardens crowded with laurel, myrtle, and boxwood, and in the middle there was to have been a mosaic pavement, one thousand feet long, flanked· by short columns and small statues on each side,[25] which was to serve as a promenade at the end of which there was to have been a basilica five hundred feet long. In addition to these structures he had conceived the idea, along with Timesitheus, of building summer baths in his own name behind the basilica, and he had also decided to place winter baths at the beginning of his porticoes so that his gardens and porticoes would not be without some practical use. But all of this area is now occupied by the grounds and gardens and buildings of private citizens.

"Philip the Arab," as Gordian's successor came to be called, managed to come to terms with the Senate and was still ruling the Empire at the time of Rome's thousandth anniversary in 248. But in 249 an officer named Decius (later Trajan Decius), whom Philip had sent to Dacia to control Gothic incursions along the Danube, was proclaimed emperor by his troops. Decius marched to Italy and defeated and killed Philip in a battle near Verona. The Goths seized the opportunity to invade Thrace, and when Decius returned to face them, he himself was defeated and killed (251). Decius' death was due at least in part to treachery on the part of the governor of Moesia (Bulgaria), Trebonianus Gallus, who was now proclaimed emperor. During his brief, unproductive reign, Mesopotamia was lost to the Persians, and the Goths overran Moesia, Thrace, and Asia Minor. The latter were suppressed, however, by Aemilianus, the new governor of Moesia, who proceeded after his victory to proclaim himself emperor and invade Italy. Treachery, which had begun Gallus' career, also ended it. In 253 his own troops murdered him and swore allegiance to Aemilianus. Shortly afterward, a descendant of an old Roman family, P. Licinius Valerianus, whom Gallus had appointed to a command on the lower Rhine, was proclaimed emperor by his troops. As Valerian approached Italy the troops which had betrayed Gallus also betrayed Aemilianus and murdered him.

Valerian, in the unusual position of being respected by both the army and the Senate, might have been able to restore internal order in the empire had external pressures not interfered. Between 253 and 256 the Franks made their first appearance by crossing the Rhine into Gaul and Spain, the Goths invaded Asia Minor, and the Persians under King Shapur overran Syria and seized Antioch. Valerian left his son Gallienus, whom he had made co-regent, in Rome and marched east to meet the Persians. He was initially successful and won back Antioch, but after a defeat at Edessa coupled with an outbreak of plague in his army, he attempted to negotiate a peace. During the negotiations he was treacherously abducted by Shapur (259) and died in captivity. His son Gallienus succeeded him. The Persians proceeded to sweep across Asia Minor, but the situation was saved by the rich oasis city of Palmyra in the Syrian desert. Led by a nobleman named Odaenathus, the Palmyrenes attacked the Persians in the rear and drove them out of both Syria and Mesopotamia. Gallienus, who had faced innumerable pretenders at home, recognized Odaenathus as king of Palmyra and made him military commander of the East. The foremost of the pretenders was C. Latinius Postumus, the mili-

25 "On each side" = *altrinsecus*. Presumably the columns and statues were to alternate on each side.

tary commander on the Rhine, who set up a "Gallic" empire of his own to which Britain, Gaul, and Spain adhered. But since Gallienus was forced to fight the Alamanni, who now invaded northern Italy, and Postumus had to deal with the Franks, the civil war never really came to a decisive conflict. Greece in the meantime was invaded by the Goths, and Gallienus, after dealing with the Alamanni, proceeded to attack them in the Balkans. While he was absent from Italy, Aureolus, who was appointed to oppose Postumus, betrayed the emperor and tried to seize Rome. Gallienus returned to punish him but was murdered by officers on his own staff (268). At about the same time Postumus was killed by his troops.

Gallienus was succeeded by one of his officers, Claudius (later given the cognomen *Gothicus*), who disposed of Aureolus, defeated the Alamanni, and won two great victories over the Goths, before he died of the plague in 270.

Gallienus: 253-268

Historia Augusta, The Two Gallieni XVIII, 2-5: He ordered that a statue of himself with the attributes of the Sun, but greater than the colossus [of Nero], should be made, but he died while it was still unfinished. All the same, it had been begun on such a great scale that it gave the impression of being twice the size of the colossus. He had wanted it to be placed on the summit of the Esquiline hill and also desired that it should hold a spear, through which a child could climb to the top. But the project later seemed foolish to Claudius [*Gothicus*] and, after him, to Aurelian, especially since he had ordered that a horse and chariot were to be made on a scale appropriate to that of the statue and that [the group] should be placed on a very high base. He had also intended to build a Flaminian portico [26] which would run as far as the Mulvian bridge; it was to be constructed with four rows of columns, or, as others say, with five rows, so that the first row would consist of pillars with columns supporting statues in front of them, and that the second, third, and other rows would consist of columns, four deep [behind the pillars].

Titus Macrianus was an officer of Valerian who in 260 participated in a revolt against Gallienus in the east. His family treasured portraits of Alexander as good luck pieces. A description of these portraits casts some light on the minor arts in the time of Gallienus.

Historia Augusta, Thirty Tyrants XIV, 4-6: For the men [of the family of Macrianus] always had representations of Alexander the Great of Macedon carved in relief on rings and on silverware, and the women had them on their tiaras, bracelets, rings, and on every kind of ornament, so that even down to this day there are tunics and borders of garments and matrons' traveling cloaks which have a likeness of Alexander woven

[26] That is, a portico flanking the *Via Flaminia*.

with a variety of threads. We have recently seen Cornelius Macer, a man of the same family, when he was giving a dinner in the temple of Hercules, drink a toast to the priest with an offering bowl made of electrum which had the face of Alexander in the middle and, encircling the face, his [Alexander's] whole history represented by simplified, minute figures; he ordered that this bowl be passed around to all those who were most ardent in their admiration of the life of that great man. I point this out because it is said that whoever wears an image of Alexander rendered in relief on either gold or silver is aided in his every action.

Claudius Gothicus: 268-270

Historia Augusta, The Divine Claudius III, 2-7: I speak of the *Princeps* Claudius whose life and probity and all the acts which he performed for the state brought him such fame among later generations that the Senate and the Roman people conferred new types of honors on him after his death. By a decree of the entire Senate a gold *clipeus,* or *clipeum,* as the grammarians say, was placed in the Roman *Curia,* and even now his face may be seen on the bust which has been raised in relief on the shield. To him also, and this was an honor granted to none previously, the Roman populace set up a gold statue, ten feet high, in front of the temple of Jupiter *Optimus Maximus.* Again in his honor, with the assent of the entire world, a silver statue of him in the *tunica palmata,* weighing 1,500 pounds, was set up on a column. It was he, mindful of the future, who enlarged the *Templum Gentis Flaviae,*[27] which had belonged to Vespasian, to Titus, and, although I shrink from saying it, to Domitian. It was he who in a very short time brought the Gothic War to an end. The Senate became his flatterer, as did the Roman people; foreign nations became his flatterers as did the provinces; for all orders, all ages, and all communities have honored this good emperor with statues, with banners, with crowns, shrines, arches, altars, and temples.

Some light is shed upon the minor arts in the time of Gallienus and Claudius Gothicus by a letter quoted in the Historia Augusta *in which Gallienus writes to one of his agents describing gifts which he has sent to Claudius in order to win his general's favor.*

Historia Augusta, The Divine Claudius XVII, 4-5: I myself have sent him gifts which you will see that he accepts willingly. Care must be taken to see that he does not realize that I know this[28] and that he does

27 The house of the Flavian family on the Quirinal, which was converted into a temple by Domitian (see p. 160).
28 I.e., that Claudius and his troops were displeased with Gallienus' supposedly immoral personal life.

not get the idea that I am angry with him and so, out of necessity, devise some plot as a last resort. I have sent him offering bowls, inlaid with gems, weighing three pounds; gold drinking cups, also inlaid with gems, and also weighing three pounds; a silver disc decorated with ivy-berries, weighing twenty pounds; a silver platter decorated with a vine pattern weighing thirty pounds; a silver bowl with an ivy-leaf pattern weighing twenty-three pounds; a silver fish plate weighing twenty pounds; two silver pitchers inlaid with gold weighing six pounds; also smaller vases in silver weighing twenty-five pounds; ten cups of Egyptian and diverse workmanship. . . .

After the death of Claudius *Gothicus* the army chose one of his prominent officers, L. Domitius Aurelianus, as his successor. Aurelian began his short but impressive career by defeating the Vandals and other German tribes on the Danubian border. He then visited Rome, where he built the great "Aurelian Wall" which still rings the city. The fact that the wall, Rome's first defensive installation in centuries, seemed necessary indicates how serious the barbarian border invasions were becoming. But the new emperor's greatest task was to subdue Queen Zenobia of Palmyra, the wife of Odaenathus, who seems to have murdered her husband in 267 and taken power into her own hands. Having captured Egypt and Syria and overrun most of Asia Minor, Zenobia may have been in the process of forming a Palmyrene empire when Aurelian attacked her. Between 271 and 273 he waged a skillful campaign which ended in the capture of Zenobia and the total destruction of Palmyra. He then promptly marched back to Gaul to put an end to the "Gallic" empire which was now governed by a successor of Postumus named Tetricus. Tetricus surrendered without a fight, and Aurelian returned to Rome where he celebrated a great triumph in which both Zenobia and Tetricus were paraded as captives. But the glory of the man who was now called the *Restitutor Orbis* was short-lived. In 275, as he was setting out for a campaign against Persia, he was murdered by some dissident officers.

The Senate eventually chose an aged senator named M. Claudius Tacitus as Aurelian's successor. Tacitus won a surprising victory over the Goths in Asia Minor (276) but died immediately afterward, apparently murdered by his troops. The army chose Tacitus' half-brother Florianus as the new emperor, but when the eastern legions proclaimed one of their own officers, M. Aurelius Probus, as emperor, Florianus was murdered too. Probus waged several successful campaigns in which he drove the Germans out of Gaul and defeated the Vandals on the Danube. But a series of revolts by subordinate officers plagued his career, until finally the emperor's personal troops, chafing under Probus' attempts at discipline, switched their allegiance to the Praetorian prefect Carus and murdered their commander. Carus left his son Carinus in charge of Italy and launched an astonishingly successful campaign against the Persians, whom he drove from Mesopotamia. But as he was in the process of following up his victories he was killed "by a thunderbolt," an explanation which undoubtedly masks another example of legionary treachery. The army temporarily came under the control of Carus' son Numerianus, who also soon died under obscure circumstances. The troops then proclaimed the Praetorian prefect C. Aurelius Diocletianus as emperor (284). Diocletian returned to Europe, fought and defeated Carinus in a great battle on the river Morava (Yugoslavia), and became the sole emperor.

Aurelian: 270-275

BUILDING PROJECTS

Historia Augusta, The Divine Aurelian **XXV, 4-6:** Therefore, when the orderly state of the Orient was restored [after the defeat of Palmyra], Aurelian came as victor to Emesa and proceeded immediately to the temple of Heliogabalus, as if, prompted by the sense of duty common to all men, he were going to fulfill his vows. But he found there the same form of the deity which he had seen helping him in the war. For this reason he founded a temple there, endowing it with an enormous quantity of offerings, and he also built a temple to the Sun at Rome which was consecrated with an even greater bestowal of honors.[29] . . .

XXXI, 7-9 [a letter from Aurelian to Cerronius Bassus]: Of course I want the temple of the Sun, which the eagle bearers of the third legion, along with the standard bearers, the *draconarius,* the buglers, and the trumpeters sacked at Palmyra, to be restored to its former condition. You have eighteen thousand pounds of silver from the Palmyrene treasury, and you have the royal jewels. See that reverence is shown to the temple from all these resources. You will perform a service which will be most pleasing both to me and to the immortal gods. I will write to the Senate asking it to send a priest who may dedicate the temple.

XLV, 2: Aurelian planned to construct winter baths [30] in the trans-Tibertine region, because a good supply of cold water was lacking there. He also began to lay the foundations for a forum in his own name at Ostia on the sea, in a place where later the *praetorium publicum* [31] was built.

XXXIX, 2: He built the temple of the Sun with the utmost magnificence. He also so extended the wall of the city of Rome that its circuit came to about fifty miles.[32]

XLIX, 1-2: When he was in Rome he disliked living in the Palatine palace and preferred rather to live in the Gardens of Sallust or in the

[29] The temple was in the *Campus Martius,* but its exact location is uncertain. Among the elements in its decoration were statues of "the Sun and of Belus" (Zosimus I, 61); another was a painting showing Aurelian and one Ulpius Crinitus, a descendant of Trajan (*Historia Augusta, The Divine Aurelian* X, 2).

[30] "Winter baths" = *Thermae hiemales.* It could also mean "cold water baths." Cf. Platner-Ashby, s.v. *Thermae Aurelianae.*

[31] Perhaps the headquarters of the officer called *praefectus annonae,* who was in charge of the grain supply coming into Rome via Ostia; cf. R. Meiggs, *Roman Ostia* (Oxford 1960), p. 186.

[32] Large stretches of Aurelian's wall are still visible in Rome; cf. Nash, *Pictorial Dictionary,* II, 86-103. Its circuit is actually about twelve miles.

Gardens of Domitia.[33] He embellished the Gardens of Sallust, in fact, with a portico one thousand feet long, in which he would exercise both his horses and himself every day, even if he happened not to be in good health.

One of the many offerings which were to be set up within the temple of the Sun, Aurelian's most prominent monument in Rome, was a statue of Jupiter. It was to be made in part from spoils taken from Firmus, a petty pretender who had been an ally of Zenobia.

Historia Augusta, Firmus, Saturninus, Proculus, and Bonosus III, 4: This man is said to have possessed two elephant tusks, each ten feet long, from which Aurelian intended to make a throne by adding two other tusks; on this throne there would sit a gold statue of Jupiter, studded with gems and wearing a sort of *toga praetexta,* which would be set up in the temple of the Sun. . . .

Possibly also built during Aurelian's reign was the house of the Tetrici. C. Pius Tetricus, governor of Gaul, it will he remembered, was for a time a pretender to the throne but finally came to terms with Aurelian.

Historia Augusta, Thirty Tyrants XXV, 4: The house of the Tetrici still exists today on the Caelian hill between two groves facing the temple of Isis built by Metellus, a very beautiful house, in which Aurelian is depicted bestowing the *toga praetexta* and senatorial rank on both the Tetrici [C. Pius and his son] and receiving from them his scepter, crown, and fringed robe [*cyclas*]. The picture is a mosaic, and they say that when the two Tetrici dedicated it, they invited Aurelian himself to the banquet.

FINAL HONORS

Historia Augusta, The Divine Aurelian XXXVII, 1-2: Such was the end which came to Aurelian, an emperor who was necessary rather than good. After he was assassinated and when the act was revealed, those by whom he had been killed conferred upon him a large sepulcher and a temple. Mnestheus, of course, was later taken away to the stake and exposed to wild beasts, as the marble statues which were set up in that place on either side indicate; it was also on this spot that statues in honor of the Divine Aurelian were erected on columns.[34]

33 The Gardens of Sallust ran northward from the northern slope of the Quirinal. The Gardens of Domitia (*Horti Domitiae*) were on the right bank of the Tiber near the Mausoleum of Hadrian.

34 Mnestheus, called Eros by other sources, was a freedman in the service of Aurelian. He organized the conspiracy to murder the emperor.

Historia Augusta, Tacitus IX, 2: In the same speech·he [the Emperor Tacitus] proposed the setting up of a gold statue in honor of Aurelian on the Capitoline, also of a silver statue in the *Curia,* in the temple of the Sun, and in the forum of the Divine Trajan. But the gold statue was not set up; only the silver ones were dedicated.

Tacitus: 275-276 and Florian: 276

Historia Augusta, Tacitus X, 4-5: He ordered that his own house be destroyed and that public baths be constructed on the site at his own expense. He donated from his own property a hundred columns of Numidian marble, twenty-three feet high, to the people of Ostia. He also assigned the possessions which he held in Mauretania to provide for repairs on the buildings of the Capitoline.

Historia Augusta, Tacitus XVI, 2-3: A portrait of him was placed in the house of the Quintilii, a quinquiplex portrait on a single panel, in which he was shown simultaneously in a toga, in a *chlamys,* armed, in a Greek cloak, and in a hunting outfit. It was this portrait that a writer of epigrams made fun of when he said, "I do not recognize the old man who is armed, or who wears a *chlamys,*" and so on, "but I do recognize the old fellow in the toga." [35]

XV, 1: There were two statues of them [Tacitus and Florian], thirty feet high and made of marble, at Interamna [Terni], because their cenotaphs were erected in that place on their own property; but these were knocked down by lightning and so shattered that they lie there in scattered fragments.

Probus: 276-282

Historia Augusta, Probus XXIV, 2: Naturally I cannot pass over the fact that, when a portrait of Probus in the area of Verona was struck by lightning, the colors of his *toga praetexta* were so changed that the soothsayers predicted future members of his family would rise to such prominence in the Senate that all of them would serve in the highest positions.

Carus, Carinus, and Numerianus: 282-284

Historia Augusta, Carus, Carinus, and Numerianus XI, 3: The speech which was sent to the Senate is said to have possessed such eloquence that a statue was decreed to him not as a *Caesar* but as a rhetorician, a statue which was to be set up in the *Bibliotheca Ulpia* [in the Forum of Trajan]

[35] Referring to the fact that Tacitus had always been a senator and that the other aspects of his new role as emperor hardly suited him.

with this inscription on it: "To Numerianus Caesar, the most powerful orator of his time."

XIX, 1-2: The most memorable event of the reigns of Carus, Carinus, and Numerianus, was the festival of games, marked by novel spectacles, which they gave to the Roman people; these games we have seen depicted on the Palatine near the Portico of the Stable. For a tightrope walker, who seemed like a man in high boots borne along on the winds, performed, and also a wall-climber who, having eluded a bear, ran up the wall; in addition there were some bears performing a mime, one hundred trumpeters sounding a single blast together; one hundred performers on the *cerataulas*,[36] one hundred flutists for choruses, one hundred concert flutists, one hundred pantomimists and gymnasts, and also a theater machine *[pegma]*, of [or from] which the stage was consumed by flames, which [37] Diocletian later restored on a more magnificent scale.

With Diocletian the half-century of chaos ended almost as abruptly as it had begun. Diocletian's organizational genius told him that the empire was too far-flung to permit all executive decisions to be made by one man. In 286 he nominated a comrade, Maximianus, as co-emperor in charge of affairs in the West, and in 293 he expanded upon the principle of compartmentation by establishing a tetrarchy in which he and Maximian were to be the senior emperors, called *Augusti*, while two younger officers, Constantius Chlorus and Galerius, became *Caesares*, junior emperors in line for succession. Diocletian was to control the eastern provinces, while his personal *Caesar*, Galerius, was in charge of the Danube. Maximianus controlled Italy and Africa and his *Caesar*, Constantius Chlorus, was in charge of Gaul, Britain, and Spain. Each of these regional commanders in time won important military victories which helped to secure their provinces and restore stability to the empire as a whole.

In addition to compartmenting the empire, Diocletian instituted economic reforms which were aimed at stabilizing the currency of the empire and checking inflation. At the same time he attempted to create a new respect for the position of the emperor by introducing a number of Oriental customs into imperial court procedure, most notably mandatory obeisance (*adoratio*) before the emperor. Dissident elements in the empire which challenged the authority of the emperor, most particularly the Christians, were ruthlessly persecuted.

In 305 Diocletian astonished a world which had become accustomed to the violent end of emperors by quietly retiring from office and compelling Maximian to retire at the same time. Galerius and Constantius Chlorus became *Augusti* and two new *Caesares*, Maximinus Daia and F. Valerius Severus, were appointed. But civil war broke out almost immediately. Maxentius, son of the retired Maximian, staged a revolt supported by the Praetorian Guard and seized Italy and Africa. First Severus, then Galerius, and eventually even Maximian tried to dislodge Maxentius but failed (306-308). In the meantime Constantius Chlorus had died, and his son Constantine had been saluted as their leader by his troops. Constantine was first challenged by Maximian, back from retirement and fresh from a defeat at the hands of his son. Maximian was defeated in Gaul and eventually committed suicide (310). Maxentius, under

36 Meaning uncertain. Probably some type of flute or horn.
37 "Which" can refer either to the *pegma* or the stage (*scaena*). The exact nature of this theater machine is unclear.

the very implausible pretext of wanting to avenge his father, prepared for a struggle with Constantine. In 312 the latter invaded Italy and defeated Maxentius at the battle of the Mulvian bridge, during which, according to popular tradition, he had a vision which inspired him ultimately to convert to Christianity. Galerius, in the meantime, had died in 311, and a struggle between his successors Maximinus Daia and Licinius, had resulted in a victory for Licinius. Constantine and Licinius were now *Augusti* of the West and East respectively. In the inevitable struggle for power between the two which followed, Constantine won major victories over Licinius in 315 and 323 and finally put him to death in 324.

The building of a new Christian capital in 330 on the border between Europe and Asia culminates the process, which had been in evidence since the time of Septimius Severus, of de-emphasizing the importance of Rome within the "Roman Empire." Even under the tetrarchy of Diocletian, Milan rather than Rome had been the seat of the *Augustus* of the West. With the building of Constantinople, the *urbs Romuli* yielded once and for all its primacy and became a repository for tradition while European history moved in new directions.

Diocletian: 285-305

Lactantius, On the Death of the Persecutors VII: [The author, who understandably has a Christian's bias against Diocletian, has been criticizing the emperor's edicts on price control and their effects on Nikomedia, Diocletian's imperial seat in the east.] At this time much blood was shed for small and worthless things; out of fear nothing was put up for sale, and the cost of things rose much higher than before. Eventually, after widespread ruin, the law, out of necessity, was annulled. Added to this was a certain immoderate desire for building; it involved no small exaction from the provinces to provide for workmen, artisans, all kinds of wagons, and whatever else might be necessary for the building operations. Here a basilica, there a circus, here a mint, there a factory for armament, here a palace for his wife, there another for his daughter. A great part of the city was quickly razed. Everyone migrated with his wife and children as if from a city which had been captured by the enemy. And when these buildings were completed (and along with it the ruin of the provinces) he [Diocletian] would say, "This has not been done correctly; they should rebuild it in another way." And so it was necessary to pull down a building or alter it, with the possibility that it might be knocked down a second time. Such was the perpetual folly which he revealed in his zeal to make Nikomedia rival Rome.

Diocletian's building projects in Rome are less well-documented. One of the authors of the Historia Augusta *speaks of a statue which once stood "in the area where the Baths of Diocletian have been built, a structure of which the name is as undying as it is revered" (Historia Augusta, Thirty Tyrants XXI, 7). The author of the* Life of Probus *reports that in his time the books which had formerly been in the* Bib-

liotheca Ulpia *in Trajan's forum had been moved to the Baths of Diocletian* (Historia Augusta, Probus *II, 1*). *The famous villa at Spalato, to which he retired in 305, is briefly mentiond by Eutropius (IX, 28).*

Constantine: 305-337

THE BUILDING OF CONSTANTINOPLE [38]

Zosimus II, 30-31: Not being able to endure the condemnation which was on everyone's lips [in Rome], Constantine sought for another city, a counterpoise to Rome, in which he might establish his own imperial seat. Being in the Troad in the vicinity of ancient Ilion and finding a spot which was appropriate for the founding of a city, he laid the foundations and raised the walls to a certain height. It is possible to see these works even today as one sails toward the Hellespont. But changing his intention and leaving the work uncompleted, he moved on to Byzantium. Admiring the site of this city, he decided that he would greatly enlarge it and make it fitting for the dwelling of an emperor. The city lies on a hill, occupying a part of the isthmus which is formed by what is called "the Horn" and by the Propontis. In times past it had a gate at the end of the porticoes which the Emperor Severus constructed when he ceased being angry at the Byzantines because they had received his enemy [Pescennius] Niger. The wall was constructed running down the hill from its west slope to the temple of Aphrodite and the sea opposite Chrysopolis. From the north slope of the hill it ran down in the same manner to the harbor which they call the *Neōrion* [dockyard], and beyond that to the sea which lies directly before the mouth through which ships enter the Euxine [Black Sea]. The length of this narrow space running up to the Pontus is about three hundred stades. This was the ancient extent of the city. After building a circular agora on the spot where the old gate had been and surrounding it with porticoes two stories high, he constructed two very large arches of Proconnesus marble facing one another, through which it was possible to enter the porticoes of Severus and to go out of the old city. Wishing to make the city much larger, he constructed a [new] wall fifteen stades beyond the old one so that it included the whole isthmus, running from sea to sea, within its boundary. By this means he accomplished the task of making the city much larger than it had been before; he also constructed an imperial residence not much inferior to that at Rome. He embellished the Hippodrome with every type of beautiful ornament, and in one part of it he installed the sanctuary of the Dioscuri, the images of whom may

[38] On the evidence for the topography and monuments of early Constantinople see the summary in J. B. Bury, *A History of the Later Roman Empire, A.D. 395-565* (London 1923; reprint 1958), pp. 67-88; also A. M. Schneider, *Byzanz, Vorarbeiten zur Topographie und Archäologie der Stadt* (*Istanbuler Forschungen*, 8; Berlin, 1936).

still be seen today in the porticoes of the Hippodrome. Also standing in a part of the Hippodrome is the tripod of Delphian Apollo which has upon it the image of Apollo. The agora in Byzantium is very large and is surrounded by four porticoes; at the end of one of these porticoes, in which there are a good many steps, he built two temples and established cult images in them, one of Rhea, the Mother of the Gods, which Jason and his comrades, when they happened to be sailing through this area, set up on Dindymon, the mountain dominating the city of Kyzikos. They say that because of his callousness toward the divine he [Constantine] mutilated this statue, removing the lions which flanked it on either side and altering the arrangement of the hands. For previously it had seemed to be holding the lions [with its hands] but now the arrangement has been altered to an attitude of prayer, looking out over the city and diligently taking care of it. In the other temple he installed an image of the Fortune of Rome [*Fortuna Romana*]. He constructed houses for some of those from the Senate who had followed him, but he did not bring any war to a successful conclusion. When the Thaïphaloi, a Scythian tribe, attacked with five hundred horse, he not only declined to offer them opposition, but lost most of the force, and after watching them ravage the land right up to the ramparts, he willingly saved himself by fleeing.[39]

PHILOSOPHICAL AND LITERARY TRADITIONS IN THE ART CRITICISM OF LATE ANTIQUITY

The Life of Apollonios of Tyana

Apollonios of Tyana was a (perhaps essentially legendary) philosopher and wizard who lived during the second half of the 1st century A.D. *Although formally categorized as a neo-Pythagorean, he came to be thought of as the archetype of the eclectic wandering sage, possessed of miraculous powers, whose wisdom probed the depths of all Classical philosophy and religion and was a match for that of the Brahmins in India.*

Almost all that is known about Apollonios comes from a life of him written by Flavius Philostratos, a philosopher and biographer who frequented the court of Septimius Severus and Julia Domna. The Life *of Apollonios was, in fact, written at the request of Julia Domna, and probably reflects the religious sensibilities of the cultured Syrian empress as much as it does those of the obscure Apollonios.*

As has been indicated in the companion volume in this series on

[39] Zosimus, it should perhaps be noted, was a pagan and had a certain bias against the Christian emperors, whom he held responsible in some measure for Rome's decline.

Greece, the Life of Apollonios *contains one of the clearest statements
of the theory, prevalent in Late Antiquity, that the greatest sculptors
relied more on imagination and intuition* (phantasia) *than on imitation
of the external world* (mimēsis) *in creating their masterpieces.*[40] *The
same idea is also applied, although less lucidly, to painting (cf.* Vit. Ap.
Ty. *II, 22).*

The essentially rational discussions of the relative merits of phan-
tasia *and* mimēsis *in the* Life of Apollonios *mark a transitional stage be-
tween the "classical" outlook of high Graeco-Roman civilization and the
more mystically inclined outlook of Late Antiquity. Another interesting
passage which marks this transitional stage occurs in Book IV, section 28,
where Apollonios discusses a statue at Olympia of the athlete Milon of
Kroton, who lived in the late 6th century* B.C.

For Milon seems to be standing on a disc with his feet close to-
gether; in his left hand he holds a pomegranate, and on his right hand
the fingers are straight and rigid as if passing through a narrow space.
The story that they tell about this athlete around Olympia and Arcadia
is that he was inflexible and could never be dislodged by force from the
place in which he was standing. They point out how tight the grip of the
fingers is as they grasp the pomegranate and say that, in the case of the
extended fingers, one would not be able to separate some of them from
the others, even if he struggled with them one at a time, since they fit
together so snugly. As for the fillet which is bound around his head, they
say that it is a symbol of self-control and moderation. These conclusions,
Apollonios said, were wisely conceived, but there were conclusions still
wiser and truer. "So that you may grasp the true significance of the
statue of Milon, let me point out that the people of Kroton made this
athlete a priest of Hera. Now as to what you must know in order to
understand the headband, is there anything I need explain beyond call-
ing to mind the fact that the man was a priest? As to the pomegranate,
it alone of things which grow is grown for Hera. The disc beneath the
feet, furthermore, indicates that the priest prays to Hera while standing
on a shield; the fact that he is praying is also indicated by the right hand.
As to the way the fingers are represented, the fact that there is no space
between them should be ascribed to the archaic style of image-making."

*Since the statue of Milon was undoubtedly a late archaic work,
Apollonios' observation shows a remarkable awareness of sculptural
styles. Whether the other details of his explanation are true or not is
difficult to say. The "fillet" or "headband" may simply have signified a
victorious athlete. The disc was perhaps an archaic plinth. But by con-
trast with the somewhat gullible explanation of the local people, who*

[40] Cf. *The Art of Ancient Greece*, pp. 223-4.

characteristically were looking for symbolic and magical features in the statue, the explanation which Philostratos puts in the mouth of Apollonios seems like that of a scientific archaeologist.

Plotinos: c. 205-270

The seemingly instinctive tendency in the mental climate of Late Antiquity toward transcendental mysticism, which expresses itself in art especially in the reaction against the forms and proportions of Classical Greek sculpture, finds its most mature and serious expression in the neo-Platonic philosophy of Plotinos. Plotinos is said to have been born in Egypt around A.D. *205 and to have accompanied the Emperor Gordian III on his expedition against Persia in the hope of learning something of Oriental philosophy. After the failure of the expedition he seems to have moved to Rome, where between 245 and 270 he lectured on philosophy to a wide circle of pupils and friends, including the Emperor Gallienus and his wife Salonina.*

Plotinos' writings consist of essays (or perhaps lecture notes) which were collected after his death by his pupil Porphyry and arranged in six books, each consisting of nine essays. The entire collection is hence known as the Enneads *(from Greek* ennea, *"nine"). It was almost inevitable that such an artificially arranged collection should have a number of inconsistencies. Essentially, Plotinos' thought involves a working out of the implications about the transcendental nature of being (and the perception of being) inherent in the Platonic dialogues. In the realm of art and aesthetics, as we have attempted to show in* The Art of Ancient Greece *(pp. 223-4), this trend had already begun in the late Hellenistic period with the* phantasia *theory, the theory that the role of a great artist is to perceive transcendental beauty through his personal powers of spiritual insight* (phantasia) *and to give physical form to that vision as best he could.*

At times, however, it is clear that Plotinos supported the traditional Platonic view that art involved nothing more than the simple imitation (mimēsis) *of external nature and that works of art were consequently "images of images," twice removed from reality.*[41] *This feeling is clearly expressed in Porphyry's anecdote about the problems involved in making a portrait of Plotinos.*

Porphyry, *Life of Plotinos* **1:** Plotinos the philosopher, who lived in our own time, gave the impression of being ashamed that he dwelt in a body. As a result of this attitude he could not endure to discuss his lineage nor his parents nor his fatherland. Moreover, he deemed it so degrading to submit himself to being a subject for a painter or sculptor that he said to Amelius, who asked him to permit his portrait to be

[41] Cf. *The Art of Ancient Greece*, p. 233.

made: "Is it not sufficient just to carry around that image which nature has imposed upon us, without making concessions to it by deciding to leave behind a more lasting image of the image, as if it were one of those things which is particularly worth seeing?" Whereupon, when he prohibited the making of his portrait and for this reason refused to pose, Amelius arranged to have his friend Karterios, the best painter of those who were then active, enter and participate in the philosophical gatherings of Plotinos. For it was possible for anyone who so desired to frequent these gatherings. From seeing Plotinos frequently he became accustomed to visualizing more and more striking likenesses of him, owing to his increasingly accurate observation. Finally Karterios drew the portrait from the mental image which had been impressed on his mind, and Amelius corrected the first sketch to an even more exact likeness. Thus the natural talent of Karterios provided a portrait of Plotinos, although he [Plotinos] himself knew nothing of the likeness.[42]

The same Platonic attitude toward the function of art is also directly expressed by Plotinos.

Plotinos, Enneads IV, 3, 10: Art is posterior to nature and imitates it by making representations which are indistinct and weak, playthings of a sort and not worth very much, even though it makes use of many mechanical devices in the production of images.

But elsewhere Plotinos inclines toward the view of late Hellenistic idealism that art has value insofar as it can produce a reflection of and point the way to the intelligible beauty which lies beyond the reach of the senses.

Plotinos, Enneads V, 8, 1: Since we say that the person who has attained to the contemplation of intelligible beauty and who has understood the beauty of the true *nous* [cosmic mind], that this person will also be able to immerse himself in the thought of the transcendent father of that *nous*, we must try to see and to describe to ourselves, to the extent that such things can be described, how one may behold the beauty of the *nous* and of that intelligible world. Visualize, then, if you will, two stones lying near one another, one of them shapeless and bereft of art, the other already wrought by art into a cult image of a god or a figure of some

42 A 3rd century sculptured portrait type of which four replicas exist (one in the Vatican and three in Ostia) has been identified as a portrait of Plotinos. There is no evidence that it has any connection with the painted portrait by Karterios, but the assumption is not improbable. On this Plotinos portrait cf. H. P. L'Orange, "I ritratti di Plotino ed il tipo di San Paolo nell'arte tardo-antica," *Atti del Settimo Congresso Internazionale di Archeologia Classica,* II (Rome 1961), 475-82; "Plotinos-Paul," *Byzantion,* XXV-XXVII (1955-57), 473-85. L'Orange believes that the Plotinos portrait served as the prototype for early representations of Saint Paul. Cf. also G. M. A. Richter, *The Portraits of the Greeks* (London 1965), vol. III, p. 289, figs. 2056-2058.

man—of a god such as the one of the Graces or a Muse, or of a man who is not just any man, but one whom art has created by combining all the beautiful features of men. It is obvious that the stone which has taken on the beauty of the form through art is beautiful not simply from its nature as stone (for in that case the other would be equally beautiful) but by virtue of the form which art has conferred upon it. Now it was not the material which had this form, but rather the form was conceived in the mind [of the artist] before it entered into the stone. And it was in the artist not by virtue of the fact that he had eyes and hands but because he participated in the art. This beauty, moreover, existed in the art in a much greater degree. For that beauty which passed into the stone is not the beauty which is in the art; the latter remains [in the art], while the former, which is extracted from the art, is inferior to that [original] beauty. Nor does even this [derivative] beauty remain pure in the stone, as it would like to, but it exists only to the extent that the stone has yielded to the art. If the art, then, makes an object in conformity with what it is and what it has (and it makes it beautiful in accordance with the form of what it is making), it itself is more, and more truly, beautiful in that it possesses the beauty of art, a thing greater and fairer than whatever may exist in the external object. For to the extent that, in entering into matter, it [that is, the beauty of art] diversifies itself, to that extent is it weaker than when it remains as a unity. For everything which is diversified diminishes itself—if it is strong, it diminishes itself in strength; if it is hot, in heat; if generally powerful, in power; if beautiful, in beauty. The original making-force is of necessity always superior in itself to that which it makes. It is not the lack of music which makes one musical, but music itself, and music in the sensible world is made by a music which is anterior to this world. Now if someone should criticize the arts because they make things which are simply imitations of nature, he should first of all be told that the things in nature are themselves imitations of other things. And then he should also realize that they [the arts] do not simply imitate the visible world but that they refer back to the sources of emanation [*logoi*] [43] from which nature is derived. Then he should also know that they do many things themselves. For since they possess beauty, they add to a particular thing whatever it may lack. When Pheidias made the Zeus [at Olympia], he did not use any model which could be perceived by the senses, but rather he formed a conception of what Zeus would be like if he chose to reveal himself to our eyes.

[43] A *logos* in Plotinos' system is a force projected from a higher plane of existence which shapes a reflection of itself on a lower plane. Thus the cosmic mind is a *logos* of the absolute oneness, and the universal soul is a *logos* of the cosmic mind. The *logoi* referred to are presumably the (Platonic) "forms" or "ideas"—that is, the transcendant archetypes for the objects of the sensible world. Plotinos here breaks away from Plato's attitude toward the arts and aligns himself with the late Hellenistic *phantasia* idea mentioned earlier.

The departure from the Platonic view of the artist as the imitator of nature is paralleled by a departure from the venerable classical conception of beauty as a harmony of parts. Symmetria, the commensurability of parts, seems to have been the most important criterion by which Classical Greek sculptors and painters evaluated beauty in a work of art.[44] *In the following excerpt, Plotinos points out that beauty is also ascribed to things which cannot be analyzed in terms of their component parts.*

Plotinos, *Enneads* I, 6, 1: . . . For the same bodies appear to be sometimes beautiful and sometimes not, as if bodies were one category of being and beautiful objects another. What is the beauty, then, which is present in bodies? First, we should examine the following question. What is it that moves the eyes of the beholders, which turns them toward it, attracts them, and makes them glad at the sight of it? Discovering this we could use it as a ladder by which we might [ascend and] behold still other beauties. It is said by just about everyone that the *symmetria* of parts to one another and to the whole, with the addition of a healthy complexion, produces beauty to the eye and that the beauty in these people, as in all other beautiful things, is dependent upon their being commensurable and measured. To people who hold this opinion, no such thing as simple beauty exists, but of necessity that which is beautiful is composite. To them the whole will be beautiful, but the parts by themselves will not be involved in this beauty except insofar as they contribute to the whole in order that it may be beautiful. But surely it follows of necessity that if the whole is beautiful the parts must be so. For certainly beauty does not arise from ugly things, and it must encompass all the parts. According to these people, beautiful colors, such as the light of the sun, not being composed of parts and not having a beauty arising from *symmetria,* are outside the limits of what is beautiful. In that case how is gold beautiful? By what standard are lightning in the night and the stars beautiful to look upon? Likewise in the case of sounds, beauty will appear and vanish in a simple sound. And often each sound of those which appear in a polyphony which is beautiful will be beautiful in and of itself. And so, when the same face, while its *symmetria* remains constant, appears sometimes beautiful and sometimes not, how is it possible to deny that the beauty, which is in the commensurable object is something different from it, and that the face endowed with *symmetria* is beautiful by virtue of something else? [Plotinos goes on to argue that beauty in an object comes from its participation in a *logos* which emanates from a divine form.]

[44] Cf. this writer's "Professional Art Criticism in Ancient Greece," *Gazette des Beaux Arts,* LXIV (1964), 317-30. Cf. also *The Art of Ancient Greece,* index s.v. *symmetria* and in particular pp. 76-7.

It has been suggested that, in rejecting the Classical insistence that beauty was to be found in the rational analysis of proportion, and in favoring rather the idea that beauty was more directly experienced through a simple, unanalyzed, intuitional experience of light and sound, Plotinos pointed the way toward a medieval aesthetic.[45] *At the same time it is probably also true that Plotinos' influence discouraged any further serious art criticism in the ancient world; for while he recognized that the artist's personal experience could be significant, he seems to have considered individual works of art—whose beauty was "indistinct and weak"—scarcely worthy of attention. Formal analysis of specific statues and paintings and recognition of the specific qualities of proportion and color which characterized them, personal styles of individual artists, technical innovations and changes—all these belonged to an impermanent world from which a perceptive soul aspired to escape.*

The Philostrati

Describing works of art as a rhetorical exercise [46] *continued to be a popular literary genre well into the late Empire.*[47] *Three complete collections of such descriptions have survived from Classical Antiquity, two by writers named Philostratos, the other by Kallistratos.*

The Philostrati were descendants of a prominent family of Lemnian origin which produced several important literary men. The author of the Life of Apollonios of Tyana, *Flavius Philostratos, was, as already noted, a contemporary of Septimius Severus. The author called "Philostratos the Elder" or "the Lemnian" was apparently the son-in-law of Flavius Philostratos and was born in the late 2nd century. "Philostratos the Younger" was, by his own testimony, a grandson of the Elder Philostratos and was active c. A.D. 300.*

Absolutely nothing is known of the life of Kallistratos, although he has been dated on the basis of his style as late as the 4th century.[48]

45 Cf. A. Grabar, "Plotin et les origines de l'esthétique médiévale," *Cahiers Archéologiques* (1945), 15-34. On Plotinos' view of the visual arts in general cf. E. de Keyser, *La signification de l'art dans les Ennéades de Plotin* (Louvain 1955), pp. 29-52; F. Vanni Bourbon di Petrella, *Il Problema dell'Arte e della Bellezza in Plotino* (Florence 1956), pp. 106-21.

46 The Greek term *ekphrasis* is conventionally used by modern critics to describe this practice. In a recent doctoral dissertation, "The Description of Paintings as a Literary Device and its Application in Achilles Tatius" (Columbia University, 1965), Eva C. Harlan has convincingly demonstrated that the exercise which the ancient orators referred to as *ekphrasis* did not encompass literary descriptions of paintings prior to the late 3rd century A.D.

47 Examples of such descriptions by Lucian and by minor poets in the *Greek Anthology* have been given in *The Art of Ancient Greece*, pp. 102, 151-3, 163.

48 Cf. the discussion in the edition of Kallistratos by C. Schenkl, E. Reisch (Leipzig 1902), pp. xxii-xxiii. For a translation of the complete text of the *Eikones* of the Philostrati and of Kallistratos cf. the Loeb edition of A. Fairbanks (London and New York 1931).

The treatises, describing paintings by the Elder and the Younger Philostratos, are both entitled Eikones *(Latin* Imagines*), i.e., "Pictures." Kallistratos' work, which describes statues, is untitled but is usually referred to as the* Descriptions.

Although none of these writers gives us a thoroughgoing theory of aesthetics, certain characteristic attitudes can be discerned in each. We begin with the Elder Philostratos, who, by pointing out the importance of symmetria *in painting and by accepting the principle that painting's primary function is to imitate nature, clearly belongs to a conservative tradition of criticism which we have already seen represented in Roman literature by Vitruvius (see pp. 127-129) and which ultimately goes back to Classical Greece.*[49]

Philostratos the Elder, *Eikones* **I, proem:** Whoever despises painting does an injustice to truth and also to wisdom in the degree that it has come to the poets—for an equal contribution has been made by both toward representing the deeds and appearances of heroes. This person also fails to praise *symmetria,* through which art partakes of reason. For one who wishes to indulge in a clever subtlety, the invention [of painting] may be ascribed to the gods, both on the basis of the appearances which the earth assumes at those times when the Seasons paint the fields and on the basis of celestial phenomena; but for one who investigates the origin of the art with a critical mind, imitation is recognized as an extremely venerable invention and one which is very closely related to nature. Wise and skillful men discovered imitation, calling it at one time painting and at another the art of sculpture [*plastikē*].

Of sculpture there are many varieties—there is modeling itself, and imitation in bronze; then there are those who carve Lygdian and Parian marble; and what is more, by Zeus, there is ivory carving and gem carving. Painting, on the other hand, composes its forms from colors. Not only does it do this, but it cunningly achieves more with this single endowment than the other art does with its many forms. For it not only conveys shadow but also makes known the facial expression at one time of a man who is raging, and at another of a man who is in pain or who is rejoicing. The sculptor scarcely catches at all the different types of radiance belonging to the eyes; but painting knows the "bright eye" and the "grey eye" and the "dark eye," and it also knows auburn, red, and flaming blond hair, the color of clothing and weapons, chambers and houses, groves, mountains, springs, and even the very air in which all these exist.

Now as to all the men who have gained mastery over the science [of painting] and all the cities and kings who have made loving use of

[49] For background on Philostratos see the old but still useful work of E. Bertrand, *Un critique d'art dans l'antiquité: Philostrate et son école* (Paris 1887).

it, these have been narrated by others, especially Aristodemos of Karia, whom I stayed with for four years in order to study painting. (He painted according to the theory [*sophia*] of Eumelos [50] but brought much more charm to the art.) But the present treatise is not about painters and their careers; rather we are going to deliver discourses [*homiliai*] on the features of certain paintings, discourses which have been composed for the young and from which they may be able to interpret paintings and cultivate a taste for what is estimable in them.

The occasion for which these speeches of mine were composed was the following. There was a festival of games held by the people of Naples (this is a city in Italy which was settled by people who are Greek in race and highly urbane, whence they have a typically Hellenic zeal for discussions), and since I did not wish to present my rhetorical exercises in public, the young lads frequently used to come in a throng to the house of my host. I lived outside the city in a suburb facing the sea. Not only did it sparkle with all those building stones which luxury commends, but its brightness was also enhanced by paintings on panels which were fitted into its walls, paintings which, in my opinion, someone had collected with considerable taste. For in them the practiced skill [*sophia*] of many painters was evident. It had already occurred to me that I should speak in praise of paintings, and [the intention was reinforced by] the son of my host, quite a young boy, only ten years old, but fond of listening and endowed with the joy of learning, who followed me like a guard as I approached the pictures and begged me to interpret them. In order that I should not be thought gauche, I said, "All right, these will be my subject, and I shall offer an explanation of them when the young men come." When they arrived I said, "Let the boy come forward and let the effect of my discourse be directed at him. And you must follow the discussion, not only absorbing it but asking questions if anything I say is unclear."

Philostratos proceeds to describe sixty-five paintings, most of which illustrate stories from Greek mythology, although a few depict more generalized mythological landscapes, three represent historical personages (Pindar, Themistocles, and the athlete Arrichion), and three seem to be genre scenes.

A number of the descriptions bear a general similarity to known Pompeian paintings, and it seems not unlikely that Philostratos did have certain actual paintings in mind when he composed these rhetorical

[50] The Greek word *sophia* originally meant "handicraft" or "skill" but by the 4th century B.C. it also came to mean something like "speculative wisdom." In connection with the arts it seems to imply both abstract theory and practical technique. Eumelos is also mentioned briefly in the *Lives of the Sophists* (II, 5) of Flavius Philostratos. He seems to have been active in the late 2nd century A.D. and is known to have painted a picture of Helen which was exhibited in the Forum.

display pieces.[51] *The preserved paintings from Pompeii, Herculaneum, and the neighboring seaside resorts of Campania indicate that the tradition of decorating the walls of villas and town houses with wall-paintings representing subjects similar to those described by Philostratos was flourishing at the time of the eruption of Vesuvius* (A.D. *79), and there is no reason to believe that it died out in the towns which were not destroyed by the volcano. Philostratos' descriptions suggest that the sort of painting which existed in these towns in the 3rd century* A.D. *was not substantially different from that which existed in the 1st.*[52]

A typical example of the mythological paintings described by Philostratos is that depicting the story of Perseus and Andromeda. This story was frequently represented in Pompeian painting.[53]

Philostratos the Elder, *Eikones* I, 29, *Perseus:* This is not the Red Sea, and the people are not Indians; rather they are Ethiopians, and the man is a Greek in Ethiopia. The heroic exploit of this man, which he willingly undertook for love—this, my boy, I think must already be not unfamiliar to you—the exploit, I mean, of Perseus, who they say slew the Atlantic sea-monster in Ethiopia, where it was accosting the herds and the people. The painter celebrates this story and expresses pity for Andromeda because she was given over to the monster. The struggle has already come to an end, the monster has been cast down upon the shore, weltering in pools of blood (which is why the sea is red), and Eros is freeing Andromeda from her bonds. Eros has as usual been depicted with wings but also as a young man, which is somewhat unusual. He is shown gasping for breath and not yet free from the effect of his exertions. For prior to the exploit Perseus offered up a prayer to Eros to stand by him and swoop down with him against the beast; and Eros heard the Greek's prayer. The maiden is very pleasing, both because she has fair skin even in Ethiopia and because her very form expresses sweetness. She would surpass a Lydian girl in daintiness, an Attic girl in seriousness, and a Spartan girl in healthy vigor. Her beauty is heightened by the moment. For she seems to disbelieve what has happened, and she rejoices amid perplexity, and as she looks at Perseus she is already directing a kind of smile toward him. He is seen not far from the maiden in the sweet and incense-laden grass, moistening the earth with sweat as it drips from him, keeping hidden the head of the Gorgon lest the people, upon encountering it, be

51 Obviously, however, one must allow for a certain rhetorical embellishment of the details in each painting.

52 On the subjects used by Philostratos and their relationship to extant Roman painting cf. K. Lehmann, "The *Imagines* of the Elder Philostratus," *Art Bulletin*, XXIII (1941), 16-44; Mary Lee Thompson, "The Monumental and Literary Evidence for Programmatic Painting in Antiquity," *Marsyas*, IX (1960-1961), 36-77.

53 For example cf. A. Stenico, *Roman and Etruscan Painting* (New York 1963), plates 95, 97 (both in the National Museum in Naples). For representations of this scene at Pompeii cf. K. Schefold, *Die Wände Pompejis, Topographisches Verzeichnis der Bildmotive* (Berlin 1957), index, p. 366, s.v. "Andromeda."

turned to stone. Many cowherds are there offering him milk and inviting him to sip some wine. These are Ethiopians, who are charming because of their unusual color, who are smiling grimly, and who, without a doubt, are rejoicing. Most of them look alike. Perseus acknowledges these gifts in a kindly way and, as he leans on his left elbow, throws out his chest, still panting for breath, and stares at the maiden. His purple traveling cloak he exposes to the wind, sprinkled as it is with the blood which the beast breathed upon it during the combat. . . . Handsome and robust as he is by nature, he appears even more so owing to his exertion; his veins are dilated, which is what usually happens to them when gasping for breath increases. And great is the admiration which he wins from the maiden.

Xenia *was the Greek term denoting paintings sent by hosts to their guests depicting various types of food which the host planned to offer.*[54] *Philostratos offers two descriptions of still lifes of this sort, one of which follows.*

Philostratos the Elder, *Eikones* II, 26, *Xenia*: The hare in the cage is a prize of the hunter's net. It is sitting up on its hind legs, moving its fore-paws gently, and slowly perking up its ears; but it looks about as keenly as it can, and wishes that it could also see what is behind it, owing to its suspicion and continued fear. Another hare has been hung on a withered oak, with its belly torn open and [its skin] drawn down over its hind feet; it bears witness to the swiftness of the dog, who sits beneath the oak resting and indicating that he caught the hare all by himself. As for the ducks which are near the hare (count them, there are ten) and the geese, of which there are the same number as of the ducks, it is not neces-sary to squeeze them. For the part around their breasts where the fat is most ample on water birds has been completely plucked. If you like leavened loaves of bread or loaves with eight sections, they too are nearby in the deep basket. Now if you have need of rich fare, you have these very loaves—for they have been seasoned with fennel and parsley and also with poppy seed, which is the spice of sleep—and if you yearn for a [second] course, defer in this matter to the cooks, and turn to the food which requires no cooking. Why, for instance, do you not take the ripe fruits, of which there is a heap piled up in the other basket? Do you not realize that only a short time from now you will no longer find them in the same condition, but that they will already have lost their dew? And do not overlook the desserts, especially if you have any taste for the fruit of the medlar tree and the acorns of Zeus [sweet chestnuts], which that very smooth tree bears in a spiky sheath—a problem to peel. Let even the honey be put aside, since we have on hand this *palathē*[55] (or whatever

[54] On this genre of painting cf. also Vitruvius VI, 7, 4.
[55] Apparently a kind of paste made mostly from figs.

you want to call it). It is, to be sure, a delicious sweet. Its own leaves envelop it, thereby furnishing a beautiful freshness to the *palathē*.

I believe that this painting bears host gifts [*xenia*] to the master of the farm. He is bathing and perhaps visualizes Pramnian or Thasian wine. But it is possible for him to drink the sweet new wine which is on the table, the result of which would be that, upon returning to the city, he would smell of pressed grapes and idleness and could belch at the city-folk.

The Eikones *of the younger Philostratos were, as the author him-self tells us, written in imitation of those of his grandfather. By praising* phantasia *at the expense of* symmetria *in his introduction, the younger writer more clearly reflects the late antique attitude toward art which has been discussed in connection with Plotinos. Of the seventeen pic-tures described in this later set of* Eikones, *fifteen represent mythological subjects, one represents an historical personage (no. 13, "Sophocles"*) and *one represents hunters in a landscape (no. 3).*[56]

Philostratos the Younger, *Eikones, proem:* Let us not deprive the arts of their opportunity to be preserved forever just because we think the challenge of an earlier era is hard to face; nor should we, if a certain task has already been undertaken by someone in an earlier generation, shrink from emulating it to the best of our ability, glossing over our laziness with specious propriety. Let us rather challenge the one who has anticipated us. For if we succeed in our objective we shall achieve something worthy of note, and if in some respect it should happen that we fail, we shall still earn for ourselves the benefit which derives from good intentions by showing that we seek to emulate the things which we praise.

Why have I delivered this prelude? There is a certain description [*ekphrasis*] of works of painting deftly composed by one with the same name as mine, my mother's father, making use of the Attic dialect and employing it with exemplary beauty and crispness. Wishing to follow in the footsteps of this treatise, we feel it necessary, prior to embarking upon this extensive project, to offer certain comments on painting itself, so that our treatise may encompass the basic subject matter which is ap-propriate to the proposed descriptions.

The pursuit of the art of painting is a most noble occupation and does not deal in trivia. For the person who would properly master this art must also be a keen observer of human nature and must be capable of discerning the signs of people's characters even though they are silent;

56 A similar type of picture is described by the Elder Philostratos, *Eikones* I, 28. It may be that some of the descriptions of Philostratos the Younger simply emulate a prototype in rhetoric and do not describe actual paintings.

he should be able to discern what is revealed in the expression of the eyes, what is to be found in the character of the brows, and, to state the point briefly, whatever indicates the condition of the mind. If he has these capabilities, he will seize upon all such indications at once, and his hand will best interpret the individual drama of each person, whether the person happens to be mad or angry or pensive or joyful or aggressive or in love; and in every case he will paint what is appropriate to each. The deception which is in a work of painting is pleasant and deserves no reproach. For to stand before things which do not exist as if they did, and to be affected by them so as to believe that they do exist (from which no harm results)—how is it possible not to regard this as a proper diversion for the spirit, and one which is completely free from blame? [57]

The wise men of former generations, it is my impression, have written much about *symmetria* in painting, establishing laws of a sort for the proportion of each of the parts of the body to the others, as if it were not possible to capture successfully the various mental states unless the harmony of the body came within the scheme of measurement derived from nature. For an unnatural form, one which is outside of this measurement, cannot [in their opinion] convey the mental experience which properly belongs to the natural world. But if one reflects on this matter, the art of painting will be found to have a certain kinship with poetry, and it will be found that a certain inventive imagination [*phantasia*] is shared by both. For the poets produce the actual presence of the gods on their stage and all the dignity, holiness, and delight of soul which it involves. Painting likewise indicates those things through line which the poets convey through speech.

But why need I discourse about what has been admirably discussed by many others, or, by saying more, make it seem that I am producing an encomium on this subject [painting]? For these comments, even though they have been quite brief, are sufficient to show that this earnest effort on our part will not have been in any way wasted. For when I have come upon pictorial compositions by a cultured hand, pictures in which the ancient exploits are represented in a fashion not lacking in refinement, I do not deem it right to pass over them in silence. But in order that our writing need not go forward on one leg, let it be assumed that there is another person, to whom one must explain each detail, in order that the discourse may thus have what is appropriate to it.

As the following excerpt will indicate, the interest in depicting psychological states, which the younger Philostratos demonstrates in his introduction, is also revealed in his actual descriptions.

[57] Contrast this idea with the conservative rationalism propounded in Vitruvius' discussion of wall-painting (see p. 128), which in turn is derived from Plato's view that painting is reprehensible because it indulges the human capacity for self-deception.

Philostratos the Younger, *Eikones* 5, *Herakles in Swaddling Clothes* [58]:
You are playing, Herakles, you are playing and already laughing at your
exploit—and what is more, you are still in swaddling clothes—as you
grasp in each hand the serpents sent by Hera, paying no attention to
your mother, who stands by and is almost mad with fear. But the serpents
are already exhausted, and they stretch out their coils on the ground and
droop their heads toward the infant's hands, still menacing somewhat
with their teeth. These are sharp and poisonous. The serpents' crests are
slumping to one side at the approach of death, and their eyes have
ceased to see. Their scaly skin no longer glistens with gold and purple,
nor does it shine at their different twists and turns; rather, it is sallow and
livid even in its tawniness.

 The appearance of Alkmene, to one who studies her closely, seems
like that of a person who is getting over an initial shock. The shock
makes it intolerable for her to remain in bed. For you perhaps notice
how, without her slippers and wearing only a single tunic, having
jumped up from the bed with her hair unkempt and her arms stretched
out, she shouts while the servant girls who were present when she gave
birth are in a state of alarm, and each converses nervously with whomever
happens to be next to her. These men here are in armor, and one of
them is ready with an unsheathed sword. They are the choice troops of
the Thebans who have come to aid Amphitryon, and it is Amphitryon
himself who, having drawn his sword to ward off danger as a result of the
first report, is now present to witness the events which are transpiring;
and I do not know whether he is petrified by shock, or whether, in the
final analysis, he is rejoicing. For his hand is still poised in readiness, but
the thoughtfulness revealed in his eyes imposes a bridle on his hand,
since there is no danger which he might ward off, and the [interpretation
of] the situation which he sees requires the foreknowledge of an oracle.
And in fact Teiresias is depicted nearby, prophesying, I suppose, just
how great a hero this child who is now in swaddling clothes will become;
he seems divinely inspired as he breathes out his mantic utterance.
Night, which is when these events took place, is also depicted in the form
of a personification, illuminating herself with a torch, so that the heroic
exploit of the child may not pass without a witness.

Kallistratos

 The fourteen rhetorical display pieces which make up the Descrip-
tions *of Kallistratos purport to describe famous statues which the author
had actually seen, but the generalized and formulaic nature of the
descriptions suggests that they could have been composed even if Kal-*

 58 A fourth-style wall painting of this subject from the house of the Vettii at
Pompeii bears a general similarity to the scene described by Philostratos; cf. A. Maiuri,
Pompeian Wall Paintings (Berne 1960), no. XII; G. Rizzo, *La Pittura Ellenistico-
Romana*, pl. XXXVI.

listratos had not actually seen the statues in question. Each work is praised for its marvelous realism; the author repeatedly expresses his amazement at the fact that the bronze or marble is not really flesh and that the statue does not really breathe or move from its base. Kallistratos' aesthetic, in other words, marks the last stage of what we have called the "popular criticism" of Antiquity.[59]

The following highly characteristic excerpt supposedly describes a Dionysos by Praxiteles. Whether Kallistratos really had a statue by Praxiteles in mind or whether he is simply describing a common statue type (and enhancing its importance as a rhetorical subject by attaching a famous name to it) is difficult to determine, since the work is described in only the most general terms.

Kallistratos, *Descriptions* 8, *On the Image of Dionysos:* It was possible for Daedalus, if one is constrained to believe that miracle connected with Crete, to devise statues which could move and to compel gold to experience human sensation; but the hands of Praxiteles created works which were thoroughly alive. There was a grove, and Dionysos, represented in the form of a young man, stood within it; so delicate was he that the bronze seemed transformed into flesh, so pliant and relaxed was his body that it seemed to be made of another material and not of bronze. Though it was of bronze it nevertheless blushed, and though not really partaking of life, it nevertheless wanted to convey the appearance of life; it would draw back from the tip of your finger if you touched it, and the bronze, though in reality quite hard, nevertheless, being softened into flesh by art, evaded the touch of the hand. He was represented in the bloom of youth, full of languid charm, and was melting with desire, just as Euripides made him appear when he represented him in the *Bacchae*. A garland of ivy encircled his head—it seemed that the bronze was actually ivy, bent as it was into sprigs and holding up the curly locks which poured down his forehead. He was full of laughter; in fact, the statue passed completely beyond the limits of wonder, since the material betrayed all the signs of a feeling of pleasure, and the bronze, like an actor, gave every indication of human emotions. A fawn-skin covered the figure, not like that which Dionysos usually has draped over him; rather the bronze was wrought into an imitation of the hide. He stood there leaning heavily upon a *thyrsos* [Dionysiac pine wand] with his left arm. The *thyrsos* deceived the senses, and, though it was made of bronze, it seemed to gleam with a certain greenness and fertile richness, as if it were changing its actual material into the vegetation which it represented. The eye glowed with a fire which gave the impression of madness. For the bronze did reveal the Bacchic frenzy and seemed to be inspired, just as, I believe, Praxiteles, through inspiration, was able to instill the Bacchic madness [into the statue].

59 Cf. *The Art of Ancient Greece*, p. 6.

Appendix

Supplementary information on authors and collections used in this volume.

(Where biographical information on particular authors has been given in the text it is not reproduced here.)

Greek

Appian (mid 2nd cent. A.D.)—lawyer and historian born in Alexandria, author of a history of Rome from the earliest times to Trajan. Ten (plus additional fragments) of its twenty-four books survive.

Athenaeus (c. A.D. 200)—rhetorician and antiquarian from Naukratis in Egypt.

Damascius (later 5th cent. A.D.)—neo-Platonist philosopher, born in Syria, who wrote commentaries on the works of Plato and Aristotle.

Dio Cassius (Cassius Dio Cocceianus, c. A.D. 150-235)—Roman senator, born at Nicaea in Bithynia, who held high government offices (including the consulship twice) and was an intimate of Alexander Severus (see p. 192). His partially preserved history of Rome from the earliest times to A.D. 229 ends with an eye-witness account of the age of the Severans. The numeration of books and sections in the present volume follows the edition of U. P. Boissevain (Berlin 1901).

Dionysios of Halikarnassos (late 1st cent. B.C.)—rhetorician, literary critic, and historian. His *Roman Antiquities* in twenty-four books analyzes the institutions of Rome down to the time of the First Punic War.

Herodian (c. A.D. 165-250)—historian from Syria, author of a history of Rome from A.D. 180 to 238.

Josephus (c. A.D. 37-100)—Jewish soldier and historian who received Roman citizenship under the Flavians. He wrote a general history of the Jews and also a history of the Jewish wars from the revolt of the Maccabees to the capture of Jerusalem by Titus.

Pausanias (middle and late 2nd cent. A.D.)—Greek traveler and antiquarian, author of a *Description of Greece,* probably written during the reigns of Antoninus Pius and Marcus Aurelius.

Photios—Patriarch of Constantinople (c. A.D. 858-867, 878-886), Byzantine lexicographer and encyclopaedist.

Plutarch (c. A.D. 46-120)—Greek biographer, essayist, and moralist from Chaironeia. His *Parallel Lives* compare the achievements of famous Greeks and Romans.

Polybios (c. 202-120 B.C.)—Greek historian from Megalopolis. He was taken to Rome as a hostage after Pydna (168 B.C.) and became the tutor and friend of Scipio Aemilianus. He wrote a history tracing the rise of Rome to world power between 264 and 144 B.C.; only portions survive.

Porphyry (c. A.D. 232-305)—philosopher and scholar from Tyre, author of a biography of Plotinos, and editor of the *Enneads.*

Procopius (6th cent. A.D.)—Byzantine historian, a prominent figure at the

court of Justinian. His *Anecdota* ("Secret History") chronicles the scandals of the court.

Strabo (c. 64 B.C.-A.D. 21)—geographer and historian from Amaseia in the Pontus region.

Zosimus (5th cent. A.D.)—Byzantine governmental official and historian, author of a history of Rome from Augustus to c. A.D. 410.

Latin

Ammianus Marcellinus (4th cent. A.D.)—historian and soldier from Antioch, author of a history of Rome from A.D. 96 to 378.

St. Augustine (Aurelius Augustinus, A.D. 354-430).

Aurelius Victor (2nd half of the 4th cent. A.D.)—politician, soldier, and historian from Africa, author of a work known as the *Caesares,* consisting of biographies of the emperors from Augustus to Constantius.

Cassiodorus (c. A.D. 487-583)—a high government official under Theodoric. He later became a monk and wrote a variety of historical, scholarly, and devotional works. His official writings, dating from his governmental career, were published under the title of *Variae.*

Cicero, Marcus Tullius (106-44 B.C.)—Roman orator, statesman, and philosopher.

Eutropius (2nd half of the 4th cent. A.D.)—author of a brief history of Rome down to A.D. 364.

Festus, Sextus Pompeius (late 2nd cent. A.D.)—grammarian and scholar, author of an epitome of the treatise "On the Meaning of Words" by the Augustan scholar Verrius Flaccus.

Florus (2nd cent. A.D.)—rhetorician and historian active during the reign of Hadrian, author of a short Roman history up to the time of Augustus.

Gellius, Aulus (c. A.D. 123-165)—Roman lawyer, author of the *Noctes Atticae (Attic Nights),* a collection of grammatical, historical, and philosophical anecdotes.

Historia Augusta—the name given to a collection of biographies of thirty emperors (from Hadrian to Numerian). The biographies are dubiously ascribed to authors named Julius Capitolinus, Aelius Lampridius, Aelius Spartianus, Vulcacius Gallicanus, Trebellius Pollio, and Flavius Vopiscus. Estimates for the date of their composition range from the time of Diocletian to that of Julian the Apostate (A.D. 361-363).

Lactantius, Caecilius Firmianus (2nd half of the 3rd cent. A.D.)—Christian theologian and polemicist— born in Africa.

Livy (Titus Livius, 59 B.C.-A.D. 17)—Roman historian born at Padua. At the instigation of Augustus he wrote a history of Rome from the foundation of the city to his own time. Of its 142 books, thirty-five plus fragments and epitomes of others survive.

Martial (c. A.D. 40-104)—Roman poet from Spain; a specialist in the epigram.

Ovid (Publius Ovidius Naso, 43 B.C.-A.D. 18)—versatile *Roman* poet who

specialized in amatory verse; this displeased Augustus and was a contributing cause of the poet's exile in A.D. 8. The *Fasti*, a sober work describing the Roman ritual calendar, was intended to win the emperor's favor.

Plautus (c. 254-184 B.C.)—Roman comic playwright, born at Sarsina in Umbria.

Pliny the Elder (Gaius Plinius Secundus, c. A.D. 23-79)—Roman encyclopaedist, born near Lake Como. Books 33-36 of his *Natural History* constitute the single most valuable ancient literary source for the study of Greek and Roman art.

Pliny the Younger (c. A.D. 61-113)—the nephew and later the adopted son of Pliny the Elder; he attained prominence as a rhetorician and government official under Trajan.

Porphyrio, Pomponius (early 3rd cent. A.D.)—author of a commentary on the poems of Horace.

Seneca, Lucius Annaeus (Seneca the Younger, 4 B.C.-A.D. 65)—rhetorician, moralist, philosopher, and playwright born at Corduba in Spain. He was the tutor and political adviser of Nero.

Servius (later 4th cent. A.D.)—grammarian, author of a commentary on Vergil.

Suetonius (Gaius Suetonius Tranquillus, c. A.D. 69-140)—Roman lawyer and biographer who was for a time secretary to Hadrian. His biographies emphasize the scurrilous and the sensational.

Statius, Publius Papinus (c. A.D. 45-96)—epic and epideictic poet, born at Naples. He was intimately connected with the court of Domitian.

Tacitus, Cornelius (c. A.D. 55-120)—distinguished Roman historian, rhetorician, and government official. His *Annals* were a year-by-year account of events in Rome from the accession of Tiberius to the death of Nero. The *Histories* recount events from the reign of Galba through Domitian. Both are only partially preserved.

Tertullian (c. A.D. 160-225)—early Christian theologian and apologist, born in Carthage.

Valerius Maximus (early 1st cent. A.D.)—Roman rhetorician and historian; author of a collection of moralistic historical anecdotes.

Varro, Marcus Terentius (116-27 B.C.)—Roman scholar and antiquarian (see Introduction).

Velleius Paterculus (c. 19 B.C.-A.D. 31)—Roman military officer and amateur historian; an admirer of Tiberius.

de Viris Illustribus (4th cent. A.D.?)—a collection of short biographies of prominent figures in the history of the Roman Republic. The work is sometimes ascribed to Aurelius Victor.

Index

INDEX OF ARTISTS

(A) = architect; (E) = engraver; (P) = painter; (S) = sculptor

AGORAKRITOS (S), xix note 12
Apaturius (A), 128-129
Apelles (P), 148, 153 note 114
Apollodoros (A), xv, 170, 175
Apollonides (E), 116
Apollonios (S), 75
Arellius (P), 87
Aristeides (P), 47
Aristodemos (P), 221
Arkesilaos (S), xix note 12, 75, 88, 89

BATRACHOS (A), 46

CELER (A), 142, 143
Chares (S), 90
Coponius (S), 89, 113 note 37
Cossutius (A), 64

DAEDALUS (S), 227
Damophilos (S,P), 17
Decrianus (A), 175
Demetrios (P), 52 notes 93 & 94, 147 note
 104
Diogenes (S), 107
Diognetos (P), 184
Dionysios (P), 87
Diopus (S), 6
Dioskourides (E), 117

EKPHANTOS (P), 7
Eucheir (S), 6
Eugrammos (S), 6
Eumelos (P), 221
Euphranor (P,S), 79, 90, 175
Eutychides (S), 75
Evander, Avianius (S), 79, 89

FABIUS PICTOR (P), 26, 52
Famulus (P), 143, 146, 156

GABINIUS, Antiochos (P), 87
Gorgasos (S,P), 17

HELIODOROS (S), 112
Heniochos (S), 75
Hieron (P), 72, 73

IAIA (P), 87

KALAMIS (S), 4 note 110, 90, 145
Karterios (P), 216
Kleomenes (S), 75
Kronios (E), 116
Kydias (P), 79

LABEO, Titedius (P), 156
Lysias (S), 112
Lysippos (S), xiii, xix note 11, 42, 45, 132,
 133, 164

MENTOR (E), xix note 12, 80
Metrodoros (P), 45, 52
Myron (S), xii, 68

NIKIAS (P), 115, 133

ONATAS (S), 145 note 102

PACUVIUS (P), 52, 155
Papylos (S), 75

GEOGRAPHICAL INDEX

(Major geographical areas and sites of archaeological or art historical importance)

GENERAL INDEX

(R) = representation or portrait of